After the Avant-Gardes

After the Avant-Gardes

Reflections on the Future
of the Fine Arts

Edited by
ELIZABETH MILLÁN

OPEN COURT
Chicago and La Salle, Illinois

To find out more about Open Court books, call toll-free 1-800-815-2280, or visit our website at www.opencourtbooks.com.

Open Court Publishing Company is a division of Carus Publishing Company, dba Cricket Media.

Printed and bound in the United States of America.

ISBN: 978-0-8126-9892-3

Library of Congress Control Number: 2015934983

Contents

III The Prison of Avant-Gardism

Introduction

Elizabeth Millán

The following collection is the fruit of intellectual labors begun at an Arts Colloquium held under the auspices of the Hegeler Institute, at the Hegeler-Carus Mansion in La Salle, Illinois, on March 28th–30th, 2003. The theme of the meeting, "After Modernism and Postmodernism: New Directions in the Arts" was approached from a variety of disciplinary angles. The resulting collection is interdisciplinary, with literary theorists, philosophers, music scholars, poets, public intellectuals, and studio artists articulating their views on the future of the fine arts.

The book is divided into three parts. Part I, "The Future of Art," is the most theoretical, with each contributor developing views on the meaning of modernism and the future of art. The two essays in Part II, "Progress and Permanence" deal with the problem of progress in art and the marks of truly progressive art. The final part, "The Prison of Avant-Gardism," poses some biting challenges to the view that the avant-garde opened productive spaces for the future of art. While no essay sings a song of nostalgia for some lost Golden Age of art, many of the essays do emphasize that there is much of value to be found in the models of art offered in the past, and that there is still room for beauty in art. A theme connecting the essays is a tone of alarm with the way in which art has been "progressing" in our culture.

The following lines from Frederick Turner well capture a sentiment of the contributors:

> It is my contention that our "high" or "academic" or "avant-garde" culture is in a state of crisis. This crisis is not a healthy one, but a sickness unto death, a decadence that threatens to destroy our society.[1]

Turner was the keynote speaker at the La Salle meeting, and in his work he diagnoses a sickness from which our culture suffers and prescribes

what he calls, "a real cure"—one which "treats our mind and imagination as well as our behavior."[2] The spirit of Turner's concern for the crisis confronting our culture inspired the meeting and it inspires the contributions to this volume.

Most of the contributors are pessimistic about certain paths that art has taken, but like Turner, express hope about the future for art, as long as art can break away from a certain obsession with the avant-garde. Turner speaks in terms of a "new constellation of hope."[3] The essays in this collection can be said to be part of such a constellation of hope for the future of art.

Due to various circumstances, some of the essays have remained untouched for several years while others have been updated more recently.

1

The Future of Art

[1]
The Importance of Being Odd: Nerdrum's Challenge to Modernism

PAUL A. CANTOR

Modern art cannot be exempt from history. It will fail by its lack of sensual presence. Modern art lacks flesh.

— ODD NERDRUM

State is the name of the coldest of all cold monsters. . . . Only where the state ends, there begins the human being who is not superfluous: there begins the song of necessity, the unique and inimitable tune.

— FRIEDRICH NIETZSCHE

I

The Norwegian artist Odd Nerdrum is one of the greatest painters of the century. Unfortunately, according to his detractors, the century in question is the seventeenth. Thus Nerdrum has emerged as one of the most controversial artists of our day. His admirers praise him for his superb Old Master technique, while his critics condemn him as hopelessly reactionary. To look at Nerdrum's paintings does seem to involve a step back in time. His work calls into question all our customary narratives about art history, and especially the modernist dogma that the artist can be creative only by turning his back on the past. Nerdrum has openly acknowledged his debt to the Old Masters. He uses heavy layers of paint to create chiaroscuro effects reminiscent of Caravaggio and Rembrandt, and he also continually recalls the great Italian and Dutch painters in his ability to capture the texture of things on canvas—from shiny metals to rich fabrics—above all, he knows how to convey every shade of human flesh. Viewing a Nerdrum painting is thus an uncanny experience. We are not used to seeing such mastery of the art of figurative painting in a living artist. And yet the subject matter of Nerdrum's

3

works is usually enough to place him in the modern world. Early in his career, his works reflected contemporary political concerns; for example, he painted German terrorists and Vietnamese boat people. And in the major phase of his career, commentators have seen him creating some kind of post-apocalyptic universe, with his dark palette underwriting a dark vision of the end of civilization as we know it. In terms of his painterly technique, Nerdrum may seem like a reactionary, but there is something disturbingly futuristic about the way he pictures the world.

Nerdrum's career thus presents a challenge to the modernist establishment that still dominates the international art scene. He refuses to paint like a modernist, but thematically he seems to be responding to a crisis in the modern world; indeed he seems to be coming to grips with the spiritual state of modernity in a way far more profound than that pursued by most painters who style themselves 'modernist'. Thus few contemporary painters have managed to enrage the modernist establishment as much as Nerdrum has. The artists, critics, curators, dealers, and professors who comprise the modernist establishment sense that if Nerdrum is right, then they must be wrong, and he has been greeted by derision and rejection from modernists at every stage of his career. Nerdrum has in fact managed to shock a modernist establishment that generally prides itself on its unflappability. They will accept almost anything on canvas—a scribble, a scrawl, even a blank—but evidently it upsets them to contemplate a recognizably human form well rendered in all its fleshiness by a living painter. That is the paradox of Nerdrum's place in the art world today. For all its claims to being avant-garde, modernist art has long since lost its ability to surprise; nothing has become more predictable than the decades-old strategies of modern art to try to do something new and daring. But by returning to the Old Masters, Nerdrum has broken with modernist convention and come up with a form of painting all his own. With apologies to Robert Hughes, one might credit Nerdrum with having invented a new artistic effect, 'The Shock of the Old'.

My own encounter with Nerdrum is representative. I had never heard of him when in the late 1980s I noticed two small paintings by him in the Lila Acheson Wallace Wing of the Metropolitan Museum of Art in New York, one a self-portrait and one a painting of a baby wrapped in swaddling clothes (two typical Nerdrum subjects as I was later to learn). I was immediately drawn to these paintings; in the midst of a good deal of standard modernist art, they caught my eye. It was the Old Master technique that first impressed me. I could not believe that any living artist was painting with such richness of detail and warmth of color. But I also was struck by the subject matter of these paintings. In its psycho-

logical depth, the self-portrait reminded me of Rembrandt (at the time, I knew nothing of Nerdrum's devotion to Rembrandt), and I found the painting of the baby even more haunting, for reasons I could not articulate back then, but I would now speak of how Nerdrum's sleeping infants capture the vulnerability of human life in its most fragile form. Unfortunately, in my first encounter I was unable to learn anything about Nerdrum other than what was recorded on the labels of the Met's paintings—that he was Norwegian and was born in 1944.

My next encounter with Nerdrum came in 1996 when I was visiting the New Orleans Museum of Art with a fellow English professor, Michael Valdez Moses of Duke University. As I entered the central hall of the New Orleans museum, I had a vision from more than a hundred feet away of a large painting that could only be by that Norwegian artist I had discovered at the Met. Although my Met experience had taught me to recognize a Nerdrum when I saw one, it had not prepared me for the impact of one of his genuine masterpieces. The painting in New Orleans is his 1992 *Five Persons around a Waterhole*—a huge canvas—111 × 140 inches—that exhibits all his trademark strengths—the enigmatic subject matter captured in dark, mellow colors, the twilight mood, the deep sense of desolation, the feeling of humanity at the limits of its endurance. From the moment I saw that painting, I became a confirmed believer in Nerdrum as an artist. Indeed, given the nature of his technique, and especially the careful and deep layering of paint, his works must be seen in person to be truly appreciated. Reproductions simply cannot do them justice, just as they cannot convey the full greatness of Caravaggio's or Rembrandt's paintings.

And yet my intermittent efforts to track down more of Nerdrum's paintings in the flesh, so to speak, have proved disappointing. I have gone to several museums that are listed as having Nerdrum paintings in their collections: the Fort Lauderdale Museum of Art, the Frye Art Museum (in Seattle), the Hirschorn Museum (in Washington, DC), the Milwaukee Museum of Art, the Museum of Modern Art (in New York), and the Portland Art Museum (in Oregon). Unfortunately, none of these museums had their Nerdrum paintings on display when I visited. I realize that museums have limited wall space for display, and at any given moment they must keep significant portions of their collections in storage. Some of these museums may in fact be well-disposed toward Nerdrum; after all, they own his paintings, and the Frye, which is explicitly devoted to the figurative tradition in painting, had a major Nerdrum exhibition in 1997. Still, my nation-wide search for Nerdrums has led me to suspect that museum curators are reluctant to display his works

even when they own them. My colleague Moses, who became as much of a Nerdrum fan as I am during our New Orleans visit, reports that when he was at the Museum of Contemporary Art in San Diego, he found a postcard of a major Nerdrum painting, *The Sleeping Twins* (1987), in the museum store. The painting was not, however, on display, and he had to talk a curator into letting him see it in the basement vault. Moses tracked down one more American museum that displayed a major Nerdrum painting—the North Carolina Museum of Art in Raleigh has on loan from one of the galleries that represents Nerdrum one of his best-known paintings, *The Water Protectors* (1985–1993), and I made a special trip to see that. In short, Nerdrum's works can be seen in the United States—especially as it turns out at galleries in New York and Los Angeles—but it does take some effort.

I tell the story of my personal encounter with Nerdrum's work because it reveals something about the current state of the art world. I had to learn about Nerdrum entirely on my own. Although I am reasonably aware of art news, and go to museums more frequently than most people, nobody alerted me to the emergence of a major talent from Norway. Fortunately, and to its credit, the Met did have two of his paintings on display rather early in his career, but they were not prominently displayed—no stickers proclaiming 'Director's Choice' or announcing that Nerdrum was a stop on the audio tour. From my experience in search of Nerdrums, I feel compelled to conclude that the art establishment would be happy if Nerdrum would just go quietly away and take his figurative paintings with him. Seeing Nerdrum's works side by side with the supposed masterpieces of modernism might lead museum visitors to make invidious comparisons and ask all sorts of questions that might embarrass the art establishment.

With all my difficulties in just seeing Nerdrum's paintings, I do not wish to give the impression that he remains unknown to the art public. Despite all the efforts of the modernist establishment to keep Nerdrum in obscurity, he has built up a substantial reputation over the years and it shows signs of growing. I would like to be able to say that this is a tribute to the sheer power of Nerdrum's art, and to some extent I believe it is. But I have to admit that some of Nerdrum's success must be attributed to a genius for self-promotion that reminds me of nothing so much as the early modernists. Indeed, Nerdrum seems to have learned from his opponents—a lesson in the value of casting himself in the role of the rebel against the artistic establishment. Now that modernism has lost its edge and become the artistic establishment itself, Nerdrum knows that the way to stand out from the crowd is to position himself against mod-

ernism. He really is a rebel by temperament and his quarrel with modernism is genuine and runs deep. Nevertheless, at a number of points in his career he seems to have milked his opposition to modernism for all that it was worth in terms of publicity. He has a modernist's sense of theatricality and an unerring feel for how to shock the public when it will work to his advantage. For example, he used the occasion of a series of serious exhibitions of his paintings from 1998 to 2000 in Norway to proclaim himself publicly the King of Kitsch.[1]

As a result of his talent for painting and for self-promotion, Nerdrum has emerged as a significant figure on the international art scene, although more in the realm of private galleries than in that of museums. Between 1994 and 2001 three major monographs on his career have been published, each more lavishly illustrated than the last.[2] For the past two decades, there has been a Nerdrum solo exhibition in Europe or America nearly every year. The Nelson-Atkins Museum of Art in Kansas City seems to be the most famous museum that has hosted a Nerdrum exhibition (1989), but if one includes galleries, his paintings have been featured in major artistic centers such as New York, Los Angeles, Paris, London, and Berlin. Although Nerdrum is not yet a figure for the art history books, let alone art history classes, he is discussed in several important works on contemporary painting.[3] Nerdrum's paintings are reported to sell well, especially in New York and Los Angeles. Sales figures for contemporary paintings are difficult to verify, but one of the galleries that represents Nerdrum, Martina Hamilton in New York, states on its web site that his prints sell for about $7000, his charcoal drawings are in the $25,000–75,000 range, and his paintings in the $40,000–300,000 range. I have seen an early portrait by Nerdrum (circa 1980) listed on the Internet with an asking price of $45,000, and a painting entitled 'The Brick' quoted at $50,000. An article in the Norwegian newspaper *Aftenposten* (8/20/02) discusses a documentary film being made about Nerdrum by Solveig Kjoek, who wants to find out "why Nerdrum is popular in the US but often scoffed at home in Norway." She says that in New York "collectors pay huge sums for Nerdrum's paintings" and he "has a near 'rock-star' following" (speaking of rock stars, David Bowie is rumored to be a collector of Nerdrum's art, and the two have been photographed together). Beyond his commercial success, Nerdrum increasingly shows signs of artistic success where it most counts—among young artists. He has become an underground hero for figurative painters everywhere, and I have seen evidence of young artists being influenced by his work, even to the point of their paying homage to specific Nerdrum paintings.

As disturbing as it may be to the modernist establishment, Nerdrum may thus represent the wave of the future in painting. He has fared extremely well on the most cutting-edge of all phenomena, the Internet. There are many websites devoted to Nerdrum, both official (from his galleries) and unofficial.[4] The great advantage of the Internet is that it weakens the power of all establishments and especially cultural mediators, allowing people to communicate their views directly, without being monitored by so-called experts or authorities in the field. If one looked at official academic discourse on contemporary painting, Nerdrum would not be featured prominently, if discussed at all, but if one looks at the Internet, he clearly has a wide following. In December 1999 one of the most useful art sites on the Web, artcyclopedia.com, ran a poll to find out: "Who is producing the most interesting art today?" The results were announced in February, 2000 and Odd Nerdrum came in second, surpassed only by Andrew Wyeth, and followed by Chuck Close, Cindy Sherman, Mark Tansey, Carole Hand, Lucian Freud, Tracey Emin, Dale Chihuly, and Bill Viola. This list suggests that the voters were biased in favor of figurative art, but in any case, it is a rather distinguished group in which Nerdrum finds himself. I happen to know one person involved in artcyclopedia.com and checked with him about the reliability of this poll. He reassured me that there were no anomalies in the voting and that "the polling was strictly scientific in its tabulation" (the sample was small—under a thousand people). The person who ran the poll did suggest that one reason Nerdrum might have done so well is that he had been featured in July 1999 as "artist of the month" on the website. One should not make too much of this one poll, but one should not entirely discount or dismiss the results either. Nerdrum is clearly catching on with the general public. The modernist establishment may have known what it was doing all these years of trying to keep Nerdrum's paintings off the walls of museums. His work is a genuine threat to the dominance of the modernist aesthetic.

II

Nerdrum's career as an artist has been one long struggle against modernism, and as such he demonstrates the intolerance of an artistic establishment that publicly professes to be pluralist and open to all artistic possibilities, but in fact rejects anyone who fundamentally questions its assumptions. Like many artists, Nerdrum was precocious and began to demonstrate an eye for form and color at an early age. Thus Nerdrum's encounter with and struggle against modernism began in his childhood:

I was captured by art at an early age, and painted Poliakoff-like abstractions before I turned nine. A reason for this was probably my stepfather. He was a cultivated man who collected modern art. Often he took me on skiing trips. . . . Once, when we reached a height, we stopped and looked at the scenery. The valley in front of us lay bathing in the light from a magnificent sunset. For a moment we were enthralled by the sight. Then he said: "It is beautiful, but remember never to paint anything like this if you become an artist, then you will not be accepted at the Autumn Exhibition."[5]

This anecdote of little Odd being browbeaten into becoming a modernist by a wicked stepfather is a marvelous inversion of the foundation myth of modern art—the young Picasso rebelling against his father, who kept telling him that he must paint in a traditional style if he wanted to be a commercial success. Here, more than half a century later, the situation is reversed. The young Nerdrum is forbidden by his stepfather to paint a beautiful sunset, lest he ruin his artistic career, and he is coerced into painting in the abstract mode. Nerdrum's amusing anecdote is a serious measure of how completely the modernist credo had come to dominate the world of art by the middle of the twentieth century.

Thus to be a rebel, Nerdrum had to revolt against modernism and he quickly began to develop doubts about the artistic principles being forced upon him. In 1962, he entered the National Academy of Art in Oslo, but in such a way that to him the whole process seemed tainted. As one of his supporters explains: "The application had included three paintings. Two of them were reasonably finished, while the third one had been hurriedly thrown together to meet the deadline. The fact that this was the one that the committee found so promising as to admit him into the nation's leading art school, made him question the criteria applied to modern art. This was too easy; it offered too little resistance."[6] Already in his early teens, the audacious Nerdrum began to take advantage of his stepfather's executive position in the Scandinavian Airlines System to travel all over Europe and eventually even to New York to broaden his knowledge of art. The result was two-fold—he learned to appreciate Old Masters such as Rembrandt and Caravaggio, and he grew increasingly disillusioned with the work of modernists such as Robert Rauschenberg. As Nerdrum himself reports: "Modernism felt old and sad. I had seen so much of it that I was fed up."[7]

With such an attitude, it was not long before Nerdrum began to run afoul of the Norwegian art authorities. In 1964 he took part in an exhibition in Oslo, for the first time unveiling to the public what one reviewer called his "old-masterly gravy."[8] Nerdrum immediately provoked the hostility of the Norwegian art press; a critic named Ole Henrik

Moe wrote in *Aftenposten* (June 11th, 1964): "It simply won't do to ignore a whole generation of progress towards the limits of abstraction, to deny surrealism, cubism, Klee, Kandinsky, Picasso, Francis Bacon. . . . It takes courage, however, to face up to one's own time, more courage than is needed to beat the baby drum of reactionism."[9] One might quarrel with an art critic who chooses to measure a twenty-year-old art student against the likes of Picasso, but the real question is whether Nerdrum was in fact exhibiting more courage by his willingness to challenge what had become in his day the rigid orthodoxy of modernism. Nerdrum soon found that he could not get along with his professors in Oslo and eventually was "chased out of the Academy like a mangy dog," as he put it.[10] Nerdrum never gave up trying to exhibit his works in his native country, but his efforts continued to be met with opposition. In 1998, he recalled with some bitterness the humiliation he had suffered some twenty years earlier:

> I had been allowed to hang two of my larger paintings—*The Arrest* and *The Murder of Andreas Baader*—in the new students' house at the University of Oslo. . . . They were beautifully hung in a staircase, which almost looked like a Caravaggio chapel. But it did not take long before someone disliked the show. A committee at The Academy of Art had decided that the paintings in this particular staircase had to come down. They surprised me with a letter saying that all "decorations" had to be removed within a fortnight. (OK, 9–10)

We should bear in mind that we are dealing here with a man who went on after the 1970s to become undoubtedly the most famous Norwegian painter since Edvard Munch.[11] Norway has not had that many internationally famous artists to boast of—in addition to Munch, there are Edvard Grieg in music, and Henrik Ibsen and Knut Hamsun in literature (to be generous, one might include Bjørnstjerne Bjørnson and Sigrid Undset). One might truly wonder why the country has been unwilling in Nerdrum's case to celebrate the achievement of one of its few internationally recognized artists. Although Nerdrum has by now attracted champions among Norwegians, he still encounters fierce opposition in his homeland. As recently as the 1990s, he became embroiled in a bitter battle with the Norwegian art establishment. Nerdrum had long been publicly complaining that the Norwegian National Academy of Art did not offer classes in figurative painting, and in 1988 a group of his private students joined in the agitation, writing an open letter to the government on the issue. By 1994, a Nerdrum supporter, Jan Åke Pettersson, had become head of the Academy in Oslo, and he tried to get

two professorships in figurative technique established. As Pettersson himself describes the results: "All hell broke loose. Staff and students alike protested vociferously against the idea, internally as well as in the media. Being a natural candidate for such a position, Nerdrum was drawn into the fray. . . . Following a year of turmoil the minister of education, Gudmund Hernes, was able to get both the professorships and the necessary funding to carry out the idea. Hell broke loose again." With his international reputation as a figurative painter, Nerdrum was clearly in line for one of the new professorships, and was indeed judged "in a class of his own" by the committee charged with evaluating his credentials. But as Pettersson reports, "the resistance at the Academy, as well as in parts of Norwegian society, now escalated to hysteria."[12]

Even foreigners became involved in the dispute. The Norwegian minister of education had used the occasion of a speech at the Academy to defend the idea of teaching figurative technique at a public art institution. The American artist Joseph Kosuth, who was in Oslo at the time, published a piece in which "he argued against the minister and for barring this type of art from an academy, because it was 'populist' and not in line with the art of our own century."[13] Remember that what we are talking about here used to be a standard part of artistic instruction—learning how to draw the human figure. And yet a Norwegian government official came under fire for advocating such a curricular reform. By the end of 1995, Nerdrum actually applied for the new teaching position, but the opposition to him was so strong that on June 20th, 1996, just one day before he would have been appointed, he chose to withdraw his name from consideration. To give an idea of the violence of the opposition to Nerdrum, Pettersson describes how he was treated in the press: "*Dagbladet*, the tabloid that is Norway's third largest newspaper, printed an editorial that must be exceptional even in Norwegian cultural history. . . . It concluded: 'Let it be said: Norwegian art ought to find room for many forms of expression, also Odd Nerdrum's. But we do not believe that he represents the future of Norwegian art, either at the Academy or anywhere else.'"[14] Pettersson is obviously biased in favor of Nerdrum and he was an interested party in these events; one must therefore allow for the possibility that he may be narrating this story in a way that favors Nerdrum. But making all the necessary qualifications, one cannot help concluding that Nerdrum was done an injustice in this matter.

Coming as it did right at the end of the twentieth century, the Norwegian Academy affair provides a neat counterweight to the various modernist scandals at the beginning. In the early 1900s, Picasso began to shock the world by radically departing from traditional ways of rep-

resenting the human figure, and he at first encountered fierce opposition
from the art establishment. By the late 1990s, Nerdrum was faced with
equally fierce opposition for championing traditional ways of drawing
the human figure. The reversal could not be more complete, and sug-
gests how quickly the originally rebellious tendencies of modernism
hardened into a new orthodoxy. Note that Nerdrum and his supporters
were not seeking to drive modernism out of the Norwegian Academy.
They were simply trying to make room in the curriculum for traditional
approaches to painting. It is also worth noting that Picasso had proven
that he was supremely adept at drawing the human figure before he
broke with traditional figurative art (indeed he was a child prodigy).
One might say that Nerdrum and his followers were simply trying to put
Norwegian art students in a position to make Picasso's informed
choice—to reject figurative art, not because they had never learned how
to do it, but because they had mastered it and wished to go beyond it.
Nerdrum and his supporters were not demanding that the Norwegian
government take a stand in favor of figurative art and against mod-
ernism. They simply sought peaceful coexistence for the two approaches
to painting. One must wonder about the insecurity of modernist artists
who feel it necessary to insist that their art and only their art is "the art
of our century" or "the art of the future." Despite their many gestures
toward pluralism, the modernists have ended up with as narrow and con-
fining an aesthetic as any traditionalist ever advocated. On theoretical
grounds, they claim to know what is and what is not appropriate in art,
and seek to keep young minds safe from contamination by the forces of
a false aesthetic. Do the modernists fear the challenge traditional art still
represents to the triumph of their own aesthetic? Are they unwilling to
face competition from alternative approaches to art? The way Odd
Nerdrum has been treated by the art establishment in Norway raises seri-
ous questions about modernism and its attempts to crush any deviation
from its new orthodoxy.

III

For all the bitterness generated by the Norwegian Academy affair for
those involved, outsiders might be excused for regarding it as a case of
making a political mountain out of an aesthetic molehill. It seems
strange that a national government would get embroiled in such a heated
controversy over the appointment of a single professor to an art school.
One might in fact admire the Norwegians for taking art seriously enough
to get all riled up over the question of who should be teaching painting

in their country. The small size of the Norwegian cultural community no doubt goes a long way toward explaining why the attempt to appoint Nerdrum to the National Academy created such a stir. But we must remember that the affair ultimately turned on the issue of public funding of the arts, and thus legitimately raised political questions of national importance. The debate was over appointing Nerdrum, not just to any school in Norway, but to the *National* Academy, and since public money was at stake, it was in fact appropriate for government officials to be drawn into the fray.

Thus the Norwegian Academy affair is more than just a representative incident in Nerdrum's lifelong struggle with the forces of modernism. The issue of public funding of the arts can actually take us to the heart of Nerdrum's critique of modernism. In his view, the problem with modern art is that it has made a devil's pact with the modern state. Modern art "has become a part of the official state ideology or structure"[15] in return for government support of the arts. Public funding is paradoxically intended to free the modern artist from having to please the public anymore. As Nerdrum sees it, modern art is heavily invested in the ideal of the autonomy of art, which he correctly traces back to Immanuel Kant and his *Critique of Judgment*. In this understanding of art, the artist is supposed to be free from all external pressures so that he can follow the dictates of his authentic genius wherever it leads him, and that means first and foremost that the artist should be free from all commercial pressures, any need to compromise his artistic vision to please paying customers. The ideal of the autonomy of art has become so dominant in modern aesthetic discourse that it has come to sound like plain common sense to us. "Of course the artist must be autonomous," we feel like saying; how can he be true to himself as an artist if he is constantly worrying about pleasing a public that is largely ignorant about art? It is an axiom of modernist thinking that the artist is to set the law for the public; the public is not to set the law for the artist. The history of twentieth-century art is supposed to be one long story of a public of bourgeois philistines resisting the brilliant innovations of creative, forward-looking artists, while the artists, as the prophets of modernity and the only true visionaries, heroically try to lead the public out of the wilderness of worn-out conventions into the promised land of what Richard Wagner called "the artwork of the future."

The ideal of the autonomy of art sounds wonderful in theory—who wouldn't want to be financially independent?—but in practice, it raises thorny questions. In particular, where is the liberating financial support for the artist supposed to come from? Traditionally, to earn a living, an

artist had to please someone, either a patron from the court or the church, or the paying customers who constitute the commercial public. Both the patron-based and the market-based systems of supporting art obviously had their defects, and often forced artists in directions they might not have pursued if they had possessed complete aesthetic freedom. But the only alternative to private funding of the arts is public funding, and it brings a whole new set of problems in its wake. A system of public funding must be administered, and that means that in the modernist vision, art becomes just one more part of the administered world, a public institution, bound up with the bureaucratic state. Nerdrum's career has been one long—and largely negative—encounter with the various forms of national art institutions in the modern world—national schools, national museums, national academies.[16] He has thus observed how public funding of the arts actually works in practice: it means art administered by bureaucrats and bureaucratic committees. The ideal of the autonomy of art is that anyone should be free to follow his or her artistic calling as the spirit dictates. But in practice—because the financial resources of the modern state are not infinite—money must be allocated and that means that decisions must be made. As in all the operations of the modern state, these decisions are necessarily bureaucratic in nature and are usually made by committees—in particular, the various forms of peer review that administer much of public funding in the modern world.

And the key point about committees is that they have no taste. Indeed, by their very nature they are not supposed to express personal taste, but rather to exercise expert judgment. A patron of the arts or a paying customer is free to follow his or her taste. In patronage or the commercial market, the simple statement: "Because I like it" is a sufficient reason for supporting the work of an artist. But no self-respecting government committee can offer: "Because we like it" as their justification for allocating public funds to a particular artistic project. In their bureaucratic nature, committees must render professional judgments based on expert opinions—hence in the art world they tend to be dominated by academics or quasi-academics, like museum curators. And in democratic regimes, any form of public funding is under great pressure to be democratic, to allocate money in a non-discriminatory manner and to spread it around as evenly as possible. In a democratic context, this goal sounds unobjectionable and indeed desirable. But we should remember that the traditional point of artistic taste was precisely to be discriminating. That is what it meant to be a connoisseur of art. Patronage or the marketplace did not always succeed in discriminating

properly between good and bad art, but at least these systems, in forcing artists to please somebody, imposed a kind of discipline on them and impelled them to develop their craft. By contrast, funding by committee, precisely because it seeks to substitute professional judgment for amateur taste, results in making art more and more academic, leading artists to conform, not to what the public wants, but to what the art establishment deems to be true art. That is how modernism has come to dominate the whole world of art under a regime of public funding.[17]

It is a mistake, then, to think of modern forms of public funding of the arts as the new equivalent of the old system of patronage.[18] Artistic patrons may have been members of the governments of their day, but in their decisions about art they acted as private individuals and felt free to indulge their personal taste. But, however much members of committees charged with funding the arts today may secretly be influenced by their personal taste, they must act as if they were serving a public trust and thus deciding according to publicly promulgated and acceptable procedures and criteria—which is to say that they must act bureaucratically. Committees operate by consensus and, given their composition in the modern, democratic world, they inevitably end up supporting artworks that conform to the modernist conception of art that dominates the academy and the art establishment today. Nerdrum is struck by the uniformity of art in the modern world: "Modernism itself has become a tradition which has conquered the entire western world" (OK, 10). For Nerdrum, this is the inevitable result of art becoming dependent on public funding and hence in effect a ward of the modern state.

Modern artists hoped to achieve their autonomy by turning their backs on all forms of patronage and commercialism and making a bargain with the state for public funding. But as in all areas of human endeavor, he who pays the piper calls the tune, and the modern state has not turned out to be the purely benevolent and undemanding source of support modernist artists were looking for. This has clearly been the case in the various totalitarian regimes, whether communist or fascist, that set themselves up as the saviors of art in the twentieth century, but in practice turned their artists into slaves of the state. But Nerdrum would argue that this is also true of the democratic, welfare states, which in a more insidious fashion have undermined the independence of the artist even as they claimed to be giving him his freedom. The modern artist may think that he no longer has to "please" anybody in order to go about creating his art, but to get government grants and in general to function in the world of art as a public institution, he must still "satisfy the criteria" for grant proposals and others forms of public recognition. In particular,

in a world of public funding, art must be "politically correct," however that term may be defined in a given state at a given time. In order to win and maintain government funding, the artist must ultimately tell the government what it wants to hear, or at least not tell it what it does not want to hear.

Nerdrum is struck by the way art in the modern world is judged, not by its craftsmanship, but by its political message. In a truly shocking passage, he dares to call into question the greatness of a painting generally regarded as the supreme masterpiece of modern art:

> Public art has moral, religious, ethical or just purely aesthetic obligations. We see this when we compare Picasso's *Guernica* with Goya's *Third of May*. *Guernica* represents all of humanity's suffering, it is a painting for the UN. Goya's painting, on the other hand, shows the individual victim's suffering. *Guernica* is an abstract symbol, whilst *Third of May* subjectively confirms and transcends. (OK, 30)

I was stunned when I first read this passage. In terms of my art education, I was brought up in the heyday of modernist ideology and taught to worship the *Guernica*. I remember being taken as a child to see it by my older brother, as if on a pilgrimage, when it was still at the Museum of Modern Art in New York, and I have dutifully returned to it as an adult to view it at the Reina Sofía Museum in Madrid. I still think that it is a great painting, and I disagree with what Nerdrum says in this passage. But perhaps he does have a valid point. Much of the praise of the *Guernica* has nothing to do with its qualities as a painting and everything to do with the historical circumstances in which it was created and the political message it conveys. And commentators do abstract an anti-war message from the painting, insisting that it does not apply only to the Spanish Civil War but teaches us about the horrors of war itself. I am fascinated by Nerdrum's characterization of the *Guernica* as "a painting for the UN"—I can just picture it hanging on a wall of the General Assembly. That is undoubtedly a false and unfair characterization of the painting itself, but it does say something about the way the *Guernica* has been received by the art establishment and why it has been set upon so high a pedestal in the pantheon of modern art. I myself would characterize the *Guernica* as a great painting that happens to convey an anti-war message. The problem is that in today's art world a painting will be celebrated solely because it expresses an anti-war message, even though it may be incompetently executed and in fact lacking in all distinction as a work of art. That is the issue Nerdrum focuses on in what he regards

as the unholy alliance between modern art and the modern state—the abstract message of the artwork has become more important than its concrete texture as a painting, and works that flatter modern ideology will automatically be praised and rewarded by the art establishment with its links to the whole apparatus of the state.

IV

Nerdrum sees a connection between the chief characteristic on which modern art prides itself—its abstraction—and the ideal of the autonomy of art. Traditional art was heteronomous—it did not seek to serve purely aesthetic purposes; it conceived of itself as serving the public, as pleasing the public. Thus the traditional artist felt that he had to rely on the beauty of his art, that he had to appeal to the senses of his public (whether patrons or commercial customers). In short, the sensuous beauty of traditional art reflected its lack of autonomy, its need to please the public. In its attempt to be autonomous, modern art rejects the traditional ideal of sensuous beauty and tries to become ever more abstract. As Nerdrum argues:

> What first and foremost characterizes this art, in my mind, is the conquest of the sensual expression, in favor of a philosophical purity, a purity that finds its clearest and most consistent expression in conceptualism. Here it has reached a philosophical level which makes it into a cool, clean expression of art, in sharp contrast to commercialism and sensuousness. (OK, 64–65)

The modern work of art defines itself in terms of its concept, not its beauty; it prides itself on what it is trying to accomplish qua work of art and not on what it is trying to represent or express. That is why the modern work of art so often defines itself in negative terms: "this painting does not use color to portray natural forms," "this painting does not employ traditional perspective," "this painting does not try to depict objects in three dimensions," and so on. It sometimes seems, in practice as well as theory, that for modernism the blank canvas becomes the ultimate work of art because it does absolutely nothing that traditional art prided itself on. As the logical conclusion of the impulse to abstract from all appeals to the senses, the blank canvas becomes the ultimate embodiment of the ideal of the autonomy of art.

As we have seen, Nerdrum traces this new conception of art back to Kant and his attempt in his *Critique of Judgment* to establish aesthetics

"as a separate philosophical discipline where art and beauty are considered an independent category with its own rules and values" (OK, 65). Before Kant, art was generally viewed as "a craftmanship [sic] regulated by certain technical or dramaturgical requirements" (OK, 65)—that is, traditional art was governed by its need to appeal to an audience. With a kind of Protestant asceticism,[19] Kant rejected this form of art as corruptly appealing to the senses out of mercenary motives:

> But more important in this context is Kant's disparagement of craftmanship [sic] and the sensual in favor of intellectual reflection. Art is something that pleases in itself, as opposed to craftmanship which he perceives as toil and struggle, and as an expression of greed for money. That which pleases must remain free from sensual perception. The pleasing is pure contemplation: in other words, pleasure comes from contemplation and judgement. If the assessment of a work of art is connected with sensual perception, it is considered bodily oriented and thus inferior. (OK, 66)

In Nerdrum's view of the history of painting, Kant's new aesthetic theory is translated into artistic practice by painters like Cézanne:

> Even Kant's reflections on color have been groundbreaking. When passion lies in reflection and not in the physical presence, this means that color must be left aside. A dramatic expression, in other words a substantial color, throws the spectator out of balance, and thus it is no longer art. As Kant says: "When the work is too much alive, it ceases to be art."
> The realization of this esthetics [sic] can be found in the work of Paul Cézanne, a great Kantian. Here the skin is gone, here we find the clear colors and a restrained expression which has become a mask. Here, the carnal has disappeared in favor of an intellectual understanding, as the sensuality of skin has become a color painting. This is all Kantian. Cézanne must have read his Kant very thoroughly! (OK, 66)

One may legitimately quarrel with the details of Nerdrum's history of painting—which one suspects is deliberately intended to be provocative—and especially with his claim that Cézanne was directly influenced by Kant (probably meant as a joke). But Nerdrum's basic claim is sound—that the increasing abstraction of modern art and its break with the traditional goal of representing nature are all part of a Kantian attempt to establish art as autonomous, that is, independent of any need to please or serve an audience, and especially a paying public. Modernist histories of painting essentially tell the same story; it is just that they view these developments as positive, whereas Nerdrum views them as negative.

Against the aesthetic—and ascetic—purity of Kantian art, Nerdrum argues for the validity and vitality of commercial art.[20] In his view, the need to please an audience actually inspires the artist, brings out the best in him, and forces him to come to terms with the fundamental subjects that perennially preoccupy the human heart. In a move calculated to infuriate all modern aesthetes, Nerdrum goes so far as to praise the center of commercialism in art, Hollywood:

> Even though the concept of art has achieved a predominant significance in our time, there are still cultural arenas untouched by this esthetic [sic], i.e., Hollywood film productions and the world of literature. One important reason for this is that films and literature depend on great commercial success. And when you depend on a large audience, you are facing a "vulgus" problem. The general public wants what speaks to their hearts. Intellectual reflection will not be satisfying. People wants [sic] love, death and the ocean. Film and literature are therefore examples of arenas that have not had the economic possibility to bringing the ideas of Kant . . . to realization. (OK, 67)

Speaking of "love, death, and the ocean" in December 2000, Nerdrum perhaps had in mind that most commercial of Hollywood blockbusters, James Cameron's *Titanic*. In any event, he celebrates and identifies with an art that appeals to a mass audience and welcomes the opportunity to stir their emotions, no matter how base they may seem to a modernist elite.

Thus Nerdrum believes that modern art has actually been impoverished by efforts to shield the artist from the demands of the public, and he wishes that painting would become more commercial, not less as modernists have always been demanding. The villain in Nerdrum's history of art is explicitly public funding:

> In art, on the other hand, and in figurative art in particular, the situation is quite different; it is dependent on public or semi-public funding to get by. The reason being quite simply that this commodity, the art commodity does not easily fall under the definition of mass product.
> Personally, I am convinced that art can be made into mass products by producing and selling reproductions of paintings in a far greater extent than what is being done today. This was being done towards the end of the 1800s, but the practice has all but disappeared due to the isolation of modernism. Because figurative art has been protected from the masses, it has been free to realize Kant's ideas. (OK, 67–68)

Nerdrum views government funding of the arts as a kind of economic protectionism, and like all forms of protectionism, it has a harmful effect

and stifles development. Freeing the artist from any need to please the public makes his art more intellectual and less sensual, which for Nerdrum is a formula for emotional sterility in painting. Over the years, Nerdrum has come to view the fact that he was rejected by the modern art establishment as a blessing in disguise. The fact that he seldom received financial support or other forms of encouragement from the institutional world of modern art forced him actually to become more independent in his artistic vision. Fortunately for Nerdrum, he could make an end run around the modern art establishment and appeal directly to the commercial public for financial support, especially in the United States, where the private market for art flourishes.[21] As we have seen, Nerdrum has been extremely successful commercially, and the Internet in particular has helped him—or at least his dealers—to make contact with a broader audience—and market—for his art.

Partisans of modernism might charge that Nerdrum's attack on the ideal of the autonomy of art is simply a rationalization for his rank commercialism. But they would be hypocrites to do so. Nerdrum in fact overstates the isolationism of modernist art and underrates its own commercialism. To be sure, modern artists have been more than willing to accept all sorts of government funding. But they have been willing to accept funding from all the traditional sources as well. As a number of critics have shown, modern artists have even rediscovered or reinvented patronage as a way of funding themselves, as the mere mention of the name Peggy Guggenheim is enough to remind us.[22] And modern artists have found a remarkable variety of ways to market their art commercially. Contrary to what Nerdrum suggests, modernists have in particular pioneered new forms of the mechanical reproduction of their art (consider, for example, Picasso's extremely lucrative foray into the market for ceramics—evidently, Picasso never met a form of mechanical reproduction of art he didn't like, and the same is even truer of Salvador Dalí).[23]

Modern art has in fact become a big business, and fortunes have been made by many painters who professed to despise commerce in true Bohemian fashion. Picasso died a billionaire—perhaps the wealthiest artist who ever lived—leaving behind a financial empire and virtually a brand name to his heirs. In economic terms, Nerdrum has been merely following in the footsteps of his modernist predecessors. Without the commercial infrastructure of auction houses, galleries, and dealers they helped to put in place, Nerdrum would not have had the means to mount his challenge to modernism. Modernists can level many charges against him, but if they condemn him for commercially exploiting the art mar-

ket, they would only be damning themselves. When it comes to financial support, modernists have truly enjoyed the best of all possible worlds, often drawing upon patronage, the commercial market, and government funding all at once. The idea of the starving modernist artist is the great cultural myth of our time. The twentieth century supported more artists and at higher levels of financial reward than all the rest of human history combined, and chiefly through the private art market.[24] Nerdrum could in fact rewrite the history of modern art from an anti-modernist perspective. To the extent that modern artists have relied on private funding, they have retained their vitality by maintaining a vital link to an audience; to the extent that they have turned to public funding, they have cut themselves off from the true public and lost their way in a wilderness of abstraction and pretentious and empty conceptualism.

V

I have dwelled at length on Nerdrum's writings on art in order to show that, despite his rejection of conceptualism in the practice of painting, he is a sophisticated conceptual thinker himself. He has thought long and hard about the history of art, and condemns modernism, not out of ignorance of its theoretical underpinnings, but precisely out of a profound engagement with them. Anyone who has read and genuinely understood Kant's *Critique of Judgment* has established his credentials to talk about aesthetics.[25] But the more interesting question remains: does Nerdrum's critique of modernism somehow operate in his paintings themselves? Given how mysterious they are, and how elusive their meaning seems to be, I hesitate to read any message out of them.[26] But I will offer this tentative interpretive hypothesis: the one thread that runs throughout Nerdrum's paintings is a critique of the modern state, and, since we have seen that he links the ideology of modernism with the ideology of the modern state, his paintings actually carry on his critique of modernism and in fact deepen it. The critique of the modern state is one element that unites the two principal phases of Nerdrum's career. He began by portraying the soullessness of life in the modern state, with its bureaucratic indifference to human values. And in the major phase of his painting, he went on to try to portray life in the absence of the modern state in an imaginative effort to recapture the elemental aspects of the human condition that modernity has tried to cover over and repress.

Several of Nerdrum's early paintings, particularly the best-known ones, appear to be acts of social protest. Given the fact that they were painted in the 1970s, it would be easy to associate them with a number

of student protest movements that were sweeping Europe at the time,[27] and one might be tempted to impute left-wing sympathies to Nerdrum and perhaps even to view him as a child of the New Left. Several of the paintings appear to participate in the fight for sexual liberation; one called *Liberation* (1974)[28] portrays a woman on top in sexual intercourse and thus seems to speak to the cause of women's liberation; and one of the paintings, *Spring* (1977), offers a frank depiction of homosexuality and thus might be linked to the gay liberation movement. Probably the most famous—and controversial—work from this phase of Nerdrum's career is *The Murder of Andreas Baader* (1977–78). This painting is a good example of how Nerdrum invokes his Old Master models to make a powerful statement about the contemporary world. By consciously patterning his painting on Caravaggio's *The Martyrdom of St. Peter*, Nerdrum succeeds in casting the German terrorist Andreas Baader, a member of the infamous Baader-Meinhof Gang, as a martyr to the tyranny of the modern state. Nerdrum depicts as a murder what official German government accounts represented as a prison suicide, and thus openly challenges the credibility of state authority.[29]

Because the Baader-Meinhof Gang was well to the left of the political spectrum, Nerdrum's sympathetic portrayal of one of their leaders might suggest that he was an advocate of left-wing causes and perhaps even communist in his beliefs. But shortly after painting *The Murder of Andreas Baader*, Nerdrum produced one of his largest and most visually spectacular canvases, *Refugees at Sea* (1979–80). This time using Géricault's *Raft of the Medusa* as a model, Nerdrum portrayed the plight of the Vietnamese boat people, presenting them as heroically fleeing the recently triumphant communist regime in their homeland and thus as martyrs to a left-wing tyranny.[30] Evidently Nerdrum was an equal opportunity social critic, calling into question regimes on both the left and the right. As a number of commentators have pointed out, Nerdrum's impulses at this time were in fact anarchist rather than communist. Influenced by a number of anarchist thinkers, he was challenging state authority in all its forms.[31]

In the early phase of his painting, Nerdrum often focuses on human suffering, with a strong suggestion that it is caused—or at least not ameliorated—by the state. He singles out isolated figures living on the fringes of society, rejected for one reason or another, as in *Morning* (1972), *The Shadow* (1973–80), and *Abandoned* (1977–78). As Hansen characterizes this phase of Nerdrum's career: "During the seventies Nerdrum's motifs focused on society's underdogs. He painted prisoners, social outcasts and poverty. A common trait is a focus on the individual

personality while soliciting the viewer's identification and compassion. The subject is therefore an illumination of what we can characterize as the loser, or victim of society."[32] Again, we might be tempted to give a left-wing interpretation to these paintings and assume that Nerdrum was calling for the government to come to the aid of these sufferers, as if he were some kind of typical European social democrat. But Nerdrum never portrays the forces of the state in a positive light; as Hansen writes, "it is society that is the negative opponent. This negativism is either indirectly present or represented by institutions or various authority figures."[33] One of the most powerful of these early paintings is *The Arrest* (1975–76), which melodramatically presents the supposed criminal as an object of sympathy, and casts the arresting policemen as the villains. Even the pattern of lighting in the painting confirms this interpretation. The arrested man is bathed in light à la Rembrandt from the upper left corner of the painting, thus making him the center of our concern, while the policemen appear in varying degrees of shadow, thus darkening them in our view. The arrested man is unkempt and poorly dressed, and surrounded by a group of supporters who are evidently trying to intervene on his behalf and interfere with the arrest. One of them is a weathered old man supporting himself on a crutch, and another is a young boy, perhaps the arrested man's son, who is desperately clinging to him as he is dragged away. The policemen are presented as implacable, wrapped tightly in their dark uniforms, expressionless, and almost featureless. One can almost hear them saying: "We're just doing our duty," as they tear the man out of what little community he has. In *The Arrest*, the Old Master reference is obviously to traditional depictions of the seizing of Jesus, thus creating even more sympathy for this victim of modern tyranny.[34] Nerdrum's negative attitude toward government authority is captured in a charcoal sketch he made in 1976 for a painting to be entitled *The Prisons Are Being Opened*. As Hansen describes it: "A horde of prisoners set free emerge through an enormous prison gate. They are met by a waiting crowd. The scene is portrayed like a great operatic drama; those escaping from within wear expressions of despair and suffering, while those in the expectant crowd express joy."[35]

In depicting modern society, Nerdrum thus concentrated on its carceral aspects; as if he had been reading the contemporary writings of Michel Foucault, he portrayed all the institutions of society as imprisoning and not just the literal prisons. In one of the most telling of these early paintings, *The Admission* (1976), we are apparently witnessing a troubled young woman being taken away to some kind of institution, probably a mental asylum. Her family have literally and figuratively

turned their backs on her and she has fallen into the hands of two nurses who are about to swaddle her in a cloak. Vine describes the painting as:

> a heart-breaking depiction of a huddled young woman, nude except for panties, being "taken away" by two women in white coats while her grief-stricken parents avert their faces and a sheepish younger sister looks on with curiosity and fear. All of the participants show signs of guilt; all seem implicated in personal and societal feelings that have led to this extreme measure—the removal of a damaged individual from the community of citizens. The painter's view is at once clinical and tragic, merciless in its attention to detail—e.g., the dirt on the soles of the sick girl's bare feet—yet tender in its empathy with characters caught up in circumstances beyond their control. (Vine, *Nerdrum*, 40)

Vine's last observation is exactly right and important—all the characters are caught up and participate in this sad business. The two women in white coats, the two "experts" who are the institutional representatives of a "caring" society, are not in fact presented as the saviors of the situation. They may well be taking the woman away to a worse fate. Living in Scandinavia, the home and supposed model of the modern welfare state, Nerdrum chooses not to celebrate its virtues in his paintings but instead suggests a kind of clinical coldness to its care, which seems more carceral than pastoral in its operation. In 1973, he produced a sketch ironically entitled *Social Security*, which presents an elderly woman trembling on a bed. As Hansen writes, "in her face we can read of the years of toil and failures—an expression that elicits the viewer's compassion for this loser in the struggle for the wealth and benefits of the welfare state."[36]

Evidently Nerdrum has no more confidence in the state's ability to take care of the elderly than he does in its ability to take care of artists. What unites Nerdrum's critique of modern art and his critique of modern society is his sense of the dangers and debilitating effects of becoming a ward of the state.[37] State support for the artist, far from promoting his creativity, actually stifles it, or at least misdirects it. Similarly, Nerdrum shows government intervention in society working to destroy community rather than to build it; in particular, he pictures authority figures breaking up families. The underlying message of Nerdrum's early paintings appears to be that human beings cannot fulfill themselves in society as organized by the modern state. It frustrates their desires and thwarts their development, forcing them into futile gestures of criminality and rebellion, which lead only to greater forms of repression. Already in his early

paintings, Nerdrum is drawn to images of mutilation and dismember-
ment—see, for example, *Amputation* (1972)—as if to suggest that the
forces of the modern state can only maim and cripple humanity.

VI

Nerdrum's early paintings portray the members of modern society as
largely passive, often the victims of a system that claims to care for them
but that would just as soon imprison them if they fail to fit into the sys-
tem. In his first phase, Nerdrum thus offers testimony to the failure of
the modern project, especially insofar as it has culminated in the steril-
ity of the welfare state. The fundamental link Nerdrum sees between
modern art and the modern state is that both rest on a belief in progress,
the faith that the world can be remade by the power of reason and
remade for the better: "The twentieth century was, despite all fears,
marked by a sincere belief in progress, a belief that science and tech-
nology would lead us into a new world" (OK, 28). In this respect,
Nerdrum finds Hegel's philosophy as fundamental to modernism as
Kant's:

> [Hegel] claimed that great art depends on contemporary time and its means,
> and that art must accept the values of its time. The artist is not a great artist
> unless he is completely bound to his time. This led to an evolutionary opti-
> mism which implied that artists build on each other, and that they must con-
> stantly create something new and original in history. It is important to be
> aware of the fact that the new and the original are closely linked with what
> Hegel conceived of as the course of history. . . . Here we find most of the
> basis for the avantgarde dictate of modernism. (OK, 66–67)

One can readily understand why Nerdrum would be opposed to the his-
toricism of Hegel. In the historicist view of art, the true painters are
always progressing, with the greatest making major breakthroughs to
new styles. It is on the basis of this kind of historicism that critics con-
demn Nerdrum as a reactionary, and dismiss his return to the Old
Masters as an empty gesture.

But Nerdrum is even more disturbed by the political implications of
the Hegelian foundations of modernist aesthetics, the way a blind faith
in progress links modernism to totalitarianism:

> Today, everybody is in agreement that the modernist dominance has had a
> liberating effect, for better or for worse. The idea of a new world, where our

aesthetic and moral perceptions should be improved, has been tried out by
both the Communists and the Nazis, as well as the modernists. All of them
have had "The New Kingdom" as a goal, but the sovereign winner has
become Modernism. All over the globe, we find the same art—the same
installations and the same décor—whether it be in the Muroroa Islands,
New York or Hong Kong. (OK, 21)

Nerdrum's claim that modernism succeeded in conquering the world
where communism and fascism failed may seem outrageous, especially
when it is as bluntly stated as it is in the epigraph to *On Kitsch*:
"Immanuel Kant is to art, what Karl Marx is to communism." But
Nerdrum is not the only person to see a parallel between modernist art
and totalitarian movements, and he does have a point in linking the
two.[38] He is taking the modernity of modernism very seriously, and
reveals how thoroughly it has embraced the modern project, most obvi-
ously in its famous slogan: "Make It New." As a revolutionary artistic
movement, modernism rejects the past in just the way that radical polit-
ical movements on both the left and the right did throughout the twen-
tieth century. The artistic revolutionary bears the same relation to
tradition that the political revolutionary does. In both art and politics,
the revolutionary views tradition as the enemy—the way things were
done in the past is assumed to be wrong simply because it is the way
things were done in the past, and the past is regarded as standing in the
way of a glorious future. One of the early modernist movements in art
in the twentieth century was appropriately called Futurism, and its love
affair with modern technology—especially with speed and power—is a
good measure of how eagerly the modernists embraced modernity. And,
as is well-known, Italian Futurism had affinities with and links to
Italian fascism.[39]

As artists, the modernists saw themselves as making a fresh start,
and their attraction to blank canvases reflected their longing for a clean
slate in life. Not wishing to be in any way bound or indebted to the false
ways of the past, the modernists craved to be free to build the world
anew from the ground up (often literally in the case of modernist archi-
tecture). In that respect, the modernists had the same goal as totalitarian
politics—which is totalitarian precisely because it rejects all traditional
ways of organizing society and seeks to create a totally new society on
ideological principles of the right or the left. In very practical terms,
Nerdrum sees the totalitarian impulse of modernism operating in the
fact that it tries to suppress all dissent from modernist aesthetic dogma
and will not tolerate any artistic alternatives:

> When modernism in art gradually gained acceptance and hegemony during the last century, it was recognised that this occurred with a break in tradition. However, whilst the avantgarde established itself, it would not allow other equal or secondary forms of expression. On the contrary, it was radically totalitarian, a fact which had repercussions when it became the art of the establishment. For in establishing itself, it utilised the strategy of radical definition which sought to exclude and annihilate its other. One of these strategies was a elitistically [sic] oriented demonization of figurative art with a strong emotional expression. (OK, 25)

In the strict party line and discipline of modernism, Nerdrum recognizes the mark of totalitarianism; Vine speaks of modernism as "an aesthetic politburo."[40] This link between modernist aesthetics and totalitarian politics would explain why so many artists in the twentieth century had fascist or communist leanings and in some cases ended up shamefully serving totalitarian regimes and even currying favor with their dictators (one thinks immediately of Ezra Pound's relation to Mussolini, but the record of artists and intellectuals who cast their lot with Stalin is equally appalling).[41]

Thomas Mann's novel *Doctor Faustus* is a profound exploration of the affinities between modernist art and totalitarian politics. By paralleling the story of a modernist composer, loosely based on Arnold Schönberg, with the rise of Hitler as dictator of Germany, Mann reveals the common ground between revolution in art and revolution in politics. In both cases, he shows the need to destroy in order to create, and in particular the substitution of an abstract and artificial new order for traditional artistic and social relations. Mann thus shares Nerdrum's suspicions about the political dimension of modernism. Indeed, events in the twentieth century led many thinkers to question the assumption that whatever is modern is automatically good, a belief that has often had disastrous political consequences, and disastrous aesthetic ones as well, Nerdrum would add. Nerdrum is right to trace the modernist faith in progress back to Hegel, the great prophet of modernity, who claims that history ends with and culminates in the emergence of the modern state.[42] His successors have argued over the nature of this state—whether it should be, for example, communist, fascist, or liberal-democratic—but they generally have still accepted Hegel's view that the state is the engine of modernity and hence the one true vehicle of progress. That is why in Nerdrum's view modernist artists have been able to make their bargain with the modern state on ideological grounds and hence with a good conscience.

What distinguishes Nerdrum is thus the fact that as an artist he is *anti-state*, not just in the practical sense that he has as little as possible to do with the whole world of state-supported art, but in the deeper, theoretical sense that he does not view the modern state as the genuine fulfillment of human destiny. As his early paintings suggest, for Nerdrum, if the modern project has culminated in the welfare state, then modernity has failed. Its progress, and above all its claim to bring happiness to humanity, are an illusion. Far from being the gateway to the future, artistically and otherwise, the modern state for Nerdrum has turned out to be a dead end. But if the modern state has failed to deliver on its promises, where do we go from here, and, especially for Nerdrum as a painter, where does art go from here? Such considerations no doubt lay behind Nerdrum's rethinking of his art in the early 1980s and led to his radical reconception of his role as a painter. He decided to try to imagine and depict what life would be like without the modern state. Nerdrum's conviction that modern society distorts human nature means that he could not capture the essence of humanity as long as he painted contemporary and especially urban scenes. This explains his turn to his new subject matter in the 1980s—the evocation of human beings in a primitive and even primeval condition, stripped of almost all the trappings of civilization and wandering through a barren landscape, leading a fugitive and frontier existence and eking out the barest living from a harsh environment, surviving at the very borders of humanity, what Nerdrum called "the bounds of necessity in life."[43] As Nerdrum wrote: "Man must be driven out onto the plains. Being driven out onto the plains means coming back to the essential, to the starting point. When man feels betrayed by society it is his right to return to a natural state."[44]

VII

The second and mature phase of Nerdrum's paintings thus involves an attempt to portray the state of nature. But it is not the state of nature of Rousseau, a realm where man is naturally good and at peace. Rather, it is much closer to the state of nature as conceived by Hobbes—where the life of man is "solitary, poor, nasty, brutish, and short" and he experiences the "war of every man against every man" (*Leviathan*, Chapter 13).[45] Perhaps the best way to conceptualize Nerdrum's state of nature is as the antithesis of the welfare state. In opposition to the communal spirit of modernity, he creates a grim world of rugged individualists, engaged in a Darwinian struggle for existence, with a strong sense that only the fittest will survive.[46] As is appropriate to the Icelandic settings

Nerdrum evokes in these paintings, he takes us back to the world of the Norse sagas, where tribe is pitted against tribe in endless and bitter feuds.[47] Nerdrum's paintings often focus on a single figure against a bleak background. At most he shows five or six figures in a given painting, so reduced has society become in the world of his imagination.[48] And even when Nerdrum portrays a group of figures in a painting, he rarely shows them relating to each other.[49] Sometimes they are staring off into space (*Dawn* [1990]; *Wanderers by the Sea* [2000]); sometimes they are sleeping while only one is awake (*The Night Guard* [1986–88]); sometimes they are simply looking past each other (*The Water Guardians* [1985–93]; *Five Namegivers* [1994]). Even when Nerdrum's figures are together, they appear to be alone, and if they do relate to each other, it is often with hostility and outright violence (*Woman Killing Injured Man* [1994]).

Thus the world Nerdrum creates in his paintings is the very opposite of everything we picture when we speak today of the "nanny state." There are no institutions to take care of Nerdrum's figures from the cradle to the grave—no institutions to feed them, to clothe them, to house them, to school them, to provide for their old age, to hospitalize them, or—one might add—to imprison them. They are radically on their own. The cradle and the grave are very much present in Nerdrum's paintings, but his characters must find their way from one to the other by themselves and without any guidance or help from the state. Hence, Nerdrum's characters are perpetually on guard—their most characteristic stance is watching, ever on the lookout for an enemy to emerge on the horizon. In the hostile world Nerdrum evokes, his characters appear to be permanently under threat, and sadly exposed to danger. They are often naked, or barely clothed, and when we see them sleeping out in the open and unprotected, we have to wonder how they will survive the night (*Sleeping Twins* [1987]). The number of characters who are wounded, mutilated, and crippled is testimony to the reality of the dangers they face (*The One-Armed Aviator* [1987–97]; *Unarmed Man* [1995]; *Pissing Woman* [1997–98]).[50]

Nerdrum's characters are nomads, ever on the march, moving through a bleak landscape that offers little to sustain them. They do not lead the pastoral existence often portrayed by painters trying to evoke a state of nature. They do not enjoy the luxury of lush farmland and an abundance of crops. Seeds appear to be precious in this world, and must be guarded carefully (*The Seed Protectors* [1987–96]; *Man With Seed Corn* [1985–93]). Any sign of plant life in this barren land must be treasured, and Nerdrum portrays a boy holding onto a sprouting twig as if it

might be his salvation (*Boy with Twig* [1992]).[51] The situation with animal life is no better. Unlike the stock characters of pastoral, Nerdrum's figures have no flocks of sheep or goats to tend. On one occasion a dog appears in Nerdrum's landscape (*Pissing Woman* [1997–98]), but it is mostly populated by snakes and serpents. Horses appear only in the form of skulls or severed heads, evidently remnants of better days (*Man with a Horse's Head* [1993]; *Resurrection of a Horse* [2000–01]). In this reduced existence, just to possess a fish seems to be an accomplishment, but at the same time a reason to be even more on guard, to protect one's property (*Man with Catfish* [1992]; *Woman with Fish* [1994]). Even water appears to be a limited and precious resource in this desolate and desert land—hence also something to be defended (*The Water Guardians* [1985–93]; *Five Persons around a Waterhole* [1992]).[52]

And many of Nerdrum's characters do seem capable of defending themselves, their loved ones, and their property. Some of them appear to be victims, just like the characters in Nerdrum's early paintings, but they no longer seem so passive. Their destiny is harsh, but it now appears to be in their own hands. They often have a look of grim determination in their faces, not the look of defeat and despair we see in Nerdrum's early characters. Whereas those characters often seem weak, the later figures seem strong. In particular, many of the men in Nerdrum's early paintings seem somewhat effeminate; in his later paintings, even the women project a masculine strength. To put the point somewhat fancifully, if his earlier characters met his later characters in a fair fight, there is no question who would win.[53] Indeed, his earlier characters seem to have forgotten how to fight, whereas his later characters seem always ready for a fight. Although many of the later characters are naked or semi-naked, others wear protective clothing and carry shields. Many are helmeted, and some even wear armor. The woman with a fish looks like a full-fledged Wagnerian Valkyrie. Above all, Nerdrum's figures are *armed* and prepared for trouble, with knives, spears, and bows and arrows at hand. But what is most distinctive and odd about the world Nerdrum creates is that it is filled with guns. Almost all other signs of modern technology are absent from these paintings; one character is holding a doorknob as if it were a treasured relic from a vanished world (*Woman with a Doorknob* [1990]). But a remarkable number of Nerdrum's characters have shiny new rifles slung over their shoulders and are evidently prepared to use them (for some particularly prominent rifles, see *The Memory Hall* [1985]; *The Water Guardians* [1985–93]; and *Three Warriors* [2000]; but I count rifles in roughly twenty-five of the paintings in Vine's book

alone). Even one of the shaman figures Nerdrum paints has a rifle rest-
ing on his lap (*Revier* [1985–98]). There apparently is no gun control in
the world of Nerdrum's imagination. In European terms, one could
offer no more convincing evidence of the absence of the state in his
mature paintings.[54] In his sharpest departure from the modern world of
the administered state, Nerdrum evokes a realm where men—and
women, too—must rely on themselves and their own arms (*Armed
Woman* [1986–93]). With the state no longer there to protect them, they
must be ever vigilant and prepared to defend themselves. Nerdrum does
not present this situation as particularly attractive or desirable, but he
does seem to be suggesting that it reveals something about human
nature which modern society tries to ignore and obscure. For Nerdrum,
humanity seems to be defined *in extremis* and one finds out the nature
of human beings only when they have their backs to the wall and are
forced to fight for their existence. In particular, these paintings uncover
a toughness and aggressiveness in human beings that is the very oppo-
site of the spirit of the nanny state and everything it stands for. Nerdrum
seems to be suggesting that modernity ignores and tries to repress this
aspect of human nature at its peril.[55] He speaks of one his paintings
(*Twilight* [1981]) as "a tribute to the natural, the true human being
whom we all fear."[56] He says of the people he paints: "They exist in a
greater world than our own. . . . What our world has relieved us of is
what they live in."[57]

In view of the emphasis on strength and self-reliance in Nerdrum's
mature paintings, one might attempt a description of his artistic project
in Nietzschean terms. His early paintings portray the modern world of
slave morality; his later paintings portray an ancient world of master
morality. Most commentators agree that one of the most important
paintings that inaugurates the major phase of Nerdrum's career is *Iron
Law* (1983–84), and it seems to depict the emergence of the master-slave
relationship, the moment when the slave acknowledges the master. The
bowing figure on the left appears to be submitting to the domineering
figure on the right, who threatens to beat him with a stick (in the distant
background, a third man turns his back on the whole affair). Nerdrum
seems to be suggesting that society originates in an act of violent mas-
tery. This is the archetypal moment that begins human history according
to Hegel in his *Phenomenology of Spirit*. In the struggle for recognition,
two men fight to the death for the sake of pure prestige. One persists and
the other gives up in this deadly struggle, because one values honor
more than life, and the other values life more than honor. The first
becomes the master, and the second the slave (exactly what seems to be

happening in *Iron Law*). Nietzsche's *Genealogy of Morals* is in effect a rewriting of Hegel's *Phenomenology*. He adopts Hegel's interpretation of history in terms of the master-slave dialectic, but reverses Hegel's evaluation of the results. Whereas Hegel sees the slaves' eventual turning of the tables on the masters as progress, Nietzsche views it as a falling off. He celebrates the world of the masters (for Nietzsche, essentially the heroic world of Homeric epic). By asserting their aristocratic superiority over the plebeian slaves, the masters define what is good and bad. Basically, strength and power are good; weakness and submissiveness are bad (in the sense of base and contemptible). For Nietzsche, the values of master morality become inverted when slave morality triumphs (chiefly in the form of Christianity, as he sees it). What the masters regard as good becomes reinterpreted as evil in Christianity (aristocratic superiority is viewed negatively as sinful pride and arrogance), while what the masters regard as bad becomes reinterpreted as good (submissiveness is viewed positively as humility and self-sacrifice—"turning the other cheek").

Nietzsche's scheme goes a long way toward explaining the contrast between the two worlds Nerdrum portrays in his paintings. The world of the early paintings is not a Christian world, but it is distinctly post-Christian (an apt way of describing modern Scandinavia). That is to say, Nerdrum's characters no longer seem to have a religious faith, but their world is shaped by the lingering effects of Christianity on their morality. The early paintings present a world in which love and compassion are held up as the true virtues, and any signs of aggressiveness or individual rebelliousness against the communal spirit are punished and repressed—in short, the world of the modern welfare state. Nerdrum seems to find this world stifling and untrue to human nature. In order to escape it, he turns in Nietzschean fashion to the pre-Christian, pagan past of Scandinavia, the world of Norse saga and myth. There he finds a land where strength is the only true virtue and aggressiveness can come out in the open. In this world power reveals itself in all its nakedness (see *Iron Law*), whereas in the modern world it tends to hide behind the mask of benevolent institutions, showing its true colors only in secret, in the shadow world of the prison system, for example, as Andreas Baader discovered. The modern world is one of concealed weapons, whereas Nerdrum's primitive nomads carry their weapons out in the open for all to see. In short, what is repressed in the modern world is freely expressed in the world Nerdrum imagines on the model of Norse paganism. Nerdrum appears to be talking about this kind of Nietzschean revaluation of values when he comments: "The most important thing is to

make people see that everything we now look upon as qualities are negatives of the true qualities."[58] Quoting Nerdrum, Pettersson says that his "objective was to represent all 'that man has abandoned in order to make the world go around the way it does.'"[59] These quotations from Nerdrum strongly suggest that his artistic project is fundamentally Nietzschean in his effort to reach back in time in order to move beyond a sterile present—to strip away the distortions in human nature introduced by Christianity and return to a kind of pagan past, in which man's elemental nature is once again revealed.

There does seem to be something elemental about the human beings Nerdrum depicts. It is in the nature of their situation that they find themselves with life and death staring them in the face. The characters in Nerdrum's early paintings turn away from human suffering, and the state may help them in this evasion by institutionalizing the sick, the elderly, the deviant, and the dying, and thus getting them out of sight. But the characters in Nerdrum's main phase of painting are confronted with the facts of life on a daily basis. Many of his paintings offer images of birth, and everything associated with it—infancy, breast-feeding, in general the close bond between mother and child (*Women with Milk* [1988–93]; *Pregnant Woman with Followers* [1999]; *Breast-feeding Fog* [1999]; *Twin Mother by the Sea* [1999]). Many paintings focus on the other end of life, and offer stark and uncompromising images of old age, dying, and death (*Dying Couple* [1993]; *Buried Alive* [1995-96]; *Old Man with Dead Maiden* [1997]). With life constantly under threat in the world of Nerdrum's paintings, and his characters living in the shadow of death, it is no wonder that life comes to seem precious and the one thing above all worth defending. In *The Lifesaver* (1995–96), Nerdrum shapes a striking image of a man protecting his family, as one of his fiercest Nordic warriors, with the trademark rifle strapped to his back, holds a tiny, fragile baby delicately in his huge and powerful hands. *Summer Night* (2000–01) epitomizes the whole world Nerdrum creates in these paintings, as a naked man, once again holding a rifle, stares out of a cabin to an empty horizon, on the lookout for any threats to the wife and infant who are asleep at his feet. It is as if Nerdrum is saying that human beings must lose their modern sense of comfort and safety in order to get back in touch with their primal emotions and learn what is really important in their lives. Indeed Nerdrum explicitly says of his characters: "The people I have depicted become less and less tied to our concept of security."[60] They must leave the state in order to find themselves and their true freedom to be themselves. As Nerdrum said of himself: "The only happiness I can feel is when I can get away from society and

its demands. Then there is a kind of feeling of freedom. Happiness is escaping, being set free."[61]

VIII

Where does the strange world of Nerdrum's major paintings come from? Many commentators have seen it as post-apocalyptic, the result of some catastrophe that has destroyed modern civilization. Some have suggested that Nerdrum is portraying the world after a nuclear holocaust, and point to the black clouds that loom ominously on the horizon in some of his paintings as perhaps radioactive (*The Black Cloud* [1986]; *The Cloud* [1985–93]).[62] This is undoubtedly too specific an explanation of what has brought about the world Nerdum portrays, but he has insisted that it is a world of the future; he said that he portrays man "after he has rebelled and fled our civilization in order to create a world of his own."[63] If nothing else, the ubiquitous guns in Nerdrum's world point to the fact that it comes after modern civilization. There are many senses of the term in which Nerdrum can be described as *postmodern*, but there is one way in which he is literally so.[64] His paintings portray a post-modern world, the world that comes after the collapse of modern civilization and in particular the modern state. And although Nerdrum portrays this world as wrecked and enormously reduced in its resources, he also sees it as in its own way liberating, freeing humanity from the prison-house of modernity and modernism. Stripped of all civilization, human beings are free to get back in touch with their own nature, which modernity attempted to hide from sight.

As we have seen, Nerdrum views modernism as resting on a faith in progress, and hence a linear view of history, which always tries to leave the past behind as dead and buried. The modernists saw themselves as coming at the end of history; indeed they viewed all history as leading up to them and culminating in their art.[65] Modernism is the art to end all art; that is why modernists insist that their art is the only true art, and will forever be the art of the future. No art is ever to supersede modernism. Nerdrum obviously disagrees with this view of the history of art, because he hopes to move beyond modernism in his own painting, and he believes that the only way to take a step forward is to take a step back, and learn from the Old Masters. That is why Nerdrum is attracted to a cyclical rather than a linear view of history. He says of his paintings: "Dates, for example, do not exist in this world, because it has nothing to do with the linear way of thinking in our civilization. Time has dissolved into eternity with no beginning and no end."[66]

Rather than accepting progressivist philosophies of history, like Hegel's or Marx's, Nerdrum was deeply influenced by Oswald Spengler's book, *The Decline of the West*.[67] Spengler presents cultures as following great cycles, and, as his title suggests, he proclaimed that modern civilization has passed its peak and is headed for a decline. As we have seen, Nerdrum tries in his paintings to imagine what a post-modern world would look like. And with his cyclical sense of history, the post-modern turns out to take the form of the pre-modern. Accordingly, although at one point Nerdrum says that his paintings have a "post-historic look," at another he says that he portrays "modern man having returned to a primeval society in his flight from civilization. He no longer has any roots in our time. He is back in a prehistoric condition."[68] Take away the modern state, Nerdrum seems to be saying, and human beings will regress to their primitive—and more natural—condition (while still holding on to all those guns, of course). For example, with the modern state gone, the world of print and perhaps even of writing disappears. There is no evidence of the written word anywhere in the paintings of Nerdrum's major phase.[69] He seems in fact to be portraying a purely oral society, a pre-literate or, more properly, post-literate world of Homeric bards or, more properly, Icelandic skalds (*The Storyteller* [1988]). There are singers and dancers in Nerdrum's world, but no scribes, and certainly no books (*The Three Singers* [1987–88]; *One Story Singer* [1990]; *Dancer with Snake* [1996]). For wisdom, his characters turn to shamans and prophets (*Revier* [1985–98]; *Sleeping Prophet* [1999–2000]). A painting called *Transmission* (2000) strongly suggests a world of oral tradition; an older man is transmitting his wisdom to a younger, who learns by direct example and imitation. Nerdrum's characters do not share the modernist's dismissive attitude toward tradition. Indeed, we see in his later paintings that, in the absence of the modern state, its rational regime, and its obsession with progress, tradition regains its original importance in human life. In general, Nerdrum's paintings can be viewed as a postmodern attempt to recover a pre-modern wisdom, a wisdom that has been lost sight of in the modern world with its hypersophistication and obsession with novelty for novelty's sake.

Nerdrum's quarrel with modernism as a painter is thus part of a larger quarrel with modernity. His differences from modernism are of course most clearly evident in his painterly technique. He rejects the abstraction of modern art in the name of the concrete textures and sensuous beauty of traditional art, and he insists on returning to the Old Masters as his models. But Nerdrum goes beyond mere questions of

technique and shows that the abstract character of modern art reflects its more basic attempt to establish its autonomy, to free itself from dependence on anything outside itself. That means above all that modern art tries to free itself from any dependence on a public, which paradoxically takes the form of a demand for so-called public funding of the arts. This leads in Nerdrum's view to the fateful alliance between modern art and the modern state, as modernists hope that national governments will come to their aid against a philistine public and become their saviors. Here is the deepest level of Nerdrum's critique of modernism—it buys into the ideology of the modern state, and the Hegelian faith in linear progress on which it rests.[70] Together with the modern state, modern artists hoped to lead humanity into a new and brighter future, a reconstruction of the world from the ground up. Most people have come to recognize the dangers of this view when it took the totalitarian forms of communism or fascism. But Nerdrum sees the welfare state as participating in the same modern project, only in a more insidious, because apparently more benevolent and less autocratic, way. In Nerdrum's view—and his early paintings are devoted to showing this—the welfare state takes us to the same dreary end of history, from which there appears to be no escape. It seems in fact to be the flat world of Nietzsche's Last Man in *Thus Spoke Zarathustra*. But however locked into the modern state modern man may appear to be, the paintings of Nerdrum's major phase are designed to provide an escape on the imaginative plane. As a painter, he simply wills away the modern state, and the barren landscapes of Iceland provide him with a real backdrop on which to project his fantastic vision of a postmodern/pre-modern condition. It is not, to say the least, a pretty sight, but in Nerdrum's view, in contrast to the abstraction of modernism, the very concrete world of his paintings takes us closer to the truth about humanity and human nature.

[2]
Mimesis versus the Avant-Garde: Art and Cognition

MICHELLE MARDER KAMHI

[A]rtists . . . have been pushing the boundaries of any . . . definition [of 'art'], challenging our preconceptions, and leaving most philosophers, psychologists and critics well behind—to say nothing of the general public.

— JOSEPH A. GOGUEN

One of the hottest topics of intellectual inquiry in recent years has been the relationship between art and cognition. And the idea that cognition plays a central role in the arts has great bearing on their future, the theme of this volume. As documented by Louis Torres in Chapter 9 below, today's gatekeepers of the arts—from philosophers and curators to critics and teachers—tend to favor "avant-garde" or "cutting-edge" work, most conspicuously in the realm of the visual arts. One lamentable result has been that contemporary painting and sculpture in a "traditional" vein have been virtually excluded from the main institutions of culture.[1] Yet, as the epigraph above suggests, the general public is likely to feel out of step with "cutting-edge" work. More often than not, people outside the art world do not even recognize such work as art, much less experience it as such. As reported a decade ago, for example, trash collectors in Frankfurt, Germany, hauled away and disposed of a purported work of public sculpture because they thought it was merely a heap of abandoned building material. Incidents of this kind remain quite common. Moreover, if one reads the critical literature at all carefully, the conclusion is inescapable that much of the "avant-garde" work of the past hundred years is incomprehensible even to its defenders, who appear unable to offer a reasonably intelligible and consistent account of it.[2]

The question of just how works of art are experienced is, of course, at the heart of research on art and cognition. How are works of visual art, music, dance, and literature perceived and understood? And how do they affect the emotions? Does the perception of art differ in important respects from other perceptual experience? Why does the perception of a work of art, although distinctly apart from one's "real life," often elicit an intense emotional response? These are some of the questions that researchers increasingly seek scientifically informed answers to.

Growing interest in the relationship between art and cognition has been a natural outgrowth of the "cognitive revolution" (a paradigm shift away from behaviorism's focus on stimulus-response mechanisms as the key to understanding how the mind works)—which began in academic psychology in the early 1960s and continues to expand our understanding of mental processes. Philosophers of art are recognizing that the new knowledge gained should influence their own discipline. Accordingly, in the summer of 2002, several prominent aestheticians—among them, Jerrold Levinson (then president of the American Society for Aesthetics)—organized an academic institute entitled "Art, Mind, and Cognitive Science," funded by the National Endowment for the Humanities (NEH), to help scholars of the arts take account of both cognitive science and the philosophy of mind in their undergraduate courses. As one might expect, the burgeoning interest in this subject is also reflected in numerous scholarly journals. Among others, the interdisciplinary *Journal of Consciousness Studies* (*JCS*) has devoted three special issues to the relationship between art and the brain or mind. That journal's founding editor, the late Joseph Goguen (a prominent computer scientist), is quoted in the epigraph to this essay. In 2003, the philosophical journal *The Monist* published an issue entitled "Art and the Mind." Tellingly, *The Monist*'s call for papers defined works of art as "cognitive devices aimed at the production of rich cognitive effects"—a definition that I will more than once return to in relation to purported avant-garde innovations in the arts.[3]

Finally, efforts to understand how cognitive processes are involved in the creation and perception of works of art have not been confined to higher education. Individuals concerned with teaching elementary and high school students have also been keenly pursuing this line of inquiry. Annual meetings of the National Art Education Association, for example, abound in sessions devoted to cognitivist approaches to the teaching of art. And a book entitled *Art and Cognition*—by Arthur Efland, professor emeritus of art education at Ohio State University—not only emphasized the cognitive content of art works but also argued that visual art can contribute to the overall development of the mind.[4]

I. Questioning Basic Premises

The intense interest shown in the topic of art and cognition clearly implies that the relationship between them is a distinctive one, meriting study in its own right. Further, it implies that *art* itself possesses a distinctive identity, differing from other objects of perception and cognition in significant ways. Little of value is likely to come of all this intellectual ferment, therefore, without a clear understanding of what exactly is meant by "art" in relation to cognition.

As indicated by the epigraph I chose—excerpted from the Introduction to one of *JCS*'s special issues on art and the brain—researchers in this area have tended to accept as art, and include in their deliberations, virtually all the modernist and postmodernist innovations of the past hundred years, regardless of whether they have anything essential in common with established art forms. Avant-garde works cited by Goguen in his Introduction, for example, include Robert Smithson's "earthworks" and Christo's "wrapped buildings," as well as Marcel Duchamp's "readymades" (in particular, the urinal he dubbed *Fountain*),[5] Andy Warhol's images of Campbell's soup cans, and John Cage's use of chance operations in his experimental "music." Yet one would be hard pressed to understand how such works fit the view that art is "a particularly poignant manifestation of human consciousness"—to quote from the call for papers by *JCS* for its issue on "Art, Brain, and Consciousness." By the same token, it is not at all obvious how, or even if, they aim to produce "rich cognitive effects."[6] Yet disconnects of this kind are commonplace in contemporary discourse on art and cognition. Scholars have too long failed to ask themselves whether the term *art*—customarily applied to such works as the tragedies and comedies of ancient Greece, Michelangelo's *David*, Rembrandt's portraits, Handel's *Messiah*, or the landscapes of Constable—can coherently encompass all the inventions of the "avant-garde," however bizarre or unintelligible they may be.

Interest in the relationship between art and cognition is scarcely a new phenomenon. Western thinkers since antiquity have grappled with it, albeit without the insights of modern science. In the modern era, such interest inspired the eighteenth-century philosopher Alexander Baumgarten to found a new branch of philosophy devoted to the study of "sensuous cognition." Coining the term *aesthetik* (from the Greek term meaning "perceptible to the senses") to designate this new field, he broadly defined it as "the science of perception"; but it was with the nature of perceptual knowledge conveyed *through the arts* that he was

exclusively concerned. In fact, the work in which he first used the term *aesthetik* was his *Reflections on Poetry*. That treatise aimed mainly to persuade his fellow rationalist philosophers that questions regarding the nature of art were as worthy of their attention as the more abstract spheres of thought with which they had previously concerned themselves. Baumgarten was thus ahead of his contemporaries in understanding that the arts constitute a distinctive and significant realm of "sensuous cognition," in which emotion also plays an important part. As indicated by an in-depth study of how the arts were viewed by ancient Greek philosophers, however, his ideas had clear precedents in antiquity.[7]

Baumgarten's view of the cognitive function of art was largely shared by his younger contemporary Immanuel Kant. Yet Kant has long been mistakenly associated with formalist theories, which attempt to divorce art from cognitive considerations and have played a regrettable part in the legitimization of abstract painting and sculpture, among the earliest and most influential of the avant-garde inventions.[8] Contrary to mistaken accounts of his aesthetic philosophy, Kant unequivocally states (in the sections of his *Critique of Judgement* focusing on the "fine arts"— as contrasted with more frequently quoted passages dealing with the aesthetics of nature) that the value of an art work depends on its presenting what he terms "aesthetical Ideas." He explains:

> [B]y an aesthetical Idea I understand that representation of the Imagination which . . . cannot be completely compassed and made intelligible by language. . . . [I]t is the counterpart (pendant) of a *rational Idea*. . . .
>
> The Imagination (as a productive faculty of cognition) is very powerful in creating another nature, as it were, out of the material that actual nature gives it . . . , and by it we remould experience, always indeed in accordance with analogical laws. . . .
>
> Such representations of the Imagination we may call *Ideas*, partly because they at least strive after something which lies beyond the bounds of experience, and so seek to approximate to a presentation of concepts of Reason (intellectual Ideas), thus giving to the latter the appearance of objective reality.[9]

What Kant seems to be saying here is that the arts present perceptual embodiments of important ideas—not only ideas about existential experience, such as death, envy, love, and fame, but also imaginative conceptions of other-worldly things, such as heaven and hell, as he goes on to explain. In all cases, he implies, the products of the artist's imagination are essentially *mimetic*, for they resemble to some degree the appearance of nature, or (to borrow his term) "objective reality." As he

makes clear, however, a work of art does not merely *copy* nature, for it instantiates ideas more fully than any single example could do in reality. That mimetic art does much more than merely mirror the surface appearance of reality was recognized even by Plato, it seems—despite a persistent impression to the contrary created by the often-quoted "art as mirror" passage from Book 10 of his *Republic*. Moreover, Aristotle's account of artistic mimesis, in the *Poetics* and other writings, reveals a yet deeper understanding of the complexity and richness of mimetic representation in art.[10]

In the course of the nineteenth and twentieth centuries, of course, the previously commonplace idea that mimesis is a defining attribute of the arts was increasingly challenged—most dramatically so with the advent and growing acceptance of abstract painting and sculpture. Mimetic representation as a necessary, if not sufficient, condition of art was rejected outright, first by the pioneers of abstract art (who attempted to convey their worldview without mimetic reference to recognizable objects), and subsequently by the postmodernists, who began by misconstruing and therefore flouting or denying the distinction between representation and reality inherent in all works of art. In the process, the intelligibility of art was sacrificed, on the altar of total "artistic freedom"—thus severing, I would argue, the former nexus between art and cognition.

Anyone wishing to understand art more fully in relation to "sensuous cognition," therefore, should begin by noting that the sorts of objects Baumgarten, Kant, and other eighteenth-century aesthetic theorists had chiefly in mind when they spoke of "art" or "the arts" were the *mimetic arts*, also called the *imitative arts*—which by the middle of the century came to be known, however misleadingly, as the *beaux arts*, or "fine arts." What basic forms of expression did they include? According to a broad consensus from antiquity until about 1750, these were primarily painting and sculpture in various media (i.e., two- and three-dimensional visual representations), "poetry" (which in effect included all imaginative literature—dramatic, narrative, and lyrical), music, and dance. Neither the ancient concept of the mimetic arts nor the earliest definition of the term "fine arts" included either architecture or objects of "decorative art."[11] Nor, obviously, did they anticipate the invention of myriad new forms.

If the nature of art is now to be examined scientifically in relation to cognition, researchers must first ask, Which, if any, of the new forms—from "abstract art" to "conceptual art"—legitimately qualifies as art in the sense formerly intended? Do any of them constitute a medium of "sensuous cognition" in the manner suggested by Baumgarten?

In considering the status of forms of expression unknown to the eighteenth century, one might readily concede that nondocumentary feature films, for example, may be viewed as examples of mimetic art, since they are an effective form of dramatic and narrative story-telling. But would what Baumgarten wrote in his *Reflections on Poetry* be applicable to the largely unintelligible postmodernist "poems" of John Ashbery, say? Can such work truly exemplify Baumgarten's idea of "sensuous cognition"? Further, can the phrase "rich cognitive effects" (to quote *The Monist*'s call for papers on "Art and the Mind") meaningfully apply to works ranging from Mondrian's signature grid paintings to Duchamp's "readymades," much less to Minimalist works such as Ad Reinhardt's all-black paintings or Carl Andre's "floor pieces," or to John Cage's "chance compositions" or his *4'33"*? Finally, can there be any but the most flimsy connection between "*sensuous* cognition" and the whole postmodernist category of *conceptual art*—defined by the 1988 *Oxford Dictionary of Art* as "various forms of art in which the idea for a work is considered more important than the finished product, if any"?

Contemporary aestheticians who attempt to analyze or define art are apt to cite avant-garde inventions as conceptually "hard" cases, thereby implying that they are essentially incommensurate with the traditional categories of art. Nonetheless, on the basis of such deviant work, most academic philosophers of art have adopted some sort of "institutional" definition—holding, explicitly or implicitly, that "art is anything an artist declares it is." Even aestheticians who are critical of such definitions are inclined to accept as "art" the antitraditional contemporary works in question, no matter how outlandish or absurd. To discuss art rationally in today's context, however, requires admitting that the appropriate answer to the ubiquitous question *But is it art?* may in fact be a resounding *no*.[12]

It is worth noting here that one such answer was offered in the second half of the twentieth century, when avant-gardism had already taken full possession of the art world. Reacting against contemporary work that seemed to be the antithesis of art, the popular philosopher-novelist Ayn Rand proposed a cognitive view that was similar in major respects to those of Baumgarten and Kant. In a series of four essays, one of which was entitled "Art and Cognition," she held not only that works of art are essentially mimetic but also that they serve a distinctive psychological function that is both cognitive and emotional. Through the "selective re-creation of reality," she maintained, art "brings man's concepts [in particular, his values and worldview] to the perceptual level of his consciousness and allows him to grasp them directly, as if they were

percepts." Only in that form, she argued, can such ideas be grasped with the full emotional immediacy of sensory experience. Written between 1965 and 1971, around the time when the cognitive revolution was just getting underway, her essays on the nature of art often reveal a highly nuanced understanding of the interplay of perception, cognition, and emotion in the creation and experience of works of art.[13]

II. Re-Examining the History of the "Avant-Garde" in the Visual Arts

In pursuing the question *But is it art?* in the realm of the visual arts, where it is most often raised, it is instructive to retrace the history of the twentieth-century "avant garde," from the development of abstract painting in the early 1900s through the increasingly bizarre expressions of postmodernism.

We should begin by asking, What impelled the pioneers of abstract painting—Kandinsky, Mondrian, and Malevich—to take the unprecedented step of abandoning mimesis in their work? And what did they hope to accomplish? It is clear from their ample theoretical writings (though not from their paintings) that they were led to this extreme measure by a profound desire—inspired in large measure by various occult beliefs—to escape from what they regarded as the excessive materialism of their time. Kandinsky, for example, viewed his epoch as a time "of tragic collision between matter and spirit," and proclaimed that before the "awakening soul" of man could complete its evolution, it must be liberated from the "nightmare of materialism" still holding it in thrall. By eschewing representation of recognizable objects in the visible world in favor of abstract compositions of form and color, he and his fellow nonobjective painters hoped to give expression to a realm of pure spirit.[14] Each in his own way earnestly strove to embody profound metaphysical and spiritual values in his work and to engage the emotions, as artists have always done. But both their view of reality (in particular, of the relationship between spirit and matter) and the means they employed to represent it were wholly inadequate, and antithetical to the essential nature of art—which is to concretize, in readily graspable form, ideas and feelings about the world, and about human experience and values, in particular. As their theoretical treatises reveal, they unwittingly based their work on mistaken conceptions of the relationship between mind and matter, and between perception, cognition, and emotion. In actuality, spirit is always embodied in matter, and human emotions are always

tied to the perception of particulars, and to a cognitive grasp of their relevance to one's life—not to abstractions. That is why the genuine arts have always been mimetic, rather than abstract and symbolic.

In fact, the pioneers of abstract painting were themselves painfully aware that visual art had always depended on representations of reality (that is, on the mimetic re-creation of nature) to embody meaning in perceptual form. They were therefore haunted by fears that, having abandoned such representations, their work would be perceived as merely "decorative" (as indeed it still is by many art lovers). Earnestly though they strove to create a new art, theirs was a failed enterprise. Nevertheless, "abstract art" soon gained cultural legitimacy, owing largely to the efforts of influential critics, collectors, and curators, rather than to a genuine response on the part of a broad public—which continues to find such work unintelligible, despite nearly a century of cultural dissemination and advocacy.[15]

A half century after the European pioneers invented abstract painting, artists in America drastically shifted its focus and aims, attempting to employ it as a means of direct personal "expression" in various ways. Yet they, too, had persistent doubts that their work would be understood. Like the pioneers of abstraction, leading Abstract Expressionists such as Mark Rothko feared that their canvases would be perceived as mainly decorative. Their fears were well founded, of course. A print of one of Rothko's typical canvases was advertised for sale in the Fall 2002 home furnishings catalog from Crate & Barrel, for example, with the caption: "Bright yet soothing, this appealing . . . abstract Rothko reproduction makes a contemporary color statement." It came as no surprise to me, for under normal circumstances, uninfluenced by the exalted expectations set up by critics and curators, the average person is unlikely to read Rothko's work as anything more than a mere "color statement."

The postmodernist movement that began with "Pop Art" in the mid 1950s was, on the whole, a deliberate reaction against the dominance of Abstract Expressionism and all that it stood for in the international art world. Unlike previous transformations in the course of art history, it was prompted less by a sincere desire on the part of its practitioners to create work that would be more effective or more personally meaningful than by a mindless effort to displace the reigning stars and establish their own position in the artworld firmament. Since the abstract movement's basic premise (that meaning can be conveyed without resort to objective representation) was utterly false, a reaction was surely in order. The form of reaction pursued by the postmodernists was equally false, however. True, the Pop movement reintroduced imagery, on which the

intelligibility of visual art depends. But it was an imagery largely devoid of values, either personal or social, and quite deliberately so. Works such as Andy Warhol's *Brillo Boxes*, Roy Lichtenstein's simulation of comic strip panels, or Claes Oldenburg's soft "sculptures" of ordinary household objects render the most banal of subjects in ways that emphasized their banality, while others (such as Warhol's silkscreens of celebrities) appropriate motifs from the mass media, exploiting them in repetitive arrangements that have the effect of reducing potentially powerful single images to affectless patterns. They thereby controvert the very purpose of art, which is to focus attention on aspects of experience or imagined possibilities that the artist regards as important, as worth remembering or reflecting upon in the realm of values. In effect as well as intention, therefore, such work constitutes *anti-art*, by any reasonable standard.

In fact, the radical early postmodernists Henry Flynt and Allan Kaprow (pioneers of such new genres as "conceptual art," "performance art," and "installations") frankly admitted that their work had nothing in common with past art as such. Rightly so, since all of its features were aimed—even more than those of Pop Art—at controverting the very idea of *art*. Kaprow's infamous "happenings," for example, sought to collapse the distinction between art and life that is essential if works of art are to be perceived as representations of, or quasi statements about, life—a distinction that had been recognized even by ancient philosophers. Nonetheless, postmodernists soon referred to their work as art, and to themselves as artists, although the means they employ—such as the appropriation of readymade objects and images or "composition" by chance operations—are antithetical to the meaningfully selective re-creation of reality (to borrow Rand's phrase) characteristic of the process by which works of art are created.[16]

While a younger generation of postmodernists have ostensibly reintroduced value and meaning into their work, mainly in the guise of political and social critique, they continue to employ spurious forms such as "video," "installation," and "conceptual art"—all of which grew out of the anti-art impulses of the 1960s. As I have noted, a key tendency of those impulses was the deliberate blurring of the distinction between art and life. But one should then ask, If so-called art works can now be "indiscernible" from the objects of everyday experience (as philosopher-critic Arthur Danto famously argued), then what becomes of the special significance that philosophers originally placed on art in relation to "sensuous cognition"? If there is nothing distinctive about art, why study it at all in this context?

III. Artistic Mimesis and Cognition

The "cognitive turn in aesthetics" of recent decades is often attributed to the publication of Nelson Goodman's *Languages of Art* (1968), which focused on the study of "representation and other symbol systems and processes." In my view, however, Goodman's emphasis on symbol systems (his book is subtitled *An Approach to a Theory of Symbols*) was itself an unfortunate step in the wrong direction, for it diverted attention from the mimetic nature of the arts.

That mimesis is integral to the arts has not only been recognized by Western thinkers from Plato and Aristotle to Baumgarten, Kant, and (more recently) Rand, as I have indicated, but is clearly implied in the thought of other cultures as well. According to this long-established view, the "language" of art is fundamentally *mimetic*, not symbolic, for it depends primarily on the "natural meanings" of representations—in contrast with the arbitrary, culture-specific meanings assigned to symbols.[17]

As the art historian Erwin Panofsky observed, the primary source of meaning in a work of painting or sculpture is what he termed its *natural subject matter*—that is, forms that are intelligible simply by virtue of our shared human experience, without any specialized cultural knowledge. Natural subject matter, he further explained, can be both factual and expressive (the term he used was "expressional"). Factual subject matter consists of recognizable, although not necessarily realistic, representations of such things as human beings, animals, plants, and everyday objects. Expressive subject matter has more to do with the manner in which things are represented—that is, with the emotionally evocative qualities of pose, gesture, facial expression, atmosphere, and so on.

The secondary source of meaning in visual art is what Panofsky termed the *conventional subject matter* of a work. Understanding the meaning of conventional subject matter—including, most notably, symbols of all kinds—requires culture-specific knowledge that is extrapictorial rather than intrinsic. An excellent illustration of Panofsky's distinction between natural and conventional subject matter is offered by Jan van Eyck's justly celebrated wedding portrait of Giovanni Arnolfini and his young bride, Jeanne Cenami—a work whose rich iconography is familiar to students of art history. A number of the painting's details have both symbolic and natural meaning—the figure of a little dog at the feet of the couple, as a sign of fidelity, for example, and the solitary candle burning in the chandelier, signifying the all-seeing Christ. While naturally appropriate to the domestic setting, these objects also symbolize

the sacramental character of the image as bearing witness to the Catholic union of husband and wife.[18]

The emotional power of the work does not derive from its symbolic content, however, but from its natural subject matter and its depictive and expressive features, from the intensely sober facial expressions of the young couple and the delicacy with which Jeanne lays her hand, palm out, upon her husband's outstretched hand (the joining of hands was also symbolic of the marriage vows) to the aura of tranquil solemnity in the elegant bedchamber. These are the qualities that make it a great work of art—an emotionally meaningful image that transcends the particular historical moment represented and conveys something about the gravity and importance of marriage in general. Unlike the symbolic elements, these qualities require no special decoding or explanation: they are readily accessible to an attentive viewer.

To provide an adequate account of artistic mimesis, I must again stress that the mimetic arts were never properly regarded as merely "holding a mirror up to nature," Plato's oft-quoted analogy notwithstanding. As classics scholar Stephen Halliwell persuasively argues in his exhaustive study *The Aesthetics of Mimesis,* the ancient concept of mimesis encompassed a wide variety of artistic styles, ranging from realism to idealization and stylization. Meaningful selectivity and imaginative transformation were always recognized as playing an important part in the mimetic re-creation of reality—even in the most ostensibly "realistic" styles. Moreover, Plato himself acknowledged that the highly stylized figurative representations of Egyptian painting and sculpture, for example, also qualify as mimetic art.[19]

It is of course reasonable to ask why mimesis has always been the primary means by which the arts perform their cognitive and emotional function. I have already indicated the answer to this in arguing that mimetic art is readily graspable. A further evolutionary perspective is offered by the Canadian neuropsychologist Merlin Donald in his *Origins of the Modern Mind: Three Stages in the Evolution of Culture and Cognition*, and in his more recent work, *A Mind So Rare: The Evolution of Human Consciousness.* Donald theorizes that mimesis played a crucial role in human cognitive evolution, serving as the primary means of representing reality among the immediate ancestors of *Homo sapiens,* just prior to the emergence of language and symbolic thought. *Mimesis,* in his view, refers to intentional means of representing reality that utilize vocal tone, facial expression, bodily movement, manual gestures, and other nonlinguistic means. As he insists, it is "fundamentally different" from both mimicry and imitation. Whereas mimicry attempts to render

an exact duplicate of an event or phenomenon, and imitation also seeks to copy an original (albeit less literally so than mimicry), mimesis adds a new dimension: it "re-enact[s] and re-present[s] an event or relationship" in a nonliteral yet clearly intelligible way. (Here, again, Kant's "aesthetical Ideas" and Rand's "selective re-creation of reality [that] brings . . . concepts to the perceptual level of consciousness" come to mind.)

As Donald emphasizes, mimetic representation remains "a central factor in human society" and is "at the very center of the arts." While it is logically prior to language, it shares certain essential characteristics with language, and its emergence in prehistory would have paved the way for the subsequent evolution of speech. Yet mimetic behavior, Donald stresses, can be clearly separated from the symbolic and semiotic devices of modern culture. Not only does it function in different contexts, it is still "far more efficient than language in diffusing certain kinds of knowledge . . . [and in] communicating emotions." Moreover, the capacity for

> mimetic representation remains [fundamental] . . . in the operation of the human brain. . . . When [it] is destroyed [through disease or injury], the patient is classified as demented, out of touch with reality. . . . But when language alone is lost, even completely lost, there is often considerable residual representational capacity.[20]

Commenting on the power of mimetic representation in his *Anthropologist on Mars*, neurologist Oliver Sacks wrote of an autistic boy whose capacity for abstract and symbolic thought and communication was severely impaired, but who comes fully to life through artistic expression, through his "genius for concrete or mimetic representations, whether drawing a cathedral, a canyon, a flower, or enacting a scene, a drama, a song." Mimesis, in Sacks's view, is "itself a power of mind, a way of representing reality with one's body and senses, a uniquely human capacity no less important than symbol or language." His claim is as true of music as it is of the visual and verbal arts, I should add, although music has long been mistakenly cited as a counterexample to the essentially mimetic nature of art.[21]

If, as Merlin Donald suggests, this prelinguistic mode of representation and communication developed relatively early in the course of human evolution, it would have been closely linked to the evolving psychological and physical mechanisms for emotional response, which play a crucial role in both social interaction and the arts. That would help to

explain the emotional immediacy of the mimetic arts. Mimesis is not in itself the *end*, or goal, of art, but it is the powerful *means* by which works of art convey their cognitive and emotional content. The avant-gardist tendencies of both modernism (most radically, in the trend toward nonobjective art) and postmodernism have flouted this basic truth, to the detriment of both art and cognition.

Conclusion

To return to the theme of this volume, the future of the arts, that future is likely to be a dismal one in the realm of the visual arts, unless there is widespread recognition of both the mimetic nature and the cognitive and emotional function of art—and a concomitant rejection of what has passed for art under the misleading rubric "avant-garde." Until that time, the equivalent of Gresham's law will continue to operate in the artworld. Spurious art—which, like paper money, is readily multiplied—will continue to drive out genuine art in the marketplace, as long as it is granted legitimacy by the institutions of culture.

Postscript

The preceding Conclusion, originally penned about a decade ago, holds no less true today. If anything, "avant-garde" assumptions and practices have become even more firmly entrenched in our leading cultural institutions—as Louis Torres argues in a later chapter of this volume.

To drive my point home, I will cite just two examples here. Most telling is a brief exchange I had in 2013 with Glenn Lowry, the director of New York's Museum of Modern Art. The occasion was a press preview for the museum's first exhibition of the postmodernist invention called "sound art." Contrary to what one might expect from the show's title—*Soundings: A Contemporary Score*—it did not deal with *music*. It instead consisted of such pieces as an "exploration of how sound ricochets within a gallery," field recordings of sounds made by echo-locating bats, and a manipulated recording of sounds made by various species of creatures in the range above human hearing capacity, which were then lowered to render them audible to us.

In remarks to the press, Lowry frankly acknowledged that much of the work was "almost scientific" in nature, some of it "very scientific." He nonetheless declared that he was very "excited" to present such work because he deemed it the museum's mission "to follow artists wherever they're going." When I asked if he might ever consider that where

purported artists were going was no longer *art*, he replied that Duchamp had settled that question for all time, by establishing the principle "If an artist does it, it's art."

What about the many serious artists who have chosen not to go where these "sound artists" and other avant-gardists are going, and are completely ignored by the museum? Lowry's answer was: "Our society values innovation, and artists who don't engage in it are inevitably left behind." Not considered by him (or by today's art establishment in general), of course, was the fundamental question of what properly qualifies someone to be considered an "artist."

Perhaps more disturbing, meaningful criteria have even been abandoned at an institution as formerly conservative as the Morgan Library and Museum. A recent exhibition entitled *Embracing Modernism: Ten Years of Drawings Acquisitions* included, among other dubious items, a "folded paper drawing" by Sol Lewitt and a Gavin Turk "drawing" created by placing a sheet of paper on his van's exhaust pipe. When I asked the curator, Isabelle Dervaux, how she defines "drawing," she replied: "anything on paper"—quickly adding, rather testily: "I hate splitting hairs over what a drawing is."

Such instances attest to the contemporary artworld's dominant premise that virtually anything can qualify as art. That entrenched view has, in turn, given ever freer rein to avant-gardists. What hope is there for uprooting it?

The best hope, in my view, lies in what neuroscience is teaching us about the brain's system of "mirror neurons." This powerful neural network—first discovered in the 1990s in macaque monkeys, and increasingly extrapolated to humans—helps to explain why mimetic art (that is, artistic imagery) can affect us so deeply and meaningfully. Mirror neurons are activated, first and foremost, by observing instances of emotional expression and physical action in others—clearly accounting for the "monkey see, monkey do" phenomenon. Of particular relevance for the arts, however, the mirror neuron system in humans is also activated by seeing *images*—in particular, images of things we are already familiar with from our own experience. In other words, we in fact respond to imagery as we would respond to the things represented, if we saw them in reality. That helps to explain why mimetic art is directly intelligible and emotionally meaningful, endowed with a psychological power never to be attained by the arbitrary inventions of the avant-garde.[22]

[3]
A Prophecy Come True? Danto and Hegel on the End of Art

HENNING TEGTMEYER

In a well known paper,[1] Arthur Danto claims that Hegel's prediction concerning the end of art in modern times has finally come true. Art, according to Danto, has developed into philosophy, at least it has in the most received avant-garde works from Duchamp to Warhol. For Danto, this is an ultimate stage in the history of art, at least on a conceptual level. Basically, he sees two possibilities for the further development of art: either it may disappear completely or it may cease to develop at all, continuing its existence at the level of some boring 'anything goes' endeavor instead. Neither alternative seems very promising.

In the following, I will try to show that Danto's reading of Hegel's dictum about the future of art is incorrect and misleading. Hegel's thesis about the end of art is neither a prediction nor a prophecy. The question is not merely of historical interest: a re-interpretation of the famous passages in Hegel's *Vorlesungen über die Ästhetik* will rather allow a different diagnosis of art's future in the wake of the avant-garde movements.

1. Danto's Claim

1.1 ART AND HISTORY

What Danto seeks to explain in his paper on the end of art is the poor condition of contemporary art. That art is in a poor condition today is taken for granted rather than argued for in the paper.[2] For him, as for many other art critics, 'postmodernism' is a euphemistic label for the fact that modern art has run into a fundamental crisis. Postmodernism is not—or not primarily—the label for an art historical period like 'baroque' or 'romanticism'. Rather, it is an anti-label, a term meant to express that postmodern art, unlike modern art, does not give birth to anything powerful or genuine, but only mixes old genres and styles of art.

I do not intend to quarrel with this picture. On the contrary, in my view there is strong evidence that the condition of art today is poor indeed and that Danto is right in his overall diagnosis, although, in his search for the powerful and genuine in contemporary art, he may be looking in the wrong direction.[3] But this is not my main concern here. The focus of this paper is on the question of how Hegel comes into the picture. This is important for the very understanding of Danto's thesis because Danto describes himself as offering a Hegelian explanation for the existence of postmodern art.

Danto is quite aware that his claim concerning the end of art presupposes that art is essentially historical. That means that art is a form of practice—an institution, Danto says[4]—that develops in time. This is a broadly Hegelian understanding of art.[5] That art develops in time implies two things: 1. One cannot reliably tell artworks from non-art just by 'looking and seeing', or by describing the immediately perceptible qualities of any given object. Identifying an object correctly as a work of art rather has to do with placing it in the history of art; (2) one cannot analyze the *concept* of art synchronically, without referring to art history. Therefore, any attempt to define art by stating necessary and sufficient conditions for arthood at every time and place is doomed to fail. This does not imply, however, that the concept of art dissolves into time-relative concepts like 'ancient art', 'medieval art', or 'modern art'.[6] Danto does not share any form of historical relativism with respect to the concept and the history of art.[7] On the contrary, the idea of *development* makes it possible to account for the variety of art forms, genres and styles.

Understanding art as essentially historical is tightly connected to the idea of *artistic progress*. I use the rather vague term 'tightly connected' to indicate that no strict logical necessity is involved here. A developing practice or institution need not be progressing. It might just as well decline and dissolve gradually. However, this would be a quite implausible kind of story about the history of art. Surely it would explain why art is in a miserable condition, but it would do so at the cost of making unintelligible how art could have been in a better state before. Therefore, an overall pessimistic theory about the history of art would be much too sweeping to explain anything at all. One needs the idea of artistic progress to make the idea of artistic decline intelligible. But in order to explain the real history of art, and not just an abstract idea of art history, the concept of progress invested into the theory has to be quite substantial itself.

1.2 Two Theories of Artistic Progress

Danto discusses—and partially rejects—two substantial theories of artistic progress before he offers his own as a more promising alternative. According to the first theory, art aims at mimetic representation, at depicting certain parts of the external world as faithfully and accurately as possible. If this were true, then artistic progress could be said to consist in mimetic achievements of the innocent eye test kind. That is, it would be a case of artistic progress if an artist managed to make spectators mistake his picture for the very object depicted, whereas former pictures of the same object only slightly resembled it. He who managed to make painted grapes look just like grapes, would be the greatest artist.[8] Anyway, this theory fails because it lacks generality in two different respects. First, it is not general *in scope*. It grasps only pictorial art, painting and sculpture. Second, it is not *historically* general. It does not grasp post-impressionist painting and sculpture. It is not true, Danto argues, that Matisse or Picasso failed to make mimetically accurate portraits of the persons they depicted. They did not even try. The mimetic game was already over for pictorial art when Matisse and Picasso entered the stage. Photography and film had taken over the mimetic job. Or so goes the story that Danto tells us. Nevertheless he accepts a limited version of the mimetic theory of art. He believes that mimesis was the ideal guiding painting and sculpture until about 1900.

One may wonder whether Danto takes too much for granted in the story he tells. What he does take for granted without further analysis is the very concept of mimesis. This is a mistake, but for reasons that are not obvious. The problem with mimesis does not have to do with the distinction between pictorial and linguistic representation. Nelson Goodman claimed that there is no difference in principle between pictures and texts, between depiction and description, but only gradual differences. He even took the linear perspective in paintings and drawings to be merely conventional.[9] Danto rejects both Goodman's general thesis and the claim concerning linear perspective, and he is right.[10] Goodman's claims must be false if there is any substantial difference between depiction and description at all. And there certainly is a fundamental difference. The discovery of perspective is one of the great mimetic achievements of artistic technique. The problem is rather that Danto never asks how it was possible that pictorial art ever *aimed* at mimesis of the make-believe kind. It is not open to him to simply *assume* that there is a conceptual link between mimesis and pictorial

representation. Even if this was true, it would be no trivial truth, because it would make the question urgent how pictorial expressionism or cubism were possible. Or, more generally: how is it possible to create a non-mimetic picture that still is a *picture*? In order to avoid conceptual confusion here, we must understand mimesis as pictorial make-believe to constitute a *special project* within the history of art, a project that is not identical with the project of pictorial representation *tout court*. As long as the nature and the aims of this special project are not made intelligible, it is impossible to understand why it had to end with the invention of photography and film. Despite its initial plausibility, Danto's hypothesis that mimetic pictorial art ceased to exist because of the invention of photography and film seems to be rather an *ad hoc* explanation.[11] Perhaps one could strengthen Danto's point with some effort. But I cannot do this at length in the present context.[12]

The other substantial theory of artistic progress that Danto discusses is the expression theory of art in a Crocean version. According to Croce, the aim of art is to express human emotions or, more broadly, mental states. In an admittedly oversimplified version, aesthetic expressivism claims that the main point about any sufficiently well-made work of art is that it somehow expresses the emotions of its creator, which call for an aesthetic or rather emotional response of the spectator. This helps to explain why pictorial cubism in comparison with impressionism can be seen as an artistic achievement. Cubist pictures are progressive because they are more expressive than their impressionist counterparts. Croce's aesthetic theory allows us to evaluate the merit of modern, post-impressionist painting, not as a lack of mimetic accuracy, but rather on its own terms, as a movement that went beyond mimetic standards in favour of expressive ones.

But even if aesthetic expressivism may count as a theory of artistic progress at all—which may be doubted—it nevertheless remains local. It explains the shift from nineteenth- to twentieth-century art. But it is unable to explain the development of art as a whole. The claim, Danto argues, that art always had been striving for emotive expressiveness, and that it finally succeeded in reaching such expressiveness around 1900, is simply implausible. Moreover, expressivism cannot explain how pictorial mimesis ever came to be important. Of course one might refine expressivism by building it upon a more sophisticated, cognitivist theory of the emotions. An expressivist might hold that there are no 'objectless emotions'[13] like anger or joy in the first place. Any adequate theory of the emotions has to start with emotions and attitudes *towards* persons or states of affairs, for example with 'envying Paul', 'admiring Mary', or

'being ashamed of one's own country'. Objectless emotions then come into the picture through a kind of abstraction marked by the shift from talk about 'envy of X' or 'shame because of p' to talk about envy or shame 'as such'. In other words, the possibility of objectless emotions rests on a kind of linguistic invention. They have no existence independent of this kind of inventive language game. And if objectless emotions are not given immediately, but only in abstraction from their object or content, in abstraction from their intentionality, then it is highly plausible to argue that objectless emotions cannot be objects of pictorial—or any other kind of—representation in the first place. No wonder therefore, an expressivist might continue, that the pictorial artists did not even aim at pure pictorial expressiveness before 1900. They could not possibly do so. Only after 1900 was it possible to abstract from representational content, or rather to represent pictorially the objectless emotions themselves, pure and simple, that is disconnected from their intentional context.

But a cognitivist argument like the one sketched here does not do enough to defend expressivism. Danto might respond that it still remains a mystery why objectless emotions came to be the direct objects of pictorial representation so late in the history of art. Objectless emotions may well be understood as a kind of linguistic invention. But nevertheless this invention must have taken place in ancient times. At least as early as Plato and Aristotle, we find mention of objectless emotions. Proponents of the view that expressivism was fated to appear only after 1900 are unable to explain the gap between talk of objectless emotions by the ancient philosophers and the absence of such depictions in ancient pictorial art.[14]

There is another possible reading of the expressivism that Danto discusses. Expressivism may also be taken to make a more local claim about a certain feature of modern pictorial art rather than a point about art in general. An expressivist in this sense may allow that the aim of pictorial art was once mimesis, without entering into a discussion of why this was the case. But then she is free to insist that things changed when post-impressionist painting entered the stage. Mimesis ceased to be important and pictorial expressiveness became the new game. Or at least so the story goes. Let us label this position historical expressivism. Historical expressivism is not vulnerable to the charge of not being general, for it makes no claim to be a theory of art in general. It may even coexist with a historical mimesis theory of pictorial art. We might label this kind of revised mimetic theory *historical mimetic representationalism*.

Some aspects of the conjunction of historical mimetic representationalism and historical expressivism are quite discomforting, however, at least for a philosopher of art. One might press a historical expressivist to admit that the game of being expressive is already over in the pictorial arts. Expressive art remains an episode in the history of art. And this means that historical expressivism is unable to tell us anything about the nature of pictorial art. But our historical expressivist may happily concede this and reply that no other theory of art will be able to do so either, because there is no such thing as the nature of art. That is, there is no essence, no overarching project or aim of pictorial art, or of art in general. What we call art is just a series of contingent practices and projects linked only by contingent relations or by some slight family resemblances. This would be a postmodernist version of a no-theory theory of art. Let me call it—paradoxically enough—an anti-essentialist historical theory of art.

Adherents of postmodernism will regard the fact that a given theory of art stresses the contingency of any theory as one of its major virtues. But the trouble with this position comes out rather clearly when we look more closely at the consequences of limiting our view of art to an anti-essentialist theory of art. Art, the anti-essentialists tell us, is nothing more than an umbrella title for a number of very different, only loosely connected practices and projects. So, strictly speaking, we do not have art at all but arts. The practices and projects that belong to the arts have a history. But, strictly speaking, there is not just one history of the arts but many different, mutually independent but overlapping histories of arts. The search for a principle of unity in this variety is senseless, so they say. Postmodernist thinkers believe that quests for unity are nothing more than the result of some kind of metaphysical uneasiness that has to be overcome.

A more traditional philosopher of art may shift the burden of proof by asking if the story that postmodernism tells about art is intelligible in the first place. If there is no art but rather arts, and if there is no art history but rather histories of arts, then what gives each particular artistic practice and each particular history its unity—or at least its coherence? What can an anti-essentialist theory of art do to justify the use of more specific terms like 'ancient tragedy' or 'the art of mimetic painting'? The worry of the traditional philosopher of art is that if we abandon the idea of a history of art, then the histories of arts we are after dissolve and vanish, too. Furthermore, postmodernist thinkers are in need of an error theory of art that can account for the fact that people who called themselves artists in the past (before the illusion of unity had been revealed)

believed they were partaking in a large scale cultural project while in fact there was no such project. One might suspect that aesthetic post-modernism retains some initial plausibility by employing precisely those concepts it tries to undermine—'art' and 'history' (both in the singular). We might call this a version of postmodernist irony.

1.3 ART AS PHILOSOPHY

However, Danto does not adopt aesthetic anti-essentialism himself but finally comes up with his own version of what might be called an *essentialist historical theory of art*. The core idea of his approach to artistic progress is to take art as a self-reflective enterprise, just like philosophy or Hegelian spirit.[15] Art essentially aims at understanding its own nature. This thesis is rather vague, though. Understanding the nature of a certain practice or activity, in one way or another, is often a precondition of participating in the very practice or activity in question. For example, it would be more than odd to meet a judge who had no idea of justice or law whatsoever. Having to understand its own nature thus does not seem to be a goal unique to art.

In order to give his thesis a more precise meaning Danto draws upon certain material presented in *The Transfiguration of the Commonplace* (*TC*), his 1981 book about art. There he defended a broadly representationalist conception of art. Art is representational, he claimed, because artworks are essentially *about* something. Representation has to be taken in a broad sense because artworks need not be about objects or processes 'out there'. They might as well be about rather abstract matters, such as 'blueness' or 'blessing'. They might even be about themselves.

This, however, remained just a logical, or rather, conceptual possibility within the framework of *TC*. Self-referential artworks do not enjoy any kind of theoretically privileged status here. Things change when Danto starts to think about the end of art. Now he wants to argue that 'being about itself' is not just any possibility but an ultimate possibility, the historical *telos* of artistic activity. Therefore, when artworks become self-reflective, they reach the ultimate purpose of art. In a sense, there is nothing left to do for artists afterwards. Of course, they may go on making art forever. But they will be unable to create something substantially new that is still an artwork, because this is by definition impossible.

Instances of this ultimate kind of artwork are the prototypical works of later classical modernism, ready-mades like Duchamp's *Fountain* or *In Advance of the Broken Arm*, or Warhol's *Brillo Boxes* and *Campbell's Soup Can*, or J.L. Borges's *Pierre Menard, Symbolist Poet*. These works are, each in their own way, about art or even about 'arthood as such'. As

Danto is fond of saying, these works are, by the same token, artworks and philosophies of art. According to this idea, *Fountain* entails a whole philosophy of art *in nuce* although is does not have any proposition as one of its parts. Danto treats propositionless ready-mades as basically on the same level of artistic development as those well known conceptual artworks that consist of nothing but propositions about themselves, that are nothing but interpretations without an object interpreted. *Fountain* is itself some kind of artistic manifesto. For Danto, ready-mades and artistic manifestos are not direct opposites, as they are usually seen, but rather twins or different plants growing out of one single root. Works like these are the ultimate achievements, the *non plus ultra* of art, at least in Danto's perspective. It is worth noting, however, that the notion of philosophy that Danto tacitly presupposes here is more than liberal. There are virtually no constraints on what can count as a theory of art, neither formal nor with respect to the theoretical content. Just any theory will do, as long as it is about art and expressible in a piece of art. As we see, Danto's own account of artistic progress is less substantial than the ones he criticizes. This point will become important later.

There are, of course, many ways to approach Danto's controversial thesis regarding the end of art. I shall limit my discussion to his reading of Hegel. For I believe that certain flaws of Danto's argument can be shown to rest on some misunderstandings of Hegel's project. One of Danto's decisive moves is the analogy he draws between Hegelian spirit and art. But there seems to be a striking disanalogy between Hegelian spirit and Dantonian art that Danto himself simply overlooks: There is no end of spirit. When spirit finally understands its own position, thereby reaching the level of absolute knowledge, it does not cease to exist. Philosophy, in Hegel's view, is the ultimate form of absolute spirit. Philosophy strives for absolute knowledge, but, as a rational activity, it does not stop when it has reached this level of understanding. On the contrary, Hegel believed that the task of philosophy could never be finished, because philosophy is nothing but 'its own time expressed in thoughts'.[16] This means, roughly, that spirit develops and changes over time, at least in the sphere of the practical—the sphere of morals, right, politics, and economy—just to mention the major institutions that constitute the realm of the so-called 'objective spirit'. Now, for Hegel, practical philosophy is the constant effort both to describe large-scale cultural and institutional developments and to explain them, to find the underlying rationale. Or rather, to explain large-scale cultural developments philosophically *is* just to describe them in a general way. Anyway, Hegel is quite clear about the point that reaching the level of absolute knowledge is not to be under-

stood as a kind of historical event, just as knowing absolutely is not a state or possession but rather a form of activity.

So if there can be no end of spirit, how can there be an end of art? Danto is in need of an argument for the claim that there is a disanalogy between artistic and philosophical activity, such that art comes to an end in history once it reaches its culmination, whereas philosophy does not. My thesis is that no such argument can be derived from Hegel's own writings, not even from his lectures on aesthetics. In order to argue for this thesis it is necessary to have a closer look at what Hegel's talk about the end of art amounts to.

2. Hegel's Thesis

2.1 KUNSTRELIGION AND THE NEW ROLE FOR ART

In his 1823 lectures on the philosophy of art, Hegel says:

> Thus we have completed the circle of art. Art in its sincerity belongs to the past for us. . . . We need thought.[17]

This passage seems to be an impressive confirmation of Danto's interpretation of Hegel. But is it? The answer depends on what is meant by 'the circle of art' and how the qualification 'in its sincerity' is to be understood. So, what exactly belongs to the past? And, finally, who is included in the rather obscure 'we'? We moderns? We philosophers? We philosophers of art? The interpretive issues that are raised by this remark cannot be settled in abstraction from its wider context. When Hegel develops his philosophy of art he does not start from scratch but contributes to, and takes sides in, a complex art-theoretical discussion in German philosophy and literary criticism. Therefore, it is necessary to revisit briefly the central art-theoretical debate of the period between Lessing and Schelling, concerning the role of art in the development of humanity. I will focus on F. Schlegel's and Schelling's positions in this debate, because their respective conceptions of the 'infinite', the 'unlimited possibilities' of art are the main target of Hegel's dense and enigmatic remarks about the end of art.

(A) SCHLEGEL

Just like Schleiermacher and Novalis, Friedrich Schlegel agrees with Schiller that Christian religion does not, in modern times, any longer play a vital role and that modern art is best fit to replace religion

somehow. But unlike Schiller, he does not believe that art is, above all, supposed to replace religion in the sphere of *morals*. For Schlegel, the weakness of traditional Christian faith in modernity does not amount to a loss of moral guidance and orientation that art has to compensate. Art is not an instrument for the moral and political self-education of the enlightened human race, as Schiller suggests. If art is to replace traditional religion, its task is immense: Religion does not only give us a moral outlook on human life but a whole worldview, a 'mythology', an understanding of world and nature as a whole, that is including human culture. So, if modern art is to replace traditional religion, it has to develop into some kind of *Kunstreligion*, an artistic religion itself.[18] It has to develop a new worldview, a 'new mythology'. Schiller follows Kant in reducing religion to morals. Schlegel and Novalis reject this move. For them, religion is both metaphysics and morals, and so must be any *Kunstreligion*. What we moderns lack, according to Schlegel, is not morals but "a mythological view of nature".[19] This is the major task for the new mythology.

The term 'new mythology' sounds rather utopian. However, the kind of mythology that the early romantics were talking about is not meant to be absolutely new, either. The idea was rather, first, to unite Christian faith with ancient, especially Greek, thought and, second, to unite this new, 'mythological' way of thinking with modern philosophy and science. What F. Schlegel intended was a kind of reunion of science and religion in one, overarching project that he labelled 'progressive universal poetry' (*progressive Universalpoesie*). The term poetry is well chosen here because Schlegel believed that only the arts—and especially poetry—were capable of overcoming the incommensurability between the language of religion and the language of science. If this sounds even more fantastic we have to keep in mind some peculiarities of the modern novel. The modern novel, as the Schlegel brothers, Novalis, and Schleiermacher frequently remark in the *Athenäum* fragments and elsewhere, is not a homogenous literary genre. Novels are formally complex. They consist of narrative passages as well as dramatic and even lyrical ones. Some novels contain diaries, philosophical fragments and even whole scientific treatises. Sterne's *Tristram Shandy* and Goethe's *Wilhelm Meister* are striking cases in point. These novels and Shakespeare's plays were those most extensively discussed by the early Jena Romantics.[20] But one might think of Cervantes's *Don Quijote* or Diderot's *Jacques le fataliste* as well. The romantics did not regard the formal complexity of the modern novel as evidence of a lack of coherence and harmony, but rather as a powerful expression of the possibility of unifying heterogenous

forms and matters into one work of art.[21] This is at least one aspect of the kind of irony that Schlegel writes about so many times: Romantic irony, at least to a large extent, is a kind of formal irony that results from mixing different genres and modes of representation. Schlegel sometimes calls poetic irony 'unlimited' (*unendlich*). Ironic poetry in this sense is formally unlimited because there are no limits of form or genre for modern literature, and therefore, so Schlegel argues, no possible content of thought that cannot become the content of a poetic work. Any thought that can be expressed can be expressed poetically. Thus poetry turns out to be the only unlimited medium of thought and speech, in sharp contrast to religious or scientific modes of speech which are both rather restricted, religious speech in content, scientific speech in form. Science and religion therefore both need a kind of mediator or interpreter. It seems that this job can only be done by modern poetry. Schlegel calls this feature the 'universal' or 'transcendental' aspect of poetry. So, when Hegel calls poetry, or art in general, 'limited' (*endlich*), this is meant as a direct negation of Schlegel's claim concerning the power of poetry. For Hegel, what Schlegel calls transcendental poetry is neither poetry nor transcendental philosophy in the Kantian sense but a kind of hybrid mixture of both. I will return to Hegel's criticism of Schlegel below. But let me remark in advance: when Hegel talks about the end of art, this is not intended as a neutral observation but in a polemic sense. As he does not mention any names explicitly we have to contextualize his polemics in order to understand its point. Danto, however, does little hermeneutic work in this direction. As a result, his reading of Hegel's dictum is rather free-floating.

(B) SCHELLING

Another point of reference for Hegel's discussion of the limits of art is Schelling. What Schelling wants to determine in the first place is the relation between philosophy and art. This is a conceptual matter and not to be confounded with the questions concerning the significance of art today that Schlegel is interested in. On the other hand, he is not hostile to Schlegel's program. Both share the conviction that Christian religion is bound to undergo a fundamental change and cannot be maintained in its traditional shape any longer.[22] Modern philosophy, from Descartes to Kant, has undermined its foundation by establishing stricter criteria for the justification of knowledge claims, including the knowledge claims that are part of the Christian doctrine. Science has considerably enlarged our knowledge about nature both in scope and depth. Schelling is aware

of the limits of a narrowly deterministic Newtonianism that leaves no
room for an adequate understanding of life. But that does not shake his
fundamental trust in modern science because he is quite optimistic that
deterministic physicalism can be overcome. At least he sees a new, rea-
sonable naturalism in the works of Leibniz, Buffon, or in Kant's *Critique
of Judgment*, and he sees his own *System of Transcendental Idealism* in
this tradition. This new naturalism is a version of philosophical realism.
Schelling fully agrees with Kant that one major task of modern philos-
ophy is to support empirical realism by explaining how knowledge about
the world is possible. His naturalism even goes beyond Kant's when he
insists that we need something like a natural history of mankind, which
has to make the existence of sapient beings intelligible.[23] In short,
Schelling advocates a quite robust form of modern, objective, realist
naturalism. But why then does he label his own philosophy 'transcen-
dental idealism'?

First of all, Schelling borrows the term 'transcendental idealism'
from Kant who claimed that the only possibility of defending empirical
realism against skepticism is transcendental idealism.[24] But Kant's
claim, as well as the justification he offers, is a rather abstract, elusive
matter. Schelling therefore seeks for a different justification of Kantian
transcendental idealism. In Schelling's version, the argument for tran-
scendental idealism goes more or less like this: Any version of objective
naturalism cannot, on pain of self-contradiction, deny that knowledge is
subjective in a certain sense. Any knowledge-claim presupposes the
existence of a 'subject'. No knowledge without a knower. This is the les-
son that Descartes has taught us. But knowledge is a peculiar kind of
mental state. It necessarily involves an idea of how things are. Ideas are
representational, they are about something. But in order to be knowledge
they have to be adequate. They have to represent things as they really
are. Any form of constructivism or anti-realism, Berkeleyan idealism or
scepticism is thus ruled out.

This point is rather uncontroversial, or at least it ought to be.
However, Schelling insists that there is something like a subjective, 'ide-
alistic' aspect of knowledge that simple-minded naturalists tend to over-
look, thus becoming vulnerable to skeptic challenges. It may sound rather
paradoxical for adherents of objective naturalism today, but Schelling fol-
lows Kant when he claims that the only way to avoid skepticism and anti-
realism is to recognize that any knowledge is—at least potentially—*our*
knowledge, that it is we human beings who claim to know something.
There is something like a methodological subjectivism or rather anthro-
pocentrism[25] involved in any sensible philosophy of knowledge.

The trouble with the subjectivity of knowledge is that it cannot be plainly stated in scientific or even philosophical terms. This has to do with basic features of claiming.[26] Claiming is propositional. Claiming that p typically involves uttering a sentence that has p as its content or that implies or implicates p. What does not figure in the utterance is the very person making a claim, nor the act of claiming. Of course a speaker might always add 'I believe that p' or 'I claim that p' whenever she makes a claim to the effect that p. But this would be no improvement. On the contrary, it would rather serve to undermine the hearer's trust in the sincerity of the very claim the speaker wants to make. This becomes evident when we consider the special role that expressive vocabulary like 'I believe that' or 'I claim that' plays in everyday discourse. 'I claim that p' is used in situations of disagreement. A speaker A might stick to a certain claim by uttering 'I claim that p', especially if he has no further reasons to offer in favour of p. We often take the utterance of the phrase 'I claim that' as indicating that the speaker is running out of arguments. 'I believe that' even serves as a means to make epistemic uncertainty explicit. 'I believe that p' typically implicates 'I am not too sure'. The phrase 'I know that' usually has no place in our discursive games at all.[27] In short: the use of expressive vocabulary to make epistemic or doxastic states explicit is unnecessary for claiming. And according to the familiar conversational maxim to avoid redundancy the utterance of something that seemingly goes without saying indicates that precisely this impression is wrong. So we usually take the occurrence of expressive vocabulary in an utterance as a sign of uncertainty or doubt. To simply claim something usually means to leave oneself out of the claim. One might call this a formal objectivity condition for ordinary truth- or knowledge-claims.

It would be wrong, however, to infer from this objectivity condition for ordinary truth- or knowledge-claims that there is no subjectivity involved at all. Subjectivity does not figure in the claim itself, but it is presupposed in the very act of claiming. This is why adding expressive vocabulary like 'I believe that' or 'I claim that' is always possible. But now we seem to be faced with a pragmatic dilemma. Either we stick to the idea that a claim is made by a plain assertion and that expressive vocabulary is unnecessary. This would mean that the discursive role of the speaker remains inarticulate. Or we take the explicit mode of expressing our discursive commitments and entitlements to be the standard form of claiming. This would imply that plainly asserting 'p' had to be regarded as a mere shorthand for 'I claim that p'. We would thereby considerably weaken the assertive force of statements because making

assertive moves explicit always invites scepticism about the claims involved.[28]

Philosophy and science are both confined to the impersonal mode of utterance because both aspire to general and perspective-invariant knowledge. This already implies that the word 'I' can play no essential role in scientific or philosophical speech.[29] If the phrase 'I am sure that' occurs in a scientific text this usually signals that the author does not intend to offer any proof or argument for the claim that follows.

Religious speech is different with respect to perspective. It is essentially perspectival. That means that if one were to translate religious speech into an impersonal mode of speech, it would not be *religious* speech any more.[30] Expressions like 'I firmly believe in', 'I am confident about', 'I hope for' are essential elements of the religious language game. Religious speech is irreducibly expressive and, therefore, irreducibly personal or subjective.[31] Partaking in a religious language game involves expressing one's own attitude towards God, towards mankind, towards the world or one's own past or future.[32] This does not imply, however, that religious speech is *merely* expressive, *merely* subjective. Uttering religious beliefs involves making genuine truth claims. This holds even in cases where the content of my religious belief is not too clear. For example, it may be the case that one needs the whole range of theological knowledge and acumen of St. Thomas Aquinas in order to understand what the doctrine of God's trinity is all about.[33]

Thus it seems as if the religious language game has some of the features that both the scientific and the philosophical language game lack: perspective and subjectivity. Religious speech is apt to articulate what scientific speech cannot express: how it is to be a knower, a perceiver, believer and actor, how it is to lead a human life. It thus makes explicit the tacit subjectivity that lies at the bottom even of objective knowledge claims. By employing the religious mode of speech, we bring ourselves into our picture of the world. Of course man appears in scientific theories as well. But he appears there as the object of thought, not as the thinker, not as the epistemic subject. It is quite different with religious speech. Its topic is not *man* but *me* or *us*.

Thus, the crisis of religion in modernity turns out to be a crisis of human self-understanding.[34] Fortunately, by having lost some of the *contents* of religious speech we have not lost its *forms*. Perhaps we do not pray any more, but we know psalms and poems. We do not study the Bible as people used to do, but we are deeply moved by Bach's *St. Matthew Passion*. Religious forms of expression have become forms of art. They are, so Schelling argues, 'identical'. But art has not only inherited reli-

gious forms of expression. It has also adapted, developed and refined them for its own, aesthetic, purposes. In short, modern art is the form of human self-expression and self-understanding. And this is precisely what Schelling wants to articulate when he calls art the highest *form* of knowledge.[35] Artistic forms of expressing human knowledge (including self-knowledge) are superior to scientific or philosophical modes of expression for the very reasons given above. Art does not suppress the inevitable subjectivity and perspective of its knowledge-claims.[36] It is therefore seen as a privileged mode of expressing human knowledge. One might call this Schelling's version of aesthetic cognitivism.[37]

2.2 HEGEL'S RESPONSE TO KUNSTRELIGION

We might now be in a better position to understand the point of Hegel's thesis. It is easy to overlook that the passages from the end of the lecture manuscript from 1823 quoted above echo a remark Hegel has already made in the introduction:

> [Poetry] is the general, the all-inclusive art, the one that has reached the highest level of spiritualization (Vergeistigung). . . . On this highest level, art reaches beyond itself and becomes prose, or thought.[38]

In the Hotho edition, we read:

> Thus art is limited in itself and leads to higher forms of consciousness. This limitation also determines the place that we are used to giving art in our life today. For us, art is not the highest form of the existence of truth any longer.[39]

And later in the same paragraph:

> One can reasonably hope that art will forever rise and become ever more perfect, but its form has ceased to be the highest need of spirit (Geist). May we find the Greek sculptures of the Gods ever so well done and God the father, Christ and Mary ever so full of dignity and so perfectly depicted—it is of no help. We do not bend our knee any longer. (Hegel, *Ästhetik*, 142)

Surprisingly enough, Hegel is quite optimistic about the future of art here. He explicitly rejects the claim which Danto takes him to endorse: that the end of art will come soon. Instead, he speaks about the perfectibility of art. But in what sense does art belong to the past, nevertheless? In my reading, Hegel's claim about the end of art is neither a

doctrine nor a prediction but a double-edged *ad hominem* argument. It is double-edged because the argument has a *temporal* (or historical) and a *logical* (or conceptual) meaning. Hegel makes use of this argument against both Schlegel and Schelling. In its temporal reading, the argument turns against Schlegel's project of a new mythology. In its logical reading, the argument turns against Schelling's claim that art is the highest form of human knowledge.

Hegel's rather sober reflections on the place of art in modern life are directed against Schlegel's idea of a modern *Kunstreligion*. Schlegel thought that modern times are in need of a new mythology that unifies all elements of modern knowledge into one coherent whole, and that modern art should create such a new mythology. Against this, Hegel insists that any new mythology can play this role only when it becomes accepted. One cannot simply impose a new mythology or a new religion upon a group of human beings. They have to adopt it themselves. And, for Hegel, art simply does not have the power to convert people into believers anymore. We moderns simply "do not bend our knee any longer" before any masterpiece whatsoever. The times when artworks enjoyed religious adoration are past. In Hegel's view, the only perfect instance of a *Kunstreligion* is the ancient Greek and Roman religion, with Homer and Hesiod as the fathers of mythology and with artists like Phidias as creators of the visible gods themselves, that is, of the sacred sculptures that were adored and prayed to in the temples. Hegel calls this the *classical* 'form' or period of art in the second, 'special' part of his *Lectures*.

Things change in the 'romantic' period, i.e. in medieval and modern art, and that change is due to Christian religion.[40] One important theological lesson for art is that God as a visible person, as Christ, has died. Therefore, we are told by Christian theology, it is allowed to represent God the Son in art, as long as we keep in mind that the artworks are just representations of God and not God himself. From this it follows that artworks cannot be objects of immediate religious adoration in 'romantic' art. For Hegel, there is no fundamental break between medieval and modern art in this respect. Modern culture simply holds no place for *Kunstreligion*. Schlegel's idea of a new mythology therefore rests on an illusion.[41] So, the kind of art that 'has come to an end', that is 'past and gone', is rather Schlegel's own conception of art as a basis for a modern, progressive universal religion.

Hegel is ironic in a rather subtle way here. He never mentions Schlegel explicitly in the relevant passages. He attacks him head on in a different context, though.[42] But it is not necessary to mention names

here, because the irony is directed against a core idea of Romanticism itself. Hegel shows thinkers like Schlegel, who see themselves as prophets of a time to come, to be rather envisioning times that are past and gone, as 'prophets turned backward', to quote a phrase of Schlegel's that Hegel must have known.

In its logical or conceptual reading, the argument is directed against Schelling's claim that art is the highest form of human knowledge. For Hegel, this is logically impossible. The reason for this impossibility claim is quite simple: Knowledge is a species of thought. If this holds for knowledge in general, it must hold for the highest form of knowledge all the more. But thought is essentially spiritual (*geistig*), i.e. immaterial, and many artworks are material objects, albeit bearers of aesthetic or artistic content. If the premises are correct, then art cannot be the highest form of knowledge. It is true that we can – and must – have thoughts about artworks, about how to respond to them or interpret them. As Hegel writes, "we have to understand" art. And this is so because art essentially is a manifestation of thought or even knowledge. But if thought is essentially immaterial, then the highest, i.e. most perfect form of thought cannot be material. Thus, no materialised form of thought can be the highest form of knowledge.

It is true that there are different arts. Hegel even speaks of a 'system of the arts', an order that can be described in a systematic way. It is this kind of systematic description that he aims at in the final part of his lectures and that he refers to with the phrase 'the circle of art' in the above quotation.[43] One result of his description is that the different arts operate on different levels of spiritualization. The most spiritual, the most immaterial, form of art is poetry. Poetry can exist both spatially (as a written text) and temporally (learnt by heart and performed aloud, e.g. by bards or rhapsodists in illiterate cultures). Poetry expresses thought in its natural medium, language. It is therefore the species of art that comes closest to philosophy. Yet poetry *is* not philosophy. It can serve as a substitute for philosophy only when no developed philosophy is available. For Hegel, therefore, the classical period of art was over with Plato's criticism of Homer in the *Politeia*.[44] He sees similar moves in the Jewish tradition.[45]

Art and philosophy differ *in form*. Art and religion, for Hegel, share the same *content*. Or, to put it more precisely, art is nothing but one privileged form of representing religious content. Art does not generate content on its own. It is just a way of giving form to a content that is already given.[46] This does not mean that all kinds of artistic content are religious. The relation between religion and artistic content may be fairly

indirect. But, as Hegel and Schelling claim in unison, if there were no relation between art and religion at all, the very possibility of art would be unintelligible. Thus, there is a sense in which art presupposes religion. It is a way of *"representing* the godly," after an image that is already given. The religious power of art has to do with the forming activity that art consists in and that opens up the possibility of *trans*-forming religious images. Still religion is the kind of spiritual framework which makes artistic content possible. When Hegel says that art has an end, he invites us to explore precisely those limitations of art that Schelling ignores.

If we take another look at the above quotations from the different lectures on aesthetics we will find that Hegel wants to have it both ways in each of them. He wants to attack both Schlegel and Schelling with one double-edged argument that can be offered in short thus: Art is limited in a logical sense because it presupposes religion. Nor can art be the highest form of knowledge because philosophy is in that position already. And philosophy cannot be a part of religion. Thus all hopes for a new *Kunstreligion* are illusory.

One might accept the argument in its temporal, historical, anti-Schlegel reading and still wonder if the point of Schelling's claim is also met. Schelling claims that art is the highest form of knowledge because it makes the implicit perspective of any knowledge claim explicit, whereas neither philosophy nor science can do so. And Hegel accepts that every knowledge claim is subjective in this sense. He reminds us again and again that we gain objective, invariant knowledge only through all kinds of triangulations and transformations of perspectives, that is, only through inter-subjectivity, and that a neutral 'view from nowhere' is not accessible except through relating our different 'views from somewhere'.[47] We do this, for example, when we make sure that we look at the *same* object from different points of view. We do this also when we describe different traits or capacities of the *same* person. If Hegel accepts and even stresses this point, and if he admits that philosophy cannot make subjectivity explicit, how can he consistently claim that philosophy is the highest form of knowledge? And further, if he agrees that art is explicitly subjective, how can he consistently deny that art is the highest form of knowledge?

Hegel might respond along the following lines: Art cannot be the highest form of knowledge because knowledge is propositional and assertible. But art does not make assertions, at least not immediately. It is not explicitly conceptual but rather *anschaulich*, i.e. it presents or represents objects, ideals, views or perspectives. The problem of articulat-

ing the inherent subjectivity of knowledge-claims is not a problem of linguistic expression but rather a matter of taking statements and claims in the right way. In Hegel's terms, this is not a problem of linguistic articulation but a problem of philosophical *Bildung* and reflection, of both philosophers and their audience.[48]

The point of controversy is rather deep here, and it might be hard to decide whether Hegel or Schelling is right. It would be an overstatement to say that it is a controversy between two concepts of philosophy, because this would not account for the fundamental agreement between Schelling and Hegel regarding the aim and the ends of philosophy.[49] Nevertheless, what one will accept as a contribution to philosophy depends on which side one takes: Schelling's or Hegel's.

3. The Future of Art

3.1 ARTISTIC PROGRESS ACCORDING TO DANTO AND HEGEL

Examining and criticizing Danto's interpretation of Hegel is one thing, but asking if he may be right with respect to the future of art is quite another thing. Avant-garde art could not even possibly occur in Hegel's aesthetics. So we will have to assess Danto's thesis that the progress of art has reached its end with the decline of avant-garde art without Hegel's help. But it may be useful to compare at first Danto's idea of artistic progress with the one developed in Hegel's aesthetic theory.

Let us return to Danto's overall conception of artistic progress first. It amounts to the notion of art as philosophy, as finally grasping its own nature. Other, more local projects, like mimesis or artistic expression, appear to be nothing but aspects or phases of this overall process. Artworks are supposed to be *about themselves*.[50] There are some striking similarities between this philosophical theory of art and some romantic conceptions of what art making is all about. Friedrich Schlegel wrote quite a lot about the so called 'transcendental poetry', which he also labeled 'poetry of poetry' (*Poesie der Poesie*), i.e. a kind of poetry—and art—that is essentially self-reflective or self-referential.[51] The Schlegel brothers both produced various instances of transcendental poetry themselves.[52] But neither Hegel nor Schelling liked this idea very much. It may seem astonishing, but both scorn this kind of romantic poetry vehemently. They even express their contempt in similar words.[53] Art, according to Hegel and Schelling, has to be about something important and substantial if it is to be of any aesthetic significance at all. This does not mean that they argue against artistic self-reference,

though. Both philosophers agree that self-reflectiveness is an essential feature of art. But the kind of artistic self-reference they have in mind is rather *formal*, that is via taking up a certain artistic form. According to both Hegel and Schelling, art should not be self-referential with respect to artistic *content*. Of course, things are different with music, because music, at least 'pure' music, does not seem to have any content at all. But it would be a mistake to take music as a model for the other arts.[54] From a Hegelian or Schellingian perspective, purely self-referential art could not possibly be the aim of art; rather it must be seen as a borderline phenomenon of artistic creativity. The point is conceptual. Self-referential art presupposes art that refers to something else. Just look at the expression 'poetry about poetry'. What is the meaning of the term 'poetry' on the right hand side? That is, if 'aboutness' is an essential feature of poetry then what is first-order poetry about? If art had been purely self-referential from the beginning it could not have got off the ground. And if this argument is sound, it is rather odd to claim that poetry, or art, has always been aiming at being purely self-referential. So, Schelling's and Hegel's argument against the romantic conception of poetry can be used against Danto's idea of art as well. It lacks an adequate notion of aesthetic content, of *what* art is supposed to be about.

Hegel himself developed a quite different conception of artistic progress in the second, or special, i.e. art historical part of his aesthetic theory.[55] The key term in Hegel's account of progress is 'the idea' (*die Idee*). Art progresses in grasping the idea it represents aesthetically, and this idea is the human condition, man's being in the world. According to Hegel, the idea of man is the central theme of art. This is why many scholars call Hegel's philosophy of art an aesthetics of content (*Inhaltsästhetik*).[56]

The human condition is to a large extent determined by the double nature of man, his being both a sensible and a rational—and thereby social, or political—creature. This double nature shows itself in both spheres of human activity, the theoretical and the practical, knowledge and agency. As a knowing animal, man is a perceiving and a thinking being, that is, a judging and inferring creature. As an agent, man is both driven by needs and desires[57] and compelled to act according to practical reason. That the sensitive and the rational side may eventually conflict is a possibility that is rooted in human nature. But they may as well harmonize. Thus Hegel, like Schiller, brings home the ancient idea that the form of the good human life is a kind of harmony of the human faculties and that discord between the faculties is the main cause of a bad life.

The characteristic features of human life are the central theme of art. They are what art is all about. Different arts refer to this theme in a different mode. Pictures refer to life in a different way than poems or novels do. Pure, or 'absolute', music has content in still another, rather indirect mode. Architecture, at least in its developed form, does not refer to anything at all. Yet it is related to the 'idea' in a special way.

But if human life is the central theme of art, the first task of the artist is to conceive an idea of human life, and this is not just a subjective matter. This idea can be adequate or not, rather correct or rather incorrect. A failure to grasp the idea of human life adequately may turn out to be not just an individual failure but rather a collective mistake. Hegel believes that whole communities can be wrong about human life, about its form and its salient features. If they have art nonetheless, their artworks will betray their lack of understanding what human life amounts to. Hegel calls such an art 'symbolic'.[58] The distinction between symbolic and classical art rests on the difference between a grossly inadequate and a more adequate understanding of human life. Classical art represents human ideals, i.e. examples of a good human life, figuring as gods or half-gods and heroes.[59] But classical art is still deficient, insofar as it lacks 'negativity', that means an adequate notion of those aspects of living a human life that have to do with human imperfection, with mortality, fallibility and suffering. These become central in romantic, or modern art, i.e. the art of the age of Christian and Islamic monotheism that is still ours. Romantic or modern art is concerned almost exclusively with aspects of negativity, with human finitude, the fragility of goodness and the possibility of evil, but also with the quest for individuality, solidarity and love, and with the possibility of moral learning and moral progress.

That does not mean, though, that Hegel denies the possibility of progress in the sphere of artistic craft and technique. On the contrary, he repeatedly stresses the importance of craft.[60] But perfect craft is something that artists have always been after anyway, and a merely craft-theoretical notion of artistic progress cannot account for fundamental differences between the works of different art historical periods. For example, from a Hegelian point of view it would be simply naive to claim that, with the invention of central perspective in modern painting, the world could be represented as it really appears to us. It would be naive because it would take for granted that ancient and early medieval painting had been looking for something like central perspective but could not achieve it.

3.2 THE CONDITION OF ART TODAY

What, then, does art today look like from a Hegelian point of view? After what has been said concerning Hegel's thesis about the end of art, this is an open question. Hegel never claimed that there is some kind of inner teleology or some mysterious necessity that drives art to its inevitable end. As we have seen, he even explicitly denies that there is reason to think there is any such inevitable end. However, this does not preclude that art might come to an end for different, external, reasons. No practice or institution has an inbuilt guarantee against corruption or decline. What is more, there is reason to worry about the condition of contemporary art from a Hegelian perspective.

A frequent complaint is that contemporary art is unintelligible. But this is not quite true. Our problem with art today is not a problem of understanding. We understand contemporary art perfectly well. We know how to look at an abstract painting or a ready-made. We are acquainted with twelve-tone and serial music, with micro-interval scales and with the possibilities of electronic sound production. We know how to read and interpret a stream of consciousness novel or a fragmented poem and how to deal with the mind-twisting techniques of narration that are typical of a David Lynch movie. We hardly have any fundamental problems understanding contemporary art. On the contrary, many people find it easier to understand a Jackson Pollock painting or a novel by James Joyce than a painting by Velázquez or a song by Josquin des Prez because they lack the relevant kind of background knowledge about formal conventions and mythological or religious themes that is necessary for an adequate conception of what those works of art are all about. We even suspect that there is something in the works of Vermeer that constantly escapes our attention even in his plainest everyday scenes. In general, contemporary art is more accessible to us than the works of remoter periods. Our problem seems to be rather that art is not so *important* for us any more. The latest art is often witty, sophisticated and even funny. Still we often have the impression that we would not miss it should it eventually vanish. We would find it difficult to name a recent work of art that has become an important part of our life. Somehow, things seem to have gone worse with art since Hegel's days.

The reason is neither a decay of artistic capacity nor a loss of creative energy. But it is not a lack of aesthetic understanding on the side of the audience either. The loss or lack is rather a collective matter: both artists and audience are concerned. Just take Tom Tykwers movie *Heaven* as an example of the kind of modern art I have in mind here. The film seems

almost flawless with respect to craft and aesthetics. It is based on a very demanding script, it has a gifted director and excellent actors, and it is beautifully filmed and cut. But nevertheless it is a pompous, presumptuous, and empty work, because it fails to treat adequately the metaphysical and moral questions that are raised by the plot. There is a lack or loss in the sphere of *Geist*. Hegel's description of periods of symbolic art turns out to be instructive here. Remember that the reason for art being merely symbolic, in Hegel's view, is a failure to grasp human nature adequately. For Hegel, both classical and romantic art share a more adequate conception of human life. But this does not imply that such a level of understanding can never be lost; in fact, we may already have lost it. We may have embraced the wrong sort of naturalism too hastily. We moderns might be thrown back to the level of symbolic art for that reason. If one looks at things this way, one will see that it is highly unfair to blame modern, avant-garde art because of this development. Avant-garde art is just a way of expressing the modern condition. It cannot be blamed for having caused this condition.

Art today can be seen as the adequate expression of our common but inadequate conception of ourselves. Therefore, if art does not matter to us any more this may be because it makes us feel uneasy. It makes us feel uneasy because it reminds us that we are in an uneasy situation. Such a diagnosis would be even more troubling than Danto's claim concerning the end of art.

[4]
The Humanizing Function of Art: Thoughts on an Aesthetic Harm Principle

Elizabeth Millán

In an age during which the prognosis for art is dire, as art seems to move from one crisis to another with such regularity that some even speak of a "permanent crisis"[1] facing art today, it is perhaps time to step back and consider more carefully the use and abuse of art in our age.

Why do we need art? That is, what are some of the human needs that are met in our experience with art and how does art fill these needs? What sort of tendencies in art might undermine art itself, leading to the permanent crisis bemoaned from so many quarters? As these preliminary questions already indicate, my interest lies more centrally in our experience of art rather than in the work of art itself. There is a rich tradition of scholarship that addresses the philosophical dimensions of aesthetic experience, to which I shall turn in due course. Yet, to refine my focus even more, my primary interest is not in aesthetic experience per se: I am interested in examining one particular function of art and its particular aesthetic effects, namely, what I call "the humanizing function of art" and certain tendencies in art that might undermine this function.

So, the end of art that concerns me is rather different from the end of art so eloquently articulated by Arthur Danto, that is, the end of art that comes as art dissolves into its own philosophy, with art "vaporized in a dazzle of pure thought about itself"[2]—the end of art that comes with the "ascent to philosophical consciousness of the art movements."[3] Danto's thesis regarding the end of art, is not, as he is careful to point out, that "the history of painting [stops] dead in its tracks after the ascent to consciousness [which] took place in the 1960s."[4] Danto is concerned with art (and as some critics point out, perhaps too narrowly with painting) and its relationship to philosophy. He is *not* concerned with aesthetic experience: he is after a definition of art, one that, in fact, endeavors to

"exclude aesthetics from the concept of art." Danto's interest is in art as philosophy, which is what we are left with after the end of art that he has announced.[5] The particular aesthetic merits of a work are not important for the developments of art that Danto cares about, for such merits are no longer interesting. As he points out: "A lot of Warhol's works are aesthetically as neutral as the personality he endeavored to project"[6] Indeed, Danto looks almost with a kind of sympathy upon those scholars trapped within the narrow confines of an approach to art via aesthetics. After bracketing out aesthetic experience from his discussion of art, he feels the need, "by way of concession" to add that:

> I think aestheticians have had far too restricted a range of aesthetic qualities to deal with—the beautiful and the ugly and the plain. And have assigned to taste far too central a role in the experience of art. I feel that expanding this range will itself be an exciting philosophical project. ("The End of Art," 133)

I don't share Danto's pessimism regarding the range of aesthetic qualities with which aestheticians work. In fact, I shall argue that a more careful look at the role of aesthetic experience gives us deep insight into one of art's most powerful functions: its humanizing function. I am interested in demonstrating that art's humanizing function provides us with an orientation point even in the midst of dizzying modernist trends in culture.

Danto is not the only thinker to have linked the end of art to the development of modernist trends in culture. The end of art that Theodor Adorno describes is also to be found in the particular conditions of modernity that give rise to it. For both Danto and Adorno, Hegel is a crucial reference point.[7] Adorno points out that the thesis regarding the immanent or already reached end of art has been repeated throughout history, perfected since the modern period, and philosophically articulated by Hegel (though not invented by him).[8] Of course, Adorno is aware of the irony in these repeated calls that art has ended, the end of art becomes a sort of never-ending story all on its own, as culture moves from one crisis to another with such regularity that the familiar and perhaps by now tired expression of a 'permanent crisis' is invoked.

Danto is not troubled by the end of art that he sees, for the end that comes into view under his philosophical lens is a sort of liberating move, which can be seen as a new beginning for the history of art, one in which the future of art is left wide open. As Danto himself reminds us: "It is not part of my claim that there will be no stories to tell after the end of

art, only that there will not be a single metanarrative for the future history of art."[i9] The end of art that is of interest to Danto is the end of art as an object of study with fixed limits. For Danto, art becomes of a set of mirrors of our modern condition, and it reveals a multiplicity of stories about that condition. Art no longer has to induce the "retinal flutter" that Duchamp referenced with disdain; such flutters are dismissed as mere signs of sensory gratification. Art should be able to skip the senses and go straight to the intellect. Danto's talk of the end of art is part of his move to separate the philosophy of art from aesthetics. This sort of end is of interest to art critics, philosophers, artists, and other insiders of the avant garde world, a world that turns its back on aesthetics and sensory pleasures, precisely those elements that lure most of us to the world of art in the first place.

In what follows, I shall *not* be interested in tracking the end of art that affects the specialist audience Danto has in mind: my focus will be on the end of art as something that matters to all human beings. To investigate this end, I shall first have to make a case for why art matters to humans at all, and then move to a discussion of what directions in art might upset the meaningful role that art can play in human life.

In situating their discussion of art, both Adorno and Danto focus upon specific aspects of the modern condition and its role in shaping art. Whereas Danto's reflections on art have their origins in the art movements of the 1960s, with special focus on artists such as Duchamp and Warhol, Adorno is more concerned with how art is affected by social and political forces that disrupt the march of progress in modernity. His comments on the fate of art after Auschwitz are an example of his concern with making modernity itself a philosophical object of investigation, in particular, with thematizing the trauma of post-Holocaust society. The story I want to tell about art is quite different, and more limited in scope, than either Danto's or Adorno's. I shall turn to how aesthetic experience came to save one particular prisoner *in* Auschwitz and use this case to reflect upon art's enduring value for human beings.

The thinkers whose insights are most pertinent to my presentation of the humanizing function of art and the ensuing discussion of both the factors that might strip art of this humanizing function and those that might help protect it from corrosive influences, are two figures whose names do not often surface in discussions of the end of art: John Stuart Mill[10] and Primo Levi. I turn to Mill, an English philosopher who espoused liberal ideas that he believed would help society move away from tyrannies, both political and of the majority, so that true, human flourishing could be achieved, because I believe that his "harm

principle" can be tweaked to apply to the arts.[11] Mill's harm principle is one developed out of a concern for protecting the conditions that enable human liberty to flourish, while curbing injury to innocents. One may never use freedom to cause unjustified harm to others. It is my view that a harm principle for the arts might help us guard against the tendencies that do harm to art itself, thus undermining art's humanizing function. Just as freedom is essential for the flourishing of human society, and so is something that needs to be protected from forces that would undermine it; the humanizing function of art is essential to the vital role that art can play in human life, and may need to be protected from the forces that might undermine it.

Levi's work is essential to the case I want to make for the humanizing function of art. Levi was an Italian chemist turned essayist, whose accounts of what he suffered in the Nazi death camps provide ample evidence of the evils and dangers of political tyranny; he experienced and insightfully expressed art's humanizing function. While Adorno's provocative claims regarding the impossibility of art *after* Auschwitz have received wide attention, Levi's insights regarding the role of art *in* Auschwitz have been largely overlooked by philosophers. Adorno offers a quite pessimistic view of art's future, while Levi's reflections on the power that art exerted *in* Auschwitz, rather surprisingly, given the conditions that gave rise to his reflections on art, provide us with reason to be optimistic about the enduring role that art can play in human life.

1. Art in Auschwitz: The Humanizing Function of Art

Let us turn to a time when something much more sinister than any foretold end of art cast a looming shadow and to a historical place where the human spirit was crushed and threatened with extermination. I refer to the death camp of Auschwitz as reflected in the narrative of Primo Levi, who was a prisoner there and who survived his ordeal, his subjection to the darkest side of humanity. Art, he claims, helped him survive:

> [Art] was useful to me. Not always, at times perhaps by subterranean and unforeseen paths, but it served me well and perhaps it saved me. (*The Drowned and the Saved*, Random House, 1998, 139)

How did art help save Primo Levi, as the dark tides of a bleak, evil world engulfed him? Levi goes on to reflect upon the importance of some lines from "The Canto of Ulysses," Canto 26 of Dante's *Divine Comedy*

(which is the section that has become known as the *Inferno* and which is also the title of a chapter in Levi's book, *Survival in Auschwitz*). Levi recalls having said that he would give up his daily ration of soup to know how to join two lines of poetry that had been on his mind during the day's labors:

> [In the death camp, those lines from Dante] had great value.[12] They made it possible for me to re-establish a link with the past, saving it from oblivion and reinforcing my identity. They convinced me that my mind, although besieged by everyday necessities had not ceased to function. They elevated me in my own eyes and those of my interlocutor. They granted me a respite . . . in fact liberating and differentiating: in short, a way to find myself. (*The Drowned and the Saved*, 139–140)

In *Survival in Auschwitz*, Levi describes in more detail *what* the lines from Dante helped him to recover:

> [those lines from Dante's Canto had] to do with all men who toil, and with us [my labor partner and me] in particular; ... who dare to reason of these things with the poles for the soup on our shoulders. (Random House, 1998, 114)

Art helped Levi to connect to a particular past, a past that tied him to a culture of humanity, releasing him, if ever so briefly, from the depravity he faced in Auschwitz. Of course, the past is not necessarily uplifting and art does not necessarily connect one to an uplifting culture of humanity. But some art does this, and it is worthwhile to reflect upon what kind of art can do this and why. The path to barbarism of which Adorno speaks when describing Auschwitz and the liquidation of the self involved therein, was, for Levi, diverted through art.[13] Art elevated him, liberated him, it helped him to find himself again through helping him to re-establish his identity as a member of the group of humanity. In Primo Levi's words, words which take us to his experience of relocating his lost humanity, we find a poignant example of what I call the humanizing function of art, a function that, according to his own account, helped Primo Levi survive. So, in the first broad brushstrokes of my account, the humanizing function of art is related to art's role in helping us to survive by putting us in touch with our humanity. This may strike some readers as too utilitarian, but any utility in this connection is related to the realm of value, especially the value of respect for the dignity of other human beings, so we are not dealing with any sort of vulgar utility.

Works of art are important to us, because they communicate some-thing of value to us; what is communicated in a poem by Dante, what "saved" Primo Levi, was not a recollection of facts about the world that could be empirically verified, what is communicated by a poem (or any work of art) has something to do with history in a larger sense, with, as Levi's comments indicate, the evocation of a memory of our shared humanity, an evocation that had a powerful effect on his own self-image. Richard Rorty, in mounting his case for the value of the arts against those skeptics who would claim that art disorients us, makes a claim that helps clarify the humanizing function of art: "[art] serves to develop and modify a group's self-image by, for example, apotheosizing its heroes, diabolizing its enemies, mounting dialogues among its members, and refocusing its attention."[14] Following Rorty's lead, we can add that art not only has the power to put us in touch with our humanity, but to define our humanity. Truly great art is constitutive of our humanity—giving shape to ideas and giving rise to feelings and sensibilities that might not exist were it not for the artifacts created by the artist.

Masterpieces of art can be said to be part of the patrimony of human-ity itself. Think of Shakespeare's tragedies or his sonnets, of Keats's and Wordsworth's poetry, of Mozart's symphonies. These works have helped develop the very conception of what it means to be human. Take the con-cept of human envy and jealousy: without Shakespeare's *Othello*, wouldn't our view of jealousy be impoverished? Shakespeare's art is a model of how art connects us to the world: Iago personifies envy and the jealousy he elicits from Othello is an important source of our notion of jealousy as a "green-eyed monster." Returning to Dante's poetry, con-sider what Alexander von Humboldt remarked upon seeing the Southern Cross in the night sky as he approached the South American continent for the first time:

> Impatient to explore the equatorial regions I could not raise my eyes to the sky without dreaming of the Southern Cross and remembering a passage from Dante.[15]

Dante's work made a mark so strong in the mind of Humboldt, that lines from his poetry become part of the experience of seeing the night sky and understanding the meaning of the Southern Cross for the human observer gazing upon its brilliant light.

The traces left upon the human mind by works of art can transform reality, offer a new light, and if the work of art is beautiful, then we are elevated to the realm of perfection. Recall Mill's claim that "poetry

address[es] [itself] to the desire for ideal conceptions grander and more beautiful than life provides."[16] Yet, in a society that prizes the promise of progress offered by more practical transformations of reality, the question of whether we really need art comes up again and again, and this sort of questioning of art's value becomes part of its "permanent crisis." What use do the ideal conceptions that are "grander and more beautiful" than the ones life provides, really have? Is it not more important to master and control reality than to appreciate it and be inspired by it? To pose this question is to be guilty of a most pernicious false dichotomy: either we attempt to measure, quantify, and master the world around us or we simply sit by filled with delight, appreciating the world. There is no good reason to accept such a simple dichotomy. One can, of course, do both.

Humboldt found himself on the seas gazing upon the night sky, not to recover some connection with Dante's poetry, or to be delighted when gazing upon the night sky, but rather to measure the sky, to advance our scientific knowledge of the world. Measurements of the sky have helped us to predict weather patterns, draw maps, and engage in other practical tasks, and come to more truths about the world. Certainly, the aesthetic effects offered by art add color to our lives, but what value does the work of artists such as Shakespeare, Dante, Mozart, have? What use do their grand and beautiful conceptions of an ideal realm have for us? Life *would* be grayer without the work of such artists, and there would be a loss of inspiration and elevation of certain feelings, precisely those feelings which might very well lead other individuals to make discoveries about the workings of the universe. As Clifford Geertz observes, without art: "some things that were felt could not be said—and perhaps, after a while, might no longer even be felt—and life would be the grayer for it."[17] As Primo Levi's words attest, when human society has indeed fallen apart, sunk in the bleakest abyss of dark cruelty, art can help to put meaning and color back into certain aspects of human life. The color lent to life by a memory of Dante's poetry helped to save Levi, insofar as it took him back to his sense of himself as a member of the group of humanity. So, we should not quickly dismiss the value of art or underestimate how devastating a colorless life without art would be to human existence. The color and feeling that art, with its unique power of elevating transformation, lends to life are just as important as the mastery that empirical observations add to our understanding of the world; indeed the color lent to human existence by art might very well play a role in developments that lead to new discoveries about the physical world. Within the context of human history the humanizing function of

art takes on an especially vital role, given the numerous examples of political forces that work to transform reality, and not in any elevating direction, but rather work to drag humanity down to a place of dark, sinister forces that dehumanize culture.

Art, then, I propose, matters to us in part because it can help us to see the world in a different way, it has the power to elevate us and connect us to what is best about our shared humanity and to give rise to new feelings and ways to respond to even the grimmest of realities. This, in turn, can have important effects upon how we see ourselves, that is, upon our self-image. In his, *Humanity: A Moral History of the 20th Century*, Jonathan Glover discusses the many traps of terror that have stood in the way of moral progress, and the many political tyrannies that have transformed social reality in the most violent and appalling ways, affecting, of course, identity (both individual and national) and culture. In what he has to say about identity and culture, we find a fruitful point of connection with the experience of art:

> A person's identity is something not completely given, but is partly created. Some characteristics, including those linked to tribal membership, such as skin pigmentation or other ethnic features, are just given. We do not choose our parents, where we are born, or what language we are brought up to speak. We do not choose the religion and culture we absorb as children. But there is also the identity people create for themselves, typically elaborating on, or branching out from, this 'given' identity. This self-creation gives part of the sense people have of their lives being worth while.[18]

The story we tell about ourselves is central to "our sense of our own identity."[19] Art shaped the story that Primo Levi told to himself, the memory of the lines from Dante helped him to think himself back into humanity, a humanity that the Nazis were bent on speaking and thinking him (and all other Jews, gypsies, and those they deemed unfit for inclusion in the human race) out of. Art shaped the "content and tone" of the private and secret story that Levi told to himself in order to save himself from the slow death that the narrative of the Death Camp was structured to carry out.[20]

One point that Levi's reflections place in clear light is that art helps us to expand our sense of identity, to avoid the impoverishment of identity thrust upon groups by pugnacious nationalisms of the sort so well described and documented by Glover in his book. Art's connection to humanism is central to the use of art in our culture, and art that severs its connection with humanity is, or so I shall argue, art that negates one of art's most vital roles.

Let us now turn to the question of how art fulfills this humanizing function and what conditions might undermine it.

2. The Central Role of Aesthetic Experience for Art and Its Future

If art is to put us in touch with our humanity (or our identity as human beings) and even define it, there must be a particular connection between a given artifact and the world of human values and history; there must be some *ordered, coherent* relation between the two, an order quite unlike the order used to merely describe the world. The aesthetic experience which a work of art opens to us is an experience of what Ruth Lorand, in her analysis of beauty, has well captured with the notion of a "lawless order."[21] In order to communicate, the work of art must bring forth an order, a way in which we can make sense of the abstract realm of values, of goodness and beauty in particular. Any art that breaks from the concept of order altogether will not be able to say anything to us, and will thus endanger the very communicability of art and hence the future of art. The order, however, cannot unfold in a lawful way, for aesthetic judgment has to do with the freedom that comes of having an experience with an object that does not fall under any given concept, but leads us to search for a new way to describe our experience of that object. Kant captures this well with his notion of a reflective judgment, which is all about the free play between the imagination and the understanding. The free play involved in aesthetic judgment is connected to the sense of lawlessness involved in aesthetic judgments. Since an aesthetic judgment is a judgment, there is order involved. When the judgment is made that "x is beautiful," the free play of the cognitive faculties (imagination and understanding) has come to an end, but the production of that judgment (which is the result of a cognitive order) is the result of a kind of free play (which is lawless).

The conversation with a work of art evokes a set of feelings, it engages the mind in a particular way, ordered so that a coherent meaning emerges, a meaning that has affective value. The affective value that most delights us has to do with the realm of perfection, where we find that almost holy trinity that has long captivated philosophers and poets: the true, the good, and the beautiful. In complicated ways, truth, goodness, and beauty can serve as regulative ideas for the improvement of humanity. Of course, works of art can also expose us to ugliness and evil, and so to the realm of imperfection, but art can even present evil in a way that is productive to our humanity, cultivating us through such

representations. Clearly, it would be irresponsibly optimistic to overlook the fact that works of art and the aesthetic experience to which they give rise may also fail, and then the aesthetic experience will not be pleasant, affirming, or do much in the way of cultivating our humanity. Obviously, one can hate works of art, be disgusted by them because they are so imperfectly executed (which is quite different from the case of admiring an exquisitely represented disgusting scene), and be led to concepts of evil by them as well. Not all art is good art, so not all art elevates humanity.

But in Auschwitz, Levi, for obvious reasons, did not turn his mind to art that had failed, but to art that had succeeded: art that could put him in touch with his humanity. Certainly, some presence of order is part of what any successful work of art must possess and communicate; indeed, works of art can take what seems ineffable and chaotic and communicate something coherent about this disorder. Art challenges traditional paths to order and coherence, completely giving up on them would be sure to end in disaster.

Art is notoriously difficult to define, and I will resist offering final definitions of what art is. In fact, I am suspicious of any reductionist definitions of art. Certainly, although I take my lead from Primo Levi, and so have privileged lyrical poetry, I would not want my comments on art to be limited to just the medium of poetry. I think what I have said about the humanizing function of art holds also for mediums such as dance, painting, music, and architecture. As I stressed above, I also want to avoid the tendency to define art in terms of its merit. Those guilty of following this tendency overlook the obvious, but essential point, that bad art is still art.[22] Indeed as Oscar Wilde observes in *De Profundis*, "In art, good intentions are not of the smallest value. All bad art is the result of good intentions." [23] My aim is to explore one central and defining function of art, a function that would be shared by all forms of art, whether the art in question involves the moving body, color on a canvas, animated figures on a movie screen, or notes played on a piano, and whether the work of art in question is the most celestial object ever created or a clumsy, ugly excuse for a work of art.

Works of art have meaning for an audience insofar as they communicate something to the audience, and this semiotic approach to art makes, as Geertz points out, "a theory of art . . . a theory of culture" rather than "an autonomous enterprise."[24] He explains:

> For an approach to aesthetics which can be called semiotic—that is, one concerned with how signs signify—what this means is that it cannot be a formal science like logic or mathematics, but must be a social one like his-

tory or anthropology. It is, after all, not just statues (or paintings or poems) that we have to do with, but the factors that cause these things to seem important—that is, affected with import—to those who make or possess them, and these are as various as life itself. . . . If there is a commonality it lies in the fact that certain activities everywhere seem specifically designed to demonstrate that ideas are visible, audible, and—one needs to make a word up here—tactible, that they can be cast in forms where the senses, and through the senses the emotions, can reflectively address them. The variety of artistic expression stems from the variety of conceptions men have about the way things are, and is indeed the same variety. ("Art as a Cultural System," 1499)

In this passage, we find some of the central features of what has become known as aesthetic experience. Aesthetic experience is central to how certain objects "come to seem important" to us. Geertz's emphasis on the fact that there is a strong historical dimension to our encounter with works of art suggests that aesthetic experience is not immediate, but rather that it is mediated by the traditions of which we are a part. Hans-Georg Gadamer develops the view of aesthetic experience as a historically mediated process, a type of hermeneutical (interpretative) engagement with a given work. Indeed there is a strong tradition in aesthetics of using aesthetic experience as the inroad to an understanding of art's value for us.[25] John Dewey placed aesthetic experience at the center of his conception of art as part of his goal to free art from its narrow confines in museums (for our experience of a sunset or appreciation of a view of a mountain landscape cannot be confined in the enclosed halls of the museum).[26] Richard Shusterman further develops the move toward an understanding of art in terms of human experience. In his article, "The End of Aesthetic Experience," Shusterman points to Dewey's desire to free art from its "object fetishism and from its confinement to the traditional domain of fine art."[27] There are, of course, problems with the approach to defining art in terms of aesthetic experience, so I don't want to present aesthetic experience as some sort of magical *pharmakon* for the problem of defining art and its value for humans. But I do stand in strong agreement with some points that Shusterman develops, as he emphasizes that, despite the problems with using aesthetic experience as the inroad to our experience of art, there are even more dire consequences when we flippantly reject the importance of aesthetic experience and its central role for art. As Shusterman emphasizes, aesthetic experience, "rather than defining art or justifying critical verdicts, [is a directional] concept, reminding us of what is worth seeking in art and

elsewhere in life."[28] Art that cannot offer us any aesthetic experience at all has no value of the sort Levi found in Dante's poetry. The work of art that thwarts aesthetic experience is stripped of value and meaning. Such a work may still count ontologically as a work of art, but it would not play any role in cultivating a deeper sense of humanity, it would not have a humanizing function.

Shusterman's worry about the future of art centers around what he calls "the decline of aesthetic experience from Dewey to Danto," for

> [This decline] reflects . . . deep confusion about this concept's diverse forms and theoretical function. But it also reflects a growing preoccupation with the anaesthetic thrust of this century's artistic avant-garde, itself symptomatic of much larger transformations in our basic sensibility as we move increasingly from an experiential to an informational culture. ("The End of Aesthetic Experience," 29)

For Shusterman,

> The union of art and experience engendered a notion of aesthetic experience that achieved, through the turn of the century's great aestheticist movement, enormous cultural importance and almost religious intensity. (30)

In short, aesthetic experience became "the central concept for explaining the distinctive nature and value of art." Shusterman highlights the goals of pleasure, affect, and meaningful coherence that are part of aesthetic experience. Aesthetic experience, for Shusterman, is "transfigurative because of its affective power and its meaning."[29] Aesthetic experience is central to the meaningful existence of works of art:

> Though many artworks fail to produce aesthetic experience—in the sense of satisfyingly heightened, absorbing, meaningful, and affective experience—if such experience could never be had and never had through the production of works, art could probably never have existed. . . . If artworks universally flouted this interest (and not just on occasion to make a radical point), art, as we know it, would disappear. (38)

With aesthetic experience we find what I take to be the concept that defines the humanizing function of art. In flouting aesthetic experience, we risk endangering the humanizing function of art, pushing it to extinction. Art that categorically flouts aesthetic experience is art stripped of any "powerful experience, enjoyable affect, or coherent meaning."[30] What is the harm posed by such art and can we do anything to stop this

reduction of art to something that in shunning retinal flutters really does not signify anything terribly relevant to human experience? To explore a response to these questions, I now turn to Mill's views on liberty, for some of the problems facing the individual as she tries to achieve a flourishing human life are similar, or so I would like to suggest, to the problems facing the future of art.

3. An Aesthetic Harm Principle?

J.S. Mill's essay, *On Liberty*, is a celebration of human creativity and individuality in all of its manifestations. The essay is basically an elaboration of what has become known as the harm principle: human beings should be free to do what they choose, orchestrating their life projects as they see fit, so long as they are not harming others.[31] Mill is careful to respect human choice in all of its manifestations: foolish choices are no less choices, because they are foolish; the brilliant scientist and the couch potato are both individuals exercising the same freedom, their right to choose a path in life. Just as a bad work of art is still a work of art, so is the life of liberty used foolishly still a life of liberty. Bad choices must be allowed in Mill's liberal society, but not *the* bad choice that makes all future choice impossible. For example, no human being can choose to become a slave, because the condition of slavery harms human liberty to such an extent that it destroys freedom and makes any future choices impossible. As Mill puts it:

> [A]n engagement by which a person should sell himself, or allow himself to be sold as a slave, would be null and void; neither enforced by law nor by opinion. The ground for thus limiting his power of voluntarily disposing of his own lot in life, is apparent, and is very clearly seen in this extreme case. The reason for not interfering, unless for the sake of others, with a person's voluntary acts, is consideration for his liberty. His voluntary choice is evidence that what he so chooses is desirable, or at the least endurable, to him, and his good is on the whole best provided by allowing him to take his own means of pursuing it. But by selling himself for a slave, he abdicates his liberty; he foregoes any future use of it beyond that single act. . . . The principle of freedom cannot require that he should be free not to be free. It is not freedom to be allowed to alienate his freedom.[32]

In this passage, Mill identifies a case of the exercise of liberty which alienates freedom itself and thus negates the principle of freedom, and he goes on to clearly caution us that there are cases in which individual freedom cannot be the sole guide for an individual's choices: freedom

may not be used to destroy freedom. Yet, clearly, people *can* agree to become slaves, even if they do so on pain of contradiction with the principle of liberty, so Mill's point is not an existential one, but a logical one. Any choice that would prevent all future choices is a liberty harming choice and should not be protected by the principle of liberty that Mill is developing in his work. Only on pain of contradiction may one use liberty to alienate one's liberty, that is, to harm liberty itself. In a similar way, it is only on pain of punishment that one may use one's liberty to harm others.

While struggling to free space for the liberty of the individual under the yoke of what he perceived to be an ever more tyrannical state, Mill was well aware of the need for some limits on the cultivation of human liberty. One cannot use liberty to alienate liberty and one cannot use liberty to harm others.

In what ways is this limit issue relevant to an investigation of art? While Mill's essay belongs properly in the domain of political thought, there are aesthetic insights to be gleamed from a careful (and admittedly selective) reading of the *Liberty* essay. In *On Liberty*, Mill describes human life as a work of art, whose perfection and beauty can only be accomplished within certain limits. Moreover, Mill's reference to human life as a kind of work of art is framed by the concepts of beauty and perfection:

> It really is of importance, not only what men do, but also what manner of men they are that do it. Among the works of man, which human life is rightly employed in perfecting and beautifying, the first in importance surely is man himself. (59)

The work of art that is the human life is not a work of art that is created with nothing to guide it, for there are "limits imposed by the rights and interests of others." It is only within those limits that "human beings become a noble and beautiful object of contemplation" and Mill is ultimately interested in the work of art arising from the binding of each individual to the other; that is to a humanizing social project.[33] His emphasis on the perfecting and beautifying project that is part of what a life of liberty must entail connects us to his insight on the role of art in granting us ideal conceptions "grander and more beautiful" than life can provide. To improve, human beings need ideals of beauty and perfection, and good art can provide these ideals.

Not all experiments in living are successful, human beings are, as Mill does not tire of reminding us, fallible creatures, but there should be

as wide a scope possible for individuals to experiment with life projects, choose their paths to fuller development. Space for the development of a full human life does not preclude limits that must be in place to protect the well being of others:

> As it is useful that while mankind are imperfect there should be different opinions, so that there should be different experiments of living; that free scope should be given to varieties of character, short of injury to others; and that the worth of different modes of life should be proved practically, when any one thinks fit to try them. It is desirable, in short, that in things which do not primarily concern others, individuality should assert itself. (57)

Again, one limit on freedom is "injury to others." Tradition or custom should not curb individuality, for a person's own character is a "principal ingredient" of human happiness, and it is the "chief ingredient" of individual and social progress. We could say the same for works of art, namely, that they should not be limited by deference to traditions, to what has come before, but rather that they should be expressions of the artist's individuality, and should represent the world in new, innovative ways. Yet, if we accept this part of the analogy, that is, if we accept that like an experiment in living, the creation of a work of art should not be bound by conventions and tradition, should we not be prepared to explore whether the other part of the claim might not apply to works of art as well, namely, that "short of injury to others" the experiment should go forward? Can a work of art pose an injury to others or to art itself, and would this then constitute a harm to art?

The exercise of liberty makes human life valuable and the choices of our life give rise to a series of acts that make us deserving of praise and reward or blame and punishment. Yet, the experiment of agreeing to enter into slavery is not a permitted option in Mill's liberal universe, for the reasons sketched above. Is there an experiment in art that is so destructive to art itself that it alienates art? That is, just as Mill claims that one is not free to use one's freedom to enter into slavery, for "it is not freedom to be allowed to alienate freedom," can we find some tendency in art, some move that presents the same affront to art that slavery does to liberty? If there is such a tendency in art, should we not take actions to prevent its spread, so that we protect the future of art from the harms of an unbridled direction of art that might very well lead to what some pessimists have already hailed as its sure demise? In short, can we stop the forecast end of art by identifying that which threatens to make art as we know it disappear?

Morally offensive art, tacky or ugly art, and other breeds of bad art may have all sorts of unpleasant (or even downright painful) consequences, yet they are not necessarily harmful to the future of art. True to the liberal ideals espoused by Mill, we should strive to create a society where a true diversity of opinions and tastes is allowed to freely develop (even while we pass judgment on those opinions and tastes). If we are to avoid falling prey to becoming a kind of taste police, we must distinguish carefully between offensive art and harmful art. For the purposes of my argument, art that is harmful is *not* harmful because it is tacky, ugly, in poor taste, or even offensive, but rather because it puts the very future existence of art into jeopardy, undermining a primary function of art (regardless of how that function is executed). While I have a strong interest in the role of aesthetic experience for the humanizing function of art, I am *not* interested in the particular aesthetic merits (or lack thereof) of works of art, but rather in identifying the conditions that destroy art's humanizing functions and have catastrophic consequences for the future of all art. My concern is with the conditions that negate art itself.

Art that negates art is caught up in the same sort of alienating and self-annihilating act as the individual who uses his freedom to abdicate his freedom. Just as the individual who agrees to become a slave kills all of her chances at future freedom, so too the artwork that flouts aesthetic experience, kills the future of art. One can, of course, speak of a human life, even if a particular individual has used her liberty to become a slave, and one can speak of a work of art, even if the artist has thumbed her nose at aesthetic experience, yet just as Mill claims that "it is not freedom to be allowed to alienate freedom"—so, too, "it is not art to be allowed to alienate art," and art that makes aesthetic experience impossible, alienates art, for it undermines the humanizing function of art.

Concluding Remarks

The crisis of art is not caused by the fact that some art is too accessible, that is, so-called "low-brow" art is not a threat to the humanizing power of art—there is no clear danger in making art accessible. As Paul Cantor points out in Chapter 1 of this volume, there is a sense in which catering to the tastes of the public is a way to keep art grounded. Dante was not the only artist whose work had a healing power for Primo Levi—the Hollywood movies of Fred Astaire and Ginger Rogers could do this too (indeed a reviewer of one of Levi's biographies complains that the index does not reference "low-brow" sources of art that were clearly redemptive for Levi).

There are abundant examples of "low-brow" art that certainly maintains a tie to our shared humanity and augments the very meaning of our humanity. In fact, one could argue that these forms of art are essential to the creation of the narrative of our shared humanity, for they are accessible to a wider number of members of the human society. The exploration of mendacity in *Cat on a Hot Tin Roof*, the portrayal of love and despair in *Phantom of the Opera*, the reflection on art and taste in *The Big Lebowski*, take place in films that are readily accessible to a broad public, and their accessibility in no way detracts from the powerful depiction of aspects of our shared humanity.

Indeed, there seems to be a whole set of problems that emerge when art turns its back on the public. Shusterman criticizes contemporary art for denying the role of aesthetic experience in art, explaining that popular art, precisely because it has not disconnected from the importance of aesthetic experience, continues to enjoy a strong interest from the public:

> [A]esthetic interest is increasingly directed toward popular art, which has not yet learned to eschew the experiential goals of pleasure, affect, and meaningful coherence, even if it often fails to achieve them. ("The End of Aesthetic Experience," 38)

What do the sophisticated verses from Dante have in common with a popular Hollywood film? Both kinds of art serve to connect the viewer to a shared world of values. Through the aesthetic experience to which they give rise, works of art offer us new insights into our shared humanity, they can lead us to see reality in a new way, offering us glimpse of beauty and perfection, thereby elevating us. Certain works of art are more powerful than others in fulfilling this function, but an exploration of those differences would lead us to a discussion of the particular aesthetic merits of works of art, a discussion which is certainly worthy of attention but which is not the focus of this paper. Certainly, there are qualitative differences between artifacts, and the work of the critics is important in opening discussions of this sort. I do not wish to suggest that there are not important differences between bad art, tacky art, and offensive art, yet art can be bad, tacky, and offensive and yet not harmful to the very future of art and its humanizing function.

As Mill emphasizes in his essay, *On Liberty*, in society there will be a wide diversity of tastes: one may "without blame" either like or dislike x, y, z. To extend Mill's point, I would emphasize that one may also, of course, "without blame" create art in keeping with a variety of tastes and with a variety of views of what the function of art should be.[34] Yet, if one

violates certain principles of communicability, coherence, order, and the experiential goals of pleasure and affect, that is, if an artist creates art that undermines aesthetic experience, we may speak of a kind of "artistic delinquency."

And what do we do with artistic delinquents? We do not curb their freedom, but we are perfectly within our rights (and perhaps we even have a duty) to denounce their art, to warn others of its harmful consequences. This appeal to "denunciation" is inspired by an insight Mill articulates:

> Though doing no wrong to any one, a person may so act as to compel us to judge him, and feel to him, as a fool, or as a being of an inferior order. . . . We have a right, also, in various ways, to act upon our unfavourable opinion of any one, not to the oppression of his individuality, but in the exercise of ours. We are not bound, for example, to seek his society; we have a right to avoid it (though not to parade the avoidance), for we have a right to choose the society most acceptable to us. We have a right, and it may be our duty, to caution others against him, if we think his example or conversation likely to have a pernicious effect on those with whom he associates. (*On Liberty*, 77–78)

So, if we think that a certain kind of art is "likely to have a pernicious effect" on the very future of art in general, it behooves us to communicate that to others, to try to prevent the possible harm.

Now, this may sound quite troubling to some ears, with my talk of "protecting art" and of "preventing future harms," it may seem that I am interested in creating something that no liberal would welcome, a most paternalistic environment for the arts, that is, the creation of a sort of "taste police" (analogous to the "moral police" introduced by Mill in his essay, which places inappropriate limits on the freedom of individuals in a given society). A taste police would not help with the problem I have been diagnosing: a wide variety of works of art may have what I am calling a humanizing function, and yet be radically different in terms of their aesthetic merit. Bad art is not as threatening to the future of art as art that destroys the very possibility of aesthetic experience, undermining the humanizing function of art.

For the "sake of the greater good of human freedom,"[35] we can and should put up with many offenses, including aesthetic ones. But those acts of artistic delinquency that put the future of art into harm's way stand in need of denunciation, a warning bell that will help to stave off the danger of undermining the humanizing function of art. Nothing I

have said in this paper should lead the reader to think that I endorse any sort of censorship in the arts; to denounce certain tendencies in art is certainly not the same thing as to prohibit their expression.

I do believe that certain tendencies to disrupt aesthetic experience are quite problematic for the humanizing function of art, which is a function that, I believe, gives art its greatest value. When surrounded by monstrous, barbaric conditions such as those that surrounded the prisoners of Auschwitz, art that privileged incoherence, turned away from any engagement with the sensibilities of the viewer, from any attempt to create a window to ideal conceptions grander and more beautiful than life provides, would disconnect prisoners from the world, uproot them from all connections to their past. Dante's verses or the Hollywood films of Astaire and Rogers enabled Primo Levi to reestablish a link with the past, saving it from oblivion and reinforcing his human identity. In recollecting works of art, Levi was reminded that his mind had not ceased to function, that he belonged to a tradition of human creation that was larger than the dead, gray environment in which he was imprisoned. In reconnecting him to a sense of shared humanity, art helped to save Primo Levi. We do well to keep in mind that coherence and the experiential goals of pleasure and affect, elements central to aesthetic experience, are also central to the very possibility art offers to give us access to grander and more beautiful ideals than life can offer, so if we want to preserve art's humanizing function, we should be worried and prepared to take action when confronted with art that turns its back on aesthetic experience.[36]

II

Progress
and
Permanence

[5]
What Shall We Do After Wagner? Karl Popper on Progressivism in Music

Jonathan Le Cocq

1. Why Popper?

There is never a shortage of critics of the avant-garde, almost by defini-
tion. However, most theoretical or historical accounts of it tend to be
either tacitly or explicitly supportive of the developments they describe.
This is unsurprising, for theorists and historians generally and rightly
study what interests and enthuses them. Moreover, since the job of his-
torians and theorists is largely to explain history's successes (that is,
developments that endure or have an enduring legacy), it is always
tempting to write history as though one is describing or seeking an
explanation for what was in some way bound to happen, or was at least
a natural course of events.

Thus theoretical or historical literature on the musical avant-garde
(typified by, say, the Schoenberg school in the pre-war period, and the
Darmstadt modernists of the 1950s) tends to explain it in terms of one
or both of a necessary response to changing social conditions, or the log-
ical outcome of a chain of technical (purely musical) developments. For
instance, a conventional musicological view of atonality and serialism is
to see them as the outcome of the expanding harmonic vocabulary of
nineteenth-century composers such as Richard Wagner, which meant
that further harmonic development in the art required a fully chromatic
vocabulary which abandoned key relations altogether (atonality) and
ultimately a new formal principle to organize it (serialism). Social his-
tory on the other hand typically emphasizes influences such as urban
lifestyle, psychoanalytical concepts or economic alienation on the mind-
set of composers (and indeed, artists in all fields, social history being
intrinsically more cross-disciplinary than technical history) to account
for the same phenomena.[1] In both cases the drift of the exposition will
be that such developments were the natural, logical, and possibly
inevitable outcomes of their historical situation.

The philosopher Karl Popper offers a contrasting perspective. He was interested in music from the point of view of a critic of the avant-garde, or musical "progressivism," as he called it. Whilst he did not publish papers directly relevant to aesthetics (he maintained that his friend, Ernst Gombrich, had said everything that he, Popper, might have said about art better than he could have hoped to do himself), he held characteristically strong views on art and especially music, and he did theorize about it. In fact it appears from his intellectual autobiography *Unended Quest* that his thoughts on music had an important influence both on his philosophy of science, and on his critique of historicism— that is, the notion that history has a plot or direction, or unfolds under the influence of historical laws.[2]

In seeking a theoretical basis for understanding the development of twentieth-century music that offers an alternative to conventional ideas about the natural or logical progress of modern music, Popper's ideas are a useful place to start, not because they are necessarily correct, but because they are intelligent and original. And they are especially interesting because they are informed by direct experience of the Viennese avant-garde between the wars, through a limited involvement with Schoenberg's immediate circle in the early 1920s.

There are then two points of interest in looking at Popper on music. There is his first-hand experience of avant-gardism from the perspective of a critic rather than an exponent, and there are the ideas on music he formed partly in response to that. We can add to these an assessment of them (problems, implications and application) to see how useful they are for understanding the direction taken by the arts in the twentieth century. The remainder of this paper will be concerned with exploring these three things.

2. Popper and the Viennese Avant-Garde

Between 1920 and 1922 (that is, when he was in his late teens) Popper considered taking up music as a career, and went for theory lessons with Erwin Stein (1885–1958), best known as a writer, conductor and music editor (he founded *Tempo*, one of the leading reviews of modern music). Stein was a strong supporter of Arnold Schoenberg during a period when Schoenberg was closely identified with musical avant-gardism, and a controversial figure both in the Austro-German musical world and internationally.

Stein had studied with Schoenberg ten years before (between 1906 and 1910), and was closely involved with the *Verein für musikalische Privataufführungen*—The Society for Private Musical Performances.

This was an organization that Schoenberg had established in 1918 to promote performances of new music at a time when Viennese cultural life had contracted due to the war, and when avant-garde music such as his own was badly received by the public—a situation that never substantially altered. The Society gave weekly concerts of chamber music, mostly new music, with exceptional amounts of rehearsal time, in some cases up to fifty hours. Schoenberg's power over the society was dictatorial (it was informally known as the 'Schoenberg Society'), and amongst its rules were that no critics were allowed in, and no applause nor booing nor any other kind of audience response was permitted.

Stein was *Vortragsmeister* and acting President when Schoenberg was abroad in late 1920–early 1921. Whether Popper came to Stein as a result of joining the Society or the other way around isn't clear, but either way, rather than give the young Popper lessons, Stein mainly seems to have involved him with the Society as a junior helper at rehearsals. At these rehearsals Popper came to know some works by Schoenberg, Berg, and Webern intimately. He knew Webern well enough to converse with him, and admired him as a person if not as a composer. Popper describes Webern as a "dedicated musician and a simple, lovable man. . . ." but adds that "there was not much music to be found in his modest compositions," and he reports Webern explaining to him why his pieces were so short: "he just listened to sounds that came to him, and he wrote them down; and when no more sounds came, he stopped."[3]

Apart from this, Popper's links with the Schoenberg circle were not very close. Another of Schoenberg's pupils, Lona Truding, who had an interest in philosophy, remembered Popper at the concerts but described him as "an outsider in the best sense of the word": "He came to these concerts, but he was not in close relationship. I think he wasn't related with any of that particular circle."[4] By 1922, when the Society was wound up, Popper had decided that a career as a musician was not for him. Not only that, but aside from his autobiography and a few passing references in various articles, he did not write about music or any other aspect of aesthetics in his subsequent career. He did however continue to compose as a private recreation throughout his life, and what he wrote was precisely the sort of thing that composers of his generation and later generally felt they could not do: he wrote in an 'outmoded' style— fugues in the style of J.S. Bach, which he described as his "Platonic model."

Popper's status as an outsider to this avant-garde circle is not very surprising. He was, he tells us, always musically conservative. He seems to have joined the Society largely because he recognized the problem of

being a composer in the early twentieth century. For him, the last
unequivocally great composer was Schubert, though he had a little time
for Bruckner, Brahms and (temporarily) Mahler, and at least recognized
Wagner and Richard Strauss as "full-blooded musicians" even though he
disliked the music. His involvement with Schoenberg's circle seems to
have been mostly one of putting his own conservatism to the test, and by
the end of the process he was confirmed in it and remained so till the
end of his life. In 1991 he characterized the twentieth century as one of
a "terrible decline in art" and explained this in terms of artists' attitudes:
"It is because all artists hear what historicists predict about the future
and then, instead of trying to create good work, they concentrate on
becoming leaders for the future. They are too much interested in them-
selves . . ."[5]

Such attitudes were, according to Popper, apparent in the Society for
Private Musical Performances which had, he says, some of the charac-
teristics of a clique, political pressure group, or church faction that are
typical of any avant-garde. He traced the idea of avant-gardism in music
to Wagner, and noted that Schoenberg and his contemporaries started as
Wagnerians for whom the crucial problem was what we might call the
Wagner problem. He relates how one of Schoenberg's circle (he doesn't
say who) described their main problem as "How can we supersede
Wagner?" This problem, says Popper, turned into: "How can we super-
sede the remnants of Wagner in ourselves?" and eventually "How can we
remain ahead of everybody else, and even constantly supersede our-
selves?"[6] Thus for Popper, a dislike of Wagner and skepticism about the
avant-garde sat very comfortably together.

3. Popper's Three Theories about Music

Popper's experience of the Viennese avant-garde seems to be intimately
bound up with three theories which he formulated about art in general
and music in particular in these early years. One of these is precisely a
criticism of progressivism or avant-gardism in art: that is, of the view
that the artist's job is to make artistic progress, to innovate, and above all
to be ahead of his time. These aims are the hallmarks of modernism and
avant-gardism and they are, Popper says, badly misguided.

Popper has two arguments on this. First is the historical evidence
that, as a matter of fact, great composers have almost always been appre-
ciated in their own lifetimes. They may not always have been success-
ful—Schubert could be such a case—but in art as in life, luck is as or
more important to success than merit. Schubert was appreciated by

those who heard him, and had be been more widely heard (perhaps if he had lived longer) he would have been more widely appreciated.

Popper's second argument against avant-gardism is more interesting, namely that its values of originality and progressiveness are different from the values of artists as artists—values which have to do with solving the objective problems of a work, with perfecting it, and with making it effective. Consequently, they are likely to be a distraction from artistic values, perhaps even get in the way of them. Originality is a lucky gift that is incidental, not essential, to art, and is not an appropriate goal for a composer. Some of the most admired composers, like a Mozart or a J.S. Bach, were not particularly innovative. This is a position that, at face value at least, differs markedly from that of musical modernists.[7]

We can understand these arguments more fully if we place them (as Popper does in *Unended Quest*) alongside two other related theories that the young Popper formed about music. One of these is to make a fairly commonplace distinction between composition as self-expression on the one hand, and objective working out of purely musical ideas or problems on the other.[8] Whilst these represent two genuine attitudes towards music, exemplified by Beethoven and Bach respectively, the former rests on a mistake, for whilst music can represent emotions and perhaps stimulate an emotional response, that does not in itself make it expressive except in the most trivial sense that anything can be seen as the expression of whatever gives rise to it. In Popper's view, Beethoven's unique genius made a success of the error of self-expression against the odds, but it is an attitude likely to lead lesser composers astray, and this seems to have been the fate of Wagner and those who sought to supersede him.

Popper's other theory concerns the mechanism by which art and music evolve, and is addressed particularly to the evolution of harmony and counterpoint, and the question of why this should have developed in Western Europe rather than elsewhere. Whilst this might appear to take us rather far off the point, it is essential to understanding Popper's point of view as a whole.

Popper suggests that Western harmony evolved in response to the dogmatic strictures of plainchant in the Roman church. This single-voiced plainchant acted as a scaffolding on which composers gradually learned to hang independent voices, perhaps through a process of trial and error. So Popper conjectures that:

> it was the canonization of Church melodies, the dogmatic restrictions on them, which produced the cantus firmus against which the counterpoint could develop. It was the established cantus firmus which provided the

framework, the order, the regularity that made possible inventive freedom without chaos. (*Unended Quest*, 58)

Out of this he draws the more general conclusion that:

> musical and scientific creation seem to have this much in common: the use of dogma, or myth, as a man-made path along which we move into the unknown, exploring the world, both creating regularities or rules and probing for existing regularities. . . . Indeed, a great work of music (like a great scientific theory) is a cosmos imposed upon chaos—in its tensions and harmonies inexhaustible even for its creator. (58–59)

Popper here offers a view of musical evolution that is obviously related to his scientific methodology of conjecture and refutation. Theory comes first (that is, it precedes observation and testing) in art as in science. But in art (or at least in counterpoint) it takes the form of traditional practices. In art, these may look like restrictions, but they are fruitful restrictions—a means to the growth of ideas—and the character of this growth is problem-solving and testing by a process of trial and error.

Quite what is the range of things that can count as a productive musical "dogma" for Popper is not clear. His example of canonized plainchant—that is, plainchant that was regularized and officially sanctioned as church doctrine around the ninth century—suggests a musical practice related to social conditions: in this case the need for the church to consolidate its authority. But in any event, from the composer's point of view the origin of the tradition in which, and in some respects against which, he works is probably as irrelevant as the origins of a hypothesis are to a scientist engaged in testing and revising it. The important thing is that it provides him with musical problems to solve.

This emphasis on the role of dogma and tradition as supplying useful problems for artists finds a parallel in Popper's later writings about the social sciences, where it is combined with skepticism about revolutionary social change which could equally well be applied to the arts. Thus in 1948 he observed that:

> the creation of traditions plays a role similar to that of theories . . . bringing some order and predictability into the social world in which we live . . . [and] giving us something upon which we can operate; something that we can criticize and change. . . . But too many social reformers have an idea that they would like to clean the canvas, as Plato called it, of the social world, wiping off everything and starting from scratch with a brand-new

rational world. This idea is nonsense and impossible to realize. If you construct a rational world afresh there is no reason to believe that it will be a happy world. There is no reason to believe that the blue-printed world will be any better than the world in which we live. Why should it be any better? An engineer does not create a motor-engine just from the blue-prints. He develops it from earlier models; he changes it; he alters it over and over again. If we wipe out the social world in which we live, wipe out its traditions and create a new world on the basis of blue-prints, then we shall very soon have to alter the new world, making little changes and adjustments. But if we are to make these little changes and adjustments, which will be needed in any case, why not start them here and now in the social world we have?[9]

On the basis of the above, we might summarize a Popperian view of music as follows, with only minimal extrapolation from his actual writings. The proper business of a composer is solving objective musical problems. Other goals, such as originality or self-expression, are as irrelevant in music as they should be in science. Musical problems arise from a set of givens—myth, strictures, dogma, or tradition—which are valuable precisely because of the restrictions and opportunities they supply. Avant-gardism or progressivism in music errs in concerning itself with non-musical problems such as originality or self-expression (and by extension, we might add, to the expression of social forces in the case of artists who seek to be "relevant"). Whilst they might be radical, the radicalism of the avant-garde does not stem from the appropriately critical attitude of problem-solving, and for that reason avant-gardes acquire the character of clique or faction. The outcome of this distraction from genuine artistic values was a decline in art in the twentieth century.

4. Some Observations on Popper

So much for Popper's direct comments on music. In the remainder of this paper I would like to elaborate on some aspects of Popper's account, noting some possible problems, implications, and applications.

Immediate questions that come to mind are: how accurate was Popper's account of the Viennese avant-garde; and is there really a gulf between the objective attitude to music which Popper advocates, and that of Schoenberg and his contemporaries and successors? It is, for instance, hard to know what to make of his comment that there was "not much music" in Webern's works (assuming he meant something more than to say that they are relatively short and sparing of notes) given the tight technical organization that made them such an agreeable model for the post-1945 generation of formalist modernists. Moreover, to judge by

his writings, at least Schoenberg's own attitude to music seems alto-
gether Popperian. He decries innovation for its own sake, and argues that
like any great composer, he was motivated by the exploration of his
musical material. Whilst as mentioned above, he explicitly values origi-
nality as a precondition for art ("Art means New Art"), he tacitly con-
trasts this with innovation in a manner which Popper might well have
approved. Thus for Schoenberg, Bach is original because of the way in
which he engages with his musical material (for example, in deriving a
fugal theme and manipulating its successive entries). Whether he was
innovative in the sense of inventing new harmonies or musical forms,
say, or finding new instrumental combinations, is neither here nor there.
In this sense it is originality that matters, not innovation. Engagement
with one's musical material—what Popper calls musical problem-solv-
ing—is all that is important. More generally still, by the 1920s the focus
of concern for "progressive" composers like Schoenberg had shifted
from post-Wagnerian expressionism to (often anti-Wagnerian) objec-
tivism, and the development of serial technique, which Schoenberg
announced to his students in 1923, is often seen as an aspect of this.

In fact, one could argue that Popper's own account of harmonic evolu-
tion hardly squares with a criticism of progressivism. The progress from
plainchant to organum to counterpoint, which Popper describes as the out-
come of composers addressing musical problems within a given dogma,
seems little different from the development of serialism out of atonality,
and atonality out of extended chromatic harmony, for both describe a
process of musical evolution through creative problem-solving.

It is difficult to answer this. It is possible to square Popper's account
of artistic change with all manner of modernist innovation, and it is a
contingent matter whether this was largely motivated by the desire for
originality or by a desire to solve purely musical problems. On the his-
torical point that Schoenberg's writings suggest the latter, it is fair to sig-
nal that most of Schoenberg's published comments are retrospective,
often written in the 1940s when he was no longer seen as avant-garde.
Earlier unpublished comments, such as his triumphant claim in 1910 to
have "broken all the barriers of a past aesthetic," may be more typical of
his attitude during the Viennese years,[10] and contemporaries testify to
the sense of and enthusiasm for radical innovation in Schoenberg's cir-
cle at the time.[11] But there remains Popper's apparent ambivalence
towards musical progress. Popper seems to be aware of this, and allows
that we can have musical progress in certain respects, as in the opening
up of new musical possibilities and problems, an expansion of tech-
niques equivalent to a growth of musical knowledge, or technical

progress as in the refinement of musical instruments. But he argues that this is different from the type of progress which he identifies above all with Wagner (the central figure in the so-called "Music of the Future" movement) or the concept of artist as unappreciated genius.

Popper's position might therefore be seen as boiling down to the unsatisfactory proposition that "it does not matter what you do so long as you do it with the right attitude." But one could perhaps refine this reply to give it more weight. There are two ways in which one might do this. If Popper's objection is not to the importance of progress as such, but rather to progress on a grand scale conceived as the composer's main objective, then it is in effect a defense of piecemeal innovation in contrast to radical experimentation, and this is directly comparable to his attitude to social engineering in the social sciences. Or alternatively, one might argue that what is at issue is not the attitude of the composer to his task, but rather the nature of the objective problem being addressed. A composer who tries to supersede Wagner is worrying not about a musical problem, but rather about the dogma which gives rise to it. He is in a position analogous to the scientist who worries about the origins of his hypothesis, or somehow imagines that those origins justify the hypothesis, rather than engaging with the task of testing that hypothesis.

A second issue is the relationship between Popper's ideas, as described above, and his attack on historicism. Popper does not, in fact, criticize musical progressivism or avant-gardism as an outright embodiment of historicism, but this does seem to be clearly implicit in his writings.[12] He seems to have viewed historicism as an undercurrent of movements like avant-gardism, and consequently one of the features undermining them.[13] It would not in fact be difficult to argue that avant-gardism is intrinsically historicist to some degree. If a composer is ahead of his time in what he writes, rather than his simply writing music that people do not appreciate, this implies some standard regulating his music to which he can appeal objectively. It implies that there is already a musical future to which the composer has somehow gained access through his genius or insight or whatever. There is, in short, a 'right' way to go. Whether a musical development bears the seeds of what will supersede it, or whether music in some way reflects its social circumstances, the avant-garde composer is simply one who has recognized what these are, ahead of the listening public. Similarly, it is difficult to imagine a style or technique (such as tonality) being exhausted without some sense of there being a historical direction which has reached a culmination. Both types of explanation of artistic change mentioned earlier—as due to changing

social conditions, or changing conditions within the art—suggest such a mechanism of historical change.

To some extent Popper could be said to offer a unifying model of these two accounts which attempts to avoid historicist traits.[14] That is, social forces contribute to the set of "givens" against which a composer works. In the Middle Ages and Renaissance this included the facts that the cathedrals were centres of learning for musicians, as well as sources of income and locations of expert performers, and with that went the need to work with canonized plainchant which, Popper suggests, was fruitful for the development of counterpoint. One might thus say that society is the principal source of the dogmas within and against which a composer works. In our own time, those social influences might include the balance between the demands of commercial music-making on the one hand, and those of academic creation on the other, each with its own sets of requirements or criteria of success. But the musical problems to which these social conditions give rise are quite distinct from them, and are developed in their own turn. Social pressures give us the *cantus firmus*, but learning to develop the *cantus firmus* by imitating it at the interval of a fifth is a purely musical problem, and brings in its train various other musical problems and possibilities.

This is different from the view that music reflects its society. When Adorno, say, argues that modern music reflects the alienation of late capitalist society, we might say he is giving us a collectivist equivalent of the expressionist fallacy which Popper attacks. On a Popperian view, music can no more express such a thing than it can personal emotional states. It might, in some aspects, carry the marks of the social forces which provided it with the "givens" on which it is built, like the plainchant running through a *cantus firmus* mass. But that is no more expression than external seams on the bodywork of a car express the spirit of cheap manufacturing techniques. It is certainly not something that a composer has any reason for trying to place or find in his music. The influence of social forces will be present, and might or might not be fruitful, but this has nothing to do with expression. In this case, a whole manner of talking about music, and a framework for criticising whatever type of music seems to be "out of touch" or "irrelevant" or in some way "inauthentic" turns out to be based on an error: a misreading both of music as an in expressive art, and of the way in which social forces influence it.

As to a composer's sense that a style has become outmoded and hence unavailable, the Popperian account would presumably say that this is more likely to reflect modernist preoccupation with innovation and

originality than musical problem solving. A musical problem is "How do I develop this material well?" not "How do I develop it in a way in which it has never been developed before?" Stylistic change occurs when there is either a change in the underlying forces which provide composers with their musical problems—the rise of a paying concert public in the eighteenth century, say—or when the exploration of musical ideas based on these forces throws up new musical possibilities. A musical style is rather like a mineral deposit that is never exhausted, but which might become uneconomic, depending on the discovery of new deposits which are easier to mine, or new modes of production which favour other minerals, or new patterns of demand.

We might also use the distinction between solving musical and non-musical problems to explain what makes a musical device into a cliché, or what makes it banal.[15] It does not matter how familiar or well-used a musical idea is. It rings true if a composer turns to it as a solution to a distinct musical problem. It is only if he borrows it wholesale, together with its problem that it becomes a cliché. If a composer wants merely to be "dramatic" and so automatically writes a diminished seventh chord, then he is using a cliché. But if he has a more specific and distinct musical problem in which he's involved, as with Schubert and his detailed working of a *Lied*, then it will be different.

We might also observe that implicit in Popper's account of the source of musical problems is a critique of the idea of compositional freedom. Composers are never free from some set of givens—partly musical, partly social—which influence what they write. And neither should they aspire to be, because these influences present the very problems, the solution to which is at the heart of creativity. The Romantic bid for freedom from constraint in favor of self-expression is an error, and this has implications for the view that certain types of restrictions on musicians are invariably pernicious.

This has implications for restrictions on musicians which are sometimes seen as pernicious. The complaint that art is incompatible with commerce, for instance, that commercial pressures are too restrictive on artistic freedom, sits unhappily beside this Popperian view. In the eighteenth century, the rise of commercial music in the form of the subscription concert encouraged both the development of concert halls, and the writing of "dramatic" orchestral music to fill them, which was an important component in the evolution of Mozartian classical style. In that case, commercial dogma performed well, which is as much as can be said for it. The rise of university-based composition and the tendency to regard composition as a form of research might present another

dogma that could inform the direction composers take. In neither of these two cases is the composer significantly freer than the other, though they might *feel* freer if underlying conditions match what they are used to, or what they are otherwise more personally inclined towards.

Finally, for all his despair of artistic developments in the twentieth century, there is a thread of optimism running through Popper's account about the prospects for art. It is a common theme in Popper's writings that the origins and nature of the dogmas we hold are comparatively unimportant; that what counts is our ability to test and correct them, as contemporary composers have perhaps been doing with the assumptions of their modernist predecessors. Whatever misapprehensions or social circumstances led to the decline of art, measured in whatever terms you like, in the twentieth century, there is no necessary barrier to musical progress (again, measured as you will). In his discussion of tradition quoted above, Popper goes on to say the following:

> It does not matter what you have and where you start. You must always make little adjustments. Since you will always have to make them, it is very much more sensible and reasonable to start with what happens to exist at the moment, because of these things which exist we at least know where the shoe pinches. We at least know of certain things that they are bad and that we want them changed. If we make our wonderful brave new world it will be quite a time before we find out what is wrong with it.[16]

In these lines, Popper is writing about the value of tradition in general; yet, it is not difficult to apply his comments more specifically to the traditional in art.

[6]
Does the New Classicism Need Evolutionary Theory?

RAY SCOTT PERCIVAL

In what way might the new classicism gain support from evolutionary theory? My rough answer is that evolutionary theory can help to defend a return to more classical artistic standards and also explain why classical standards are not simply imposed by social conditioning or by powerful elites, but arise naturally from something more fundamental in the human constitution.

Classical standards and themes are an expression of our evolutionary history. The mind can be seen as a biological organ or function, produced by evolutionary selection pressure. The most arguable and interesting expression of this point of view is that which says that the human mind is more like a Swiss army knife than a general purpose computer or sponge for information. Our minds are modular. First propounded by Jerry Fodor, the idea was taken up by evolutionary psychologists and fleshed out with a history. Evolution has given us cognitive modules, partly self-contained mental "machines" that are attuned to solving problems within a narrowly defined domain. Darwinian evolution has shaped our minds in particular ways that fundamentally affect our evaluation of everything we perceive and therefore our appreciation of art.

What are the implications of seeing our minds from this evolutionary modular point of view for a return to classical standards, or at least for an escape from the excesses of the avant-garde? My provocative conjecture is that the standards and themes of classic art better satisfy the relevant cognitive modules and their disposition for active use to an inbuilt excellence than does much of the avant-garde. Beauty is the patterns that our ancestors had to detect in the pursuit of opportunities and the avoidance of dangers and the incidental properties of the relevant cognitive modules. Any module that evolved would also likely have a taste for excellence or virtuosity, for its exercise and full engagement. Two corollaries of an evolutionary perspective are that we may not avoid

elitism in the arts or varied tastes (even between the sexes), and that, although classical standards are a good proxy for our native aesthetics, our native standards may be fragmentary across types of art, thereby undermining the classical call for universality. In an attempt to understand the nature of our cognitive modules, and therefore our native aesthetic, I tentatively analyse them in terms of a conjecture-and-refutation model of knowledge growth, arguing that they are crystalized conjectures about conjectures. I also analyze Stephen Kaplan's work on aesthetic preferences for landscapes in these terms in an attempt to make clearer what his categories of complexity, coherence, legibility and mystery are, thereby enabling me to generalize the application of his work to other arts.

By classical standards I mean those we associate with ancient Greece and Rome, and also with the revival of those standards in Renaissance Italy and France. This is a broad brush stroke, I grant. There are substantial differences between ancient Greece and ancient Rome and it can be argued that the Renaissance Italians, though trying to copy what they only dimly understood to be ancient standards, went far beyond them, creating (or discovering) new standards. I do not intend to belittle the achievements of other civilizations such as ancient Egypt, India, China or Japan. Indeed, if one takes the classical standards of harmony, restraint, accuracy, coherence and concord at an abstract level, one can see these (or at least strong hints of them) in all the arts of antiquity, even back to Paleolithic art.

I want to suggest that of all such artistic flowerings, classical art standards best approximated our native aesthetics. There are strong hints that classical western art shared the same latent standards with non-western artists, in the fact that western techniques such as perspective were rapidly accepted by them once they saw them, in the same way that anthropologists have found that tribes isolated from industrial society will readily adopt modern tools, such as knives and axes, as soon as they see them. The archetypically Japanese artist Hokusai adopted perspective as soon as he learned of its existence (without losing his Japanese syle).[1] On the other hand, much avant-garde art is a substantial mismatch to our native aesthetics. But I think that our native aesthetics can be seen in all periods and cultures, and—if glossed as classical—even surfaces where one might least suspect. Even the so-called avant-garde is not altogether innocent of a deference to them.[2]

However, the avant-garde (which I take to include modernism and post-modernism) has exhausted itself.[3] Initiated by Cézanne in painting and then rapidly imitated by the other arts, modernism was at least, if not

an aesthetic, then an intellectual adventure, in self-criticism. As Clement
Greenberg put it:

> The essence of Modernism lies, as I see it, in the use of the characteristic
> methods of a discipline to criticize the discipline itself—not in order to sub-
> vert it, but to entrench it more firmly in its area of competence. (*Art and
> Literature* 4, Spring 1965, 193–201)

Greenberg argues that Modernism had its source in Kant. Kant used
logic to show the limits of logic, but thereby entrenched it more securely
in its better-defined home ground. By analogy, modern art used the
methods of each art to show their limits, but thereby confirmed its own
domain. For example, painting strove to distinguish itself from sculpture
and emphasise the flatness of its medium. A significant amount of
avant-garde art is a genuine attempt at self-criticism and the exploration
of the medium and standards and techniques handed down.[4] And just
because an aesthetic is genetic, it does not follow that it is manifest and
easily satisfied: it may require a great deal of learning and experimenta-
tion to both execute and to appreciate.

But there were other non-artistic forces at work in the growth of the
avant-garde. Driven by the historicist conception of progress (the
obsession with anticipating and divining the next stage of artistic cre-
ation), and the self-marketing power of the novel work, artists produced
more and more novel, shocking, controversial works. Stretching the
notion of what counts as art beyond the elastic limit of logic, the avant-
garde has branched out to a number of withering twigs: nihilism, polit-
ical or social activism, and a disguised pluralism. The ideology behind
some modern art is a limp nihilism: anything goes. Michelangelo's
David and the bust of Nefertiti are seen as equivalent (just a point of
view) to a pile of bricks and Leonardo's *Mona Lisa* to daubs of paint on
a Diesel T-shirt. Other art is simply or mainly a Trojan horse or "fire-
work display" to get your political or social message across. Another
branch of art is the disguised pluralism that is advertised as a call for
the liberation of artistic creation, but has an authoritarian shriek: aes-
thetic discrimination, except when motivated by the "correct" political
perspective is, within many circles, seen as authoritarian and elitist. The
rise of relativism within the humanities has offered encouragement and
defenses for these developments.

This paper assumes a defiantly absolutist position with regard to
the existence of evolutionary aesthetic standards. But it is also equally
aggressive in the defense of an experimental pluralism in attempts to

discover those standards. We can learn from the methodology of science that the existence of competing conjectures does not mean that we live in different worlds, but that this is the best way to get closer to the truth. Similarly, the existence of different and competing standards in art does not mean that there is no objective reality to our aesthetics against which these postulated standards could clash. And even if there are genetic standards, this still leaves open room for individual variation.

Great art, that which tends to be accorded highest status across cultures—if only it has been discovered—has a three-fold character: skill, form and meaning. Different types or examples of art will embody different amounts or emphases on the three aspects. The lesser arts of decoration (wallpaper, mosaics, T-shirts, ambient music, and so forth), having an almost exclusive concern with form, are valuable, but do not constitute high art or grand art. The difference between high art and low art is like the difference between a cheese sandwich and a three course meal at a sophisticated restaurant. One does not always want the grand meal—the sandwich will often suffice, but the grand meal is clearly superior to the cheese sandwich. The grand meal satisfies more aspects of our interest in eating: the meaning and mood of the place, the various aspects of our taste (savoury, sweet, and so forth). At one time opera was the grand aesthetic meal, now I think that movies have taken this role. Computer games have the potential to take over here, with their great capacity for a totally immersive experience in which many central and peripheral mental modules are fully engaged.

1. Darwinian Evolution

One could argue that a theory of universal aesthetics does not need to postulate an evolutionary origin for this. For example, one could simply explore the neurological basis of it and how it is expressed in different cultures. However, I assume that one can better understand something from the way it was produced. Because I am arguing that our aesthetics are an expression of our evolutionary history, as Palaeolithic hunter gatherers (and even before), I ought to make clear what I assume to be the dominant evolutionary view: Darwinian theory. By dominant I mean that it is the best explanation available.

Darwin proposed that all the great variety and form of life on earth could be explained by the action of three fundamental processes on a common ancestor over many millennia. Design was not necessary. These processes are:

1. Natural variation (the progeny of an organism are similar to but different from one another and their parents, and this variation occurs spontaneously and independently of the environment and the action of the organism);

2. Natural selection (the environment eliminates the relatively unfit, those variants less productive of self-reproducing off-spring); and

3. The inheritance of variations (selected variants are copied with errors).

There are various elaborations of this, for example, gradualism (which assumes a steady accumulation of slight variations) versus saltationism (which assumes periods of more rapid change), and species versus group selection, but the three-process schema is accepted by all variations.[5]

2. The Evolutionary Psychology of Art: Interpreting the Claim for Universal Aesthetics

There are standards and themes of art that appeal to native dispositions that have evolved either as a direct adaptive response to an ancient evolutionary pressure to survive and reproduce or are a by-product of such direct adaptation. Any organ that evolves will have directly adaptive properties, but it will also have incidental properties. Some of these may, in their turn, be adaptive for some other reason (for example, a dog's ability to swim may be incidental to its attempts to walk when in water and not to its ancestors having adapted to swimming), while other incidental properties may have no adaptive function at all (such as the human mind's ability to understand abstract mathematics). Some of our innate art standards may be of this nature.

What is the evidence for our standards of art being a reflection of evolutionary pressure? Well, one's first thought would be that if these standards were indeed genetic, then they would be evident across all cultures and historical periods. Such a finding would not be surprising in the light of Donald Brown's book, Human Universals (1991), which is a carefully assembled account of traits found in all cultures. The list contains hundreds of items, including body adornment, music, dance, romantic poetry, mourning the dead, exchange of goods, food taboos. Child psychologists no longer argue for the blank-slate view of the human infant: the infant is already equipped with assumptions and preferences about the world that govern its perception and behaviour with

respect to people, objects and tools.[6] Charles Murray has also compiled a survey of great achievers in both the arts and sciences from 800 B.C. to 1950. He found a surprising degree of consensus across cultures about the rank ordering of artists, with Shakespeare, Michelangelo, Mozart, and Beethoven coming at the top of people's assessments. Faced by such diverse evidence of cultural universals, it does not seem far-fetched to entertain the hypothesis of a universal aesthetic. I mention these findings not because they establish a universal aesthetic by themselves, but just to indicate the tide of evidence that the cultural relativist has to face when arguing against my thesis: it is no longer sufficient to simply point to cultural variation to undermine the idea of a universal propensity. We have to be a bit more subtle here. Being general, standards and themes can allow for much cultural and historical variation. I conjecture that our native aesthetic was most clearly expressed during certain periods of Ancient Greece and Rome, but especially during the Renaissance. But at least some of these standards may be found (or at least hinted at) in many periods and civilisations, ancient Egyptian, Indian, and Minoan, for example.

There are two points to be made here. First, there are, when one looks more carefully, fundamental "atomistic" standards. An example of an atomistic standard would be the golden ratio[7] in architecture. Secondly, native tastes need not be manifestly obvious to those who have them. They may become apparent only after much exploratory trial and error and the development of both the refined skill and technology that can create the requisite object of art. Also, they may be used even though there is no explicit formulation of the standard, as perhaps happened with the golden ratio. It has been suggested that the Parthenon and the Acropolis both incorporated the golden ratio. One criticism has it that even though the Greeks knew of the golden ratio in their mathematics, there is no evidence that they explicitly applied it to the design of these buildings. However, my thesis does not require an explicit formulation or application of the golden ratio as a standard in order for it to count as one tacitly discovered and accepted as a result of hundreds of years of building practise. There is a creative leap between knowing a theory or definition in one domain and explicitly applying it to another domain. My main point is that, counterintuitively, the expression of these standards have a certain cultural and historical fragility. They need to be discovered and once discovered by a civilisation they may be lost with the demise of that civilisation, as happened with the fall of Ancient Greece and Rome. We may be witnessing the loss of classical standards in our own time. I want to qualify the status I have accorded classical art. It

may be the best approximation to our native aesthetics. It is therefore a good proxy to our native standards. But it is not the last word on what constitutes our native standards: it is simply a good short-hand for referring to standards that we are still exploring. I think we have to leave room for other themes and standards to be discovered and their satisfaction elaborated and refined. For example, it is arguable that the themes of mystery, horror and the sublime may be native themes that the classical world did not fully develop, leaving it to the romantic movement in painting and literature to embody elaborations of the mysterious and horrific,[8] and gothic architecture to embody the sublime. It is clear that mystery and horror have a genuine enthusiastic audience in contemporary movies and literature, if not in some post-modern painting.

3. The Modularity of Mind Hypothesis

I am arguing that psychology is the mediator of our evolutionary aesthetics, so I need the most persuasive psychological theory. It will become clear that the most powerful psychological theories reinforce the difficulty for the cultural relativist in arguing against a universal aesthetics.

The main ally of the evolutionary approach in psychology has been cognitive psychology, which effectively refuted and has supplanted the behaviorism of J.B. Watson and B.F. Skinner[9]. The most spectacular event here was Chomsky's devastating review of Skinner's *Verbal Behavior*.[10] Behaviorism was the last hold out in psychology of the oversocialized conception of human beings, the so-called blank slate view of the human mind. The blank slate perspective is now in retreat, with a few hold-outs in Humanities and Literature departments.

A guiding principle of cognitive psychology from the beginning has been that the mind can be understood as a general purpose computer: Perception, thinking, and acting are a matter of procuring, processing and storing information. One of the most interesting developments in cognitive psychology, which has accelerated debate in evolutionary psychology is the theory that our minds are not general purpose computers, but are fragmented into a number of modules, specific purpose mental "machines" attuned to solving problems in a limited domain.

Jerry Fodor conjectured that the mind should be split into peripheral input and output modules, a set of sense-specific modules and motor-specific output modules. The main reason for suggesting that the mind uses modules rather than a general purpose computer is that the problems the organism solves are so-called "ill posed," the data of

perception are insufficient to define a solution: specific assumptions about each domain are required.[11]

But there is also a central cognition, the part of the mind that takes output from perception and solves general problems, uses inferences, analogy and metaphor and creates new thought. This is not modular. There are input modules for vision, audition, face recognition and language. Each module is:

a. Innately-specified,
b. Mandatory (when you open your eyes, you cannot help but see an environment that is placed before you),
c. Swift in operation (seeing the environment is experienced as instantaneous),
d. Encapsulated (what you see is not influenced by what you hear or touch and vice versa. Also, what we know has little effect on our perception; for example, visual illusions persist even when we know they are illusions.),[12]
e. Delivering shallow or non-conceptual outputs (In the case of vision, producing a $2\frac{1}{2}$ D "sketch".)
f. Associated with specific neural systems, (g) liable to specific patterns of break down, (h) develop according to a specific sequence.

In our ancestral environment it paid in many circumstances to be able to perceive and act rapidly to opportunities and dangers. In other circumstances, it paid to be able to think more strategically and with greater reflection and creativity. Fodor's conjecture is that evolution equipped us with perception modules that are perfectly suited to rapid action, and also with a general purpose intelligence that is more suited to the more reflective phases of adaptation. Fodor's view can be called peripheral-systems modularity.

Since Fodor's book there has been a flurry of various versions of modularity. At the other extreme to Fodor are a number of positions that argue for massive modularity, that even central cognition is a set of modular systems.[13] On this view, there is little learning; most of our ability to think about the world is already hard-wired into us. In between these two views lies a moderately modular view, that there are both peripheral and central modular processes, but there is still room for general purpose thought and creativity.[14]

What all these modular views have in common is the assumption that the mind is not designed from scratch with the goal of adaptation to an

exhaustive and distinct specification of a set of current demands. The various modules have evolved piece-meal in an *ad hoc* manner, building on structures and functions that existed before, adapting to circumstances that in many cases do not exist today. Darwin referred to this phenomenon as pre-adaptation. A good example is the evolution of insect wings from organs that originally served only as heat-exchangers, keeping the insect cool in the heat and warm in the cold. Research has shown that there is a range of wing sizes that can serve both functions. There is a TV program called "Scrap Heap Challenge," in which contestants are charged with the goal of building something from what they can find in a scrap heap. They may have to construct, for example, an amphibious car. They can only use what is to hand in the scrap yard. This is similar to the way evolution has to work. The main differences are that whereas the contestants can look ahead to see how best to put the parts together (for immediate use and for possible changes of function later), evolution charges ahead blindly producing something rather clunky and perhaps also difficult to alter later for a changed use.[15] So we can expect that the modules for our hearing and seeing and touch are quite different from one another.

What does this mean for the standards of classic art? I think it means that there may be no standards or themes or aspects of form that are applicable across all types of art. Any universal art standards can come only from the central cognitive systems and is confined to the area of meaning and the skill of execution.

4. The Modular Fragmentation of Standards Across the Arts

There is a puzzle here from the point of view of combining classicism with evolutionary theory. The modular view would suggest that there are no classic standards that apply across the arts, only within each one and across cultures and times. Even though the standards may all be produced by the same mechanism, we have seen that the *ad hoc* and piece-meal nature of evolution means that the relevant modular systems for each art may be very different. This becomes more plausible when we recall that the relevant modular properties may be purely incidental. One might wish to hazard the guess that if classic art is a reflection of evolved dispositions, then there are classic standards to each art, but no standards that pertain to all types of art. On the modular view it is tempting to conjecture that each art has its fascination with the forms appropriate to its perceptual field (as Greenberg emphasized), and that the

aspects of form, standards, and themes for each art are constrained by the characteristics of the modules responsible for processing that sense channel or domain.

We should expect to find some standards that are specific to each peripheral sensory module, but that what pertains to all arts is largely imposed by our more fluid, creative, and conjectural central cognition. Another source of cross-art standards is the value of skill. Charles Murray has noted the universal desire for the exercise of and attainment of excellence in a skill. This is to be expected on an evolutionary view of human beings. Any cognitive module that evolved to process a particular domain of problems would also likely have a "taste" for its activation and engagement to the full. Any variant module with a half-hearted interested in its function would likely be eliminated in favour of other more dedicated variant modules.

Classic art is well-known for its veneration of clear, coherent form. The configuration of parts in a building is just as important as the configuration of parts in a painting or sculpture, emphasized by Clive Bell in his theory of "significant form" as the only aesthetically relevant aspect of a work. The standard of clarity is probably as basic as the pleasure someone with poor sight gets in wearing their first pair of well-designed glasses. Being able to perceive clearly an environment (real, simulated or imagined) is a product of the fact that our cognitive modules actively seek and prefer clear input to work on. By clarity here I mean information that would enable us to form a single stable interpretation. There probably is some pleasure in making clear what is initially unclear. We take some pleasure in resolving an ambiguous illusion, such as the beautiful lady and hag, and also in the autostereogram.[16] But the goal of the relevant visual module in these cases is still clarity and not an impasse of unresolved obscurity. At the level of form, much avant garde art does not allow such resolutions. Our ancestors had to make quick decisions such as "Is that a pattern of moonlight on the bush or is it a sabre-tooth?" The classical standard of coherent form, where the boundaries and integrity of objects presented are evident, likely derives from a similar ancestral demand of adaptation. It is extremely useful to be able to discern objects and their environment. There are significant odd exceptions to the stricture of coherence in mosaics from Antioch and Ancient Rome. The Ancients were keen on *trompe l'oeil*, in which there is no one coherent interpretation of the three-dimensional shapes suggested by the mosaic, rudimentary forerunners of Escher's visually amusing and clever depictions of impossible environments. However, these constructions still strongly hint at coherent objects and can be seen

as a play around the standards imposed by our visual modules. They are at least coherently incoherent. One can easily imagine how, through too great a neglect of coherence (a non-systematic neglect), the work would be spoiled. Our visual module gives us pleasure in resolving a coherent interpretation, and these works continually prompt repeated resolutions, squeezing every last drop of processing pleasure out of our visual module. Work on the visual system by Marr and Beiderman indicates that the visual module solves its specific problems by searching for definite simple cues in the environment such as edges, various idealised curved shapes, called geons, and symmetry. Having analyzed the environment into such components, it synthesizes a perception. From a two-dimensional array of photon impacts on the retina, the module constructs a perception of a three-dimensional world in the form of a model that can be examined and experimented with in the way that computer models of cities can be used. The module uses these cues because they are signs (or have been signs) of evolutionarily significant things in the world, such as objects distinct from the background, moving organisms (which are symmetrical) and obstacles to movement. If the scene has little coherence the visual system is given extra, possibly unsolvable, work to do.

Work on preference for different types of landscape by Stephen Kaplan helps to elaborate my rough conjectures about classical art being a good proxy for our native aesthetics. Kaplan conjectured that humans are knowledge-seeking and knowledge-using organisms, and he conducted research into landscapes that allow different levels of exploration and information gathering.

For many years the dominant view in cognitive studies of aesthetics was that the best art contained an optimal amount or complexity of information. Too little information makes for a drab work; too much information makes for an overly busy work. Kaplan's work suggests that a better understanding of the aesthetics of landscapes is in terms of a 2 × 2 matrix.

Classes of Information → ↓	Understanding	Exploration
Immediate	Coherence	Complexity
Inferred	Legibility	Mystery

The pairs "Understanding and Exploration" and "Immediate and Inferred" are supposed to represent classes of information. The first covers the human need for understanding and exploration; the second concerns how much time it takes to process the information from the scene.

Kaplan's general point is that safe and useful movement through a landscape requires a great deal of skill and knowledge, and that landscapes that aid exploration, way-finding, and information processing would be preferred over those that impede these needs. Preferred landscapes contain moderate degrees of complexity, coherence, and semi-open spatial arrangement. Preferred landscapes also contained a degree of what Kaplans calls "mystery"—indications that more interesting information could be obtained with further exploration (such as roads or paths that bend round hills, entering woods, partially blocked views). Preferred landscapes also contain high levels of "legibility", indications that one could easily maintain one's orientation and find one's way both into and out of the scene, extending one's cognitive map of the environment (it looks like one could learn it). Looking into murky environments in deep sea diving or in a fog or dense forest is relatively unpleasant, and the avoidance of such environments has had evolutionary advantages.

I want to suggest that if there are cross-art genetic classical standards, Kaplan's work is most likely the best way of teasing them out into the open. Kaplan's work is a way to delineate the formal qualities stressed by classicism. The highly predictive variables of coherence and complexity seem to have an affinity with the formal qualities of harmony, clarity, and restraint. Legibility and mystery may be ways in which other more meaningful (and conjectural) qualities of a scene can be used to extend and refine our conception of native standards, not only for the visual arts but for all the arts. Mystery is perhaps a post-classical discovery about our native aesthetic.

One can see how to apply these criteria to contrast classical and avant-garde art. Classical art appears to have significant amounts of these qualities; avant-garde art often does not. At the cost of some clarity, impressionism seems to have gained a degree of mystery, complexity and legibility; abstract visual art seems to have very little mystery (partly because of the obsession with the flatness of the medium), though it seems to have retained some coherence. The best examples would be from minimalist artists such as Kasimir Malevich ("Black Square on a White Ground") and later artists such as Ad Reinhart ("Black Painting," 1973, which consists of a very dark grey cross on a black ground) and Barnett Newman ("Who's Afraid of Red, Yellow and Blue III," 1966–67, which consists of a large rectangular expanse of

deep red bounded on the left side by a thin strip of yellow and on the right by a thicker strip of dark blue.)[17] They successfully eliminated both meaning and even indications of the personal and skill in an effort to present form. But in their attempt to eliminate the representational and other meaning, they produced works that lack complexity and mystery, and therefore any enduring interest apart from their curiosity value for the public and their interest for a minority of artistic and intellectual connoisseurs. My point is that Kaplan's work explains why these paintings will never attain mass appeal to the public.

A similar point can be made about such musical compositions as John Cage's *4'33"* of silence. From the point of view of our native aesthetics, the best one can say about this is that it is intellectually intriguing. It clearly lacks complexity, mystery, and legibility. It is not clear that it lacks coherence, but this is because it has no parts that can be coherent.

Can an object that is perceptually homogenous be a work of art? I want to suggest that it cannot be because it fails to have complexity and coherence. I want to suggest that if a supposed work of art cannot be forged in part, then it is not a work of art. A work of art needs to have parts that are recognizably part of the work and of no other object. It needs to be "Incrementally recognisable." Any classical work meets this criterion, but many avant-garde pieces fail. British composer Mike Batt found himself in a legal battle over a composition called "One Minute of Silence" that appeared on an album by his band, The Planets. The defense lawyer had a field day, asking the prosecution to identify which particular one minute of silence out of Cages's 4' 33" the group was supposedly plagiarising. The same point could be applied to overly abstract paintings and ready-mades (such as Warhol's *Brillo Boxes*).

The interesting question here is: do these formal qualities extend over to the other arts? Music seems to have analogous formal qualities of coherence, complexity, legibility and mystery. But there are no equivalent aspects for the tactile, olfactory and kinaesthetic senses. Music is especially interesting. We have well-established classical pieces of music that have no representational or symbolic qualities, but that are delightful and moving sequences of sound. But we have no equivalent for the sense of light. We have no delightful and moving works of light lacking any representational or symbolic quality. The closest candidates here are firework displays and Kaleidoscopes. But these seem pale analogues (and one can hardly imagine going to see the same firework display many times over as one repeatedly listens to a work by Bach) and they do not share all of the important variables that Kaplan has isolated.

Similarly, we have no orchestrated sequence of aromas or touches. Massage is aimed not at a disinterested appreciation but at certain bodily states of relaxation or therapy. But if classical standards apply across the arts, that is what one would expect. The answer is that the peculiarities of the relevant modules of each sense makes for distinctive standards for the associated art. Another intriguing possibility is that these arts are waiting to be developed. However, I suspect that aromatic art would remain purely decorative and simple and, when most complex, purely supportive of some other art, because there are no plausible complex changes of aroma of evolutionary significance that such an art could tap into. Perhaps the cross-modal standards we think we see are imposed by our central cognitive systems by our ability to ratchet up the level of abstractness through language.

Classic art not only satisfies the formal pleasures afforded by our perceptual modules, but also satisfies our central cognition because it is rich in meaning and engages our pleasure in interpreting objects in terms of representation, metaphor and analogy. Although still sharing an interest in form with classic art, much avant-garde art lost interest in imbuing art with meaning. Much of that which did retain meaning adopted an obscure style, a typical tactic when one has little to say, a tendency noted and scorned by Tolstoy. There is a strong suggestion that what we take to be art in general may actually be many disparate independent domains of intrinsically pleasurable creative activity in the same way that Wittgenstein suggested that games form family resemblances, but do not form a set definable in terms of a set of necessary and sufficient conditions.

What role does meaning have in our larger conception of standards? I think that our more abstract conception of art almost compels us to see uniform themes and standards across the arts, and that these more freely created conceptions may come into conflict with our native tastes.

The eternal conflict between our crystallized formal modules and our fluid imaginative cognition meaning is hardly separable from works of art, but nevertheless it can be discerned as another aspect of art and different from form or the execution of skill. Form is the perceptible arrangement of the physical parts of a work of art; the meaning is the interpretation that is attached to it. With proper training one can learn to appreciate the form alone of a work of art. This is the truth in Clive Bell's theory. Still, much great art has both form and meaning. Arthur Danto has stressed the importance of interpretation. Puzzled by Andy Warhol's *Brillo Boxes*, Danto argued that anything can be art given the right theory and situation. These theories or interpretations exist as the

historically variable background to presentations of works in galleries, thus explaining why Warhol's *Brillo Boxes* would not be accepted in different eras such as classical Greece or Renaissance Italy. It is not so much that Socrates or Leonardo would dislike *Brillo Boxes*: they simply would not understand what was going on if they had been presented in a situation normally interpreted as a place for art. I resist this over socialized, over-historicised conception of the role of meaning in art. The outstanding ability of the human mind is to create radically new things: new theories, new technologies, new methods—new ways of looking at and coping with the world. We are not simply a set of hard-wired modules, but creators. But at the same time we cannot ignore the promptings of our genetic dispositions. We have the ability to imagine being radically different from what we in fact are. We can imagine having very different wants and tastes from those we do have. We can also formulate in language these fancied sets of wants as the latest fashion or ideology, what all humans should aspire to. We can thus go to a gallery to look at Warhol's *Brillo Boxes* or listen to a performance of a piece by Stockhausen,[18] and pretend that we are engaged and satisfied. We are not deeply moved, as we can be by classical art, but simply intellectually intrigued by these adventures and sometimes awed or impressed by their skilful execution (Stockhausen's pieces can require exceptional musicianship and Warhol's *Brillo Boxes* were an example of good carpentry). But at the same time the public's taste for the less ideologically motivated (or simply intriguing) can be expected to assert itself, rejecting these proposed tastes as only superficially satisfying.

Still, this tussle between ideological or fashionable theories and our genetic delicacies will always be active. This is partly because our ability to produce complex theories with which we interpret our experience is almost boundless. Art that relies on embodying or transmitting an interesting "interpretation" is here to stay. The human mind cannot help but see meaning in the world, even if there is none there. This does not conflict with Bell's point about form, as he is talking about the focus of one's attention, say on the form of the *Mona Lisa* and not on the fact that it represents the *Mona Lisa*.[19] Seeing meaning and making guesses about what is happening in the world about us is as continual and mandatory as our breathing lungs and beating heart. An organism that does not continually produce and check hypotheses about its world would be rapidly eliminated in favour of its more alert competitors.

This perspective is consonant with discoveries in neuroscience and with the logic of scientific methodology. Neuroscientists have discovered that the brain does not require continuous stimulation to be

active: it is spontaneously active, even down to the level of individual peripheral sensory nerves. For example, our retinal nerves, cones and rods, are spontaneously active and the process of seeing an object begins when this activity is modified (in some respects inhibited) by incoming light, not simply by a pattern of cones being switched on by a correlative pattern of photons.

Concluding Remarks

I want to distance myself from an overly reductionist perspective. I find it fascinating that the universe is truly creative. New properties and structures emerge in the course of the evolution of the cosmos. Biology and human beings themselves are prime examples of the emergence of radically new things that have their own lawful organization. Language and art are relatively recent examples of this phenomenon.

Are there classical values that cannot be reduced to evolutionary theory? Works of art may be produced by our evolutionary leanings and judged by a perceived degree of matching with genetic preferences. But once created they may present other problems whose solution is not wholly governed by (determined by) our evolutionary dispositions. Also, creating a standard is—though bounded by, made possible by, and encouraged by an evolutionary process—non-deterministic. And once created it too can have a life of its own, which is especially clear when it assumes the form of a linguistic formulation. Consider the Cubists's standard of the priority of the surface and form in a painting. This creates a problem, for the Cubists intuitively understood the mandatory nature of representational viewing: people could hardly help themselves search for representations. As Ernst Gombrich suggests, the Cubists' solution was to break up and distort the objects so that no one coherent representational interpretation could be formed, thus forcing the viewer to concentrate on the surface of the canvas. Whether their work satisfied or matched our genetic proclivities for form is another matter. The point is that some standards, both classical and avant-garde, will have this free conjectural and independent quality that is not determined by our genes. On the other hand, they can be tested by our genetic propensities.

Does evolutionary theory exclude elitism in the arts? It is argued, powerfully by Frederick Turner (1995), that the rise of the avant-garde, with its requirements of "deep interpretation," has spawned an elite class of academic interpreters, who are called on to explain to the public just what clothes the emperor is wearing today. One of the attractive things about the appeal to evolutionary theory is that it appears to reassert the

innocence of artistic appreciation by showing it to be a universal human need or preference, the kind of art that Tolstoy (1898) esteemed. That it is not simply a sign of acquiescence in the peculiar tastes of a power elite or the requirements of a particular social structure. As we have seen, in Darwin's theory of evolution, there are two fundamental processes: the production of natural variation and the elimination of relatively unfit variations. In each generation, there is always variation. For example, in humans there are always both dwarfs and giants and variation between these extremes. The variation often closely approximates the form of a normal distribution (bell-shaped), a relatively small number of extreme variants with the great majority clustering around the mean. But there is always the presence of extremes. This is true of all characteristics.

Now, if artistic appreciation is an evolutionary product, then you might expect to see variants, just as you see variants in body size, athletic prowess, memory, scientific achievement, or other characteristics. Perhaps some forms of art can only be fully appreciated by a small number of genetic mutants, just as some areas of mathematics require a rare ability to handle abstractions. The natural variations here might be in either or both the ability to handle the abstract intricacies or the taste (preference) for such qualities. If this is admitted, then the return to classical standards may not be popular in all respects.

Sexual Selection and Sex Differences in Aesthetic Appreciation

If we allow evolution to be the guiding principle in determining what constitutes art and the distinction between good and bad art, then we may also have to admit there may be two standards for a new classicism: the aesthetic standards for males and those for females. The selection pressures faced by males and females have been different, so it would not be surprising to discover a difference in their in-born tastes in art. Such a view allows an overlap, but the differences may be significant. For example, males that had a preference for female body shape would have had an advantage over males who were indifferent over shape. Equally, females having a preference for male form would also have an advantage over those who were indifferent. This difference seems to be reflected in the shape of the women's bodies that adorn women's magazines and the shape of women's bodies that adorn men's magazines. Twiggy and Kate Moss are not pinups; Jayne Mansfield and Marilyn Monroe were not fashion models. Anyway, this could be made into a statistically testable hypothesis. The psychologist Devendra Singh has

shown hundreds of pictures of female bodies to people of many differ-
ent ages, sexes and cultures and there is a clear preference for those hav-
ing a waist to hip ratio of 0.7 or less. Even most of the Upper Palaeolithic
Venus figurines show the same proportions.[20]

III

The Prison of
Avant-Gardism

[7]
A Changing of the Avant Guard

FREDERICK TURNER

In a *New Yorker* article a few years ago Peter Schjeldahl, the mag's art critic, solemnly praised Richard Serra for the "beauty" of his recent sculpture. The article was illustrated with a small photograph depicting a miserable and very large piece of cor-ten steel, identical in inspiration and intelligence to his earlier work, *Tilted Arc*, which was removed from the plaza of the Federal Building in New York City as a public nuisance. The article contrasted Serra's "beautiful" work with what Schjeldahl called the "florid" and "Victorian" art of Frederick Hart, who, having recently died, was in no condition to respond and thus constituted a safe target. Discretion is, after all, the better part of valor.

Obviously the first reaction of the reader who has some idea of what is going on in the art world would be to laugh. The idea that an establishment art critic, who prides himself on his peculiar expertise of being savvy about the New York art world, should be appropriating kitschy old words like "beauty"—which no avant-garde art courtier would be caught dead using a few years ago—is deeply funny. Things must really be getting desperate down at postmodern headquarters, for them to be rolling out the antique cannon of the great tradition, and trying to get it to fire. Dave Hickey, who is the Peter Schjeldahl of intellectually responsible art criticism, has been saying similar things, as empty of philosophical substance, but with a colorable and interesting twist—that the "jouissance" or pleasure of art cannot be constrained within a political program, however righteous. In *Art News* and similar house organs, an agonizing self-appraisal is going on, with words like "beauty," "quality," and "value" being freely bandied about.

Of course there is no acknowledgement of the current source of these shocking old ideas—that is, outlaw publications like *The American Arts Quarterly*—and only abuse for those of us, such as Tom Wolfe, who have been pointing out that the avant-garde emperor is wearing no

clothes. But it looks as if artistic and critical postmodernism has recognized the bankruptcy of its (second-hand modernist) ideas, and lacking the body of skills and taste to start making beautiful art again, and lacking also the philosophical rigor and scientific knowledge to develop a serious body of theory, is trying to see whether, if the stolen label "beauty" were pasted on its work with enough authority, people will believe it. Can the intellectual excitement that is growing around the recovery of classical ideas about value be whisked away to prop up the teetering economic edifice of the avant-garde art market? Can the Whitney Museum wheedle itself back into the public trust, as really representing the values of the good ol' American people after all?

But one's first impulse to laugh might be followed by soberer reflections. Observers of the extraordinary cultural currents that were flowing in the Sixties could well interpret what happened then as the natural end of the movement, already a lifetime old, that we know as modernism. Something genuinely new seemed to be trying to be born. There was a renewal of the popular grounds of art, an upsurge of interest in the past (represented especially by the interest in Asian art and religion, and the medieval ideals embedded in Hobbitdom), an optimism and rock'n'roll confidence that was well on the way to healing the rift between the world of commerce and the world of culture, an embrace of a different kind of future. But then the movement was hijacked by the dour commissars of the old left-wing modernism, who used the huge scandals of the Vietnam War and race segregation as a tool to abort the nascent cultural emergence, and divert its remaining energies into the dead end of postmodernism. Left-wing modernism can be a wily and indefatigable enemy, having appropriated to itself the whole cause of innovation and revolution, which it now uses, paradoxically, to suppress all change. Richard Serra's message, for instance, is not essentially different from the hoary old industrial functionalism and anti-bourgeois politics that thrilled our great-grandparents; yet all he needs is an exegete like Schjeldahl, and the congregation goes on with the service.

The present ferment in the arts and the culture at large is now, I believe, too deeply rooted to be as easily deflected as it was in the Sixties. But people like Schjeldahl can, by corrupting our vocabulary, confuse and depress and slow the emergence of the truly new (which is also the truly old). As an exponent of "language poetry" (itself a brilliant piece of terminological misdirection, since this school of poetry attempts to dissolve the semantic, logical, and syntactical DNA that makes language generative in the first place), Schjedahl is an expert in obfuscatory language. It would be tragic if the true successor to mod-

ernism were aborted again, and we were to endure another thirty years of postmodernism. I do not believe this will happen, for there is a novel system of cultural communication emerging around the internet, the new understandings of biology and biotechnology, the new corporate campus, and the electronic media—a system of communication that the print-based old avant-garde does not understand and therefore cannot manipulate. Here the new cultural life will go on, instinctively attracted to what it finds beautiful and true and good, unconscious of the suicidal metaphysics of twentieth-century artistic radicalism. But the traditional avant-garde is still the guardian of much that is great and splendid in our history, our art, and our ideas, and the new movement will be prone to major mistakes without the mentorship of a past that is sequestered from the rising generation by the hierophants of postmodern orthodoxy.

Let us take a brief look at what Schjeldahl and Hickey mean when they say "beauty," "beautiful," so that we will not be deceived or confused when we run across such usage again in a less obvious context— less obvious, in other words, than when illustrated and hilariously undercut by a frankly ugly little picture of a Serra piece. Schjeldahl's description of the piece gives us the necessary clues. He praises it in the same terms as one might praise the topology of those MacDonaldland kiddie adventure gyms that entertain the sucrose-addled young while their parents are finishing up their fries: the passage through turns this way, then that, and then, gosh, it does thus and so! But MacDonaldland sculpture has the advantage of bright colors, even a weird poetry in the semitransparent glow of its red and green plastic, and the odd blue sky one comes out into at the end. Its youthful audience cannot yet know the boredom of an ungenerative set of angular differences, of a limited set of permutations, the misery of an endess tic-tac-toe game; the MacDonaldland passageways are a brave new adventure, the tic-tac-toe game is a mysterious realm of strategy and counter-strategy. The plastic jungle gym is also portable and easily disposed of afterwards, which is more than one can say for a Serra. But perhaps this is unfair: Serra praises himself in a recent interview for his use of cor-ten steel, which only rusts to a certain depth, forming a brown, excrementitious crust, and which thus still counts towards the nation's strategic steel reserves.

But seriously, current avant-garde aesthetics cannot do other than flail around aimlessly, in the absence of a real connection with nature (which might come from solid scientific knowledge) or with the world of the spirit (which might come from a philosophy and practice of religion). Neither science nor religion have any legitimacy for the avant-garde, because to a self-styled rebel of postmodernism, they postulate

essences and transcendent realities that feel to them to be constraints on their desires and limitations on their power and pride. When they are reduced to praising their materials (cor-ten steel, for instance), it is because of the absence of other criteria of value—and is, in their own terms, actually an illegitimate appropriation of the real properties of nature. In a sense, the only legitimate postmodern art genre is conceptual art; its only legitimate virtue, novelty. As Dave Hickey puts it, with his typical brio—I like the guy's style, actually—"in the twentieth century that's all there is, jazz and rock'n'roll. The rest is term papers and advertising . . . bad taste is real taste . . . and good taste is the residue of someone else's privilege."

In "language poetry," the linguistic equivalent of "conceptual art," the realities and essences that are shunned are the basics that make language language—meaning, reference, grammar and logic—and the formal shapeliness that makes poetry poetry—meter and narrative coherence. These constraints are too humiliating for bold and trendy postmodern writers. The poet and critic Paul Lake, in a brilliant recent essay included in this volume, compares their technique to that of the academics in Jonathan Swift's Lagado, the imaginary island in *Gulliver's Travels*. These savants, weary of the plodding conventionality of ordinary language, have created a sort of computer, wherein a lexicon of words on wooden blocks is randomly recombined by turning a set of cranks, whereupon a team of clerks write down whatever combinations seem to make some sort of sense. These fragments are then printed in folio volumes, which constitute a Borgesian library of universal wisdom. Here novelty is assured by the effortless recourse to blind chance. To change the metaphor slightly, it is as if, taking the rules of language to be tyrannical impositions, we resorted to making up random sound-combinations, as babies do when they babble—waboo! ooga! lalala!—under the impression that they must contain mysterious meanings never yet thought, because after all the "words" are not in any dictionary. The neat trick is that if one has tame critical theorists who will convince the public that the words do have meanings that everyone who is on the inside of the art world understands immediately, then the public, afraid of appearing stupid and uncouth, will pretend to find meanings there too, artists will be encouraged and come to believe that the public is actually enjoying their work, and so the great sting operation continues. Even so, this analogy understates the breathtaking scope of the con game: for the meaning is that there is no meaning, because meaning is a hegemonic patriarchal europhallogocentric mystification invented by rich white heterosexual males.

The con game of avant-garde art is thus surprisingly robust. But this illusion requires very strict policing and absolute solidarity to maintain itself. Schjeldahl likes to tell his students that they are like a gang, whose one loyalty is to the gang colors:

> I have what I call a "gang theory" of education. All gangs are formed by individuals who, for one reason or another, are misfits, wander to the margin by themselves, discover each other, discover other people like themselves. They bond together. If all they have in common is that alienation, they're a very dangerous group of kids. But if they have some aspiration in common, they can be intensely creative. In a way, everybody does this growing up. Every age group is a cohort—particularly in our culture, which is intensely generational. When we grow up, we tend to trust only those who share our exact historic and cultural period, who watch the same television shows with the same attitudes. Childhood, for everyone, is more than formative. It's a trove of spiritual material for a lifetime. But this is especially true of artists.
>
> Gang members are extremely competitive, but not with each other. They pool their resources, their information, their knowledge, and attack the world. Teams work this way, too, but I like the concept of the gang because, with art, there has to be an element of condoned anarchy. You can't measure creative development by criteria that are like crisply executed football plays. Coaching a gang, it seems to me, one must concede the role of judging individual worth to the group.
>
> In a gang—of art students, say—everybody knows without saying who is the best. It's very primitive, very hierarchical, in the way wild animals are hierarchical. Everyone knows who's best, who's second best. There's a lot of doubt about who's third best, because everybody else thinks they're third best. Except for one person who is absolutely hopeless. This person, as a mascot and scapegoat, is cherished by everyone.
>
> The problem is: How do you nurture a gang in academe? I don't think academia should take much responsibility for this. A college education is, and should be, people wanting typical careers in the structure of the world. Education must not distort itself in service to the tiny minority of narcissistic and ungrateful misfits who are, or might be, artists.
>
> You're learning about the course of art, the course of society, the course of the world, the course of your life. You are joining a conversation. You do not prepare to join a conversation. You come up to the edge of it and listen and kind of get the beat, then you jump in. And maybe if you jump in too soon, everyone's going to give you a look and you'll slink off and come back later.

What Schjeldahl omits to point out, but which is implied in his pep-talk, is that it is the duty of a gang to maim anyone who tries to muscle

in on their territory, and to torture and kill any member of the gang who wavers in his loyalty to it. I have heard real fear in the voices of those art and poetry insiders who have confessed their doubts to me, and who have wished they could escape the orthodoxy of their group; it was the same fear that I sensed in a friend who fled Yugoslavia because he would not break off his friendships with Muslims but could not take the threats against his family.

What does one propose as the goal of art, when nature and the spiritual world are disallowed as foundations? Schjeldahl's notion of beauty (like Hickey's) is a version of the French critical-theory concept, "jouissance." "Jouissance" is French for the pleasure of orgasm, and in the hands of the followers of Roland Barthes, Michel Foucault, and Jacques Derrida is itself an appropriation, having been diverted from its lusty and full-blooded carnal meaning to characterize a much thinner gruel indeed: the "play of différance," that is, the interest one gets from something that goes in a different way than one expected. "Différance" is a French coinage by Jacques Derrida, combining the meanings of difference and deferral. The pleasure of "différance" can be interpreted as the pleasure of deconstruction, that is, the tearing apart into meaningless fragments of what previously was recognized as meaningful—and the indefinite postponement of any final reference, significance, or value, whether in nature or in the supernatural. In the absence of any natural or spiritual foundations of pleasure—the generative urge toward natural reproduction, which is now detached from sexuality, or the mystical urge toward the vision of God, which is now discredited—this play of différances is about the only pleasure that can be intellectually defined. In Michel Foucault's last days in Berkeley, he provided an illustration of what such an idea might mean in practice, by his enthusiastic participation, despite an infectious case of HIV, in the Bay Area's S&M sex scene—thus neatly combining the pleasure of doing the abnormal and the destructive with the pleasure of "jouissance" in its literal sense. But there is no blue sky, and no egg demanding to be fertilized, at the end of that passageway. Fertility is forever deferred.

Sociologists connect gang membership with broken families—with the separation of natural fertility from cultural connectedness. Gang members try to find in the "jouissance" of social transgressiveness the true familial love that is missing in their lives.

The aesthetic philosophers of postmodernism all believe beauty to be, at bottom, the frisson attendant upon the exercise of power and the crushing of obstacles to the will. Beauty is the pleasure of grinding one's teeth upon the innocent flesh of the world or of another person, the

breaking of that flesh into morsels that do not have their own integrity or meaning any more, but the integrity and meaning of the biter, the deconstructionist. The greatest appreciator of "beauty" in the postmodern cinema is Hannibal Lecter, the "cannibal lecteur", the Dahmer-deconstructionist who likes to have his friends for dinner with a nice Chianti. *Lecteur* is French for "reader," as in T.S. Eliot's quotation of Baudelaire's early modernist phrase: "Hypocrite lecteur—mon semblable—mon frère!" Hypocrite reader—my mirror-image—my brother!

But all is not lost. New classicists are aiming to restore the pleasure of the arts.

One way of defining the new movement is in terms of a return to traditional forms, genres, and techniques in the arts. In "serious" music there is a recovery of the deep pan-human roots of melody, a renewed interest in worldwide folk music, a focus on the immediacy of performance, improvisation, and the context of audience and performer, and a disillusionment with Schoenberg's theories of seriality and the twelve-tone row, with the atonality of Stockhausen and his followers. In architecture and landscape design there is a renewed attention to the classical languages of building, ornament, fittingness to the environment, and humane proportions.

In visual arts there is a return to representation, to landscape and the figure, a rejection of the modernist authority of abstraction, and a turn away from the idea of art as the ideological enemy of ordinary human life. In poetry there is a wave of renewed interest in poetic meter, rhyme, and clear storytelling, a questioning of the role of poetry as therapeutic private expression, and a return to the great public themes of enduring human interest. Modernist critics of the new formalism have suggested that versification is elitist, but have been staggered by the rejoinder that it is free verse that is confined to a small group of academic cognoscenti, while meter and rhyme are the normal forms for blues and jazz lyrics, country and western songs, Cole Porter songs, rap, and Broadway musicals. In theater there is a renewal of the audience's ability to feel concern about the fate of the characters. In fiction there has been a swing toward storytelling and "moral fiction," identifiable characters and plot and theme and setting.

In painting and sculpture the new art has been dubbed "visionary realism." The new art does not make a fetish of exactly representing gritty reality, although many of its landscapes, portraits and still-lifes are exquisitely detailed. The realism is rather a revelation of the psychological, spiritual, and cultural meanings that burn beneath the surface of the world. A central term associated with the new movement is "classi-

cism". But the movement is not simply a return to ancient European ideas. It has learnt from the extraordinary advances in the sciences that have happened in the last few hundred years; it recognizes that classicism is not an exclusively European property, but a miracle that has happened many times throughout the world in a variety of societies. Ancient classicisms have proposed fixed and perfect ideals that never change; the new classicism sees the world as evolving into a richer and richer mix of physical and spiritual complexity. I have proposed the term "natural classicism" for the movement as a whole; our capacity for making and experiencing beauty is part of our nature, beauty is a real property of the universe, and our ability to feel and create it is founded on identifiable brain functions that are as universal as human speech. Thus beauty is not a mere convention but a fundamental human capacity and human need.

The movement is still a minority element within the arts establishments, and is subject to various degrees of formal, informal or covert censorship by the academy, the public and private foundations, and some museums, publishers, critical periodicals, galleries, and the like. But in poetry the new movement is now recognized throughout the academy, and university and college creative writing classes have started teaching the techniques of meter and rhyme again. Several new periodicals, such as *The Edge City Review, Light,* and *Pivot,* together with a rush of online magazines like *Expansive Poetry and Music,* cater to the new literary taste.

The Derriere Guard, an artistic group named tongue-in-cheek by its founder, the musical composer Stefania de Kenessey, is one of the most prominent representatives of the movement as a whole, bringing together parallel developments in architecture, music, sculpture, painting, poetry, and city planning in a cheeky and insouciant riposte to the avant-garde. The Derriere Guard has already staged major arts events in New York, Chicago, and San Francisco, and on December 7th–8th 2001 initiated the first of a series of salons at its headquarters in the upper west side of Manhattan.

Dozens of vital, fresh-faced young painters, refugees from the grim cloisters of the Politically Correct arts schools, throng Jacob Collins's atelier in New York. The Art Renewal website (http://www.artrenewal.org/) gets thousands of hits every month. Fort Worth's beautiful Bass symphony hall, the cities of Celebration and Seaside in Florida, and Prince Charles's village of Poundbury, together with many new building projects in cities and universities, exemplify the New Urbanism movement in architecture and planning. Robert Stern, the neotraditionalist

architect, is getting major commissions. The arrival of NewKlassical, the website, directory, and nascent multimedia arts group, is another major milestone in the emergence of the new movement.

The driving force of the whole movement is a desire to return to the ideal of beauty. As James Cooper, editor of the *American Arts Quarterly*, has said, "Beauty is not simply an optional aspect of art: it is the object and purpose of art." For new classicists, beauty cannot be detached from either moral beauty or from what Shelley called intellectual beauty. Thomas Aquinas, the great medieval theologian, argued that the fundamental characteristic of the divine was its beauty. One does not have to buy his theology to find inspiration in the idea that beauty might be what we need to draw us out of the despair of the twentieth century.

At a weekend retreat at the Blue Ridge home of the sculptor Frederick Hart (creator of the Washington Cathedral "Creation" sculptures and the Vietnam Memorial "Three Soldiers" sculpture) some of the founding members of the movement put together a manifesto:

ART RECENTERED: A MANIFESTO

We stand for:

1. The reunion of artist with public.

Art should grow from and speak to the common roots and universal principles of human nature in all cultures.

Art should direct itself to the general public.

Those members of the general public who do not have the time, training, or inclination to craft and express its higher yearnings and intuitions, rightly demand an artistic elite to be the culture's prophetic mouthpiece and mirror.

Art should deny the simplifications of the political left and right, and should refine and deepen the radical center.

The use of art, and of cheap praise, to create self-esteem, is a cynical betrayal of all human cultures.

Excellence and standards are as real and universal in the arts as in competitive sports, even if they take more time and refined judgement to appreciate.

2. The reunion of beauty with morality.

The function of art is to create beauty.

Beauty is incomplete without moral beauty.

There should be a renewal of the moral foundations of art as an instrument to civilize, ennoble, and inspire.

True beauty is the condition of civilized society.

Art recognizes the tragic and terrible costs of human civilization, but does not abandon hope and faith in the civilizing process.

Art must recover its connection with religion and ethics without becoming the propagandist of any dogmatic system.

Beauty is the opposite of coercive political power.

Art should lead but not follow political morality.

We should restore reverence for the grace and beauty of human beings and of the rest of nature.

3. The reunion of high with low art.

Popular and commercial art forms are the soil in which high art grows.

Theory describes art; art does not illustrate theory.

Art is how a whole culture speaks to itself.

Art is how cultures communicate with and marry each other.

4. The reunion of art with craft.

Certain forms, genres, and techniques of art are culturally universal, natural, and classical.

Those forms are innate but require a cultural tradition to awaken them.

They include such things as visual representation, melody, storytelling, poetic meter, and dramatic mimesis.

These forms, genres, and techniques are not limitations or constraints but enfranchising instruments and infinitely generative feedback systems.

High standards of craftsmanship and mastery of the instrument should be restored.

5. The reunion of passion with intelligence.

Art should come from and speak to what is whole in human beings.

Art is the product of passionate imaginative intelligence, not of psychological sickness and damage.

Even when it deals, as it often should and must, with the terrifying, tragic, and grotesque, art should help heal the lesions within the self and the rifts in the self's relation to the world.

The symbols of art are connected to the embodiment of the human person in a physical and social environment.

6. The reunion of art with science.

Art extends the creative evolution of nature on this planet and in the universe.

Art is the natural ally, interpreter, and guide of the sciences.

The experience of truth is beautiful.

Art is the missing element in environmentalism.

Art can be reunited with physical science through such ideas as evolution and chaos theory.

The reflectiveness of art can be partly understood through the study of nonlinear dynamical systems and their strange attractors in nature and mathematics.

The human species emerged from the mutual interaction of biological and cultural evolution.

Thus our bodies and brains are adapted to and demand artistic performance and creation.

We have a nature; that nature is cultural; that culture is classical.

Cultural evolution was partly driven by inventive play in artistic handicrafts and performance.

The order of the universe is neither deterministic nor on the road to irreversible decay; instead the universe is self-renewing, self-ordering, unpredictable, creative, and free.

Thus human beings do not need to labor miserably to despoil the world of its diminishing stockpile of order, and struggle with one another for possession of it, only to find that they have bound themselves into a mechanical and deterministic way of life.

Instead they can co-operate with nature's own artistic process and with each other in a free and open-ended play of value-creation.

Art looks with hope to the future and seeks a closer union with the true progress of technology.

7. The reunion of past with future.

Art evokes the shared past of all human beings, that is the moral foundation of civilization.

Sometimes the present creates the future by breaking the shackles of the past; but sometimes the past creates the future by breaking the shackles of the present.

The enlightenment and modernism are examples of the former; the renaissance, and perhaps our time, are examples of the latter.

No artist has completed his or her artistic journey until he or she has sojourned with and learned the wisdom of the dead artists who came before.

The future will be more, not less, aware of and indebted to the past than we are; just as we are more aware of and indebted to the past than were our ancestors.

The immortality of art goes both ways in time.

In the light of these principles we challenge contemporary thinking and urge the reform of existing institutions.

[8]
The Enchanted Loom: A New Paradigm for Literature

PAUL LAKE

I

Increasingly over the past few decades, as postmodern critical theories have percolated from the academy down to the general culture, the prestige of literature has declined. Vulgarized ideas from deconstruction and other postmodern schools now permeate the zeitgeist, spreading the notion that words don't refer to things, but exist in a self-enclosed system divorced from the world. In classrooms and academic journals, literary texts are often treated as little more than tissues of self-serving lies—or subtle snares set by culture and language to entrap readers' minds. A devotion to precise and memorable language is considered either a quaint anachronism or dangerous resistance to a liberatory new social scheme. Consequently, the new "unacknowledged legislators of the world," postmodern critics, often disdain traditional poets and storytellers while lauding experimental writers who in effect burn down their own houses to expose the sinister illusionism of words.

The irony of the situation is that for all of their revolutionary posturing, postmodern critical theories and the literary avant-garde are rooted in a paradigm established more than three centuries ago by René Descartes. Before it reached its *reductio ad absurdum* in the linguistic experiments of so-called L=A=N=G=U=A=G=E writing, Jonathan Swift satirized the absurd conclusions to which this method led. Now that the arts have entangled themselves in the very absurdities Swift predicted, it is time to reassess the basic premises underlying them. Fortunately, the foundation of a new paradigm is already being laid. Though the news has not yet broken through to academic departments of literature, this newly evolving paradigm gives support to common-sense notions about the power of literary representation to illuminate and transform human life. As the old model of language and thought

141

crumbles under the weight of new evidence, poets and writers can believe again in the value and meaningfulness of their art.

Before we can talk of a cure, however, we have to diagnose the disease. Luckily, Swift provides a preliminary diagnosis in "A Voyage to Laputa," the third book of *Gulliver's Travels*, where he describes an academic establishment as theory-maddened as our own. During Gulliver's visit to the Academy of Lagado, professors in the School of Language there have (like our modern theorists) discovered that natural language has dangerous properties that must be allayed. To reduce its harmful effects on the human body, they first propose "to shorten discourse by cutting Polysyllables into one, and leaving out Verbs and Participles" since "in Reality all things imaginable are but Nouns." Then, perhaps sensing the chasm between "signifier" and "signified" posited by our own theorists, the Lagadoan professors propose ". . . that since Words are only Names for *Things*, it would be more convenient for all Men to carry about them such *Things* as necessary to express the particular Business they are to discourse on." Thus the professors of Lagado abolish logocentrism at a stroke, replacing those slippery, dangerous, and unstable things called *words* with an entirely new method of communication, whose operations Swift describes:

> . . . many of the most Learned and Wise adhere to the new Scheme of expressing themselves by *Things*: which hath only this inconvenience attending it; that if a Man's Business be very great, and of various Kinds, he must be obliged in Proportion to carry a greater Bundle of *Things* upon his Back, unless he can afford one or two strong servants to attend him. I have often beheld two of those sages almost sinking under the Weight of their Packs, like Pedlars among us; who when they met in the Streets would lay down their Loads, open their Sacks, and hold Conversation for an Hour together; then put up their Implements, help each other to resume their Burthens, and take their leave.

Swift adds that most people could pack enough implements to engage in ordinary conversation, but complex situations required a more elaborate artifice: rooms kept "full of all Things ready at Hand, requisite to furnish Matter for this kind of artificial Converse."

Absurd as it appears, the Lagadoan scheme is rooted in the best science and philosophy of Swift's era. Impressed by Descartes's success at reducing complex problems to their elements, Enlightenment thinkers like Locke and Leibniz tried to apply the same method to language and philosophy. Sharing Descartes's atomism, Locke believed that words could be fully understood if they were reduced to their constituent parts.

Leibniz, a mathematician, similarly believed that once "words of vague and uncertain meaning" were reduced to mathematical "fixed symbols," the language of philosophy could be purified so that even in matters of ethics ". . . there would be no more need of disputation between two philosophers than between two accountants. For it would suffice to take their pencils in their hands, to sit down to their slates, and to say to each other (with a friend as witness, if they liked): Let us calculate." An idea which even in its phrasing recalls Swift's implement-toting conversationalists, who ". . . when they met in the Streets would lay down their Loads, open their Sacks, and hold Conversation for an Hour together. . . ." Swift clearly rejects this absurd reasoning, even summoning up the ghost of Aristotle in a later chapter to refute "the *Vortices* of *Descartes*."

Another Enlightenment thinker hovering in the background of Swift's book is Sir Isaac Newton, whose mathematical explanation of nature's laws seemed to reduce the universe to a vast machine. After centuries of doctrinal controversy and religious wars, Newton's image of a clockwork universe must have provided comfort to religion-haunted Europeans. As time passed, however, and people's lives became more mechanized, it became an emblem of horror, inspiring a Luddite revulsion against the scheme's cold determinism. Later scientific developments like the Second Law of Thermodynamics, which showed that the universal clock was winding down, only added to the confusion and terror.

Later, in the twentieth century, Einstein's theory of relativity and Heisenberg's concept of quantum uncertainty further quantified and demystified nature, yet, paradoxically, some artists and thinkers interpreted the ideas more positively, believing they offered loopholes allowing some measure of freedom. Rejecting order and symmetry, they embraced chaos, uncertainty, and randomness instead. Dada was born of this new zeitgeist. Since the early twentieth century, poets and artists have fractured the elements of their media and inserted randomness into the process of creation. Poets have pulled words from hats, artists spattered paint, and musicians flipped coins to determine the arrangement of their compositions—or offered ambient noise in place of orchestral harmonies. More recently, writers and computer programmers have collaborated to produce "poems" by inserting randomly selected words into program-generated patterns.

And yet, as modern and revolutionary as these experiments once seemed to be, they appeared—fully developed—centuries earlier in Swift's great satire. During Gulliver's tour through the Academy of Lagado, a professor bent on improving "speculative Knowledge by practical and mechanical Operations" devised a large mechanical frame

designed so that even "the most ignorant Person at a reasonable Charge, and with little bodily Labour, may write Books in Philosophy, Poetry, Politicks, Law, Mathematicks and Theology, without the least Assistance from Genius or Study." Here is Gulliver's description of its operation:

> He then led me to the Frame, about the Sides whereof all his Pupils stood in Ranks. It was Twenty Foot Square, placed in the Middle of the Room. The Superficies was composed of several Bits of Wood, about the Bigness of a Dye, but some larger than others. They were all linked together by slender Wires. These Bits of Wood were covered on every Square with Paper pasted on them; and on these Papers were written all the Words of their Language in their several Moods, Tenses, and Declensions, but without any Order. The Professor then desired me to observe, for he was going to set his Engine at work. The Pupils at his Command took each of them hold of an Iron Handle, whereof there were Forty fixed round the Edges of the Frame; and giving them a sudden Turn, the whole Disposition of the Words was entirely changed. He then commanded Six and Thirty of the Lads to read the several Lines softly as they appeared upon the Frame; and where they found three or four Words together that might make Part of a Sentence, they dictated to the four remaining Boys who were Scribes. This Work was repeated three or four Times, and at every Turn the Engine was so contrived, that the Words shifted into new Places, as the square bits of wood moved upside down.
>
> Six Hours a-Day the young Students were employed in this Labour; and the Professor shewed me several Volumes in large Folio already collected, of broken Sentences, which he intended to piece together; and out of those rich Materials to give the World a compleat Body of all Arts and Science . . .

Brilliantly translating Descartes's mathematical-coordinate grid into the realm of mechanics, Swift's frame is a postmodernist's dream-machine. Pasting words onto dice, the tools of gamblers and mathematicians, and arranging them by purely mechanical, chance operations reduces language to a game, mocks reason, and turns Newtonian science and modern engineering on their heads. If put into actual use, Swift's marvelous invention could produce books worthy to sit beside the collected lectures of John Cage.

Furthermore, such Lagadoan texts would nicely illustrate the tenets of poststructuralist theory. Literally, "authorless," these works would engage "nothing outside the text." From such a closed system, no "totalizing narrative" could emerge to oppress innocent readers. It was no doubt for these reasons that Swift's work–along with that of another eighteenth century English writer, Laurence Sterne—was seized on by Futurist and Russian Formalist critics trying to establish a scientific the-

ory of literature. Tomashevsky wrote admiringly of how Gulliver's descriptions of English society defamiliarized and decontextualized its elements by removing their "shell of euphemistic phrases and fictitious traditions." Shklovsky wrote a monograph on Sterne's *Tristram Shandy* to show how in "laying bare" the various devices of fiction, Sterne drew attention to the artifice of novelistic form. Indeed, Sterne's protracted descriptions, misplaced prefaces, typographic games, and parodic language seem oddly out of place for his time, making him seem a postmodern artist miraculously transported to the past.

From Swift's time to ours, atomization, fragmentation, and decontextualization have been the hallmarks of modern art and criticism. Like Swift's professors, modern critics have tried to untether literary texts from authors and reduce language to its constituent elements. Avantgarde writers have responded by creating texts that accord with the latest theories.

The modern approach to literature is perhaps best exemplified by the Deconstructionism of Jacques Derrida—a movement whose very name epitomizes modern thought. Beginning in Cartesian dualism, Derrida first proposes to reverse traditional binary categories of thought (such as mind and body) and so stymie any attempt to establish a "center" of discourse. According to Derrida, this desire to establish a center is the root of all error in Western philosophy and constitutes the sin of "logocentrism." To keep this seductive illusion at bay, Derrida follows the Structuralists in asserting that words (signifiers) are composed of atomlike elements called phonemes, which function in a system of "*différance*" that forever frustrates their ability to communicate meaning.

Though seeming to pose a revolutionary challenge to Western philosophy, Derrida's system is rooted in the same nexus of Enlightenment ideas that produced Swift's Academy, among whose professors he would surely feel at home. In creating his deconstructive philosophy, Derrida duplicates two fundamental errors made by Swift's professors: He believes words can be reduced to their constituent elements, and he believes these elements are actual things. Unfortunately for his system, recent developments in science suggest that language cannot be reduced to a linear chain of signifiers strung out like dice on a wire; that meaning is not perpetually deferred, but rather pervades language down to its smallest elements. To understand how stories and poems work, we first have to take language off the rack on which it's been stretched for the last three centuries and consider how it's woven on the mind's enchanted loom.

In *Eve Spoke,* Philip Lieberman, a professor of cognitive and linguistic science at Brown, disproves the first of Derrida's premises. He demonstrates that when we speak we don't simply arrange discrete lin-

guistic units in a neat row, but "continually plan ahead, modifying the immediate movements of our speech-producing organs . . . to take account of what we're *going* to say." To illustrate this, he proposes the following experiment:

> . . . say the word *tie*. If you carefully watch your face, you'll see that you don't round your lips at the start of the word. Now say *too*, which contains the vowel [u]. If your speech producing system is working correctly, you will round your lips at the start of the word when you are articulating the initial [t], anticipating the [u] that is produced "after" the initial [t]. Your speech production has been encoded. The rounding of the initial [t] of *too* makes its acoustic properties different from the "same" sound, the [t] of *tie*.

Other researchers undermine Derrida's second premise, that "signifying forms" like words and letters possess an absolute "self-identity," which they retain, like things, even when removed from a given context. In his seminal essay "Signature Event Context," Derrida asserts:

> . . . a certain self-identity of this element (mark, sign, etc.) is required to permit its recognition and repetition. Through empirical variations of tone, voice, etc., possibly of a certain accent for example, we must be able to recognize the identity, roughly speaking, of a signifying form.

Derrida suggests we can recognize words and their elements despite variations in tones and accents because they possess an immutable self-identity.

Douglas Hofstadter, a pioneering thinker in artificial intelligence, has also considered the problem of "signifying forms." In *Metamagical Themas,* he notes the curious fact that we can recognize variations of the letter "A," for instance, in different—and sometimes bizarre—fonts. He suggests we can do this because inside each letter "lurks a concept, a Platonic entity, a spirit." But unlike Derrida, Hofstadter argues that this Platonic entity is not an immutable form, but a mental abstraction composed of modular "roles" it shares with other letters, like the crossbar in "A" and "H." Letters don't exist in isolation, he writes, but "*mutually define each others' essences*," and so any attempt to find an "isolated structure supposedly representing a single letter in all its glory is doomed to failure."

Pioneers in the new field of "fuzzy logic" share Hofstadter's belief that words are mental abstractions. In their view, words don't possess immutable identities, but rather exist as "fuzzy sets" in the minds of those sharing a language. Even a concrete noun like "chair" signifies a

class of objects—ranging from wingback to folding metal to beanbag chair—possessing some indefinable essence of "chairness."

The philosophical problem confronted by Derrida, Hofstadter, and fuzzy logicians becomes clear when we consider what Swift's Lagadoan conversationalists would have to pack in order to communicate. What *thing*, for instance, could signify a simple noun like *tool*? A hammer, screwdriver, ax, crow bar, wrench? For that matter, what should they carry to signify *screwdriver*—a philips head, flat head, or motor-driven electric? What if they wanted to speak of a *pet*? Should they pack a dog, a snake, a gold fish, a ferret? Exactly what degree of "petness" does each possess—and how far can we extend the continuum?

Fuzzy logicians point out that neither words themselves nor the concepts they represent have clearly defined parameters. We use the word *tall*, for instance, when describing people, buildings, and mountains. And yet, tests show that people generally agree on what constitutes a "fuzzy set," determining with remarkable statistical consistency, for example, what degree of "toolness" is possessed by objects ranging along a continuum from *hammer* to *spoon*. It has also been found that cultures throughout the world categorize the colors of the spectrum in similar ways, despite different languages.

Lotfi Zadeh, one of the founders of fuzzy logic, has observed how simply combining adjectives with nouns alters their meaning. Commenting on his work in *Fuzzy Logic*, authors Daniel McNeill and Paul Freiberger note, for instance, "*red hair* alters the meaning of *red*. *Ice cube* changes *cube*. We bring knowledge to these terms. In the past, *red hair* has always referred to a special kind of red, quite different from the red of the spectrum. Our experience perfuses language."

Meanings don't reside within individual words any more than human memories reside within individual neurons. This is quite a different thing from saying, as deconstructive critics do, that there exists an unbridgeable gap between signifier and signified. Consequently, Derrida's "iterable marks" are not entirely graftable, as he asserts, but change in subtle ways from context to context. In focusing on the printable and reproducible elements of linguistic forms, deconstructionists are committing an error that scientists in the fields of complexity and artificial intelligence call "level confusion"—an idea with particular relevance to the art of writing.

One of the fundamental insights of complexity science is that by following simple rules, complex dynamic systems self-organize to produce higher levels of order from lower ones, in a process called "emergence." Trying to reduce emergent orders to lower level phenomena results in all

manner of confusion. In talking of computers, for instance, we have to make various level distinctions between the computer's hardware—that is, its actual circuitry, the semiconductors inside its plastic frame—and the software—the program running on it. In the language of complexity, the software constitutes a higher level than the hardware. Similarly, if we were to run a chess program on a computer, the rules of chess would constitute yet another, higher level. We can't talk about chess by referring to computer codes or silicon chips. Though it arises from the passage of electricity through semiconductors and the chunked rules of a digital software program, the game you play against your computer is an emergent phenomenon—like human consciousness. To talk about it, you need a new language—of gambits and strategies, advantage and disadvantage, placement and position.

In a similar fashion, in speaking of a poem or story, we have to avoid confusing the various levels involved. At the lowest level, the printed ink on the page is a novel's "hardware" analogous to the computer's circuits. *Pride and Prejudice*, for instance, can be printed on different types of paper with various inks and fonts and it's still *Pride and Prejudice.*

At the next level, we find the "software" of the grammatical and syntactic rules of English. At a still higher level, we find the generic rules of novelistic fiction. When we read a story or novel, we engage several levels at once. At the lower levels, we run our eyes across a printed page, decoding words and their grammatical relationships. At higher levels, we follow imaginary characters living out their lives in a "virtual" world of the imagination. Emergent levels include this dramatic unfolding of fictive lives, the novel's "theme," and the alteration in consciousness we experience when observing—or reflecting on—the tragic or comic nature of the imagined experience.

The problem with much modern literature is that writers from Sterne to Silliman have deliberately concocted strategies to thwart the emergence of higher-level orders from lower ones. In "laying bare" the devices of fiction and calling attention to the "constructed" nature of their language, postmodern writers often frustrate a reader's attempt to imagine a story's characters and events. Similarly, one of the key problems with deconstructive criticism is that it dwells mostly on the level of linguistic coding—on the hardware of printed "grapheme" and the software of grammatical and semantic form. By isolating linguistic elements in order to reveal their incomplete, self-contradictory, or indeterminate nature, they give short shrift to emergent orders such as character, voice, theme, or the tensions and resolutions of a work's unfolding form.

The reproducible sign so beloved of deconstructionists is a meaning-less nothing outside its human context, as a simple thought experiment will show. If NASA transmitted all the printed texts in the Library of Congress into space, an alien race would still be unable to decipher the information in its various codes without a large database of human cul-tural contexts to give them meaning. The problem, as Jack Cohen and Ian Stewart explain in *The Collapse of Chaos,* is that

> The meaning in a language does not reside in the code, the words, the gram-mar, the symbols. It stems from the shared interpretation of those symbols in the mind of sender and receiver. This in turn stems from the existence of a shared context. For language, the context is the culture shared by those who speak that language.

Cohen and Stewart usefully define words as "data compressors" and argue that the problem with such compressed data is that one needs to "make a computational effort to decompress the data before they exist in usable form." This, in a nutshell, is the problem of literary interpreta-tion. There's a cost for unpacking the information packed in a story or poem's codes. While reading a text, a reader has to de-compress the meaning of words and sentences the way a CD player unpacks the digi-tal information encoded on a disk. The player is the cost of decom-pressing data. Similarly, the cost for unpacking information in a literary text is a life spent in a human culture, learning the rules of language and social behavior. That's why, contra deconstruction, there is always some-thing outside the text.

Furthermore, this packing and unpacking process is nonlinear and recursive, since language begins and ends in a human brain. Neuroscientists now define the brain and its various sub-mechanisms as complex dynamic systems since from their earliest prenatal develop-ment they are governed by self-organizing feedback processes. Scientists now use terms like "attractors," or "basins of attraction" to describe how memories are stored in its neuronal weave. The fractal nature of memory is also evident when we see how, from the merest fleeting detail, we reconstruct complex patterns and scenes.

Sir Charles Sherrington, Nobel Prize-winning physiologist, in *Man on His Nature*, describes the brain as "an enchanted loom, where mil-lions of flashing shuttles weave a dissolving pattern, always a meaning-ful pattern, though never an abiding one: a shifting harmony of sub-patterns." If Swift's mechanical frame represents the old paradigm, Sherrington's loom represents the newly emerging one. When we recall

that *text*, *context*, and *textile* all have the same root, meaning "woven thing," the applicability of Sherrington's metaphor becomes clear. However, the human brain is not like a textile loom; it's multi-dimensional, operates in time, and has an infinite fractal complexity. The texts it generates are interwoven with all nature and culture. Using Magnetic Resonance Imaging (MRI), scientists have begun to show what happens on the neural loom when people use their imaginations. What they've found has interesting implications for what we've termed the "level confusion" inherent in deconstructive analysis. Describing the work of Xiaoping Hu and colleagues at the University of Minnesota in *Frontiers of Complexity*, Coveny and Highfield write:

> The scanner showed that centers of the brain responsible for vision were activated when subjects used their imagination, although the brain activity was approximately half as much as when they actually looked. The same team has revealed a similar phenomenon in the sound-processing centers of the brain when subjects are asked to *imagine* saying words. And they also found a part of the brain that is involved in forming a mental picture or map, situated in the fissure between the parietal and occipital lobes.

The implications of this for literature and criticism are immense. If, for instance, while reading *Moby-Dick* we can mentally "see" the swelling ocean, great white whale, and harpoon-clutching crew, then it appears that, contrary to theory, signifiers *do* evoke the signified. The meaning of a text is not wholly indeterminate, but collapses into relatively clear, determinate pictures. Though the imagined details may vary somewhat from reader to reader, a moving drama unfolds inside our heads, above the level of decoding, like movie clips transmitted to our PCs.

This discovery has implications for poetry, as well. If merely *imagining* saying words activates our hearing center, then silent reading must download a poem's music like Napster downloading a hot CD to our home computers.

Thanks to complexity science, we no longer need to imagine an ideal realm above the mundane world to explain the existence of complex forms. We now know they arise spontaneously when rules operate on chance elements through feedback. Nature, it appears, has a bias toward symmetry and beauty. Studies have shown that neural networks have an inherent aversion to asymmetrical and irregular patterns, and prefer symmetrical ones instead, partly because they're easier to discern from various viewing angles. Other studies have shown that this human preference is shared by monkeys and crows. Artistic forms arise just as natural ones do, through rules and feedback. Since nature is the context in

which art and language evolved, it's logical that our brains and the artistic forms that emerge from them partake of the same bias. What the last three centuries have shown is that if we short-circuit our natural bias toward order and beauty, relying instead on reductionism and chance to produce books in "Philosophy, Poetry, Politicks, Mathematicks and Theology," we will wind up with the same fragmented and meaningless nonsense cranked out on Swift's absurd frame.

II

To avoid the errors that have plagued modern thinkers from Descartes to Derrida, we have to place language and literature within a larger hierarchy of symbol systems. After all, the human brain that produces language is itself produced by the coded symbol system of DNA—a code shared by all other living things in the eco-systems of planet Earth. Each individual human being also exists within the complex symbol system of a human culture, which in turn exists within a larger natural economy. Each of these systems is complex and dynamic and interacts with the others in a general level mixing, involving countless exchanges of information.

A key function of higher-level systems is their ability to make models. John Holland, one of the pioneers in artificial life, observes, "All complex, adaptive systems—economies, minds, organisms—build models that allow them to anticipate the world." To illustrate how context affects the model-making adaptations of living things, he points to the viceroy butterfly, an insect apparently appetizing to birds. To prevent itself being eaten, the viceroy butterfly has evolved a pattern on its wings that resembles the awful-tasting monarch butterfly. "In effect," writes Holland, "the DNA of the viceroy encodes a model of the world stating that birds exist, that the monarch exists, and that monarchs taste horrible. And every day, the viceroy flutters from flower to flower implicitly betting its life on the assumption its model is correct."

The butterfly's modeling does not depend either on the conscious intentions of the butterfly or an intelligent designer, but on the behavior of the complex adaptive system in which it lives and the self-organizing properties of living things. It is a beautiful example of what science now calls "downward causation," a process in which higher levels of organization reach down and influence the operation of lower level ones. In the case of the viceroy butterfly, the larger ecosystem has reached down to fiddle with its DNA code to select for the monarch pattern on its wings.

As the example of the viceroy butterfly shows, it's impossible to fully understand living processes by reducing them to their constituent elements and treating them separately from their contexts. Even in the cloudy realm of quantum physics, many scientists now doubt that the so-called fundamental particles of matter are in fact fundamental. Instead, scientists like Ilya Prigogine and David Bohm believe that there is an "implicate" order enfolded into even the lowest levels of matter. John Wheeler asserts, "Physics is the child of meaning even as meaning is the child of physics." Paul Davies in *The Cosmic Blueprint* suggests that in a sense nothing—not even an elementary particle—exists independently, unaffected by downward causation:

> In principle, all particles that have ever interacted belong to a single wave function—a global wave function containing a stupendous number of correlations. One could even consider (and some physicists do) a wave function for the entire universe. In such a scheme the fate of any given particle is inseparably linked to the fate of the cosmos as a whole, not in the trivial sense that it may experience forces from its environment, but because its very reality is interwoven with the rest of the universe.

Returning to the human realm, Davies goes on to describe how, although mental events represent quite a high level of organization in the cosmic scheme, there exist above them still higher ones. Using Karl Popper's classification system, he divides the human and natural orders into three "Worlds." Material objects are defined as World 1 entities, mental events as World 2, and societal and cultural events as World 3. Davies then describes how downward causation operates in a way that applies directly to literature and writing: "Thus an artistic tradition might inspire a sculptor to shape a rock into a particular form. The thoughts of the sculptor, and the distribution of atoms in the rock, are determined by the abstract World 3 entity 'artistic tradition.'"

As we've seen, it's perilous to discuss literature by referring only to its lower levels of organization. The literary tradition not only provides the context in which literature is read, it operates in a top-down manner to help shape it as well. As with other symbol systems, literature is created jointly by complex human brains, language, and artistic traditions. In addition, each skill we bring to reading and writing is itself—in Holland's words again—"an implicit model—or more precisely, a huge, interlocking set of standard operating procedures that have been inscribed on our nervous system and refined by years of experience." We are able to encode and extract real meaning from literary texts because

each of our brains shares the same model-making abilities and standard operating procedures.

Douglas Hofstadter suggests that human brains share certain "isomorphisms" that make coding and decoding possible and adds that these isomorphisms represent a "correspondence which not only maps symbols in one brain onto another, but also maps triggering patterns onto patterns." Though exact correspondences might not always appear at smaller scales, there are enough global similarities in these patterns to make real communication possible. This is also what makes translation possible from language to language and culture to culture.

The implications of this for literature are obvious. Somehow, writers pack four dimensions of space-time implicate with human meaning into two-dimensional strings of letters on a page, which readers must then unpack, using built-in procedures they share with the writer. A further complication is that in order for this process to work, the writer must first model the minds of prospective readers to predict how they'll respond. To satisfy and subvert reader expectation, he must continuously refer to his own internal model of the reader's mind and adjust the writing process to accommodate it. Because both writer and reader share a language, a culture, and certain universal human experiences, their mental maps of the world share similar patterns. The full context of any text must include this large, recursive mapping process.

To understand the complex nature of writing, consider how a novel is written. The writer may begin with an intuition of the novel's overall tone, plot, or theme, which he may have glimpsed—in toto—in a tiny scrap of memory or an overheard conversation. Proust found the seed of his seven-volume *Remembrance of Things Past* in the taste of a madeleine (tea cake). From as little as a single phrase, a voice or character can emerge, bringing with it a tangle of associations. Once sensing the gist of a plot or a character, the novelist begins typing, starting with a single letter, then a word, then a phrase, then a sentence, looking ahead to the small episode in which each element is lodged—and perhaps to the entire story—as he writes.

The first declarative sentence the writer types contains within it a tiny plot, which will take place within and help comprise the novel's larger plot: "Once upon a time and a very good time it was there was a moocow coming down along the road and this moocow that was coming down the road met a nicens little boy named baby tuckoo. . . . " This first sentence anticipates, and helps create, all that follows by establishing a tone, a repetitive rhythm, and a specialized diction evocative of early childhood.

Then another sentence follows: "His father told him that story: his father looked at him through a glass: he had a hairy face." To the first sentence's single character, the second adds another and situates them both in a dramatic situation. Since the second sentence states that the first was only a story, the writer has already engaged potential readers in a marvelously tangled and recursive process of models packed within models, forcing them to readjust perspectives since this second sentence too is part of a larger story.

Soon, however, as the writer continues, sentence blurs into sentence; a larger pattern emerges and the unfolding story acquires an illusionistic reality. Partially forgetting he's composing individual sentences now, the writer looks ahead to where each new sentence might lead in the larger scheme. As sentences build into paragraphs, paragraphs into episodes, and episodes into subplot and plot, every sentence now includes a gist of all that precedes it and contains within it the seeds of all that will follow. In the language of complexity, the novel has become a complex hierarchy of nested scales. This is what allows the writer to initially glimpse the whole in the part.

Between the low level of the sentence and the high one of plot, lies a middle level, where characters develop and take on a life of their own, forcing the writer to adjust the action of other characters and accommodate the plot to their motives and actions. This is one of the ways that feedback occurs in writing. Paradoxically, though each individual sentence contains a tiny part of a character, characters can't be reduced to the sentences that compose them any more than people can be reduced to their atoms. They have a holistic nature—another element of complex systems. Similarly, though each sentence constitutes a small part of the plot, the plot is an emergent quality that exists on a higher level than its constituent elements.

Plot, as Aristotle perceived, is the central mapping device of drama and fiction; it's also a large-scale map of time. Its rhythms ripple through pages and chapters like large, low-frequency waves. Incidents and episodes are smaller-scale rhythms whose vibrations contribute to it. Curiously, time can also be mapped at different scales within the novel: from summary paragraphs that condense many years into a few pages to dialogue-filled scenes that move in real time. We accept these odd conventions unconsciously until a writer like Sterne comes along to deliberately bore and annoy us with exaggeratedly long descriptions or until a Joyce invents stream-of-consciousness to model time and thought in a new way.

Of course, not all stories begin, like *A Portrait of the Artist as a Young Man*, by calling attention to their own artifice and declaring their status

as fiction. They don't have to. The reader knows she's reading a novel from the moment she picks up the book and willingly submits to its conventions. Joyce, in his first novel, was already moving toward the experimentalism of his later style, but even more traditional writers of realistic fiction sometimes draw attention to their writing's artifice, unintentionally laying bare its devices, as it were. Here's how Dickens begins *David Copperfield*:

> Whether I shall turn out to be the hero of my own life, or whether that station will be held by anybody else, these pages must show. To begin my life with the beginning of my life, I record that I was born (as I have been informed and believe) on a Friday, at twelve o'clock at night.

With the protagonist's speculation about whether he's going to be the hero of his own life and his words referring to the very pages (part of the "hardware") on which it's written, we enter a dizzyingly recursive self-referential loop reminiscent of an Escher print. By the end of the second sentence, however, Dickens has drawn our attention away from the fictional conventions he's employing and begun to immerse us in the grand and compelling illusion of the life of David Copperfield. To a slightly greater degree than Joyce in *A Portrait of the Artist,* Dickens subordinates his language, style, and use of novelistic conventions to character and plot.

Sometimes, however, perhaps without intending to, writers employ a language and style that prevents readers from rising above the level of decoding into emergent worlds of imagination. Poststructuralist critics balk at the idea of seeing through a text to its action and characters, arguing that a text's "transparency" is an illusion, that readers can never see "through" language to what it names. But once again they have trapped themselves in binary thinking. It's not a matter of either-or. In *On Becoming a Novelist*, John Gardner makes some practical observations about this dilemma, offering the useful notion that the language of fiction partakes of varying degrees of opacity ranged in a continuum from relatively opaque to relatively clear. Most novelists, Gardner writes, subordinate their language to plot and character. Others, however, "do present characters, actions, and the rest, but becloud them in a mist of beautiful noise, forever getting in the way of *what* they are saying by the splendor of their way of saying it." The *what* novelists say is, of course, the encoded model of the world that readers must unpack from their words. Gardner adds that when, at the other end of the continuum, writers direct readers' attention more toward imaginary worlds than their language,

we begin to forget that we are reading printed words on a page; we begin to
see images. . . . We slip into a dream, forgetting the room we're sitting in,
forgetting it's lunchtime or time to go to work. We create, with minor and
for the most part unimportant changes, the vivid and continuous dream the
writer worked out in his mind . . . and captured in language so that other
human beings, whenever they feel like it, may open his book and dream the
dream again.

Some virtuoso stylists, Gardner suggests, are able to combine the best of
both worlds, using a brilliant prose style and richly embroidered lan-
guage to evoke vivid characters and large human situations, among
whom he names Proust, the later Henry James, and Faulkner. Of
Shakespeare, that incomparable master of language, Gardner argues that
although he employs brilliant language, Shakespeare always "fits lan-
guage to its speaker and occasion," making his poetic language ulti-
mately "subservient to character and plot."

With Shakespeare, however, we leave the realm of fiction and enter the
new realm of verse, where a different set of rules prevails. In
Shakespearean verse drama, as in the classical Greek analyzed by
Aristotle, plot is paramount. But being poetry, plot and language have a
different relation. To explore this new realm more closely, let's put aside
verse drama and narrow our attention to lyric poetry. For though narrative
elements exist in varying degrees in lyric poems, verse presents a far more
tangled situation than prose fiction or verse drama. Lyric poems organize
time differently than prose, and at finer scales. In place of narrative, argu-
ment often serves as the poem's large-scale organizing scheme, as in the
poems of Donne or Marvell. To the rhythms of syntax, which prose pos-
sesses, poetry adds another unit of rhythm: lines. Together, the interacting
rhythms of syntax and line generate an intersecting wave pattern within
the poem's middle-level time scale. Meter adds yet another, finer-scaled
rhythm within the line, at the level of syllables.

All writing contains a large element of feedback as writers listen to
the sounds and rhythms their words make and adjust their writing in
response. Writing in lines and meter greatly increases this feedback
since the poet has to listen to and arrange words at multiple levels to
make the line cohere. In addition, a line in meter has a holistic integrity
independent of its semantic meaning. Readers literally use a different
part of the brain to recognize metrical patterns. As in prose, the seman-
tic meaning of a line of verse is decoded primarily in the linguistic pro-
cessing areas of the left brain; but meter is perceived in the
pattern-recognition areas of the right. Consequently, reading a line of

metrical poetry activates both halves of a reader's brain simultaneously. In writing metrical verse, a poet is literally transmitting different sets of triggering patterns in readers, forcing them to co-ordinate both semantic and spatial elements in multiple processing areas of their brains.

Rhyme—along with other sonic devices like assonance and alliterations—adds yet another element, requiring a different sort of processing. Jeremy Campbell in *Grammatical Man* writes that the right brain is "poor at comprehending consonants and does not do well at syntax." He adds, "While it can understand the meaning of word pairs like 'ache' and 'lake,' recognizing them to be different, it is unable to preserve the sameness amid the change; it does not know that the words rhyme." Despite these limitations, however, the right brain plays an important role in poetry, helping readers see larger patterns than merely semantic ones. First, rhyme folds time by forcing readers to recall previous rhymes and raising expectations for future ones, thus adding another nonlinear element to the poem. In addition, rhymes generally occur in "schemes" or in complex formal patterns like sonnets. In these cases, the right brain helps readers perceive the formal architecture of an entire stanza or poem.

Though not good at syntactical coding, the right brain, according to Campbell, is good at "detecting pitch, intonation, stress, cadence, loudness and softness." It can also construct

> imaginary "situations" into which these various different non-verbal items of information might fit and make sense. On hearing the sound "bee," the left hemisphere will be dominant if it is clear that the speaker is talking about the letter b. However, if the speaker says, "I was stung by a bee," the right brain will be more accurate in identifying the meaning of the sound.

The right brain is not only good at fitting words into larger, narrative contexts, it also knows "what words connote, what associations they have"; it recognizes "the ridiculous and inappropriate," and is "aware that words and sentences are embedded in a wide matrix of relationships."

We have already noted how poststructuralist critics tend to define language and literature in terms of left-brain decoding. Literature, however, involves more. Campbell remarks that in limiting interpretation to the functions of the left brain, "Meaning converges into the sentence instead of diverging out into wider contexts" and adds:

> The right hemisphere corrects this tendency to constrain meaning. It makes the brain as a whole less literal-minded. It probably plays a role in

understanding poetry, where words have many shades and levels of mean-
ing beyond mere reference and dictionary definition. It pays attention to the
meaning of sound and tempo, not merely to the content of words.

In addition to its other functions, the right brain is also where metaphors
are fashioned and understood. Metaphors are a particularly "effective
decoding device" because they provide contexts for new ideas, find like-
nesses between things from different realms of experience, join the
familiar to the strange, and compress large amounts of information into
a very small compass.

Depending on left-brain activity alone to understand literature is, in
psychologist Howard Gardner's words, "like reading the script of a play
instead of going to see it"—a metaphor with particular resonance for our
discussion of postmodern criticism. Reading Campbell's description of
brain-damaged patients whose mental activities are restricted to the left
brain, one can't help noting their similarities to left-brained critics:

> They could not appreciate the pattern of connections among key points of a
> story, and intruded themselves into events when retelling the plot or answer-
> ing questions about it. Instead of treating a fictional narrative as something
> with a separate existence of its own, they failed to respect its integrity, tin-
> kering with details which did not conform to their notion of truth. . . . Many
> of their comments were feasible and even appropriate when applied very
> narrowly, to a single incident. Only when the wider context and the general
> setting of the story were taken into account did the comments stand out as
> bizarre and out of tune with the clear, overall intention of the author.

In contrast to such strict left-mindedness, a poet has to use her entire
brain to write. Taking account of the semantic meaning of words, their
various connotations, their sounds and echoes, and the rhythms they
make, the poet has to engage in a special sort of level-mixing, which
Douglas Hofstadter calls a "tangled hierarchy." He defines a tangled
hierarchy as a situation where different hierarchical levels, such as a
computer's hardware and software, fold into each other in hierarchy-vio-
lating ways.

Paul Davies, in a dramatic thought-experiment, illustrates such a
hardware-software tangle by describing a computer with a robotic arm
attached: the software program running on the computer controls the
arm, making it reach into and alter the computer's hardware, which in
turn affects the way its program operates.

A similar tangle occurs when a poet writes. Poets frequently select
words more for their sound, a low-level phenomenon, than for their

meaning. Once having selected a word, the poet then becomes aware of interesting semantic relationships with others in the poem. After selecting the word for its rhyme, the poet then has to construct meaningful sentences, images, and metaphors around it. Through such entangling, the physical sound, or even typed appearance, of words (which we defined as "hardware") can influence the poem's "software" of grammar, syntax, metaphor, and argument.

Poets also entangle language in other ways. Logical paradoxes and puns engage words in multiple levels, as when John Donne writes, "And death shall be nor more, Death, thou shalt die," joining "death" and "die" in a paradox involving their mutual cancellation. Similarly, when in "A Hymne to God the Father" Donne puns on his own name, telling God, "When thou hast done, thou hast not done, / For, I have more," he uses the low-level sonic similarity of his name to a common English verb to make the large theological point of his refrain. Far more than fiction writers, poets use words on multiple levels. In the process, they engage multiple areas of the reader's brain, activating not only their left and right hemispheres, as we've seen, but mixing thought and feeling by activating the amygdala, where emotional memory is stored.

The formal and metrical rules of poetry also make it more memorable. To borrow a term from information theory, they increase the "redundancy" of the language system they create. Redundancy enables codes to overcome noise and randomness as they transmit meaning from sender to receiver. All types of human language employ such devices for reducing noise. Redundancy also plays a vital role in enabling various living and artificial systems to become complex. It does this, according to Campbell, by

> making probabilities unequal, instead of smoothing them out evenly across the whole range of possibilities. It means that the parts of a system are not wholly independent of one another, but are linked statistically, in a pattern of possibilities. Redundancy in a message system holds information in a loose balance between total constraint and total freedom.

Unfortunately, words like "rules" and "constraints" have a bad odor in the modern era, as they are mistakenly conflated with restrictive social codes and laws imposed by authoritarian governments. They are also conflated with the clockwork order of Newton's scheme, against which so many modern artists have rebelled.

Modern writers and critics are right to believe that the constraints of language inhibit freedom. After all, a key purpose of rules is to limit

choice. Redundancy makes communication possible by imposing rules that force speakers and writers to conform to somewhat predictable patterns. Claude Shannon, the pioneering founder of information theory, estimates, for instance, that

> English is about 50 percent redundant when we consider samples of eight letters at a time. If the length of the sample is increased, the redundancy is much greater. For sequences up to 100 letters it rises to approximately 75 percent. The figure is even higher in the case of whole pages or chapters, where the reader is able to get an idea of the long-range statistics of a text, including its theme and literary style. This means . . . that much of what we write is dictated by the structure of the language and is more or less forced upon us. Only what little is left is of our own free choosing.

This explanation seems to support the paranoid notions of theorists like Foucault, who believe that language-users are puppets controlled by vast "totalizing" systems handed down from the past. The truth is subtler and more interesting. Though we do have to submit to constraints in order to communicate, within these limits we have countless opportunities for creativity and freedom. The alternative to constraints is not the anarchic "bliss" posited by theorists, but paralyzing entropy, as Campbell makes clear:

> A thermodynamic system cannot do anything useful if all its parts are free to arrange themselves in any way whatever. Its entropy will be at maximum and its energy inaccessible. To do work, the system's entropy must be reduced, and that means limiting the number of permitted arrangements of its parts. Similarly, information theory makes it clear that if symbols can be strung together at random, in any order, the messages they generate will not be intelligible, nor will they be protected from error.

This is bad news for professors of literature from Lagado to France. Despite modern critics who want to dispense with authors and treat texts as infinitely malleable globs of verbal clay, it makes far more sense to define texts in the terms of information theory as "messages" sent by authors to readers—as long as we keep in mind that these "messages" are complex systems of mind-boggling reflexivity and depth.

Every increase in freedom comes with the price of increased noise and distortion. Avant-garde texts are often boring for precisely this reason: noise and distortion aren't interesting. Roland Barthes himself

notes that the text of "bliss" can lie awfully close to boredom. Writing of *Finnegans Wake*, that ur-text of the modern avant-garde, Jeremy Campbell notes that in trying to create more possible messages than Jane Austen, Joyce created a great deal more confusion and uncertainty instead:

> The howsayto itishwatis hemust whom must worden schall. A darktongues, kunning. O theoperil! Ethinop lore, the poor lie. He askit of the hoothed fireshield but it was untergone into the matthued heaven.

It's hard to extract a meaningful message from a passage like the one above because the reader is unsure what's coming next. The lack of a clear context makes it hard even to decipher individual words. Randomness and noise have increased at the cost of intelligibility. Consequently, reading is extremely difficult.

This "difficulty" is, of course, one of the hallmarks of modern literature, as Eliot noted in his seminal essay, "The Metaphysical Poets." Although it comes in many types, one major type of Modernist difficulty results from breaking the rules and conventions that make meaning possible. If grammar is an "anti-chance device" applied at the source of a code, then when Modernist writers such as Gertrude Stein break grammatical rules, the "noise" in their texts will increase at the expense of meaning, as these lines from "Susie Asado" demonstrate:

> A lean on the shoe this means slips slips hers.
> When the ancient light grey is clean it is yellow, it is a silver seller.
> This is a please this is a please there are the saids to jelly. These are the wets these say the sets to leave a crown to Incy.
> Incy is short for incubus.
> A pot. A pot is a beginning of a rare bit of trees. Trees tremble. the old vatsare in bobbles, bobbles which shade and shove and render clean, render clean must.

The poem's appeal lies in its nursery rhyme rhythms and playful silliness, so it should rightly be classified as nonsense verse. Its status as a seminal text of avant-garde literature rests on the now-familiar gambit of focusing reader attention on the "constructedness" of the poem's language. By sometimes ignoring their semantic meanings and choosing words merely for their sounds and then placing them in ungrammatical relations, the passage subverts reader attempts to find an emergent

"meaning." This method pioneered by Stein comprises one type of Modernist "difficulty" and has been widely imitated in recent decades by so-called L=A=N=G=U=A=G=E poets.

Another source of Modernist difficulty can be found in Eliot's essay, where the poet enunciates his famous dictum:

> We can only say that it appears likely that poets in our civilization, as it exists at present, must be *difficult*. Our civilization comprehends great variety and complexity, and this variety and complexity, playing upon a refined sensibility, must produce various and complex results. The poet must become more and more comprehensive, more allusive, more indirect, in order to force, to dislocate if necessary, language into meaning.

We will hardly quibble with Eliot's comments on "complexity." But when he says that to create this complexity the poet has to "dislocate . . . language into meaning," we may remain skeptical since he is advising poets to break the linguistic, formal, and generic rules that make complexity possible. With his further suggestions that the modern poet must possess "a refined sensibility" and that poetry should be "more allusive" and "indirect," Eliot is effectively saying that modern poets should write in a private code. This attitude is characteristic of Modernist writers, who felt they comprised a cultural elite. Much of their work was designed to chasten—and perhaps forever elude—a bourgeoisie addicted to popular art.

Information Theory, which was born partly out of wartime efforts to interpret secret military codes, provides insights into Eliot's strategy since the difference between traditional and Modernist poetry is analogous to that between peacetime radio broadcasts aimed at a popular audience and coded military messages aimed at a highly select one. A popular radio broadcast, according to Campbell, uses a code that makes it easy to separate the message from noise and distortion. A secret military broadcast, on the other hand, must add a key onto its coded message "rather in the same fashion as noise is added onto the message in ordinary communications." In order to decipher such a coded military communication, Campbell adds, "one must separate the key from the message, and the idea is to design a code which makes that a very difficult task for the enemy to accomplish."

In his masterpiece, *The Waste Land*, Eliot not only dislocates narrative to make it difficult to decipher by those of insufficiently refined sensibilities, he also uses indirection and allusiveness to provide the key to his secret code. The key, of course, is the "mythical method" defined

in his essay on Joyce's *Ulysses* and alluded to in his poem's Greek and Latin epigraphs and final notes on primitive myths. In some regards, this secret code demonstrates Eliot's literary conservatism, since it suggests that even a poem as fragmented and dislocated as *The Waste Land* is intended to bear a heavy freight of personal and cultural meaning—if only to an elect few. Poets like Eliot and Pound, who were steeped in the literature of the past, could wring interesting poetry from their tactic of displacement because they worked within a vital tradition, just as Sterne could tweak the rules of fiction to comic effect during the era of the novel's ascendancy. But as experimentation displaces tradition, avant-garde one-up-man-ship inevitably pushes dislocation past the point of diminishing returns, as the last century has shown.

A third type of difficulty occurs when modern writers, like the professors of Lagado, substitute randomness for rules, placing their faith in chance to produce order and meaning. "Give a monkey a typewriter," asserts a modern adage, "and in enough time, it will produce the collected works of Shakespeare."

This strategy, too, turns out to be a myth. When William Bennett, a professor of engineering at Yale, tested this idea, substituting computers for monkeys, he discovered that "if a trillion monkeys were to type ten keys a second at random, it would take more than a trillion times as long as the universe has been in existence merely to produce the sentence, 'To be, or not to be: that is the question.'" It turns out that randomly typing monkeys can't produce even one memorable soliloquy, much less the complete works of Shakespeare.

However, after doing a statistical analysis of Act III of *Hamlet*, Bennett devised a new program. In it, he arranged for some letters to appear with the same frequency as they did in Shakespeare's texts. When he ran the new program, his computerized monkeys still typed nonsense; but after he reprogrammed again, adding new rules about which letters should begin and end words, simple words suddenly began to appear in his text interspersed with the chaos. By adding still more rules, about groups of three and four letters, Bennett's computer finally produced—after an all-night run, in the midst of endless gibberish—the following ghostly echo of Hamlet's famous line:

TO DEA NOW NAT TO BE WILL AND THEM BE DOES
DOESORNS CALAWROUTOULD.

By systematically applying rules that increased redundancy and lowered the system's entropy, Bennett came closer and closer to producing a line

of English blank verse. Paradoxically, it was by reducing the freedom of his imaginary monkeys that he liberated them to write something resembling human speech. Still, there are limits on the ability of low-level rules to produce a *Hamlet*. To generate the works of Shakespeare, we need a complex human culture, a literary tradition, and a poetic genius as well as chance. It took four billion years of an evolving Earth to produce the works of Shakespeare. Throwing off the rules that make such complexity possible produces only nonsense.

Similarly, writers who avoid closure, preferring a poetics of endless process, misunderstand the nature of creativity. Poems and stories can no more achieve perfection than people can. A "totalizing system" is a chimera. However, by submitting to conventional constraints, writers can create works of infinite depth and complexity. Like a Koch snowflake, a great poem is a fractal shape, bounded yet never complete; it can sit in the palm of one's hand, yet contain a figure of infinite length.

In creating his language machine in *Gulliver's Travels*, Jonathan Swift displayed far greater sophistication than our modern avant-garde. Like Professor Bennett of Yale, he knew that chance alone would take forever to generate interesting phrases, so he allowed his misguided professor to apply some statistical rules to govern his mechanical frame. Only after making the strictest "Computation of the general Proportion there is in Books between the Numbers of Particles, Nouns, and Verbs, and other Parts of Speech" did the professor manage to produce an occasional fragment of intelligible speech.

Swift knew that such a simple-minded system could never match the infinite generativity of the human brain. That was the whole point of his satire. But then, Swift was a brilliant poet, satirist, and author of one of the world's great books, not a theory-maddened professor trying to improve mankind. Now that modern science is supplanting old models with vital new theories of art and mind, poets and writers should work with renewed confidence in the transformative powers of the literary imagination. As they weave poems and stories on the mind's enchanted loom, the giant gears inside the academy are beginning to creak.

[9]

The Interminable Monopoly
of the Avant-Garde

LOUIS TORRES

All "postmodernisms" had in common an essential scepticism about the existence of an objective reality, and/or the possibility of arriving at an agreed understanding of it by rational means. All tended to a radical relativism. . . . the modernist avant-gardes had . . . extended the limits of what could claim to be art . . . almost to infinity.

—ERIC HOBSBAWM [1]

In matters regarding the art of our time, the avant-garde enjoys a virtual monopoly, one that is so entrenched as to seem to be without end. Its influence is felt everywhere, from kindergarten classrooms and the halls of academia to museums, the *New York Times*, and the National Endowment for the Arts. Those who optimistically predict a renaissance of traditional values and craft in painting and sculpture engage in wishful thinking. Ironically, many such optimists, while critical of the avant-garde, inadvertently lend it support by regarding its products as art, thereby granting them an ill-deserved legitimacy. In truth, the term "avant-garde art" is a misnomer, for the work it refers to is, as I will argue, not art at all.[2]

The ceaseless proliferation of avant-garde art forms began early in the twentieth century with the invention of abstract painting, which broke with all previous practice and opened the door to the notion that anything could "claim to be art" (to borrow a phrase from my epigraph). It gained new force with the advent of Abstract Expressionism around 1950, and has accelerated with each succeeding decade, with new genres (or variants of the old) invented at will, spurred on by technology and the inventiveness of would-be artists and rank charlatans alike.[3] The end to this madness—for it is in large measure a form of cultural pathol-

ogy—will require a re-birth of objectivity in philosophy, leading to a broad cultural consensus regarding what art is. Until an objective theory of art informs our educational and cultural institutions, the avant-garde will become ever more dominant.

To oppose the avant-garde effectively, its critics must first recognize how pervasive and deeply entrenched it is. The task is more easily managed if one puts a human face on it, or rather, faces, since the monopoly in question is guarded by a host of individuals (collectively known as the *artworld*), who have a vested interest in perpetuating the myth that "art" cannot be defined. At the top of the heap are philosophers of art, since philosophy deals with the fundamental principles upon which all else rests. Among the others are art historians with a particular interest in avant-garde work (including abstraction), as well as the representatives of auction houses and galleries, collectors, art critics, and sympathetic members of the public (the "artworld public"). Not least in the mix are the avant-garde artists themselves.[4]

Some Definitions

Before I proceed to unravel this web of diverse interests, let me pause to consider the definition of a few key terms. By *art* I mean what is often referred to as *fine art*. My view of art is based on the theory formulated by philosopher-novelist Ayn Rand (1905–1982), who analyzed the nature of the traditional art forms in relation to human cognition, perception, and emotion. She defined art as "a selective re-creation of reality" in which the creative process is guided by the artist's fundamental values and "sense of life."[5]

The term *avant-garde* is defined by Britain's Tate Collection (which includes Tate Modern, the most prominent avant-garde institution in the U.K.) as "that [which] is innovatory, introducing or exploring new forms or subject matter." Applied at first in the 1850s, to the realism of Gustave Courbet, the Tate explains, the term *avant-garde* refers to the "successive movements of modern art," and is "more or less synonymous with modern." According to the Tate, "the notion of the avant-garde enshrines the idea that art should be judged primarily on the quality and originality of the artist's vision and ideas."[6] Similarly, America's National Gallery of Art defines *avant-garde* as referring to "work that is innovative or inventive on one or more levels: subject, medium, technique, style, or relationship to context"—work that "pushes the known boundaries of acceptable art sometimes with revolutionary, cultural, or political implications."[7]

Ironically, today's avant-gardists themselves hardly ever use the term *avant-garde*. *Postmodern*, or *postmodernist*, is preferred, but even more common is *contemporary*. The artworld ignores the original sense of that term, however, which is simply "occurring, or existing, at the same period of time." In the latter part of the twentieth century, the term took on the-meaning of "modern" as in "contemporary furniture" and "contemporary art." The Department of Contemporary Art at Boston's venerable Museum of Fine Arts (MFA), for example, at one point noted that, while it began in 1971 by "avidly pursuing the works of color-field [abstract] painters of the day," it had since "broadened its definition of Contemporary Art to include work from 1955 through the present."[8] Not *all* such work, however, certainly not academic or Classical Realist painting or sculpture. Contemporary art museums throughout the world, in fact, focus exclusively on such avant-garde forms as "conceptual art," "installation art," "video," abstract work, and so-called painting and sculpture that is "realist" yet still not art.[9]

An Early Warning

It is worth recalling here the sober admonition voiced in 1912 (about a year after the Russian modernist Wassily Kandinsky produced one of the first completely abstract paintings) by the noted painter and critic Kenyon Cox. In a remarkable paper entitled "The Illusion of Progress" (an historical overview of poetry, architecture, music, sculpture, and painting), delivered before a joint meeting of the American Academy of Arts and Letters and the National Institute of Arts, Cox declared that he and his fellow Academicians were to some degree "believers in progress," who saw their golden age "no longer in the past, but in the future." He then observed:

> [A]s the pace of progress in science and in material things has become more and more rapid, we have come to expect a similar pace in arts and letters, to imagine that the art of the future must be far finer than the art of the present or than that of the past, and that the art of one decade, or even one year, must supersede that of the preceding decade or the preceding year. . . . More than ever before "To have done is to hang quite out of fashion," and the only title to consideration is to do something quite obviously new or to proclaim one's intention of doing something newer. The race grows madder and madder.

As Cox noted, just two years after he and his audience had first heard of Cubism (invented by Picasso and Braque in 1907), the Futurists were

calling the Cubists "reactionary." Even critics, he lamented, had abandoned traditional standards in their effort "to keep up with what seems less a march than a stampede." And abstract painting had not yet taken hold. In his wildest nightmares, Cox (who died in 1919) could not have imagined just how much "madder" the race would become. But he had identified the essence of the avant-garde—*innovation for its own sake*—against which he issued this trenchant admonition:

> Let us clear our minds . . . of the illusion that there is in any important sense such a thing as progress in the fine arts. We may with a clear conscience judge every new work for what it appears in itself to be, asking of it that it be noble and beautiful and reasonable, not that it be novel or progressive. If it be great art it will always be novel enough, for there will be a great mind behind it, and no two great minds are alike. And if it be novel without being great, how shall we be the better off?[10]

How indeed.

The Visual Arts

In the discussion that follows I focus on the visual arts, because it is in that realm that the avant-garde is the most pervasive and resistant to reform. While all the arts are adversely affected by avant-garde theory to some degree, most are relatively hidden from general public view. Experimental music, opera, theater, and dance are largely confined to concert halls and theaters, far removed from the lives of most people. Avant-garde fiction and poetry are read by relatively few individuals. Avant-garde visual art, however, is everywhere in evidence. A mere glance at the arts pages of newspapers or magazines, or at the covers of art periodicals on newsstands, is sufficient to register its existence. In the cultural or business district of any large city, moreover, one is bound to encounter abstract or postmodernist "public art."[11] Television news programs occasionally cover exhibitions by avant-garde or abstract artists, but never the work of contemporary academic or Classical Realist artists. Coverage of contemporary visual art has been dominated by PBS. Most notably, the award-winning biennial series *Art in the Twenty-First Century*, produced by ART21—billed as the "preeminent chronicler of contemporary art and artists," and aimed at teachers and students, as well as the general public—features only avant-garde figures.[12]

The Root of the Problem

Controversy is woven into the very fabric of intellectual discourse. Have an opinion on a hot social or cultural issue? A full-blown theory perhaps? Meet your adversary, who begs to differ and is eager to engage you in debate. However contentious the topic—in areas ranging from philosophy and religion to abortion and the war on terror—there is no shortage of advocates on either side. Competing ideas pour forth and are hotly debated in academia, as well as in mainstream periodicals. Regarding *the definition of art*, however, virtually all philosophers, their purported differences notwithstanding, agree in effect that anything and everything can be art. On this issue there is no controversy and, therefore, no debate. Symptomatic of this tendency is the following open-ended declaration by the American Society for Aesthetics (ASA), the principal organization of philosophers of art:

> The "arts" are taken to include not only the traditional forms such as music, literature, landscape architecture, dance, painting, architecture, sculpture, and other visual arts, but also more recent additions including photography, film, earthworks, performance and conceptual art, the crafts and decorative arts, contemporary technical innovations, and other cultural practices, including work and activities in the field of popular culture.[13]

As "include" implies, the list of "recent additions" is far longer. Apart from film (if by that term is meant feature films, including musicals and comedies, and not action movies or documentaries), none of the examples cited above should be considered art in my view. In this, I agree with Rand that the basic forms of art (painting, sculpture, music, dance, drama, fiction, poetry) were all "born in prehistoric times" because they "do not depend on the *content* of man's consciousness, but on its *nature*—not on the extent of man's knowledge, but on the means by which he acquires it." Film, she persuasively argues, is a subcategory of literature, by virtue of its basis in a screenplay.[14] ASA's inclusion of "landscape architecture" and "other visual arts" among the "traditional forms" of art—not to mention its addition of "conceptual art" and "contemporary technical innovations"—suggests that other new forms will follow *ad infinitum*).

Among philosophers of art, the "institutional theory" (which holds, in effect, that something is art merely if the artworld says it is) has long held sway as documented in Stephen Davies's *Definitions of*

Art, a survey of philosophers' failed attempts over a thirty-year period to pin down the precise nature of art. Instead of attempting to formulate a definition himself, Davies offers this utterly circular and nonsensical observation:

> Something's being a work of art is a matter of its having a particular status. This status is conferred by a member of the Artworld, usually an artist, who has the authority to confer the status in question by virtue of occupying a role within the Artworld to which that authority attaches.[15]

Davies defines *artworld* as an "informal institution" that is "structured in terms of its various roles—artist, impresario, public, performer, curator, critic, and so on—and the relationships among them." An *artist,* in his view, is "someone who has acquired (in some appropriate but informal fashion) the authority to confer art status" (87).

In view of such confused reasoning, a remarkably candid position paper presented to the American Council of Learned Societies in 1993 is telling. It listed several "seemingly intractable" central issues posing a threat to the "utility, status, and integrity" of esthetics as a philosophic discipline. Prominent among these issues was the central question, *What is art?* That question, observed the author, is thought to be "increasingly frustrating as the energies of artists . . . are directed in increasingly unconventional ways." Few philosophers of art today would be likely to admit that the question "What is art?" poses a threat to the "utility, status, and integrity" of their profession. But it does, however much they may avoid it.[16]

Art History Corrupted

As one might expect, art historians also tend to hold that art cannot be defined, and accept as art anything declared to be such by the artworld. Authors of the leading art history texts in the latter half of the twentieth century all began their surveys by raising the question, *What is art?* yet never answered it, or even explored its implications. No doubt they posed the question merely to win over readers, many of whom to this day are skeptical of the art status of abstract and avant-garde work of the sort covered in the final chapters of their tomes.[17]

Most art historians today would no doubt largely agree with the late Thomas McEvilley, a noted postmodernist critic and "Distinguished Lecturer" in art history at Rice University, who chaired the Department of Art Criticism and Writing at the School of Visual Arts in New York City:

It is art if it is called art, written about in an art magazine, exhibited in a museum or bought by a private collector. It seems pretty clear by now that more or less anything can be designated as art. The question is: Has it been called art by the so-called 'art system'? In our century, that's all that makes it art.[18]

McEvilley's avant-gardism is also evident in his book, *The Triumph of Anti-Art: Conceptual and Performance Art in the Formation of Post-Modernism* (McPherson, 2005). As Michelle Kamhi has argued, however, and as commonsense suggests, "anti-art" is not art.[19]

Robert Rosenblum (1927–2006), a professor of art history at New York University's Institute of Fine Arts, and a curator at the Guggenheim Museum in New York City went so far as to declare: "By now the idea of defining art is so remote that I don't think anyone would dare do it." What made something art in Rosenblum's view was "consensus . . . among informed people—[that is,] artists, dealers, curators, collectors"—the *artworld*, in a word.

In the twenty-first century, authors of standard introductions to the history of art have embraced the views expressed by McEvilley and Rosenblum wholeheartedly, paying much greater attention to avant-garde work than even their predecessors did. The chapters covering the twentieth century in the fifth edition of Marilyn Stokstad and Michael Cothren's *Art History*—"Modern Art in Europe and the Americas, 1900–1950" and "The International Scene since 1950" (titled "The International Avant-Garde Since 1945" in the early editions)—of course cover modernism and postmodernism. Everything from early abstraction and Cubism to Abstract Expressionism and the steady stream of bogus postmodernist art forms that followed—conceptual art, performance art, Pop Art, installation, video, digital art, and all the rest—make an appearance. What of the genuine art by painters and sculptors who have carried on the academic traditions of the nineteenth century? Their existence is simply ignored.[20]

During the second half of the twentieth century, the most popular art historical survey by far was H.W. Janson's *History of Art*, first published in 1962. When Janson died in 1982, his son Anthony F. Janson took over, issuing several revised editions until his retirement two decades later. In order to combat the growing impression that the book (which had been renamed *Janson's History of Art: The Western Tradition*) was behind the times, its publisher took the unprecedented step of issuing a major new revision in 2006 that would, among other changes, devote more space to avant-garde work of the past and near present. As one sympathetic critic

approvingly observed, the new seventh edition more closely reflects "changes in scholarship that began to place art more solidly in a social and political context . . . [using it] much more as a way to discuss race, class, and gender."[21]

The College Art Association—the principal organization of art historians (its members also include artists, curators, collectors, and art teachers)—not surprisingly pursues a decidedly avant-garde agenda in its approach to contemporary art history and criticism, setting the standards for instruction in art history at most academic institutions, as well as influencing museum scholarship. In many respects it is comparable to the ideologically driven Modern Language Association (MLA), the chief professional organization of literary scholars. As noted by a disgruntled former member of the MLA—who helped to found, two decades ago, an alternative organization dedicated to traditional scholarship, the Association of Literary Scholars and Critics (ALSC):

> It was during the 1980's . . . that the Modern Language Association passionately embraced the politics of race, class, and gender, and aggressively championed wholesale revision of the canon, while at the same time drastically reducing commitment to traditional scholarship and criticism. Discontent was widespread, but isolated and unfocused. And dissent was becoming dangerous: dissenters were marginalized and in some cases disgraced.[22]

While continuing to eschew political issues, the organization now also seeks to "explore the literary dimensions of other arts, including film, drama, painting, and music."

In 1997, a small band of intrepid art historians formed the Association for Art History as an alternative to the radical College Art Association, and issued this forthright statement of purpose:

> The Association [for Art History] seeks to provide regular occasions for sharing insights derived from systematic study of . . . art . . . through discussion which is free of jargon, ephemeral ideology and doctrinal rigidity. . . . [B]y asserting the importance of the philological, humanistic, and scholarly aspects of art history as a research discipline and by insisting upon the centrality of the art object itself, the Association nurtures and sustains the venerable but ever-maturing discipline of art history, while promoting an intellectually coherent approach to the comprehension of the object, its image and its meanings.[23]

Sad to say, the association never progressed much beyond the early planning stages, although it managed to attract a few thousand members at

its peak. With distinguished scholars such as co-founder and copresident Bruce Cole of Indiana University (a specialist in Italian Renaissance art) at the helm, the organization seemed primed for success.[24] In late 2001, however, it was in virtual limbo, and Cole became chairman of the National Endowment for the Humanities. Until an organization for art history informed by an objective definition of art takes root, the avant-garde will continue its dominance in academia, influencing not only future art historians but other students as well. Consider, for example, the course content of "Masterpieces of Western Art" in Columbia University's famed undergraduate core curriculum. It deals not only with painting and sculpture but also with that distinctly postmodernist catch-all category "other media." Of the ten figures cited in the course syllabus, the two Americans included are not esteemed, academically trained artists such as the painter Thomas Eakins (1844–1916) or the sculptor Daniel Chester French (1850–1931), but rather, Jackson Pollock (1912–1956) and Andy Warhol (1928–1987)—both icons of the avant-garde. Moreover, the only elective undergraduate course in twentieth-century art offered at Columbia claims to examine "the entire range" of art in that period but focuses instead on its "two predominant strains of artistic culture: the modernist and the avant-garde." It was formerly taught by the radical post-modernist Rosalind Krauss, University Professor of Twentieth-Century Art and Theory. Its required textbook is *Art Since 1900: Modernism, Antimodernism, Postmodernism*, by Krauss and three other of the "most influential and provocative art historians of our time."[25]

Master of Fine Art?

A telling indication of the avant-garde's monopoly of the visual arts in higher education can be found in the national standards promulgated by the College Art Association for the Master of Fine Art (M.F.A.) degree. As revised in 1991, the standards read:

> [The M.F.A.] is used as a *guarantee* of a high level of professional competence in the visual arts. It is also accepted as an indication that the recipient has reached the end of the *formal* aspects of his/her education in the making of art, that is to say, it is the terminal degree in visual arts education and thus equivalent to terminal degrees in other fields, such as the Ph.D. or Ed.D.[26]

The M.F.A. purportedly certifies that the recipient has achieved a high level of "technical proficiency" and "the ability to make art," and has

gained a knowledge of "modern" and "contemporary" (i.e. postmodernist) art history, theory, and criticism through seminars in those fields. In truth, however, few who are awarded the degree have attained any technical proficiency in the making of art at all, for they can neither draw, paint, nor sculpt competently. Learning to draw—from casts perhaps, then by copying the work of old Masters, and after that from life— is no longer considered "relevant" to the needs of future painters and sculptors, still less to the far more numerous future conceptual, installation, video, and abstract "artists," not to mention photographers.

Like "master," the term "fine arts" in the degree's title is an egregious misnomer. The M.F.A. is now awarded for study in areas having little or nothing to do with the "fine arts," as that term has long been understood. At one state university in the southwest, for example, candidates can major in what have been traditionally regarded as *craft* media—ceramics, fibers (weaving and painting or printing on fabric), metals (jewelry)—or in invented "intermedia" art forms such as installation, performance, sound, video, and Web art. Its sculpture curriculum "runs the gamut of the contemporary sculpture environment," including instruction in both "neon" and "kinetic" sculpture.[27]

The work produced in such programs is exemplified by an exhibition at Michigan State University in the spring of 2005, which featured projects by six degree candidates in "studio art."[28] One "graphic design" piece consisted of a multichannel video and "mixed-media" installation and was entitled *Crossings . . . Time in the Midst of the Pressures of Chaos*. Its maker explained her approach to art as follows: "In this post–September 11th age, drawing upon studies in visual communications and anthropology, I aim to obscure, disorient, re-orient, and engage the viewer in new angles of understanding, using design and media as tools for social change and promoting a peaceful coexistence." Another graphic design student exhibited a thirty-second movie entitled *Anger* (an online still from the film displays computer-generated white lines criss-crossing at sharp angles on a square gray field).[29] Three of the works in the exhibition—abstract paintings in acrylic and mixed media, oil, and collage and mixed media—were accompanied by the following "artist statements":

[*First painting*] I see landscape as a point where the terrestrial plain meets the sky and as a primal human condition, which acts as a metaphor for the public and private self. My work sources structures from molecular, biological, anatomical, and cultural systems, all of which provide multiple views of a constructed self.

[*Second painting*] One role of art is to voice the ineffable through allusion and abstraction. In painting/sculpture I wish to evoke this essential function through entanglement of intuition, nature, and constructions of time, history and knowledge. In doing so I find myself absorbed by the awe and beauty of the sublime.

[*Third painting*] Nature connects the interlocking knowledge passed from generation to generation. Here forces of geological, ancestral, and historical time fuse into repetitions and cycles to be observed and understood. It is in this delicate balance between creation and destruction—chaos and pattern—disorder and order—that my work is centered.

The pretentious artspeak of these students, as well as the meaningless work it purports to explain, merely reflects those of their professors, and of the artworld at large.

The Critics

Art critics now writing for general-interest periodicals are cut from the same postmodernist cloth as the philosophers, historians, and professors cited above. But unlike that of academics, their work is aimed at general readers. Roberta Smith and Grace Glueck (now retired), both of the *New York Times*, typify the breed. Smith once confided to readers that she cut her "art-critical eye-teeth" on the dictum "If an artist says it's art, it's art," while Glueck declared that something is a work of art if it is "intended as art, presented as such, and . . . judged to be art by those qualified in such matters."[30]

The avant-garde monopoly of art criticism is starkly evident in the results of a nationwide survey entitled "The Visual Arts Critic," conducted in 2002 by the National Arts Journalism Program (NAJP) at Columbia University. Designed to assess arts coverage by general-interest news publications, the survey queried 169 critics (writers whom the public would view as "shapers of opinion on matters of visual art") from ninety-six daily newspapers, thirty-four alternative weeklies, and three national newsmagazines, whose combined readership was estimated at some sixty million. The findings prompted András Szántó, NAJP's associate director and author of the survey, to observe that the artworld is "a cultural realm singularly lacking in precise boundaries and definitions" and that this "singular situation" makes the job of the art critic more difficult owing to "the continuing proliferation of art of all kinds." As he further noted: "The once seemingly linear course of art history has splintered off into a kaleidoscopic array of interdisciplinary experimen-

tation. Dozens of trends, old and new, now compete for critical attention, with no widely followed movement claiming superiority among them." It seems never to have occurred to him that what is needed is an objective definition of art and a rewriting of contemporary, as well as twentieth-century, art history.[31]

According to Szántó, visual art is popular among the general public, attracting more "spectators" (an unfortunate term) than professional sports. In his view, the survey findings highlight the need for increased investment in visual art criticism by the nation's newsrooms, particularly in smaller communities, "where some of the most noteworthy artistic developments are taking root." Without saying what these developments are or why they are noteworthy, he concludes that "in order to flourish, these endeavors need the scrutiny, validation and exposure the popular news media can provide." The notion that an art critic *validates* the art status of an object merely by writing about it (or that a museum curator does so by selecting the object for exhibition) is a key component of avant-garde critical theory. One thing is certain: the "endeavors" Szántó has in mind do not include those of artists working in traditional realist or academic styles.

People become art critics, Szántó observes, because the job enables them to "function as a stakeholder and champion of the art world, not simply as a dispassionate observer of the scene. There is a proselytizing, missionary aspect to the enterprise." *Dispassionate* implies "objective," of course, but that would not do for a "stakeholder" bent on "proselytizing" on behalf of "art of all kinds . . . splintered off into a kaleidoscopic array of interdisciplinary experimentation." As one critic of a mid-size daily candidly admitted, "most readers would . . . rather look at yet another Impressionist exhibition than a well-curated exhibit of contemporary [avant-garde] art." Szántó adds that many critics feel they are "estranged from average readers," a frustration evident in this observation by a survey respondent:

> Contemporary art critics face a dilemma. Unlike movie critics or drama critics, they regularly deal with esoteric and obscure art forms that the average newspaper reader might find completely baffling. The critic speaks the [artworld] language, understands the motives behind the art. His job then is partly one of the translator, to explain "difficult" art to the reader.[32]

It usually does not work. Most ordinary readers remain skeptical.[33]

The survey findings that most reflect the avant-garde bias of critics are reported in a section entitled "Taste and Influence." As Szántó notes:

"Criticism is ultimately a manifestation of taste, which informs the fine distinctions critics make in their evaluations of artists and artworks." He observes that critics' preferences "mirror the conventional hierarchy of art forms, but only to a point." Those surveyed prefer to cover exhibitions of paintings (which do not always qualify as art), followed by photography (not art, as Kamhi and I—and others—have argued) and sculpture (a completely open-ended concept in avant-garde circles). Postmodernist genres such as "installation art" and "conceptual art" are also favored by critics, while others such as "performance art" and "video" do not fare as well. Szántó further reports that "eclectic tastes and respect for marquee names emanate from the art critics' rankings of living artists" (selected from a list of eighty-four),[34] the twenty-five highest-rated of whom constitute a "pantheon" of the "contemporary" artworld. The top ten, in order, are: Jasper Johns, Robert Rauschenberg, Claes Oldenberg, Maya Lin, Louise Bourgeois, Chuck Close, Ed Ruscha, Gerhard Richter, Cindy Sherman, and Frank Stella. Johns and Rauschenberg, Szántó notes, are "in a class of their own," being the only ones liked by more than nine out of ten critics, and liked "a great deal" by more than fifty percent of them. Taste, it seems, trumps logic— which, if applied, would suggest to critics that the work of none of the ten (or of any of the rest) qualifies as art.

The critical repute of the top-rated Johns (who first stunned the artworld in the 1950s with his paintings of American flags and targets) clearly bespeaks the lamentable decline of standards in today's culture. He was voted one of the top six living artists in a 2013 *Vanity Fair* magazine poll of "top artists," professors of art, and curators.[35] In the view of John Elderfield, chief curator of painting and sculpture at the Museum of Modern Art in New York, Johns's "drawing" *Diver* (1962–63) is *"one of the most important works on paper of the twentieth century"* and "the most profound and intense work of art that Johns has created in any medium." Nearly seven feet tall and six feet wide, this crude sketch (said to be worth more than ten million dollars) is scarcely intelligible, except for the slight suggestion of human hands at the ends of two barely implied arms, which are utterly detached from any further human context.[36] Guy Wildenstein, president of the elite Wildenstein and Company gallery in New York City (best known for dealing in Old Master, Impressionist, and post-Impressionist work) recently opined that Johns is the "greatest living artist today," and the Paris-based Wildenstein Institute is preparing a catalogue raisonné of Johns's work—its first ever for a living artist.[37]

The future of art criticism is not promising. A telling indicator is the MFA program in Art Writing at the School of Visual Arts (SVA) in New York. Founded a decade ago, it is described as "one of the only graduate writing programs in the world that focuses specifically on criticism." Its first director was Thomas McEvilley, whose avant-garde bias I cited above. According to his initial statement for the program, "the function of art and the nature of art criticism have both undergone change and expansion. Art has . . . expanded its purview into social engagement and critique." Current SVA literature notes that the program has "a special emphasis on the history and current transformations of the image." Judging from the work of "notable" faculty members and guest lecturers, anything "innovative" can qualify as art, while "traditional" contemporary work is ignored.[38]

The NEA

The slogan "A Great Nation Deserves Great Art" was long emblazoned atop the home page of the National Endowment for the Arts website.[39] Images fading in and out beneath it ranged from that of a conductor lifting his baton to those of ballet dancers, a theatrical presentation, and a detail from a realist painting. The "disciplines" supported by the NEA included far more than just the traditional fine arts suggested by these images, however. Projects were also funded in such areas as "design" (including urban planning and landscape architecture) and "media arts" (film, radio, and television). Grants for new work in the visual arts were often described in such general terms—for example, "a professional development program for artists," "residencies for artists to create new work," and "an exhibition series featuring the work of emerging visual artists"—that the avant-garde character of the work was not evident. But it was often quickly revealed by a visit to the website of the organization receiving the grant, as it was by the frequent use of the term *contemporary*. One could be certain that none of the recent grants supported the work of academic or Classical Realist sculptors or painters.

Some of the grant descriptions clearly reflected the NEA's avant-garde bias (which affects even the traditional disciplines). In one "collaborative public art project," for example, the alleged artists would work with the residents of a public housing complex to "address the use of public space within the various buildings." In another case, a large-scale public art work would "cover a section of a building in a heavily trafficked neighborhood," and would "resemble a vertical sheet of rip-

pling water." A San Francisco organization received a grant to support a survey exhibition by a single individual, which would include a new public artwork, a catalogue, a Web component, and screenings documenting his contributions to the "emerging [i.e. avant-garde] genres of video, installation, and performance art."

Grants were also awarded to projects dealing with environmental issues. One was for an exhibition and catalogue "examining contemporary concerns regarding water and its conservation." Another supported a project in which "the artist" would create an unspecified work in which he would "use [a] river edge as the subject of intense ecological and aesthetic study."

The groundwork for support of these and countless other similar projects was unwittingly laid by Congress in 1965 when it passed the legislation establishing the NEA. Under the influence of its artworld advisors, the Congress decreed that the key term "the arts" is not limited to such traditional arts as music, sculpture, and drama, but also includes a host of other "major art forms," from industrial and fashion design to documentary film, television, radio, video, and tape and sound recording.

In testimony before Congress on April 1st, 2004, Dana Gioia, then Chairman of the NEA, declared that "the arts are an essential part of our American identity and civilization." Referring to "our Nation's artistic legacy," he extolled its "artistic excellence," "indisputable artistic merit," and "artistic ideals." He also evoked the notion of "great art." Surely he could not have been thinking of any of the works cited above when he intoned these words, nor of such projects supported by the NEA that year as the "experimental" documentary film and "installation" called *Milk*, which would examine "the controversies surrounding the many uses of this fluid food," or this one from the prior year: a "public, site-specific installation" in the Centennial Park of Lynden, Washington, which the city itself would later describe as a "house-sized interactive sculpture created from interwoven twigs" by a "twig artist."

The NEA's public reputation derives mainly from its grants to reputable arts institutions—museums, orchestras, and dance and theater companies, among others—and on such estimable "National Initiatives" as "Shakespeare in American Communities" and "NEA Jazz Masters."[40] Less well known, however, is "Operation Homecoming: Writing the Wartime Experience." Aimed at U.S. military personnel and their families, it was concerned in part with giving servicemen and women the chance to write about their wartime experiences in workshops taught by novelists and poets.[41] Such activities, commendable though they may be, had little to do with fostering work of "indisputable artistic merit." As

Gioia (himself an accomplished poet and critic) should have known, other workshops, taught by historians and journalists—on writing *essays*, *memoirs*, and *personal journals*—did not belong to "the arts" at all.

The ill-named "American Masterpieces: Three Centuries of Artistic Genius" (an ambitious program launched by the NEA in 2005) promised to "introduce Americans to the best of their cultural and artistic legacy." Grants in its Visual Arts Touring component would be awarded to museums for mounting exhibitions that would then travel to other museums. The exhibitions could "focus on schools, movements, [and] traditions " that included but were "not limited to" the Hudson River School and American Impressionism. Among the other categories were "Aspects of American Art Post-1945 [artspeak for "avant-garde"] to the Present." Given the NEA's bias, exhibitions of work by painters continuing in the tradition of the Hudson River School and the Impressionists would surely not qualify for grants.[42] Touring grants would also support exhibitions in categories that did not, in fact, qualify as art ("fine art"), among them, photography, decorative art, industrial design, architecture, and costumes and textiles. The original initiative was reduced in scope at the start when music and dance were dropped to concentrate on the visual arts.[43]

By lending legitimacy to avant-garde work and to other non-art projects, the NEA (whose grant-making influences that of state and local funding agencies, as well as that of corporations and foundations) has since its inception had a mostly deleterious effect on the contemporary practice of art. Though it no longer directly supports individual avant-gardists, it makes grants to arts organizations, theater and dance companies, museums, universities, and foundations that do. The NEA's lifetime achievement award, the National Medal of Arts, moreover, has honored numerous avant-garde figures—abstract painter Helen Frankenthaler, "sculptor" George Segal, Minimalist (abstract) painter Agnes Martin, and Pop artist Roy Lichtenstein, among others—thus further legitimizing their lofty status in the culture.[44]

Cheating the Young

The avant-garde monopoly in art is most disturbing of all in the realm of education, where it can have a pernicious effect upon impressionable students. They, after all, include our future artists, philosophers of art, art historians, critics, and teachers. And it is they who will be the audiences for art as well.

The situation is dismal. Art instruction in today's schools consists mostly of studio art, in which students learn little from teachers, many

of whom are ill-equipped to teach traditional skills, if they teach them at all. When art history is taught, the great traditional artists of the twentieth century and the present day are largely ignored. Students are led to believe, in effect, that the sort of art created from the Renaissance through the nineteenth century was no longer, or only rarely, made, and is not made at all by today's artists. In *ArtTalk*, a widely used art history survey aimed at high-school students, Rosalind Ragans suggests that *innovation* marks the art of the first half of the twentieth century, and continues to do so: "One style replaced another with bewildering speed. With the invention and spread of photography, artists no longer functioned as recorders of the visible world. They launched a quest to redefine the characteristics of art."[45] Artists prior to the twentieth century did not merely record the visible world, however. They re-created it. As for the "characteristics of art," those were determined in pre-history, not by artists launching quests to define or redefine them, but because (as Rand argued) they met the needs of human consciousness.[46]

After 1945, Ragans further explains, artists continued to make "many changes in artistic approaches, styles, and techniques," from Abstract Expressionism and Pop Art to Minimalism. But "Americans harbor a love for realism," she tells students, and "[m]any American artists continue to portray subjects in a realistic style," utilizing "new forms" of realism.[47] She cites Duane Hanson, whose "sculptures" of people are "made of bronze painted to look lifelike [and] are dressed in real clothes and accessories." including glasses, watches, and handbags. She also cites the painter Richard Estes, whose photorealism is characterized as "art that depicts objects as precisely and accurately as they actually appear," and Chuck Close, who is "not a painter of people [but one who] creates paintings based on large photographs taken of friends and family." That is followed by the ludicrous suggestion that Close's recent works were similar to paintings by "the Impressionist Claude Monet" because both use "brilliant colors."[48] Needless to say, none of the work by this trio is art.[49]

In the opening paragraphs of Laurie Schneider Adams's *History of Western Art*, a college-level text used in Advanced Placement and art appreciation classes in secondary schools, a list of materials used in "modern" sculpture—including "glass, plastics, cloth, string, wire, television monitors, and even animal carcasses"!—hints at the author's avant-garde bias.[50] A page or so later, Adams acknowledges that for ordinary people avant-garde art is a hard sell. "'Is it art?' is a familiar question," she notes. Indeed it is, but why? She makes no attempt to explain, hiding instead behind the claim that the question "expresses the

difficulty of defining 'art.'" While it is true that the concept of art is difficult for ordinary people to define, most do not even try. They have an intuitive sense of what art is, which prompts them to ask such questions as "Why is that art?" or "That's *art*?" What those questions imply is the sense that something regarded as art by experts may not be, or is not, art.

At the end of an earlier edition of her book, Adams left the reader with this parting thought:

> Having entered the twenty-first century, we are presented with a proliferation of artistic styles and expanding definitions of what constitutes art. The pace of technological change . . . spawns new concepts and styles at an increasing rate. . . . It will be for future generations to look back at our era and to separate the permanent from the impermanent.[51]

To grasp just how entrenched the avant-garde is in schools across America, one need only consider the makeup of the National Art Education Association (NAEA), which was founded in 1947. Its more than 22,000 members (many of whom refer to themselves as "art educators") teach at every level of instruction from kindergarten through twelfth grade.[52] While the vast majority are no doubt well-meaning and hard-working, albeit often ill-trained, a vocal minority are activists who proselytize their students regarding social and political issues involving race, gender, sexual orientation, the environment, and the war on terrorism, at the expense of *art*.

The most influential members of NAEA, however, are the professors who teach future art teachers. They are the ones who occupy most of the key leadership positions in the organization, and who edit its two periodicals.

Studies in Art Education, the more scholarly of the two NAEA journals, features such articles as "Students Online as Cultured Subjects: Prolegomena to Researching Multicultural Arts Courses on the Web."[53] Scholarly jargon (as in the title) and flawed syntax render it virtually unintelligible—not only to ordinary art teachers but probably to many academic readers as well. (As one retired professor of art and education has observed, "trying to make sense of written and oral presentations in our profession is like swimming in a sea of molasses.")[54] Consider, for example, this excerpt from the article's abstract:

> [R]esearchers need to recognize mechanisms by which students can be constituted as cultured (gendered, racialized, etc.) subjects, and that many of these mechanisms will depend on certain characteristics particular to asyn-

chronous, text-based learning environments. Characteristics and mechanisms discussed in this article include disembodied text-based performance of identities, speech-like writing, space-flexibility and student geographical location, space-time flexibility, and class attendance/participation, time flexibility, and asynchronous discussion threads.

In the same issue of the journal is an article dealing with the integration of "digital art" (specifically "internet art") into the curriculum. A third article, entitled "Performing Resistance," is peppered with artworld buzzwords—a sure sign that the writers are members of the avant-garde, and that the work under discussion is not art. Declaring, for example, that "the creative and scholarly works of many *contemporary* artists, critical theorists, and educators *challenge* the cultural assumptions that are embedded in our understandings of technology and its relationship to art and human life," they further refer to "*questions* that performance artists and critical theorists raise as they *explore* the multiple and fluid intersections between art, technology, and the body" (italics are mine, to indicate buzzwords).[55] The terms *explore* and *challenge* recur repeatedly throughout the text.

Art Education, the official journal of NAEA, is an illustrated bimonthly magazine aimed at the classroom teacher. Its editors therefore exert far more influence than those of *Studies*. The avant-garde bias of former editor B. Stephen Carpenter II, now a professor at Penn State University, may be taken as representative. A practitioner of mixed-media, assemblage, installation, and performance art, he exhibited work in the 4th Biennale Internazionale d'Arte Contemporanea in Florence (2003), one of the numerous avant-garde expositions dotting the international artworld calendar.[56]

Representative of many articles published in *Art Education* is "Postmodern Principles: In Search of a 21st Century Art Education," in which the author, Olivia Gude, identifies eight "important postmodern artmaking practices" characteristic of the projects in classes she has taught for teens. One of these, "appropriation," is the "routine use of appropriated materials," such as photographs, in the making of art. For the students, she reports, "recycling imagery felt comfortable and commonplace." The practice also meant, of course, that they did not have to learn the traditional skills of drawing and painting. To explain "hybridity," another postmodernist principle, Gude writes:

> Contemporary artists routinely create sculptural installations utilizing new media ["media art"] such as large-scale projections of video, sound pieces,

[and] digital photography. Indeed, multi-media works of art are now encountered in contemporary museums and galleries more frequently than traditional sculpted or painted objects.[57]

Gude, Co-ordinator of Art Education in the School of Art and Design at the University of Illinois at Chicago, holds that art education plays a vital role in developing "democratic life," a role that is properly the purview of civics and history classes.[58]

One of the most ominous signs of postmodernist influence in today's art classrooms is the "visual culture" movement of recent years. Advocated by many prominent academics in the field, it focuses not on works of art, but on *anything seen with the naked eye*, particularly if it can be viewed in relation to race or sexual orientation or other hot-button social and political issues of the day. As Kamhi observed in an article entitled "Where's the *Art* in Today's Art Education?," a "key factor in the shift to visual culture studies has undoubtedly been postmodernism—which has all too swiftly gained wide currency." In that same article, she cited a rare NAEA dissenter, John Stinespring, who argued that postmodernism is governed by a series of major fallacies, which teachers have uncritically accepted—among them (as summarized by Kamhi): "an ever-broadening definition of art—the acceptance as of equal value anything put forward as art; the rejection of all standards of qualitative judgment; the denigration of individual creativity and originality; an emphasis on 'multiculturalism' at the expense of the personally meaningful; [and] the insistence that all art makes implicit or explicit statements about socioeconomic or political issues—with the implication that there is only one "right" position on each issue, invariably to the left of center."[59]

Conclusion

Admittedly, I have sketched a rather pessimistic picture regarding the future of art. Having argued that the avant-garde enjoys a virtual monopoly, I have suggested that it is unlikely to end soon. What is needed to reverse the present state of affairs was anticipated by the philosopher Eliseo Vivas more than half a century ago. In an essay entitled "The Objective Basis of Criticism," he charged that with regard to the arts, "contemporary American criticism suffers from a serious defect: it ignores, sometimes truculently, the need for a systematic philosophy of art." His interest in such matters, he noted, "originally sprang from certain convictions which thirty-five years of study have confirmed and clarified":

The first of these is that art is no mere adornment of human living . . . for which a substitute could easily be found, but an indispensable factor in making the animal man, into a human person. Another is that its proper use can be discovered by an analysis of the work of art as an embodiment of objective meanings and values. A third is that we cannot grasp the work of art objectively unless we bear in mind the act that creates it and the distinctive mode of experience that apprehends it.

Missing from criticism, Vivas argued, was a clear idea of such fundamental issues as "the nature of art" and its role in human life.[60]

Two decades later, Ayn Rand (though no doubt unaware of Vivas's work) formulated the core of just such an "[objective] systematic philosophy of art"—part of the broader philosophic system she called "Objectivism." It remains to be seen if her esthetic theory will take hold in the culture, ending what I have termed the "interminable monopoly of the avant-garde" and ushering in a genuine renaissance of traditional painting and sculpture.

The likelihood of such a cultural upheaval anytime soon has greatly diminished since I first drafted this essay over a decade ago, even as the sheer number of contemporary traditional painters and sculptors has grown. It is an illusion to maintain otherwise. As I have documented, the ever-increasing dominance of the avant-garde is due to stubborn adherence to the notion that virtually anything can be art if the artworld *says* it is. *What Art Is* was published fifteen years ago as an antidote to such madness. Despite praise by respected academic reviewers and occasional citations in books, it has thus far been largely ignored—even, with rare exceptions, by Rand's followers.[61]

Still, I remain guardedly optimistic. In 2001, in an In-Depth interview on C-Span, the ninety-four-year-old cultural historian Jacques Barzun, who knew a thing or two about intellectual history, expressed admiration for *What Art Is* and for Rand's ideas about art. Later that year, he wrote Kamhi and me to say that "yours is the kind of work that makes its way slowly but lasts long, both because its subject is perennial and because of the breadth and depth of your treatment."[62] Time will tell.

[10]
More Matter and Less Art: The Pernicious Role of the Artist in Twentieth-Century Visual Art

GEOFFREY BENT

For thousands of years, artists have been described as people who make art. In the last century, however, the role of the artist has grown to such disproportionate prominence that the direction of the definition has been reversed and now a work of art is viewed as anything an artist makes. Artists don't even need to create objects in order to appropriate them into their oeuvres: like the original Creator, merely naming something art is enough to transform its substance. With the artist occupying the center of attention, biographies have become more important than museums since they house the source of the art rather than isolated emanations of that source. This impulse leads to an aesthetic equivalent of the *Kama Sutra* in which novelty distorts the basic impulse towards communication to ever more exotic lengths. Far from leading the troops, the avant-garde movement was more concerned with separating itself from the pack. Like Little Jack Horner, modern artists pulled plums from their Christmas pies for no other reason than to declare, "O, what a clever lad am I!" If the work takes a secondary place to the reputation of whoever created it, those viewing the work are demoted even further. When nothing more is expected from an audience than veneration, it's a long evening.

A survey of all the twentieth century's major trends in the visual arts reveals time and again this shift in focus from the act to the actor. Cubism, perhaps the era's most notorious stylistic approach, is a case in point. Heralded as a break with the past in which all perspectives are given equal prominence instead of the old privileging of a single perspective, one can legitimately ask what this supposedly contributes. Do the resulting canvases enhance our understanding of the bodies and bowls of fruit they portray? Does viewing a portrait filled with multiple planes deepen our sense of the sitter? Is the multiplicity of life even the theme of these pictures? The answer to all of the above is "No." Far from

revealing any deeper appreciation for the subjects involved, this approach keeps the viewer at a distance by superimposing a self-conscious barrier between the object and its audience. The resulting dislocation could be a possible thematic end in itself, but even that isn't pursued. The refracting of planes is superficially invoked because it lacks any apparent utility. 'How' no longer functions in the service of 'what', and becomes instead an end in itself.

One only comes away from this approach with an enhanced sense of the artist's facility. The true subject of virtuosity is always the artist. Virtuosos are marksmen, not hunters; they never hit anything more animated than a bull's-eye, although they hit the bull's-eye every time they take aim. As with circus magicians, the point of the trick isn't that silk hats produce rabbits or that bouquets of flowers spring from the ears of unsuspecting volunteers; the point of the trick is rather the illusion of the magician's omnipotence. This is why Picasso was one of the greatest narcissists of the twentieth century: his work was always only about himself. All those harlequins and minotaurs and nudes exist solely to afford the artist an opportunity for line diddling; stylistic variations merely establish the "fecundity" of their creator. Through dislocation, Picasso makes the obvious image and the obvious idea seem less obvious, thus camouflaging his clichés. When it has no affective resonance, distortion comes to resemble ornamentation: a visual tangent proceeding from a subject but having nothing to do with it. As often happens with virtuosity, the bits become overly prominent. Any sense of the woman within the nude in Picasso's work is eclipsed by the way the eyes are inverted or a third nostril is added.

Virtuosity also leads to what we might call the savoir-faire syndrome. In it, the purpose of a work of art is to demonstrate that the artist knows his trade. This is based on the assumption that if you're not a professional, you're just another punk. The emphasis of art produced by the savoir-faire syndrome is on surface, techniques employed and materials used (you get a lot of this at art fairs). We might borrow from Veblen and describe the results as conspicuous construction. Art that merely validates the artist only holds one's attention for so long. You don't write a novel simply to prove you can spell. Demonstrating proficiency is the function of homework, not art.

There is a reductive quality at work in cubism that also becomes problematic. Again the benefits for the artist are obvious: with all human figures reduced to the generalizations of geometry, only the artist seems distinct. Anatomical abstraction is the oldest art form, and there is undeniable power in such an elemental approach. But for all its strengths,

primitive art is too monolithic; it is based on a knowledge so prescribed as to be ignorance by another name. By reducing the human figure to its generic shapes, people become a redundant collection of physical landmarks; it's all nipples and navels and genital differentiation. Art's greatest strength lies in specificity. The unexpected chord, the surprising highlight, the sly adjective, all startle us into adjusting our perception. A generic performance only elicits a generic response. Detail differentiates; it transforms tragedy into my tragedy. Unfortunately, the artist acquires the general only by sacrificing the specific.

The art of Matisse suffers from this reductive impulse as well. Shorn as they are of his vital sense of color, Matisse's drawings are often too generalized to be truly affecting. One can admire the elegance of some of the lines, but again this deflects attention back to the artists (the less art, the more artist). Matisse's decorations for the Dominican Chapelle du Rosaire are an example of this. It's impossible to invest these ovals on rectangles with the emotional freight the artist intends them to carry; the connection is simply too remote between these stick figures and living, breathing human beings. All one is left with are the empty gestures of religious deference and ardor; if allusions could create their own reality, a dab of cologne would be enough to transform a woman into a gardenia. Dehumanizing the human may seem like objectivity, but it lacks the vitality of engaged inquiry that marks true objectivity. One can maintain a critical distance without leaving the room.

The impulse of generalizing the specific to conform to the tyranny of design reached its apotheosis in twentieth-century art's other great landmark: abstraction. Sold at the time as art reduced to its purest elements, it does eliminate all the conventions of visual experience and the narratives that inevitably derive from them. Here was a language in which meaning was removed and only grammar remained, in which nouns and verbs were banished so that articles and participles might flourish. The trouble with purity, however, lies in the way it makes everything else seem impure. Art that referred to visual experience would be no longer tolerated as it was compromised by extraneous, extra-visual elements. The perpetrators of this movement rejected all that proceeded them from sincere idealism, but few ambitions are as self-indulgent as high ideals.

Were the abstract expressionists accurate in saying that any portrayal of incident is unduly literary? Is depicting landscapes and casually arranged objects hopelessly sentimental? Far from offering a truer alternative, abstract art is riff with artifice. One never encounters pure color and objectless compositions in real life; in a concrete world, everything has a corporeal context. This is not to deny the decorative appeal of

abstract art; its exuberant, sensual play of shape and color comes as close to uninhibited lyricism as the last century could muster. Nonetheless, the purity of the movement's founding principles is sullied in its performance. The picturesque obscurities produced by many abstractionists are in fact too sentimental and self-indulgent to justify the movement's proclaimed Spartan aspirations. One might be tempted to parry an advocate's case with, "I've never much cared for pretty pictures."

The absence of discernable meaning in abstract expressionism is misleading since the void merely creates an opening for all the meanings attributed by professional explicators. If anything, this branch of modern art is unbearably didactic because it must always be explained. The theory that prompts the art becomes its meaning, and so, once again, how you got there supplants where you're going. Theory in art generates lots of discussion but little belief: like a cheap toupee an artist can hide beneath it and still fool no one. Theories also inevitably lead to rigidity: a sententious dilettante like Clement Greenberg is a good example of the shortcomings of theory-based perception. To say that representational art, the most natural visual experience, is no longer viable simply because it doesn't fit into your philosophic scheme of history is worse than ignorant; it's impertinent. If there is a hell, one can only hope that Clement Greenberg has found it.

As with all the artistic revolutions of modernism, there is something distinctly middle-class in how the abstract expressionists strived to distinguish themselves through competition, creating a kind of elitism that only comes from those wishing to be perceived as part of an elite. The true elite, the privileged class, are characterized not by their ambition but rather by an overweening presumptuousness: the hand holding the scepter does so with limp familiarity. The prole tries to dazzle you with the power of his mind while members of the upper class feel what reveals their status most is character and taste (Joyce wants you to think he's the smartest man on earth, while Proust would have you believe he was merely the most sensitive).

Abstraction is in many ways the ultimate middle class art because it's so safe; it can present itself as rebellious without the focus and risk of specifics. This is the main reason abstract art is the preferred décor of corporate America. An obscure configuration of hues hanging in a waiting room even confers power: it signals that the man managing your stock portfolio is privy to mysteries beyond your comprehension.

That sense of mystery is central to abstract expressionism as it is to another important development in twentieth-century art, surrealism. In surrealism, Dali and Company introduced an approach to art based on

the dislocation of dreams. Coming as it did on the coat-tails of Freudian psychoanalysis, it even acquired the heft of scientific inquiry. Any confusion now could be attributed to the workings of the super ego, not the failings of the artist.

In mystery we have a virtue that can quickly lapse into vice. There is no enlightenment without surprise, but every surprise doesn't generate enlightenment. Since surprise is a response that is easily triggered, how can we tell when it is legitimately used? Incoherence always has had a certain cryptic allure (how else to explain the perpetual appeal of *The Book of Revelation*?). But an enigma needs the coherence of veiled meaning; it must surprise, but not confuse. The difference here is between the mysterious, which permeates life, and mysticism, which is nothing more than a commitment to all things mysterious. As outlandish as the vocabulary of dreams can be, it emanates from a specific reality. If anything these nocturnal images have a meaning that reality lacks because a mind creates them out of its memories and impulses. The subconscious cannot exist without a harboring consciousness.

In the work of all the surrealists except Magritte (who anchored his analogies in meaning with his witty titles), the unfolding consciousness is largely absent. The strange idiom of dreams is exercised for its own sake, solely to signal how "weird" (read "unique") the dreamer (read "artist") really is. Dali's outlandish paintings exist merely to license Dali's outlandish behavior. While Freudians read too much meaning into dreams, Surrealists read too little. Like locking a gum drop in a vault, the prize doesn't justify the effort needed to extract it. As with orientalism in the nineteenth century, the enigmatic supplied the surrealists with nothing more than an exotic texture. Bosch's *Garden of Earthly Delights* is that rare example of an authentically strange vision's ability to endure. For the synthetic enigmas of surrealism, however, the future seems less promising: sphinxes rarely outlive their riddles.

Surrealism's hollow core derives from its nihilistic progenitor: Dada. More than any other artistic movement in the last century, Dada betrays the inflated dominance of the artist. As Marcel Duchamp, that art critic in artist's clothing, famously said, an artist's "intellectual expression" is more important than any object he creates. An art that dispenses with art only leaves the artist to be studied. The Dadaists felt that throwing the baby out with the bathwater was permissible so long as the child's father did the throwing. The central concept might be characterized as "the mediator is the message."

There is something distinctly Unitarian in the dada movement's retention of the artist, something bordering on "If you don't believe in God

then why are you still in a church?" In order to be anti-aesthetic and anti-bourgeois, must one also be pro-narcissistic by default? Dada artists were forever revealing that art is a sham in an attempt to make themselves superior to their art. Art may be a lie, but lies also strive to be credible. A lie that is patently false is a failed lie, and it doesn't reflect well on the liar, either. There is no revelation in revealing the artifice in art; everyone recognizes the gulf between an object and the rendering of that object. The suspension of disbelief on an audience's part is deliberate but provisional: it must lead to either enlightenment or entertainment. The Dadaists negate this challenge by disallowing the test, but this is a defensive ploy. They knew a tawdry idea is more illusive and hence more difficult to dismiss than a tawdry piece of craftsmanship. How much "intellectual expression" lies behind drawing a moustache on a cheap reproduction of the Mona Lisa? A stunt has intent, but it's not a dissertation. The inflation of interpretation supplies that, and the explaining class is happy to comply. Any molehill appears to be a mountain if you stare at it long enough.

The artist, however, cannot rightly lay claim to this added layer of meaning. Dada has benefited from the metastasizing hermeneutics of academia, and one only has to encounter yet another screed by Arthur Danto that attempts to transform art into philosophy to see how these notions persist like a stubborn cold. But when those who supply all the external meaning move on to other things, a gesture becomes, once again, just a gesture. Less is unfortunately less. Like serial compositions, perhaps the only thing the Dada rationale ultimately proved was that some ideas aren't worth thinking.

Once Dada established the supremacy of the artist over art, a dozen different schools appropriated the mantra. Pop Art degraded the artist's product even further through mass produced anonymity. The detritus of consumerism was presented without context, as if the flaws and implications were self-evident. The consolation it offered its audience can be translated into "I may be stupid, but I'm not *that* stupid!" Scorn can feel like wisdom if the object you scorn is far enough beneath you. But presenting a specimen of popular culture isn't the same as engaging it. This static quality limits Pop Art's range and gives its representative pieces a strangely still-born feel.

No twentieth-century school believes more deeply in the power of an artist's narrative than Conceptual Art. In it, the prosaic is translated into a *statement*. This dependency on the justification of meaning makes conceptual art unbearably didactic (although its refusal to state its thesis directly produces a didacticism that lacks the courage of its own convictions).

In the remaining loose change of isms (Op Art, Minimal Art, Photorealism, and so forth), the definitional boundaries become more and more prescribed, creating the impression less of principalities of thought than of street gangs tyrannizing a few blocks of turf. The first great modern approach, Impressionism, devised a technique that would allow the artist to engage the world in a fresh way. All that has devolved to the point where any meaningful engagement of content is almost entirely abandoned by artists as they scurry about, groping for techniques by which to define themselves. This takes us to the depleted present.

It's been my experience that when an artist has nothing to talk about he talks about himself; this is why I've waited until the end to invoke the authorial "I", not as the subject of my examination, but rather as a fellow traveler in this sorry mess. As an artist I write criticism in part to avoid the ills I describe. As Yeats once said, "We are but critics or but half create," and indeed criticism supplies the tools an artist can use to burnish his or her own work. Far from advocating an artist-less art, I hope the spirit of self-criticism might serve to right the balance in this lopsided equation.

After a hundred years this much is clear: the desire to be different corrupts the desire to be understood. When the "avant" is all that distinguishes the "garde," the positional advantage is quickly lost; every frontier eventually becomes just another staid suburb. At a basic level, seeing is the most powerful way individuals transcend their physical limits and penetrate the physical world that surrounds them. Narcissism, however, abrogates that contract and keeps individuals forever locked within themselves. It is by accepting that an artist is not the main event but a member of the audience, by embracing the difference between aristocratic imparting and egalitarian sharing, that the powerful bond of communication can be reestablished.

Art must also wean itself from all the justifications of words. If the visual arts are anything, they are *mute*! This handicap helps separate successful work from the failures. Meaning isn't supplied through annotations; in a world rife with uncertainty, the intent of great art is clear, and the role of the artist can help facilitate that clarity. While I don't agree with William Gaddis that an artist is nothing more than the dregs of his art, there are self-effacing ways for artists to assert themselves. Flaubert put it nicely when he wrote, "The artist must be in his work like God in His Creation, invisible and all powerful so that He is felt everywhere but not seen." A little invisibility is a divine thing: it allows creators to attend to their creations. Now there's an article of faith even an unbeliever can embrace![1]

Notes

Introduction

1. *The Culture of Hope: A New Birth of the Classical Spirit* (New York: The Free Press, 1995), 1.
2. Ibid., 3.
3. Ibid., 267.

1. The Importance of Being Odd: Nerdrum's Challenge to Modernism

Since this essay was originally written in 2003, there have been a number of significant developments in Odd Nerdrum's life and career that have only deepened the controversies surrounding him. It would take another essay to deal adequately with these new issues. In particular, in recent years, Nerdrum's quarrel with the modern state has taken a serious and ugly turn, resulting in his being sentenced by Norwegian authorities to jail for tax evasion. With his appeals still pending and the facts of the case in dispute. I do not feel in a position to comment on the legal aspects of this case.

1. For an account of these events, see Richard Vine, *Odd Nerdrum: Paintings, Sketches, and Drawings*, Oslo: Gyldendal Norsk Forlag, 2001, 78.
2. In addition to the Vine book cited above, see Jan-Erik Ebbestad Hansen, *Odd Nerdrum: Paintings*, Oslo: Aschehoug, 1994, and Jan Åke Pettersson, *Odd Nerdrum: Storyteller and Self-Revealer*, Oslo: Aschehoug, 1998.
3. See, for example, Charles Jencks, *Postmodernism: The New Classicism in Art and Architecture*, New York: Rizzoli, 1987, 42; Edward Lucie-Smith, *Art Today*, London: Phaidon Press, 1995, 194, 196; and Edward Lucie-Smith, *Art Tomorrow*, Paris: Editions Pierre Terrail, 2002, 152. For a perceptive appreciation of Nerdrum by a prominent art critic, see Roger Kimball, *Art's Prospect: The Challenge of Tradition in an Age of Celebrity*, Christchurch: Cybereditions, 2002, 201–03.
4. Since websites have an annoying habit of changing their addresses, I will not bother to list any of the Nerdrum sites. Anyone wishing to see what his paintings look like need only google "Odd Nerdrum," and will quickly find many images available.

5. Odd Nerdrum et. al., *On Kitsch*, Oslo: Kagge Forlag, 2001, 8. The name of the translator is not given anywhere in the volume. I do not have access to the original Norwegian text and in any case I do not know Norwegian, but it looks to me as if this translation is deficient at several points. Nevertheless, I have been forced to rely on it as my principal source for Nerdrum's views on the nature of art (and those of some of his colleagues). All future citations to this work will be incorporated into the text and abbreviated as "OK."

6. Pettersson, *Nerdrum*, 20. See also Vine, *Nerdrum*, 30.

7. Quoted in Pettersson, *Nerdrum*, 20.

8. Quoted in Pettersson, *Nerdrum*, 22.

9. Quoted in Pettersson, *Nerdrum*, 22–23.

10. Quoted in Pettersson, *Nerdrum*, 23. See also Vine, *Nerdrum*, 37.

11. Helen D. Hume provides in her *The Art Lover's Almanac*, San Francisco: Wiley, 2003, one of the most comprehensive reference works on painting. She lists only two Norwegian painters: Edvard Munch and Odd Nerdrum.

12. All three quotations in this paragraph are from Pettersson, *Nerdrum*, 184.

13 Pettersson, *Nerdrum*, 241, note 29.

14. Pettersson, *Nerdrum*, 192.

15. OK, 18. These are the words of a journalist, Sindre Mekjan, from the Oslo *Morgenbladet* (October 23rd, 1998), reporting Nerdrum's opinions in the course of an article/interview.

16. For the record, in general, public funding of the arts plays a more important role in European countries than it does in the United States.

17. Just as "public schooling" should more properly be called "government schooling," "public funding" of the arts should be called "government funding." In what is called "public funding," a government bureaucracy invariably makes the funding decisions. In such circumstances, it is precisely the public that never has any say in what art gets funded, and indeed "publicly funded art" is usually of little or no interest to the public, and often outright offends it. It is the private market that generally delivers the kind of art the public wants, above all in movies, television, and commercial music. A Hollywood blockbuster is in fact the best example of a work of art truly funded by the public. The failure of the public to embrace the kind of art modernist elites favor is what leads to calls for so-called public funding of the arts.

18. For this mistaken view, see F.M. Scherer, *Quarter Notes and Bank Notes: The Economics of Music Composition in the Eighteenth and Nineteenth Centuries*, Princeton: Princeton University Press, 2004, 200. Despite this error, Scherer's book provides a useful analysis of how patronage and the commercial market work as systems of financial support of the arts in the specific case of classical music.

19. *On Kitsch* contains an interesting essay by Dag Solhjell, "The Ethic of Pietism and the Spirit of Art" (69–104), which attempts to document the connection between Protestantism and Kantian aesthetics.

20. For a comprehensive and powerful defense of the market as a basis for art, see Tyler Cowen, *In Praise of Commercial Culture*, Cambridge: Harvard University Press, 1998. On painting in particular, see the excellent chapter "The Wealthy City as a Center for Western Art" (83–128).

21. For a discussion of Nerdrum's rejection of government support and embrace of the commercial marketplace for art, see Dag Solhjell, "The Concept of Art at Stake: The Symbolic Power and Counter-Power of Odd Nerdrum's Art" in OK, 32–37; Solhjell

concludes that Nerdrum "is completely independent, both financially and symbolically" (36).

22. For a perceptive discussion of modernism and patronage, particularly with regard to literature, see Lawrence Rainey, *Institutions of Modernism: Literary Elites and Public Culture*, New Haven: Yale University Press, 1998, especially Chapters 4 and 5. In general, this book provides an insightful analysis of the economic basis of modernism. For another helpful discussion of this subject, including the role of patronage in modernism, see Paul Delany, *Literature, Money, and the Market: From Trollope to Amis*, Basingstoke: Palgrave, 2002, Chapter 9, "Paying for Modernism" and especially Chapter 10, "T.S. Eliot's Personal Finances, 1915–1929."

23. See Cowen, *Commercial Culture*, 119–121 and Michael C. Fitzgerald, *Making Modernism: Picasso and the Creation of the Market for Twentieth-Century Art*, New York: Farrar, Straus, and Giroux, 1995.

24. Here is a representative statistic from art historian Suzi Gablik: "Recent estimates given for the number of artists in New York begin with 30,000 and go as high as 90,000. The Soho dealer Ivan Karp has commented that he sees up to one hundred artists each week, some ninety percent of whom he considers totally professional, all looking for galleries in which to sell their work." Gablik concludes: "It is easy enough to attack the restless vanity of capitalist culture under the umbrella of radical Marxist aesthetics, but the fact remains that the great art of recent centuries has emerged largely under capitalism, and not under socialism." See Suzi Gablik, *Has Modernism Failed?*, London: Thames and Hudson, 1984, 57, 31.

25. Nerdrum's view of Kant is controversial, but not idiosyncratic. For a detailed treatment of the role of Kant in the development of modernist aesthetics and the idea of the autonomy of art, see Martha Woodmansee, *The Author, Art, and the Market: Rereading the History of Aesthetics*, New York: Columbia University Press, 1994. This entirely sober and scholarly analysis ends up making claims very similar to Nerdrum's highly polemical and provocative pronouncements about Kant. The fact that this book is listed in Dag Solhjel's bibliography in *On Kitsch* may mean that Nerdrum himself is familiar with it.

26. I am also aware of the apparent contradiction in my finding a message in Nerdrum's paintings—and to some extent a specifically political one—after outlining his critique of the modern practice of judging paintings by their political message. But I am not claiming that Nerdrum's paintings should be judged as paintings on the basis of any political message they may convey. As I am sure Nerdrum himself would insist, I believe that his paintings must be judged on artistic grounds and largely in terms of their painterly technique. But that does not mean that Nerdrum may not also have something to "say" in his paintings. My discussion of what I take to be the meaning of Nerdrum's paintings is an exercise in art interpretation, and not in art evaluation.

27. See Hansen, *Nerdrum*, 17–19.

28. Hansen alternatively gives the title in English as "Emancipation" (*Nerdrum*, 20); he discusses the theme of sexual liberation in Nerdrum's early paintings on 20–21.

29. See Hansen, *Nerdrum*, 24–25 and Pettersson, *Nerdrum*, 34.

30. See Hansen, *Nerdrum*, 25.

31. The chief anarchist influence on Nerdrum was his elementary school teacher, Jens Bjørnesoe. See Hansen, *Nerdrum*, 19 and Vine, *Nerdrum*, 26. Nerdrum has called himself a "historical anarchist" according to John Bullard, "Preface," *Odd Nerdrum: The Drawings*, New Orleans: New Orleans Museum of Art, 1994, 7.

32. Hansen, *Nerdrum*, 22–23.

33. Hansen, *Nerdrum*, 23.

34. See Vine, *Nerdrum*, 40.

35. Hansen, *Nerdrum*, 22.

36. Hansen, *Nerdrum*, 23.

37. Vine, *Nerdrum*, 94 discusses how modernism leads to "in European welfare nations, a crass lobbying for financial support from the state cultural apparatus."

38. For two of the many books dealing with the complex relation between modernism and totalitarianism, see Brandon Taylor and Wilfred van der Will, eds., *The Nazification of Art: Art, Design, Music, Architecture, and Film in the Third Reich*, Winchester: Winchester Press, 1990, and David Carroll, *French Literary Fascism: Nationalism, Anti-Semitism, and the Ideology of Culture*, Princeton: Princeton University Press, 1995.

39. See, for example, Paul Johnson, *Art: A New History*, New York: Harper Collins, 2003, 704–05.

40. Vine, *Nerdrum*, 94.

41. On Pound and Mussolini, see Rainey, *Institutions of Modernism*, 107–145. On the strange attraction of modern artists to totalitarianism of the right and of the left, and especially fascism, see Peter Conrad, *Modern Times, Modern Places*, New York: Knopf, 1999, 491–96.

42. With his characteristic flair for overstatement, Nerdrum has a character named Edvard Munch say in a little dialogue he wrote called "The Curatoriat": "Individualists are called fascists, while the scoundrel Hegel gets away with his pre-Nazi concept of State" (OK, 54).

43. Quoted in Pettersson, *Nerdrum*, 100.

44. Quoted in Vine, *Nerdrum*, 47.

45. For the contrast between Rousseau and Hobbes, see Vine, *Nerdrum*, 49.

46. For the Darwinian element in Nerdrum's vision, see Donald Kuspit, "Old Master Existentialism: Odd Nerdrum's Paintings" in Hansen, *Nerdrum*, iv.

47. For Nerdrum's visits to Iceland and its importance to his paintings, see Hansen, *Nerdrum*, 38; Vine, *Nerdrum*, 64; and Pettersson, *Nerdrum*, 100.

48. To be precise, the largest number of human figures I have counted in a Nerdrum painting are seven in *Wanderers by the Sea* (2000) and eight in *Two Tongues* (1999).

49. See Vine, *Nerdrum*, 104.

50. Not all the paintings I cite may be part of the distinct world Nerdrum creates in his imagination. *Unarmed Man*, for example, depicts an actual man without arms Nerdrum knew, in fact a "Norwegian national hero, Cato Zahl Pedersen" (Pettersson, *Nerdrum*, 51). Many of the paintings, which I and others interpret mythically, are interpreted in autobiographical terms in Pettersson's book. He relates many of the most enigmatic features of Nerdrum's paintings to incidents that happened in the artist' life. But given the complexity of artistic vision, autobiographical interpretations of Nerdrum's paintings are not necessarily incompatible with mythical interpretations.

51. Hansen, *Nerdrum*, translates the title as *Man with a Green Leaf*. See also Nerdrum's 1991 drawing *Girl with a Twig*.

52. See Kuspit, "Existentialism," in Hansen, *Nerdrum*, v.

53. This point may not be as fanciful as it sounds. Pettersson, *Nerdrum*, 82, quotes Nerdrum saying of the characters in his later paintings: "But these people have to carry guns in order to protect themselves against those living in our world. For we are the ones who constitute the greatest threat to their autonomy and spiritual existence."

54. Is it significant that in Nerdrum's early paintings, the only gun to appear is in the hands of a representative of the state? It is certainly significant to Andreas Baader.

55. Vine says of Nerdrum that "his case against modernism, as both a social and an artistic phenomenon, is that it has betrayed our most fundamental experience" ("Mastery and Mystery: The Paintings of Odd Nerdrum" in Bullard, *Drawings*, 9). John Seed, in "Scrotum and Taboo: The Reactionary, Visionary Paintings of Odd Nerdrum" <www.artsiteguide.com/nerdrum/>, writes of Nerdrum's paintings: "This world, which the painter claims is set in the future, seems to be a place where whatever Freud claimed, at the opening of the twentieth century, was repressed or hidden in Western culture, is reclaimed by Nerdrum as a vitalistic principle. . . . [Nerdrum's] Nordic peoples . . . no longer need to keep their bodies, their desires, or their biological dispositions hidden. . . . Civilization, Nerdrum seems to say, is a set of taboos which can fall away and reveal our authentic passions and spirituality" (2).

56. Quoted in Pettersson, *Nerdrum*, 40.

57. Quoted in Pettersson, *Nerdrum*, 82.

58. Quoted in Pettersson, *Nerdrum*, 100.

59. Pettersson, *Nerdrum*, 100. Pettersson goes on to say of Nerdrum: "In this sense his entire archaic utopia was a counter-image, in which he reflected all that we are not, in order to show who we really are" (100).

60. Quoted in Pettersson, *Nerdrum*, 82.

61. Quoted in Pettersson, *Nerdrum*, 192.

62. On these interpretations, see Hansen, *Nerdrum*, 38; Vine, *Nerdrum*, 50; and Pettersson, *Nerdrum*, 76. Contradicting this view of his paintings, Nerdrum has stated flatly that his concern was "not with what things would look like after a possible nuclear disaster" (quoted in Pettersson, *Nerdrum*, 76; see also 82). Characteristically, in the interview published in *On Kitsch* (15–16), he says: "I have always wondered why this is supposed to be about atom bombs and fear and horror or how lonely people are. To me, the deserted wasteland is beautiful."

63. Quoted in Pettersson, *Nerdrum*, 56.

64. On Nerdrum and postmodernism, see Hansen, *Nerdrum*, 32–35 and Kuspit, "Existentialism," in Hansen, *Nerdrum*, vii–viii.

65. For the relations of modernism, postmodernism, and the end of history, see my essay "*Waiting for Godot* and the End of History: Postmodernism as a Democratic Aesthetic," in Arthur M. Melzer, Jerry Weinberger, and M. Richard Zinman, eds., *Democracy and the Arts*, Ithaca: Cornell University Press, 1999, 172–192.

66. Quoted in Pettersson, *Nerdrum*, 76, 82.

67. On the influence of Spengler on Nerdrum, see Hansen, *Nerdrum*, 43–44, Vine, *Nerdrum*, 42, and Pettersson, *Nerdrum*, 30.

68. Both quotations are taken from Pettersson, *Nerdrum*, 76, 56. Jencks, *Post-Modernism*, 142, says of Nerdrum's work that "it alludes as much to a Viking past as an Existentialist future." Seed ("Scrotum and Taboo," 5) aptly speaks of Nerdrum's "Post-Modern Vikings."

69. The situation in Nerdrum's paintings may be even more radical than this. He says of *Cloud* (1985): "This is a man who has lost all words and has a wordless conversation with the cloud. . . . All that surrounds [him] is nameless" (quoted in Pettersson, *Nerdrum*, 82).

70. Vine speaks of Nerdrum's "rejection of modernism, both as a style and as a progressive creed" ("Mystery" in *Drawings*, 8).

2. Mimesis versus the Avant-Garde:
Art and Cognition

An earlier version of this essay was published online as "Art and Cognition: Mimesis vs. the Avant Garde," Aristos, December 2004 <http://www.aristos.org/ aris-03/art&cog.htm>, and generated a lively debate in the Letters section of ArtsJournal *between the author and an abstract painter (search for "Kamhi" at <http://www.artsjournal.com/letters>).*

1. By work in a "traditional" vein, I mean representational painting and sculpture in which form is rendered realistically, not reproduced mechanically. An example of "traditional" contemporary work would be Frederick Hart's sculptures for the façade of the National Cathedral and for the Vietnam Veterans Memorial in Washington, D.C.—as contrasted with the work of postmodernists such as George Segal and Duane Hanson, who employed mechanical means of casting figures directly from a live model. Work such as Hart's is rarely, if ever, reviewed in the major media, exhibited in "contemporary art" museums, or taught about in schools and universities. Odd Nerdrum—the subject of the first essay in this volume—is a notable exemplar of "traditional" contemporary painting. For more examples of both painting and sculpture, see works displayed by the Florence Academy of Art <http://www.florenceacademyofart.com> and the Ann Long Fine Art gallery <http://www.annlongfineart.com>.

2. According to the *Guardian* ("Back to School for Binmen Who Thought Modern Art Was a Load of Old Rubbish," January 13th, 2005), the errant trash collectors in Frankfurt were subsequently assigned to monthly re-education sessions to familiarize them with "modern art" ("postmodernist art" would be the more appropriate term here), to ensure that they would never again make such a mistake. On the incomprehensibility of avant-garde work, and the incoherence of the criticism dealing with it, see Louis Torres and Michelle Marder Kamhi, *What Art Is: The Esthetic Theory of Ayn Rand* (Chicago: Open Court, 2000), Part II, *passim*. According to the late art historian and critic Thomas McEvilley—a prominent champion of postmodernist "anti-art"—countless works have in fact been deliberately made to defy normal understanding. *The Triumph of Anti-Art: Conceptual and Performance Art in the Formation of Post-Modernism,* Kingston, NY: McPherson, 2005, 89.

3. "Art, Mind, and Cognitive Science," NEH Summer Institute, University of Maryland, summer 2002; *Journal of Consciousness Studies*, special issues: "Art and the Brain," 1999 and 2000 <http://www.imprint.co.uk/jcs_6_6-7.html>, and "Art, Brain, and Consciousness," 2004; Joseph A. Goguen, "What Is Art?" (Introduction to Art and the Brain, Part 2), *Journal of Consciousness Studies*, special issue, August–September 2000 <http://www.imprint.co.uk/pdf/Introduction.pdf>); and "Art and the Mind," *The Monist*, special issue, ed. Nicolas J. Bullot and Pascal Ludwig, October 2003 (see the call for papers at <https://www.mysciencework.com/publication/read/3120921/art-and-the -mind#page-null>. See also Cynthia Freeland, "Teaching Cognitive Science and the Arts," Part I, Newsletter of the American Society for Aesthetics (ASA), Spring 2001, 1–3 <http://aesthetics-online.org/articles/index.php?articles_id=11>; Parts II (on film) and III (on Music) are also available at the Aesthetics online site. More recent examples include George Mather, *The Psychology of Visual Art: Eye, Brain, and Art*, New York: Cambridge University Press, 2013; and Arthur Shimamura, *Experiencing Art: In the Brain of the Beholder*, New York: Oxford University Press, 2013.

4. Arthur Efland, *Art and Cognition: Integrating the Visual Arts in the Curriculum*, New York: Teachers College Press, 2002—on which, see my review, "Why Teach Art?" *Aristos*, December 2006 <http://www.aristos.org/aris-06/elfland.htm>, reprinted, with source notes, as "Why Teach Art?—Reflections on Elfland's *Art and Cognition*" in the March–April 2007 issue of *Arts Education Policy Review*, 33–39.

5. The mythology surrounding Duchamp's infamous urinal and his other ready-mades has been responsible for untold error in the field of art theory and criticism, and has inspired the most absurd follies among would-be artists. For a detailed debunking of that mythology, see *What Art Is*, 263–65. Suffice it to say here that contrary to claims such as that in the *Dictionary of Art* ("[Duchamp's] conception of the ready-made decisively altered our understanding of what constitutes an object of art"), Duchamp himself emphasized toward the end of his life—having observed the mythologizing then well under way about his "readymades"—that he "didn't want to make a work of art out of [them]." He further explained: "The word 'readymade' did not appear until 1915, when I went to the United States. It was an interesting word, but when I put a bicycle wheel on a stool, . . . there was no idea of a 'readymade,' or anything else. It was just a distraction. I didn't have any special reason to do it, or any intention of showing it, or describing anything. No, nothing like that." Quoted in Pierre Cabanne, *Dialogues with Marcel Duchamp*, tr. Ron Padgett, New York: Viking Press, 1971, 47. For an especially egregious instance of mythologizing, see my article "Museum Miseducation: Perpetuating the Duchamp Myth," *Aristos*, June 2008 <http://www.aristos.org/aris-08/miseducation.htm>.

6. The idea that works of art "aim at the production" of rich cognitive effects is, in my view, misleading even with respect to work whose status as art is undisputed. Such effects are indeed achieved, but as a by-product of other intentions. What artists *aim* to do is give objective shape to their thoughts and feelings about life; if successful, their work is rich in cognitive effects.

7. As the Overview for the NEH summer institute (see note 3, above) noted: "Because of the connection of the arts to perception (the sensuous element in [Baumgarten's] formulation), aesthetics made the arts its central domain. However, the perception of artworks is not merely an affair of sensation. Memory, expectation, imagination, emotion and reason (including narrative reasoning) play an ineliminable role as well. Consequently, since its advent, the field of aesthetics has been concerned with the operation of fundamental psychological and cognitive processes." The treatise in which the term *aesthetik* was coined was Alexander Baumgarten's *Meditationes philosophicae de nonnullis ad poema pertinentibus* (1734), tr. by Karl Aschenbrenner and William B. Holther as *Reflections on Poetry*, Berkeley: University of California Press, 1954. Baumgarten's more extended work, not yet available in English, was his *Aesthetica*, Hildesheim: George Olms, 1961 [1750]. On ancient Greek thought on the nature of art, see Stephen Halliwell's masterly study *The Aesthetics of Mimesis: Ancient Texts and Modern Problems*, Princeton: Princeton University Press, 2002, to which I will refer often.

8. As evidence of the widespread (but mistaken) view that Kant was a formalist, see, for example, philosopher David Whewell's claim that aestheticism—according to which the value of a work depends solely on its "intrinsic" formal properties, not on any reference to nature, morality, or other external considerations—"owed much of its inspiration to Kant's powerfully formalistic theory in the *Critique of Judgement*." "Aestheticism," in David E. Cooper, ed., *A Companion to Aesthetics*, Oxford: Blackwell, 1995, 7. Ironically, that claim is controverted by Whewell's own entry on Kant in the

same volume, in which he accurately states: "The most influential part of Kant's theory of aesthetic value concerns the notion of beauty, which he treats as applying primarily to natural objects and only secondarily to works of art. However, he considers the value of a work of fine art to depend not only on its beauty, but also on its being the vehicle for aesthetic ideas," which "'body forth to sense' empirical notions such as love, death and fame, but 'with a completeness of which nature affords no parallel.'" *Companion to Aesthetics*, 250. More recently, James Shelley has succinctly observed: "A steady diet of nothing but Kant's 'Analytic [of the Beautiful],' which contains next to nothing about art, is partly responsible, I think, for the prevalence of the view that Kant is a formalist with respect to art" (review of *The Nature of Art: An Anthology*, ed. Thomas Wartenberg [Wadsworth, 2001], ASA *Newsletter*, Spring 2004). Similarly, in the view of Kant scholars Ted Cohen and Paul Guyer: "[T]he most compelling parts of Kant's analysis are directed at objects of nature, and this has made it singularly difficult for contemporary theorists to assimilate [his] work, for they have read these passages as if [he] were talking about art. Only very recently has the philosophy of art begun to . . . integrate [his] actual insights about art rather than simply contend with his claims for the superiority of natural beauty." "Introduction to Kant's Aesthetics," in George Dickie, Richard Sclafani, and Ronald Roblin, eds., *Aesthetics: A Critical Anthology*, New York: St. Martins's Press, 1989, 309–310; reprinted from *Essays in Kant's Aesthetics*, Chicago: University of Chicago Press, 1982.

9. Immanuel Kant, *Critique of Judgement* [1790], tr. J.H. Bernard (2nd ed., rev., 1914), §49 in Theodore M. Greene, ed., *Kant: Selections*, New York: Scribner's, 1957, 426, italics in original. As Halliwell argues, in the sections of the *Critique* that do deal with the fine arts "Kant not only admits the involvement of concepts in the experience of those arts but treats them in a way that falls within the terms of the mimeticist tradition" (*Aesthetics of Mimesis*, 10). In the same tradition, Hegel maintained that the purpose of art was "revealing *the truth* in the form of sensuous artistic shape"—although he confused the issue by treating architecture as one of the "fine arts," albeit the least "spiritual" (see more on architecture in note 11 below). *Introductory Lectures on Aesthetics*, tr. Bernard Bosanquet and ed. Michael Inwood, London: Penguin, 1993, 61, 90–92.

10. Kant, ibid., 429. On Plato's view of mimetic art, see Halliwell, *Aesthetics of Mimesis*, ch. 4, "More than Meets the Eye: Looking into Plato's Mirror." Regarding Aristotle's view of mimesis in poetry (and, by extension, in the other arts), Halliwell writes: "Poetic fictions offer (or should do [so] . . .) more than the simulation of ordinary particulars in the world, because they are constructed in unified patterns of probability or necessity. In this respect, there is more of the universal visible in them, and they are accordingly more intelligible. . . . [P]oetic structures of action will seem *to make better or richer sense* than much actual experience does" (ibid., 200, emphasis in original).

11. In tracing the genesis of the concept of the "fine arts" in his landmark essay "The Modern System of the Arts," Paul Oskar Kristeller regrettably downplayed the importance of the ancient concept of the mimetic arts. On his errors of both fact and interpretation, see *What Art Is*, 420 note 18 and 421 note 22. Halliwell, too, finds fault with Kristeller's account; see *Aesthetics of Mimesis*, 7–9. Further, he argues (13–14 and elsewhere) that the standard practice of translating *mimesis* and *mimetic* as "imitation" and "imitative" is wholly inadequate to convey the richness and complexity of the concept. On this point, see also Göran Sörbom, "The Classical Concept of Mimesis," in Paul Smith and Carolyn Wilde, eds., *A Companion to Art Theory*, Oxford: Blackwell, 2002 <http://www.blackwellpublishing.com/pdf/smithwilde1.pdf>. On the exclusion of archi-

tecture from the ancient grouping of mimetic arts and from the first formal classification of the "fine arts," see *What Art Is*, 191–93, 420 note 18, and 421 note 22; on the distinction between the mimetic and the decorative arts, 200–213.

Scholars often claim that "fine art" is a peculiarly Western European concept, with no counterpart in other cultures. That claim is only superficially true, however. Although there may not be a precise equivalent for collective terms such as "art" or "fine art" in the Chinese language, for example, there is a long tradition in Chinese philosophy and aesthetic speculation of observing and commenting upon fundamental similarities between the major art forms, the same forms initially canonized as the "fine arts" in the West. Like Western philosophers, Chinese thinkers recognized that music, dance, poetry, painting, and sculpture are basic modes of human expression, which serve to convey thoughts and feelings about life through imaginatively transformed representations of reality. Though they tended to place greater emphasis on emotion than Western theorists, they nonetheless recognized that cognition, too, plays a key role in the arts, in both the creative process and the experience of works of art. Also like Western thinkers, they often drew analogies from one art form to another—thereby indicating an implicit system of classification, lacking only the linguistic tag to designate it explicitly (such a lack was probably due mainly to their less abstract habits of mind). Illuminating sources on Chinese art and aesthetics are Li Zehou, *The Path of Beauty: A Study of Chinese Aesthetics*, tr. Gong Lizeng, New York: Oxford University Press, 1994; and Osvald Sirén, *The Chinese on the Art of Painting: Translations and Comments*, New York: Schocken, 1969. Similarities between Western and Chinese (as well as other non-Western) thought on art are further considered in my recent book, *Who Says That's Art? A Commonsense View of the Visual Arts*, New York: Pro Arte Books, 2014.

12. Among numerous other instances, the question *But Is It Art?* appears as the title of a popular Oxford University Press book (2001) by philosopher Cynthia Freeland, cited above, note 3. As is so often the case when the question is raised in a title, it is never dealt with head-on in the text. Freeland nevertheless seems to imply that the answer is always Yes, for she discusses as "art" twentieth-century examples ranging from Andy Warhol's *Brillo Boxes* to the French "performance artist" Orlan's surgical manipulations of her own body and the scenarios with "counterfeit currency" enacted by another postmodernist, J.S.G. Boggs. Though Freeland is critical of some aspects of such work, her tacit assumption appears to be that all of it is art. On the relationship between such "hard" cases and "institutional" definitions of art, see Stephen Davies, *Definitions of Art*, Ithaca: Cornell University Press, 1991, 37–47. For a critical review of Freeland's book, see Louis Torres, "Judging a Book by Its Cover" (*Aristos*, May 2003 <http://www.aristos.org/aris-03/judging.htm>).

13. Ironically, Ayn Rand probably knew nothing of Baumgarten, and had no idea how close her own theory of art came to that proposed by Kant—whom she held in notoriously low esteem. The four essays outlining her theory of art are included in *The Romantic Manifesto*, rev. ed., New York: New American Library, 1975. Her statement regarding the function of art appears in the first of the essays, "The Psycho-Epistemology of Art," ibid., 19–20. For an in-depth critique of Rand's theory, see Torres and Kamhi, *What Art Is*, as well as our responses to a Symposium in the *Journal of Ayn Rand Studies*: Kamhi, "What 'Rand's Aesthetics' Is, and Why It Matters" (Spring 2003) <http://www.aristos.org/editors/jars-mmk.pdf>; and Torres, "Scholarly Engagement: When It Is Pleasurable, and When It Is Not" (Fall 2003 <http://www.aristos.org/editors/jars-lt.pdf>). For an illuminating analysis by a cognitive psychologist of Rand's

epistemological assumptions (which bear heavily on her theory of art), see Robert L. Campbell, "Ayn Rand and the Cognitive Revolution in Psychology," *Journal of Ayn Rand Studies* 1 (1999), 107–134 <http://myweb.clemson .edu/~campber/randcogrev.html>.

14. Wassily Kandinsky, "Whither the 'New' Art?" (1911), quoted in Mark Rosenthal, *Abstraction in the Twentieth Century: Total Risk, Freedom, Discipline*, New York: Solomon R. Guggenheim Museum, 1996, 33; and *Concerning the Spiritual in Art*, tr. M.T.H. Sadler, New York: Dover, 1977, 2.

15. For an analysis of the history of nonobjective painting and sculpture—from the basic metaphysical and cognitive premises of the pioneers Kandinsky, Malevich, and Mondrian through the critical literature that lent such work legitimacy—see ch. 8 of Torres and Kamhi, *What Art Is*: "The Myth of 'Abstract Art.'" See also my review entitled "Has the Artworld Been Kidding Itself about Abstract Art?" *Aristos*, December 2013 <http://www.aristos.org/aris-13/abstraction.htm>.

16. A more detailed overview of these developments is offered in ch. 14 of *What Art Is*: "Postmodernism in the 'Visual Arts'"; statements by Henry Flynt and Allan Kaprow relevant to the non-art character of postmodernist work are cited on pp. 271, 275, and 278. See also my "Anti-Art Is Not Art" (June 2002 <http://www.aristos.org/whatart/anti-art.htm>) and "The Lights Go On and Off" (February 2002 <http://www.aristos .org/whatart/lights.htm>). In striking contrast to postmodernist tendencies in the artworld, the Yoruba people of West Africa are careful to maintain the distinction between mimetic art and reality, according to art historian Robert Farris Thompson, "Yoruba Artistic Criticism," in Warren L. D'Azevedo, ed., *The Traditional Artist in African Societies*, Bloomington: Indiana University Press, 1973, 32. Finally, the idea that art represents reality (and is therefore readily distinguishable from it) was basic to ancient thought on the subject and is evident throughout Halliwell's discussion in *The Aesthetics of Mimesis*; see, for example, ch. 1: "Representation and Reality: Plato and Mimesis."

17. The distinction between natural and conventional significance is clearly articulated by Erwin Panofsky, "Iconography and Iconology: An Introduction to the Study of Renaissance Art" (1939), reprinted in *Meaning in the Visual Arts*, Garden City: Doubleday, 1955, 26–54. Halliwell points to a similar distinction in ancient thought, and notes that eighteenth-century thinkers also concerned themselves with such a distinction, *Aesthetics of Mimesis*, 130, 158–59, and 169.

18. On the complex iconography of the Arnolfini wedding portrait, see Erwin Panofsky, *Early Netherlandish Painting: Its Origins and Character*, 2 vols., Cambridge: Harvard University Press, 1964, I, 201–03. I previously discussed this work in "Rescuing Art from Visual Culture Studies," *Arts Education Policy Review* 106 (September–October 2004)—an earlier version of which was published online in *Aristos*, January 2004 <http://www.aristos.org/aris-03/rescuing.htm>.

19. Halliwell (*Aesthetics of Mimesis*, esp. ch. 1) makes a strong case for regarding Plato's mirror analogy as intended to demonstrate that so simplistic and naive a view of the nature of pictorial mimesis is mistaken. On Plato and Egyptian art, see ibid., 127–28.

20. Merlin Donald, *Origins of the Modern Mind: Three Stages in the Evolution of Culture and Cognition*, Cambridge: Harvard University Press, 1991, 199. See also Donald, *A Mind So Rare: The Evolution of Human Consciousness,* New York: Norton, 2001.

21. Oliver Sacks, *An Anthropologist on Mars*, New York: Vintage, 1995, 240–41. For research tending to confirm the mimetic foundation of music, see David A. Schwartz, Catherine Q. Howe, and Dale Purves, "The Statistical Structure of Human Speech Sounds Predicts Musical Universals," *Journal of Neuroscience* 23 (2003), 7160–68. The mimetic

nature of music is also discussed in chapter 5, "Music and Cognition," in Torres and Kamhi, *What Art Is*.

22. For further consideration of the mirror neuron system in relation to art, see *Who Says That's Art?*, 160–62.

3. A Prophecy Come True? Danto and Hegel on the End of Art

1. "The End of Art," in Arthur C. Danto, *The Philosophical Disenfranchisement of Art*, New York, 1986.

2. Later, though, Danto told his audience in a public lecture about the reasons that led him to believe that the end of art history had arrived. See his *After the End of Art*, Princeton, 1997, especially 3–19, 31–39. The reasons he offers are partly art-historical and partly autobiographical, due to his experiences as an art critic. His pessimism about the future of art is expressed even more drastically in the lecture than in the original paper, although Danto tries hard to bring in some optimistic overtones with respect to the possibility of aesthetic pluralism after the end of art history.

3. Cf. R. Shusterman, *Pragmatist Aesthetics*, Oxford, 1994.

3. In his 1964 paper "The Artworld" (reprinted in J.W. Bender and H.G. Blocker, eds., *Contemporary Philosophy of Art*, Englewood Cliffs, 1993).

5. Broadly Hegelian because it is shared by analytic philosophers of art like Jerrold Levinson who cannot be said to be a Hegelian in a stricter sense.

6. Therefore, Morris Weitz's claim that the concept of art is indefinable in terms of necessary and sufficient conditions is Hegelian in spirit while his Wittgensteinian alternative is not. Cf. M. Weitz, "The Role of Theory in Aesthetics," *Journal of Aesthetics and Art Criticism* 15 (1956), 27–35.

7. The term 'historical relativism' is inspired by Bernard Williams. Cf. "Truth in Relativism" in B. Williams, *Moral Luck*, Cambridge University Press, 1981.

8. This kind of theory is sometimes ascribed to Plato and Aristotle—wrongly, it seems to me, although I cannot argue this point here.

9. Cf. Nelson Goodman, *Languages of Art*, Indianapolis, 1968, Part I.

10. Cf. Danto, *The Transfiguration of the Commonplace. A Philosophy of Art*, Harvard University Press, 1981, 73.

11. In this respect, it resembles Walter Benjamin's famous thesis about the artwork in the age of its technical reproducibility. Cf. W. Benjamin, "Das Kunstwerk im Zeitalter seiner technischen Reproduzierbarkeit," in R. Tiedemann and H. Schweppenhäuser, eds., *Gesammelte Schriften*, Frankfurt, 1972, Volume 1.2.

12. Following Hegel, one might argue that make-believe pictorial art like the Dutch tradition of painting from the seventeenth century became possible because of developments of *Geist*, i.e. developments of religious and philosophical thinking. Of major importance is the revival of Neo-Platonism in the late Middle Ages and during the Renaissance. Neo-Platonism taught that the beauty and splendour of the visible world—or better, the *mundus sensibilis*—are marks of the eternal and immutable world, the *mundus intelligibilis*. The visible world itself, according to Neo-Platonism, is nothing but a temporal, unstable image of the invisible, godly and perfect world, but it is the only connection to the latter that is given to us mortals. Therefore, it becomes of utter importance to grasp and depict the visible world as accurately as possible. Depicting the

visible world is the melancholy act of contemplating eternity by making passing images durable.

13. Cf. P. Kivy, *Music Alone*, Ithaca: Cornell University Press, 1991, 175.

14. Of course we find allegories in ancient pictorial art, e.g. pictures of death or of love, depicted as persons with peculiar attributes. Death is usually depicted as a young man with a torch turned down, love (amor) as a boy with an arrow and sometimes with wings, too. The famous nineteenth-century linguist Jacob Grimm even proposed to take all the ancient gods as allegories of aspects of human nature. Yet allegory and pictorial abstraction are quite different things.

15. Hegelian Spirit, at least in Danto's interpretation, tries to understand its own nature, and it finally does so when it reaches the level of absolute knowledge. It is this reading of the *Phenomenology of Spirit* that led Danto to tell a parallel story about art, as he points out himself. It is not the concern of this paper to discuss the virtues and the shortcomings of this kind of reading. For a different, more mundane interpretation, however, see T. Pinkard, *Hegel's Phenomenology: The Sociality of Reason*, Cambridge University Press, 1994.

16. Hegel makes this claim in the preface to the *Grundlinien der Philosophie des Rechts*.

17. G.W.F. Hegel, *Vorlesungen über die Philosophie der Kunst*, A. Gethmann-Siefert, ed., Hamburg, 2003, 311–12; the translation is mine. Much editorial work on Hegel's *Lectures on Aesthetics* has been done during the last decades. Cf. also G.W.F. Hegel, *Vorlesung über Ästhetik. Berlin 1820–21. Eine Nachschrift*, H. Schneider, ed., Frankfurt, 1995. Although this work is not finished yet, it has become obvious even by now that Hegel's thinking about the arts underwent considerable changes from the first Heidelberg to the late Berlin lectures on the philosophy of art. Although the role of H.G. Hotho, the first editor of Hegel's lectures on the philosophy of art, is much disputed, there can be little doubt that the thesis about the end of art is Hegel's and not Hotho's invention. See, however, A. Gethmann-Siefert, „Einleitung," in Hegel, *Philosophie der Kunst*, xxi–vi.

18. It is quite misleading to translate *Kunstreligion* as 'artistic religion'. The latter term suggests the idea of a special religion within the arts or for artists only. Nietzsche sometimes uses expressions like these. However, this is not what is meant by *Kunstreligion* or 'new mythology'. What is meant is rather a new kind of universal religion inspired and led by the arts.

19. "Eine mythologische Ansicht der Natur." F. Schlegel, *Gespräch über die Poesie* (1800), in: *Kritische Schriften und Fragmente* 2 (1798–1801), E. Behler and H. Eichner, eds., Paderborn, 1988, 203.

20. Friedrich Schlegel and Novalis both wrote critical reviews of Goethe's *Wilhelm Meister*, Schlegel for and Novalis against Goethe.

21. Schleiermacher even proposed to regard the Bible as a kind of open, 'romantic' work of literature *avant la lettre*. Cf. F.D.E. Schleiermacher, *Über Religion: Reden an die Gebildeten unter ihren Verächtern*, Berlin, 1799, Chapter V.

22. It is worth noting, however, that both thinkers later considerably changed their minds about this matter.

23. Schelling thus defends Herder's project against Kant's vehement criticism of Herder's seminal work on the history of mankind.

24. *Critique of Pure Reason*, § 6.

25. Anthropocentrism is perhaps a better expression because it does not evoke solipsism as easily as 'subjectivism' does. Schelling rejects any form of solipsism and

even accuses Fichte of being too egocentric and solipsistic. That there is perhaps a real difference between Fichte and Schelling becomes clear when one looks at the different ways both philosophers deal with the problem of other minds. Fichte, at least in the early versions of his *Wissenschaftslehre*, claims that we can overcome the gap between other people's minds and our own only by some kind of inference from our own rational nature to the rational nature of other people. Philosophy even has to show how there can be other minds in the first place. In sharp contrast to this, Schelling does not believe that there is any philosophical problem with other minds at all.

26. The picture of discursive practice sketched here is to a large extent inspired by H.P. Grice's and R. Brandom's work. Both approaches, in my view, cover important aspects of the 'dialectic' way of philosophizing that Fichte, Schelling, and Hegel developed.

27. It is not necessary to use the phrase 'I know' in order to make a knowledge-claim. But this does not mean that talk about knowledge is dispensable in general. Whereas it may be correct that uttering 'I know that *p*' instead of '*p*' makes little sense, ascribing knowledge from the second- or third-person perspective makes perfect sense.

28. Remember that I argue on the level of ordinary and scientific everyday discourse here. The pragmatic dilemma occurs only when it comes to 'real', object-level asserting. This does not tell against using expressive vocabulary on a meta-level, in a theory of rational discourse, where its use may serve to make discursive commitments and entitlements explicit.

29. It is no objection that the word 'I' occurs many times in the writings of Fichte or in existentialist philosophy, e.g. in Sartre's. Both Fichte and Sartre make it sufficiently clear that they do not talk about themselves but about a kind of abstract or general I, i.e. about subjectivity or personality as such. Cf. J.G. Fichte, *Die Bestimmung des Menschen*, Hamburg, 2000, preface.

30. Of course this account of religious language use privileges the subjective modes of religious speech, such as creed, prayer, or psalm (including religious anthems and hymns). This immediately brings with it the problem of how to deal with rather impersonal modes of speech that belong to the religious language game nonetheless. But a subjectivist account of religious speech can accommodate these cases. The opposite, impersonal approach to religious speech is faced with more serious difficulties.

31. Maybe this is what Schleiermacher wanted to say when he claimed that religion is a matter of feeling and emotion rather than reason or intellect. Cf. F.D.E. Schleiermacher, *Über Religion*. Put this way, however, this statement is rather misleading.

32. This does not mean that any expressive speech act is religious. Expressiveness is a necessary, not a sufficient condition for religious speech.

33. Of course, a lot more is necessary to show that religious speech can be veridical. But I cannot, for the sake of brevity, defend this claim here. It might be enough for the present purpose to stress that it is common ground between Schelling and Hegel.

34. Cf. my "Glaube als Hoffnung und Vertrauen: Zu einigen religionsphilosophischen Thesen Friedrich Kambartels," in *Dialektik* (2000) 1, 139–148.

35. I simplify a lot here. For example, it is not clear whether Schelling really holds that art is a higher form of knowledge than philosophy. In the same passage of the *Introduction* to the *System of Transcendental Idealism* where Schelling claims that art is the highest form of knowledge—and of reality—he also writes that the *philosophy* of art "therefore" is the completion of philosophy (§3). This remark makes the relation between philosophy and art in his system quite difficult to understand.

36. This reconstruction deserves some elaboration. Poems and songs are paradigm cases of subjective expression. But Schelling's claim is quite general and meant to include rather 'objective' artistic forms of representation like the ancient epos or the modern novel as well. However, the general claim cannot be maintained without softening the contrast between literary expression and some forms of philosophical prose drawn above in footnote 28.

37. Different versions of contemporary aesthetic cognitivism are presented in C. Jäger, G. Meggle, eds., *Kunst und Erkenntnis*, Paderborn, 2005. It is worth noting that, for the later Schelling, art no longer enjoyed the privilege of being the highest form of human knowledge. In this respect, his later philosophy is much closer to Hegel's than some scholars recognize.

38. Hegel, *Philosophie der Kunst*, 44. Translating *Vergeistigung* as 'spiritualization' is problematic, of course. But so are the alternatives.

39. G.W.F. Hegel, *Vorlesungen über die Ästhetik*, in *Hegel: Werke*, E. Moldenhauer and K.M. Michel, eds., Volume 13, 141. The translation is mine.

40. It is worth noting that Hegel makes use of a historical classification of art that is very similar to the one that Schelling employed in his *Philosophy of Art* (1805). Schelling simply distinguishes between ancient and modern art. Modern art, for him, starts with Christianity. So Schelling's period of modern art is identical with Hegel's romantic art. That which Schelling calls ancient art, Hegel labels classical art.

41. It is rather telling that Nietzsche some sixty years later attacked Richard Wagner's idea of opera in a similar way, after long years of adoring Wagner and in complete ignorance of Hegel's criticism of *Kunstreligion*.

42. I.e. in his polemic and partly unjust criticism of romantic irony. Terry Pinkard sees religious and political motives behind Hegel's attacks on Schlegel. Cf. T. Pinkard, *Hegel: A Biography*, Cambridge University Press, 2000, 286.

43. I cannot explain here why the different arts form a circle, such that poetry stands at the beginning and at the end of the arts. For an attempt to make sense of this idea, see my *Formbezug und Weltbezug: Die Deutungsoffenheit der Kunst* (Paderborn, 2006), Chapter 5.

44. Danto sees the Platonic criticism of art in a different light, of course, namely as a disenfranchisement of art. Cf. Danto, op. cit.

45. Cf. Hegel, *Ästhetik*, 142.

46. Or, to be still more precise, religion and art are originally one (*im Ursprung eins*). That means that artistic activity is an integral aspect of religious life, at least in the beginning of religious and artistic practice. The autonomy of art is necessarily a historical latecomer. At least both Schelling and Hegel argue in this vein. I have defended this claim in my *Formbezug und Weltbezug*, Chapter 6.

47. This is Hegel's own point in the third and final part of his *Science of Logic* called "The Subjective Logic." Hegel points out there that any objective knowledge (claim) is grounded in subjectivity. See also P. Stekeler-Weithofer, *Philosophie des Selbstbewusstseins*, Frankfurt, 2005, Chapter 2.3.

48. Cf. the Introduction to the *Phenomenology of Spirit*.

49. Remember that the contrast between Schelling's theory of art and Hegel's is a bit exaggerated here. That Schelling's philosophy of art, at least as it is presented in his *System of Transcendental Idealism*, really is one major target of Hegel's criticism seems obvious, however.

50. One might, by the way, regard this as a quite peculiar version of a *l'art pour l'art* theory of art.

51. For a defense of this idea of Schlegel's in terms of current hermeneutic and deconstructive aesthetic theory, see R. Sonderegger, *Für eine Ästhetik des Spiels*, Frankfurt, 2000, Part II.

52. See, for example, A.W. Schlegel's "Sonnet," which is a poem about itself, about sonnets and about poetry.

53. Compare, for example, Hegel's famous attack on romantic irony in his *Lectures on Aesthetics* with the following unfriendly remark of Schelling's: "Poetry can . . . have poetry as such and *in abstracto* as its object—[it can] be poetry about poetry. Some of our so-called romantic poets have never gotten any further than to such a glorification of poetry by poetry. But nobody has recognized this poetry about poetry as real poetry." (*Zur Geschichte der neueren Philosophie*, Darmstadt, 1953, 123; the translation is mine.)

54. Cf. Kivy, *Philosophies of Arts: An Essay in Differences*, Cambridge University Press, 1997.

55. At least in Hotho's later version of the *Lectures on Aesthetics*. In the earlier *Lectures on the Philosophy of Art*, the theory of art history is spelled out in the second section of the *first*, or *general*, part. And this fits nicely with Hegel's thesis that art is essentially historical. But this point is brought home in the later version as well. So this difference turns out to be a matter of presentation rather than content.

56. Cf., among many, R. Schmücker, *Was Ist Kunst?*, Munich, 1998, 27–32.

57. Hegel often speaks of a 'system of needs' that characterise and partly determine his being in the world. Human needs reach far beyond basic animal needs for food, shelter, and sexual propagation, although they include these. Moreover, even these basic human needs are informed by culture, man's second nature. This is to be acknowledged by any philosophical anthropology whatsoever.

58. The art-historical thesis that ancient Egypt, ancient Indian and Chinese art are symbolic in this sense is more than problematic, of course. But even if one believes, as I do, that Hegel himself betrays a remarkable lack of understanding here, this does not affect the distinction between symbolic, classical, and romantic art on the conceptual level.

59. I simplify a lot here, more than Hegel does, who knows too much about ancient tragedy to claim that classical art is always immediately concerned with ideals of human life.

60. See, for example, Hegel's remarks about the role of talent and learning in the arts in his *Lectures on the Philosophy of Art*, 22–24.

4. The Humanizing Function of Art: Thoughts on an Aesthetic Harm Principle

1. See the special issue, "Arte Hoy: La Crisis Permanente," in *Revista de Occidente* 261 (February 2003).

2. Arthur Danto's claims about the end of art have been tremendously influential. For his tale of the end of art, see Danto, *The Philosophical Disenfranchisement of Art* (New York, 1986), *After the End of Art* (Princeton, 1997), and *The Abuse of Beauty. Aesthetics and the Concept of Art* (Chicago: Open Court, 2003).

3. "The End of Art: A Philosophical Defense," *History and Theory* 37:4 (1998), 127–143, at 128. This is a special issue, entitled, *Danto and his Critics: Art, History, and Historiography after the End of Art.*

4. Ibid., 139.

5. As Danto tells us, "This happens once art raises the question of 'why one pair of look-alikes was art and the other was not' and it 'lacked the power to rise to an answer,' thus necessitating philosophy (Ibid., 134).

6. "The End of Art: A Philosophical Defense," *History and Theory* 37:4 (1998), 127–143, at 133.

7. Danto points out that for Hegel, the end of art comes because, "Art [is] no longer capable by its own means alone, to present the highest realities in sensuous form. Art had become an object rather than a medium through which higher reality made itself present" ("The End of Art," 130).

8. See Theodor Adorno, *Ästhetische Theorie*, Volume 7 of the *Gesamtausgabe* (Frankfurt: Suhrkamp, 1970), 474. He writes: "Die These vom bevorstehenden oder schon erreichten Ende der Kunst wiederholt sich die Geschichte hindurch, vollends seit der Moderne; Hegel reflektiert jene These philosophisch, ist nicht ihr Erfinder."

9. "The End of Art," 134.

10. Danto is one of the few philosophers to mention Mill in his discussion of art. In his discussion of the end of art as the end of the possibility of progression or develop- ment in art, Danto directs attention to Mill's comments on the exhaustibility of music. Mill, we are told, "declared that all possible combination of sounds would sooner rather than later have been made and with that thought the possibilities of indefinite creativity were closed" (Danto, Ibid., 138).

11. Mill does directly address the arts in some of his other writings, for example, in Chapter 4 of his Autobiography, "Poetical Culture," he tells us that "religion and poetry address themselves to the desire for ideal conceptions grander and more beautiful than life provides" (448). This insight will play a role in the case I want to make for the humanizing function of art.

12. He was able to recall the following lines (118–19): "Think of your breed; for brutish ignorance/Your mettle was not made; you were made men, / To follow after knowledge and excellence."

13. For Adorno, Auschwitz was a place "where the liquidation of the individual loomed large as part of a historical process—a final stage in the dialectic of cultural and barbarism" (Michael Rothberg, "After Adorno: Culture in the Wake of Catastrophe," *The New German Critique*, 58).

14. Richard Rorty, "Thugs and Theorists: A Reply to Bernstein," *Political Theory* 15:4 (1987), 564–590, at 587.

15. Alexander von Humboldt, *Personal Narrative of a Journey to the Equinoctial Regions of the New Continent* (London: Penguin, 1995), 42. Humboldt quotes the pas- sage in Italian, "Right-hand I turned, and setting me to spy / That alien pole, beheld four stars, the same / The first men saw, and since, no living eye; / Meseemed the heavens exulted in their flame— / O widowed world beneath the northern Plough, / For ever fam- ished of the sight of them!" (Dante's *Purgatory*, Canto I, 22–27).

16. Chapter 4 of his Autobiography, "Poetical Culture," 448.

17. Clifford Geertz, "Art as a Cultural System," *Modern Language Notes* 91:6, *Comparative Literature* (December 1971), 1473–499, at 1478.

18. Jonathan Glover, *Humanity: A Moral History of the Twentieth Century* (New Haven: Yale University Press, 1999), 145.

19. Ibid., 145.

20. Ibid., 145.

21. Lorand uses this to refer to beauty and *not* to aesthetic experience in general. See Ruth Lorand, *Aesthetic Order*, Oxford: Routledge, 2000.

22. For more on this important point, see Nelson Goodman, *Languages of Art. An Approach to a Theory of Symbols* (Indianapolis: Hackett, 1976), esp. 244–265.

23. *De Profundis* (Mineola: Dover, 1996), 74.

24. Geertz, "Art as a Cultural System," 1496.

25. See especially Hans-Georg Gadamer, *Truth and Method*.

26. See John Dewey, *Art as Experience*.

27. In Richard Shusterman, "The End of Aesthetic Experience," *Journal of Aesthetics and Art Criticism* 55:1 (Winter 1997), 29–41, at 33. Shusterman provides an excellent account of the role that aesthetic experience has played in shaping philosophical conceptions of art, discussing in great detail the criticisms leveled against the strategy of privileging aesthetic experience.

28. Ibid., 39.

29. Ibid., 30.

30. Ibid., 38.

31. Mill himself never mentions a harm principle; the term was coined by Joel Feinberg. See *Harm to Others* (Oxford University Press, 1987).

32. J.S. Mill, *On Liberty and Other Writings*, edited by Stefan Collini (Cambridge University Press, 1989), 102–03.

33. "It is not by wearing down into uniformity all that is individual in themselves, but by cultivating it and calling it forth, within the limits imposed by the rights and interests of others, that human beings become a noble and beautiful object of contemplation; and as the works partake the character of those who do them, by the same process human life also becomes rich, diversified, and animating, furnishing more abundant aliment to high thought and elevating feelings and strengthening the tie which binds every individual to the race, by making the race infinitely better worth belonging to" (Ibid., 63).

34. *On Liberty*, 68

35. Ibid., 82.

36. With thanks to participants in the Hegeler-Carus Foundation Arts Colloquium, held in La Salle, Illinois, March 28th–30th, 2003, and to the members of the Bernard Weiniger Jewish Community Center, Lakeside Congregation, Highland Park, Illinois, who heard a version of this paper on November 21st, 2005, and provided excellent feedback.

5. What Shall We Do After Wagner? Karl Popper on Progressivism in Music

1. Amongst many possibilities we might mention Jim Samson's *Music in Transition: A Study of Tonal Expansion and Atonality 1900–1920*, Dent, 1977 as an example of a technical history, and Christopher Butler's *Early Modernism: Literature, Music, and Painting in Europe 1900–1916*, Oxford University Press, 1994 as a book more inclined towards social history.

2. *Unended Quest* is included in *The Philosophy of Karl Popper* Vol. I, ed. by Paul A. Schilpp, Open Court, 1974. The following summary of Popper's ideas on music is drawn from pp. 41–57 of this work unless otherwise stated. Popper's critique of historicism appears principally in *The Open Society and its Enemies* and *The Poverty of*

Historicism, Routledge, 2002 (first English edition 1957), as well as references in numerous short papers.

3. *Unended Quest*, 56.

4. Interview in Joan Allen Smith: *Schoenberg and His Circle: A Viennese Portrait*, Schirmer, 1986, 3.

5. *Lesson of This Century*, Routledge, 1997, 41.

6. *Unended Quest*, 56

7. Compare it with, for example, Schoenberg's dictum that "Art means New Art" ("New Music, Outmoded Music, Style and Idea" [1946] in Leonard Stein ed., *Arnold Schoenberg—Style and Idea: Selected Writings*, Faber, 1975, 115), or Boulez's defense of innovation in the post-war period on the grounds that "We really must accustom ourselves to the fact that there are periods of mutation in the history of music [which] question the very principles that . . . have been generally accepted" ("Aesthetics and the Fetishists" [1961] in Jean-Jacques Nattiez, ed., *Orientations*, Faber, 1986, 36).

8. In his *Diaries* the theatre critic Kenneth Tynan captures a similar distinction when he states that the only reasons to engage in creating art are either self-expression or game-playing, the latter referring presumably to playing with the conventions or manipulating the objective technique of an art form. More broadly, the distinction between pure (abstract) and programmatic music, or even classical and romantic impulses in music, embody the same general idea.

9. "Towards a Rational Theory of Tradition" in *Conjectures and Refutations: The Growth of Scientific Knowledge*, London: Routledge, 1989, 131. Earlier in the article (122) Popper mentions the "devastating" results of an attempt to perform Mozart's *Requiem* by a musical director "who was obviously untouched by the tradition which has come down from Mozart."

10. Stuckenschmidt cites the remark from a program to the first performance of Schoenberg's song cycle *Das Buch der hängenden Gärten* (op. 15). See *Arnold Schoenberg* (tr. Edith Temple Roberts and Humphrey Searle), London: John Calder, 1959, 45. Stuckenschmidt's account is rich in historicist interpretations of Schoenberg's innovations. For instance, with regard to this remark, Stuckenschmidt writes that Schoenberg "was conscious of the irrevocability of this breakthrough: Today we know that this process was not only subjectively justified by Schoenberg's genius, but that it was a historical necessity, that since the introduction of the tempered system about 1700 the development of harmony was resolutely striving towards the results which Schoenberg had the courage to present to the world" (Ibid., 49). This was probably the dominant view in the 1950s of the importance of atonality and serialism.

11. For example, the violinist Rudolf Kolisch, when asked whether the twelve-tone method developed by Schoenberg in the early 1920s, seemed like a development of tradition or a radical departure, replied: "it appeared as something new. We could not see this [i.e. as development] from this perspective yet. That appeared really as something very fundamentally drastic." The expressionist writer and painter Oskar Kokoschka similarly notes: "We all thought it's *the* music, so there was no dispute about it. It was just *the* fact. All the others were behind and didn't understand it, so we thought." Joan Allen Smith: *Schoenberg and his Circle: A Viennese Portrait*, New York: Schirmer, 1986, 217.

12. Ernst Gombrich wrote a very fine essay commenting on Popper's approach to music where he reads it largely in terms of a critique of historicism, and Popper accepts this without comment in his own response to Gombrich. See E.H. Gombrich, "The Logic of Vanity Fair: Alternatives to Historicism in the Study of Fashions, Style, and Taste" in

Paul A. Schilpp, ed., *The Philosophy of Karl Popper*, La Salle: Open Court, 1974, vol. II, 925–957, and Karl Popper, "Gombrich on Situational Logic and Periods and Fashion in Art", Ibid., 1174–180.

13. Writing in 1967 Popper noted that in recent times there were "few people who openly defend historicism," but that despite this the doctrine was prevalent, for any reference to "movements and tendencies, ages and periods (and their spirits), signals the acceptance, tacit or otherwise, of theories that are clearly historicist in character," and amongst these he included accounts of "the age of abstract revolutionary art, which, incidentally, seems hardly to have changed since 1920 . . ." ("A Pluralist Approach to the Philosophy of History" in M.A. Notturno ed., *The Myth of the Framework*, Routledge, 1994, 132).

14. From this point on I am extrapolating freely from Popper's writings; he makes little or no direct reference to the issues discussed below

15. That a device has become a cliché is a common modernist criticism of traditional musical practices. There is a good discussion of the problem in Roger Scruton's, *The Aesthetics of Music*, Oxford: Clarendon, 1997, 479–488. Scruton ties banality to sentimentality and hence adopts a more expressionist approach than Popper would presumably have favoured.

16. "Towards a Rational Theory of Tradition," 131.

6. Does the New Classicism Need Evolutionary Theory?

1. Japanese artists, prior to learning of the techniques of perspective, used occlusion, shading and other hints at depth.

2. For example, Matisse admired the Greeks for their virtues of serenity and harmony. This is clear in his discussion of the Greeks' disdain for the literal representation of movement: "The Greeks too are calm; a man hurling a discus will be shown in the moment in which he gathers his strength before the effort or else, if he is shown in the most violent and precarious position implied by his action, the sculptor will have abridged and condensed it so that balance is re-established, thereby suggesting a feeling of duration" ("Notes d'un peintre," *La Grande Revue*, Paris, 25th December 1908).

3. One exception here might be magical realism and other literary genres. Literary fiction, despite Georges Polti's suggestion that there are only thirty-six dramatic situations, is boundless because of its ability to represent the human being's boundless imagination. It is unfettered by the need to satisfy the formal demands of the perceptual modules.

4. An important exception here is Dada, which rejected logic and formal, systematic approaches in response to the horrors of the First World War and the Dadaists' belief that the war was the result of the systematic industrialization of the world. "In art, Dada reduces everything to an initial simplicity, growing always more relative. It mingles its caprices with the chaotic wind of creation and the barbaric dances of savage tribes. It wants logic reduced to a personal minimum, while literature in its view should be primarily intended for the individual who makes it." Tristan Tzara, *Dada Manifesto*, 1918.

5. The ramifications of Darwin's revolution are still being worked out. First, obviously, within biology. But the three-process schema is so powerful and general that it can be applied outside biology. It was seen that the units undergoing natural variation, selec-

tion and inheritance need not be biological. As long as they could undergo these processes, in a sufficiently stable domain, one could have an interesting evolution productive of new structures and functions. Among writers who have argued that the Darwinian principles of natural selection apply not simply to biology but also to mental, epistemological, moral, social or even cosmic evolution, are Walter Bagehot, *Physics and Politics: Or, Thoughts on the Application of 'Natural Selection' and 'Inheritance' to Political Society*, London: Henry King, 1872; William James, "Great Men, Great Thoughts, and the Environment," *Atlantic Monthly*, 1880; David G. Ritchie, Darwinism and Politics, Swan Sonnenschein, 1890; Samuel Alexander, "Natural Selection in Morals," *International Journal of Ethics* 2:4, 409–439; Charles Sanders Peirce, *Reasoning and the Logic of Things: The Cambridge Conference Lectures of 1898*, Harvard University Press, 1992; Thorstein Veblen, *The Theory of the Leisure Class: An Economic Study in the Evolution of Institutions*, Macmillan, 1899, and *The Place of Science in Modern Civilization and Other Essays*, New York: Huebsch, 1919; and J.M. Baldwin, *Darwin and the Humanities*, Baltimore: Review Publishing, 1909. They argued that Darwinism had a wider application than to biology alone. Evolutionary thinking has been applied to the psychology of learning, perception (Gregory) and thinking; philosophy of science (Popper); micro-economics (for example Richard Nelson and Sidney Winter applied the principles of variation, inheritance and selection to routines in firms in *An Evolutionary Theory of Economic Change*, Harvard University Press, 1982.); computer science, and many other problem areas. The great polymath Donald Campbell suggested that Darwinism contained a general theory of the evolution of all complex systems. Campbell made the point that the appropriate analogy for social evolution is not biotic evolution, but the more general processes of evolution of complex systems "for which organic evolution is but one instance" ("Variation, Selection, and Retention in Sociocultural Evolution," 1965, reprinted in *General Systems* 14, 1969. Richard Dawkins introduced the term "Universal Darwinism" to connote this perspective: "Universal Darwinism," in D.S. Bendall, ed., *Evolution from Molecules to Man*, Cambridge University Press, 1983.

6. S. Baron-Cohen, *Mind-Blindness: An Essay on Autism and the Theory of Mind*, MIT Press, 1995; E. Spelke, "Initial Knowledge: Six Suggestions," *Cognition* 50, 1995).

7. Two quantities are said to be in the *golden ratio*, if "the whole (the sum of the two parts) is to the larger part as the larger part is to the smaller part." That is if , where *a* is the larger part and *b* is the smaller part.

8. The Ancient Greeks had horror in their stories, but it was only the romantics who made horror the main point of a story.

9. Even Skinner made many references to the evolutionary perspective and thought that an organism's susceptibility to reinforcement schedules was a product of evolution. In other words, even in Skinner's view, there are inherited law-like constraints on human behaviour and therefore humans are not strictly blank slates.

10. N. Chomsky, Review of B.F. Skinner's *Verbal Behavior*, *Language* 35, 1959, 26–58.

11. J.A. Fodor, *The Modularity of Mind*, MIT Press, 1983.

12. The exception here is the relatively rare condition of synesthesia, in which the senses become blended. There is the case of Matthew Blakeslee, who, when he shapes hamburger patties with his hands, experiences a vivid bitter taste in his mouth. Esmerelda Jones (a pseudonym) sees blue when she listens to the note C sharp played on the piano; other notes evoke different hues—so much so that the piano keys are actu-

ally color-coded, making it easier for her to remember and play musical scales. And when Jeff Coleman looks at printed black numbers, he sees them in color, each a different hue. The effect is insulated from their knowledge: the blending persists even when they are aware of the blending.

13. L. Cosmides and J. Tooby, "Cognitive Adaptations for Social Exchange," in J. Barkow, L. Cosmides, and J. Tooby, eds., *The Adapted Mind: Evolutionary Psychology and the Evolution of Culture*, Oxford University Press, 1992; L. Cosmides and J. Tooby, "Origins of Domain-Specificity: The Evolution of Functional Organization," in L. Hirschfeld and S. Gelman, eds., *Mapping the Mind: Domain-Specificity in Cognition and Culture*, Cambridge University Press, 1994; J. Tooby and L. Cosmides, "The Psychological Foundations of Culture," in Barkow, Cosmides, and Tooby, *The Adapted Mind*; D. Sperber, "The Modularity of Thought and the Epidemiology of Representations," in Hirschfeld and Gelman, *Mapping the Mind*; S. Pinker, *How the Mind Works*, Penguin, 1997.

14. S. Carey, *Conceptual Change in Childhood*, MIT Press, 1985; S. Carey and E. Spelke, "Domain-Specific Knowledge and Conceptual Change," in Hirschfeld and Gelman, *Mapping the Mind*; E. Spelke, "Initial Knowledge: Six Suggestions," *Cognition* 50 (1995); N. Smith and I. Tsimpli, *The Mind of a Savant*, Blackwell, 1996; P. Carruthers, "Thinking in Language? Evolution and a Modularist Possibility," in P. Carruthers and J. Boucher, eds., *Language and Thought*, Cambridge University Press, 1998; L. Hermer-Vazquez, E. Spelke, and A. Katsnelson, "Sources of Flexibility in Human Cognition: Dual-Task Studies of Space and Language," *Cognitive Psychology* 39 (1999); L. Cosmides and J. Tooby, "Unraveling the Enigma of Human Intelligence," in R. Sternberg and J. Kaufman, eds., *The Evolution of Intelligence*, Erlbaum, 2001.

15. The equivalent for the scrap heap challenge would be, for example, that the cumbersome flotation barrels attached to the vehicle cannot be removed for better dry driving without damaging the strength of the vehicle.

16. Invented by the Psychologist Christopher Tyler, autostereograms are the computer-generated squiggles that when viewed with crossed eyes or a distant gaze suddenly present three-dimensional objects that seem to leap out of the page.

17. Pardon my descriptions here for their inaccuracy: I hope they are accurate enough for my point.

18. Work by neurophysiologists has indicated that harmonically inspired music (classical) and intellectually inspired but highly dissonant music activates different areas of the human brain: the latter brain regions involved in logico-analytical skills.

19. I have some reservation here. It is hard to believe that the impact of the *Mona Lisa* would be as great if hung upside down. The visual system imposes a reference frame of top-bottom on the objects of perception in its attempts to recognize them.

20. I would like to thank the historian Vincent Moss, the archaeologist Andrew Petersen, and the artist Heather Nixon for their critical commentary and discussion.

9. The Interminable Monopoly of the Avant-Garde

Originally written more than a decade ago, this essay required considerable updating and revision for the present volume. Owing to circumstances beyond my control, only minimal changes were possible within the text itself. For that

reason, some notes are much longer than in accepted scholarly practice and include substantive material that might otherwise have been incorporated in the text itself. In lieu of paragraph breaks, I have broken some of the longest into sections marked [a], [b], and so on, for ease of reading and citation. —L.T.

1. Eric Hobsbawm, *The Age of Extremes: A History of the World, 1914–1991*, New York: Vintage, 1996, 517–18 <http://tinyurl.com/Hobsbawm-TheAgeOfExtremes>. Hobsbawm also wrote *Behind the Times: The Decline and Fall of the Twentieth-Century Avant-Gardes*, London: Thames and Hudson, 1998 <http://www.eric-reyes .com/assets/hobsbawm001.pdf>. For an informative but ultimately dismissive review of *Behind the Times* that also cites *The Age of Extremes*, see Donald Kuspit, "The Avant-Garde Dies," *Artnet Magazine*, June 25, 1999 <http://www.artnet.com/Magazine/ index/kuspit/kuspit6-25-99.asp>. Kuspit's own high regard for avant-garde art is reflected in his evident disdain for Hobsbawm's thoughts on the subject, which he characterizes as "contempt for the avant-garde."

2. To avoid cluttering the text, I will henceforth generally omit scare quotes around spurious terms such as "avant-garde art" and "contemporary art."

3. Appendix A, "New Forms of Art," in Torres and Kamhi, *What Art Is* (see below, n. 5) lists some hundred purported art forms and categories invented in the twentieth century. It is reprinted in *What Art Is* Online <www.aristos.org/whatart/append-A.htm>, followed by Part II, which includes about seventy new examples added since 2000. The list continues to grow. Regarding charlatanism, cultural historian Jacques Barzun (1907–2012) wrote us that he agreed with our contention that (in his words) "much put forward as art these days is a product of either charlatanism or invincible ignorance." Personal correspondence, September 10, 2006; quoted in "A Jacques Barzun Compendium" <http://www.aristos.org/barzun.htm#Letters From>. On charlatanism, see also Roger Scruton (who speaks of a "culture of fakes," from "fake expertise" to ""fake art"), "The Great Swindle," *Aeon*, December 17th, 2012 <http://aeon.co/magazine/ philosophy/roger-scruton-fake-culture/>. On the view of ordinary people that abstract art is made by charlatans and frauds, see David Halle, *Inside Culture: Art and Class in the American Home*, Chicago: University of Chicago Press, 1993 <http://tinyurl .com/Halle-AbstractArt>; cited in *What Art Is*, 176.

4. As defined by the late philosopher Arthur Danto, the term "artworld" refers to all the individuals who are knowledgeable about, and accept, the theories behind contemporary art. "The Artworld," *Journal of Philosophy* 61 (1964), 571–584. Danto's fellow philosopher George Dickie coined the term "artworld public" in "The New Institutional Theory of Art," *Proceedings of the 8th Wittgenstein Symposium* 10 (1983), 57–64.

5. [a] Ayn Rand, "Art and Cognition," in *The Romantic Manifesto*, rev. ed., New York: New American Library, 1975, 45–79. Rand's full definition is "Art is a selective re-creation of reality according to an artist's metaphysical value-judgments" (19). In her essay "Art and Sense of Life," she repeats the definition, adding: "It is the artist's sense of life that controls and integrates his work, directing the innumerable choices he has to make, from the choice of subject to the subtlest details of style" (34–35). On Rand's definition, see also *What Art Is*, ch. 6, "The Definition of Art," 103–08.

[b] Although Rand did not coin the term *sense of life*, she appears to have been the first writer to analyze the concept in depth and to define it precisely—as "a pre-conceptual equivalent of metaphysics, an emotional, subconsciously integrated appraisal of man and of existence." Her analysis is a major contribution to the literature on esthet-

ics. I cannot imagine thinking or writing about art without having it in mind on some level.

[*c*] Regarding Rand's ideas on sense of life and art, the Jesuit philosopher W. Norris Clarke (1915–2008) commented two decades ago that he found her thought on the subject "especially interesting. . . . She is indeed a powerful and clear thinker." See "A Jesuit's Praise of Rand's Theory of Art," *Aristos*, Notes and Comments, March 2013 <http://www.aristos.org/aris-13/brief-3.htm>.

[*d*] For a critical introduction to Rand's theory of art, see Louis Torres and Michelle Marder Kamhi, *What Art Is: The Esthetic Theory of Ayn Rand*, Chicago: Open Court, 2000; our discussion of her definition of art, with reformulations by each of us, is on pages 103–08 <http://tinyurl.com/DefinitionArt-Ch6-WhatArtIs>).

[*e*] Reviews of *What Art Is* were favorable. For example, Richard E. Palmer (Emeritus Professor of Philosophy, MacMurray College) judged *What Art Is* to be a "[w]ell documented . . . debunking of twentieth-century art . . . and art theory" and "a major addition to Rand scholarship," *Choice* magazine, April 2001 <http://www.aristos .org/editors/choice.htm>. Jonathan Vickery (now Associate Professor, Centre for Cultural Policy Studies, University of Warwick, U.K.) observed that *What Art Is* is "as trenchantly anti-modernist as anti-postmodernist," and concluded that though Rand's esthetics is "not likely to find many converts in the contemporary art world," Kamhi and I offered "a balanced critical assessment of [Rand's] arguments, finding justification for those arguments from archaeology, cognitive science and clinical psychology, and applying [her] ideas to every area of contemporary culture," *The Art Book*, September 2001; see our response <http://www.aristos.org/editors/resp-ab.htm>.

6. Tate Collection, Glossary of art terms <http://www.tate.org.uk/learn/online -resources/glossary/a/avant-garde>.

7. [*a*] Definition of "Avant-Garde," National Gallery of Art (NGA), Washington, D.C. <https://www.nga.gov/feature/manet/tdef_avant.htm>. "Pushing the boundaries" (and variants thereof) is an artworld cliché. See "Artworld Buzzwords," *What Art Is* Online <http://www.aristos.org/whatart/append-B.htm> and <http://www.aristos.org/ whatart/app-B-II.htm>.

[*b*] In the present essay, I take the term *avant-garde* to include all forms of bogus art invented since the turn of the twentieth century—from abstraction to all the forms falling under the rubrics *postmodern* and *contemporary*. See also *What Art Is*, 392*n*8.

8. The MFA's Department of Contemporary Art subsequently dropped the reference to "color-field painters," and now notes that the MFA was "one of the first encyclopedic museums in the United States to fully integrate performance art [an avant-garde invention] into its collections, exhibitions and programs" <http://www.mfa.org/collections/ contemporary-art>.

9. Most telling in this connection is the definition offered by Britain's Tate Museum: "The term *contemporary art* is loosely used to refer to art of the present day and of the relatively recent past, *of an innovatory or avant-garde nature*" <http://www.tate.org.uk/learn/online-resources/glossary/c/contemporary-art>, emphasis added. That is the sense in which the term is generally used in today's artworld, including the field of art history. According to Joshua Shannon, an historian of so-called postwar art (i.e., "avant-garde art"): "In the last twenty-five years, the academic study of contemporary art has grown from a fringe of art history to the fastest-developing field in the discipline." Quoted in Hal Foster, "Contemporary Extracts," *E-Flux Journal*, January 2010 <http://www.e-flux.com/journal/contemporary-extracts/>.

10. Kenyon Cox, "The Illusion of Progress," *Artist and Public and Other Essays on Art Subjects*, New York: Scribner's, 1914, 77–98 <http://www.gutenberg.org/files/16655/16655-h/16655-h.htm#III>. By the end of the twentieth century, Cox's prescient observation that "the only title to consideration" was "to do something quite obviously new or to proclaim one's intention of doing something newer" was corroborated in a monumental study entitled *Madness and Modernism: Insanity in the Light of Modern Art, Literature, and Thought* (New York: Basic Books, 1992), by clinical psychologist Louis Sass. As Sass notes: "[A]vant-gardism [is] the 'chronic condition' or 'second nature' of modern art." (29) "The paradoxicality of entrenched avant-gardism is captured in the notion of an 'adversary culture' or 'tradition of the new,' whose only constant is change itself, whose only rule is the injunction to 'make it new.' By their very nature, such ambitions will incite the most varied forms of expression in an ever-accelerating whirl of real or pseudo-innovation (or in the constant and ironic recycling of familiar forms)." (30) Sass also aptly observes: "The first characteristic of modernism . . . is its negativism and antitraditionalism: its defiance of authority and convention, [and] its antagonism or indifference to the expectations of its audience" (29). His book is essential reading for anyone seeking to truly understand the interminable monopoly of the avant-garde.

11. [*a*] For critiques of avant-garde public art, see Michelle Marder Kamhi's aptly titled "Today's 'Public Art'—Rarely Public, Rarely Art," *Aristos*, May 1988 <http://www.aristos.org/backissu/public-art.pdf>; her recent book, *Who Says That's Art? A Commonsense View of the Visual Arts*, New York: Pro Arte Books, 2014, 224–28; and "'Public Art' for Whom?" *For Piero's Sake*, May 5, 2015 <http://www.mmkamhi.com/2015/05/05/public-art-for-whom>.

[*b*] Virtually all current public (civic) art is avant-garde. It is also controversial, as acknowledged even by its proponents. The guiding principles of the Association for Public Art (APA) in Philadelphia likely reflect the official view of most, if not all, large American cities. The organization attempts to justify such work by claiming that public art is "the artist's response to our time and place combined with our own sense of who we are." And further: "In a diverse society, all art cannot appeal to all people, nor should it be expected to do so. . . . Is it any wonder . . . that public art causes controversy?" APA's avant-garde bias is implicit in its answers to rhetorical questions it poses in tacit recognition of widespread hostility and skepticism toward the work it sponsors. For example: Q. "What is the 'art' of public art?" A. "As our society and its modes of expression evolve, so will our definitions of . . . art. . . . Q. "Why public art?" A. "It reflects and reveals our society and adds meaning to our cities" <http://tinyurl.com/WhatIsPublicArt-AssnPA-Phila>.

[*c*] The contrast between two public works in Philadelphia created three decades apart—one traditional, the other avant-garde—belie the APA's claims: *The Signer* (1982), by EvAngelos Frudakis (b. 1921) <http://tinyurl.com/Frudakis-TheSigner>, <http://tinyurl.com/About-TheSigner>; and *Maelstrom* (2009), by Roxy Paine (b. 1966) <http://tinyurl.com/RoxyPaine-Maelstrom>, <http://tinyurl.com/AboutMaelstrom-Museo>. On Frudakis, see <http://tinyurl.com/Frudakis-Daughter>. On Paine, see various biographies online.

[*d*] For further examples of current avant-garde bias, see the Chicago Public Art Program <http://tinyurl.com/ChicagoPublicArt> and the Dallas Public Art Collection <http://tinyurl.com/DallasPublicArt>.

12. PBS, *Art in the Twenty-First Century* <http://www.art21.org/films>; ART21 <http://www.art21.org>.

13. *Journal of Aesthetics and Art Criticism* <http://jaac.aesthetics-online.org>.

14. Rand, "Art and Cognition," 73. On film, see also *What Art Is*, 253–261.

15. [*a*] Stephen Davies, *Definitions of Art*, Ithaca and London: Cornell University Press, 1991, 218–19. The passage quoted, from the book's concluding section, is preceded by the following statement: "I have no formulaic definition to offer. The arguments of the previous pages tempt me to characterize art in the following terms." On Davies, see *What Art Is*, ch. 6 <http://tinyurl.com/DefinitionArt-Ch6-WhatArtIs>.

[*b*] On the rules of proper definition, see *What Art Is,* 101–03; Ayn Rand, *Introduction to Objectivist Epistemology*, 2nd ed., ed. by Harry Binswanger and Leonard Peikoff, New York: Meridian, 1990, 41–42, 50–52; Patrick J Hurley, *A Concise Introduction to Logic*, 12th ed., Independence, Ky.: Cengage, 2015; David Kelley, *The Art of Reasoning: An Introduction to Logic and Critical Thinking*, 4th ed., New York: Norton, 2013; and Lionel Ruby, *Logic: An Introduction*, 2nd ed., Chicago: Lippincott, 1960, 102–08.

16. The 1993 ASA position paper was presented by Margaret P. Battin, now Distinguished Professor, Philosophy, University of Utah. For more recent perspectives on esthetics, see my reviews of books by prominent academic philosophers: Cynthia Freeland's *But Is It Art? An Introduction to Art Theory* (New York: Oxford, 2001), "Judging a Book by Its Cover," *Aristos*, May 2003 <http://www.aristos.org/aris-03/judging.htm>; and Denis Dutton's *The Art Instinct: Beauty, Pleasure, and Human Evolution* (New York: Bloomsbury, 2009), "What Makes Art Art? Does Denis Dutton Know?" *Aristos*, April 2010 <http://www.aristos.org/aris-10/dutton.htm>. Also of interest is Dutton's response <https://web.archive.org/web/20140830072349/ http://theartinstinct.com> [search for Ayn Rand]; and my response to him, "The Ad Hom Instinct: A Reply to Denis Dutton," *Aristos*, November 2010 <http://www.aristos.org/aris-10/dutton-2.htm>.

17. As documented in *What Art Is*, 9–11, the authors I have in mind include H.W. Janson, then Anthony Janson (*History of Art*); Frederick Hartt (*Art: A History of Painting, Sculpture, and Architecture*); John Canaday (*What Is Art?*); and E.H. Gombrich (*The Story of Art*).

18. Thomas McEvilley, quoted in Amei Wallach, "Is It Art? Is It Good? And Who Says So?" *New York Times*, October 12, 1997. Wallach's piece began: "The debate continues about where art is today and *what so many people still want it to be*. . . . The *Times* asked art-world participants and observers for answers" (emphasis added). A recent article by art critic Holland Cotter echoes one of the criteria cited by McEvilley. Referring to "an installation consisting entirely of radio waves in an otherwise empty gallery," he observes: "What made such work art was the fact that it was in a gallery." "Tuning Out Digital Buzz, for an Intimate Communion with Art," *New York Times*, March 16th, 2015.

19. See Michelle Marder Kamhi, "Anti-Art Is Not Art," *What Art Is* Online, *Aristos*, June 2002 <http://www.aristos.org/whatart/anti-art.htm>; and *Who Says That's Art?*, ch. 4; as well as *What Art Is*, 172.

20. [*a*] Marilyn Stokstad and Michael Cothren, *Art History*, 5th ed., New York: Pearson, 2013. Stokstad conceived and was the sole author of the first three editions (1995, 2001, and 2007).

[*b*] With a few exceptions—such as Thomas Cole (*The Oxbow*, 1836) and Thomas Eakins (*The Gross Clinic*, 1875)—the most eminent traditional artists of the past hundred years, including those of the Hudson River School (of which Cole is considered the founder) and the Boston School, are simply airbrushed from art history, as are the greatest of today's painters inspired by them.

[*c*] On contemporary painters working in the tradition of the Hudson River School, see the Hudson River Fellowship <http://tinyurl.com/HudsonRiverFellowship>. See also, "River Crossings: Contemporary Art Comes Home," about a recent exhibition of work by a group of mostly avant-garde artists who allegedly "have a connection to the region that Thomas Cole and Frederic Church helped ignite as a hot-bed of innovative contemporary art" <http://www.rivercrossings.org/artists>.

[*d*] On the Boston School, see R.H. Ives Gammell, The Boston Painters: 1900–1930, ed. by Elizabeth Ives Hunter, Orleans, Mass: Parnassus, 1986; Christopher Volpe, "A Legacy of Beauty: Paintings in the Boston School Tradition" <http://www.tfaoi .com/aa/7aa/7aa740.htm>; and Edward J. Sozanski, "The Boston School: A City's Art of Arts," *Philadelphia Inquirer*, July 27, 1986 <http://tinyurl.com/Sozanski-BostonSchoolCitysArt>. See also Richard Lack, ed., *Realism in Revolution: The Art of the Boston School*, Dallas: Taylor, 1985; and "The New Dawn of Painting" (my review of *Realism in Revolution*), *Aristos*, March 1986 <http://www.aristos.org/backissu/ newdawn.pdf>.

[*e*] On Classical Realism, inspired by the Boston School, see Gary B. Christensen, *Richard F. Lack: Catalogue Raisonné*, with Preface by Gabriel P. Weisberg, Department of Art History, University of Minnesota, and Biography by Stephen Gjertson (Saint Paul: Afton, Fall 2015); Stephen Gjertson, "Classical Realism: A Living Artistic Tradition" <http://tinyurl.com/Gjertson-ClassicalRealism>; and Louis Torres, "The Legacy of Richard Lack," *Aristos*, December 2006 <http://www.aristos.org/aris-06/lack.htm>.

[*f*] Is bias such as that shown by Stokstad and Cothren ethical? Probably not. Section II of the College Art Association's "Standards for the Practice of Art History" states that "[s]cholarly integrity demands *an awareness of personal and cultural bias* and *openness to issues of difference* as these may inflect methodology and analysis" <http://www .collegeart.org/guidelines/histethics>, emphasis added.

21. Randy Kennedy, "Revising Art History's Big Book: Who's In and Who Comes Out?" *New York Times*, March 7, 2006. Observing that "in many colleges, the book, while as familiar as furniture, had become something to teach against," Kennedy reported that it was Joseph Jacobs, an independent scholar, critic, and art historian, who wrote the chapters on modern art in the new edition and, among other things, "beef[ed] up both Marcel Duchamp and Robert Rauschenberg, moves he said were long overdue." Since then, the 8th edition of *Janson's History of Art: The Western Tradition*, by Penelope J.E. Davies, et. al., has been issued (New York: Pearson, 2011).

22. Norman Fruman, "A Short History of the ALSC," *ALSC Newsletter* (Spring 1995) <http://www.alscw.org/LiteraryMatters_1-1.pdf>. The organization is now called the Association of Literary Scholars, Critics, and Writers (ALSCW) <http://www.alscw .org/about/index.html>.

23. Association for Art History (AAH), Statement of Purpose, as originally published on the Indiana University website. See the slightly different version circulated to members of the Art Libraries Society of North America by AAH co-founder and co-president Bruce Cole: <http://tinyurl.com/AAH-StatementOfPurpose>.

24. The other co-founder and co-president of the Association for Art History was Andrew Ladis (1949–2007), Franklin Professor of Art History at the University of Georgia.

25. [*a*] About the twelve units of the "Art Humanities: Masterpieces of Western Art" section of Columbia's core curriculum—in particular, that on Pollock and Warhol—click on "Art Humanities Syllabus" at <http://www.college.columbia

.edu/core/classes/arthum.php>, then access the "Art Humanities Website" at <http://www.learn.columbia.edu/arthumanities> [Login: ahar, PW: 826sch], and select Pollock/Warhol at top right. On Columbia's "Twentieth-Century Art" course see the description under Spring 2015 Undergraduate Courses at <http://www.columbia.edu/cu/arthistory/courses/spring-2015/spring-2015-undergraduate-courses.html>.

[*b*] The publisher of *Art Since 1900: Modernism, Antimodernism, Postmodernism* asserts that the authors "provide the most comprehensive critical history of art in the twentieth and twenty-first centuries ever published" <http://www.thamesandhudson.com/media/images/ArtSince1900-contents_24672.pdf>. As indicated by the book's subtitle and Contents page, however, they deal only with work that was either modern, anti-modern (e.g., Nazi "Degenerate 'Art'" [1937a]), or postmodern—completely omitting the traditional painting and sculpture of that period. Such an omission violates the College Art Association's ethical standards (see above, note 20*f*).

26. College Art Association, "M.F.A. Standards," 1991 <http://tinyurl.com/CAA-MFA-Standards-1991>, emphasis in original. The standards were again revised in 2008 <http://tinyurl.com/CAA-MFA-Standards-2008>.

27. Herberger Institute for Design and the Arts, School of Art, Arizona State University <http://art.asu.edu/about>. Students in the Sculpture Program at the Institute are said to be "incredibly flexible, working with great skill in diverse media, each creating their own unique definition of the field of sculpture" <http://art.asu.edu/sculpture/program>.

28. Michigan State University, Master of Fine Arts Exhibition 2005 <http://artmuseum.msu.edu/exhibitions/future/mfa/index.htm>. Regarding another such exhibition, see Louis Torres, "The Future of the Art World," *Aristos* (May 2003) <http://www.aristos.org/aris-03/acad-5c.htm>. For more recent examples, see *Who Says That's Art?*, 173. See also the latest MFA Thesis exhibitions at Yale University's School of Art (ranked #1 among Fine Arts schools by *U.S. News & World Report*) <http://art.yale.edu/1156ChapelArchive>. The Yale School of Art's Dean is Robert Storr, who was curator in the Department of Painting and Sculpture at the Museum of Modern Art, New York, from 1990 to 2002.

29. *Crossings*, Artist Statement by Mara Jevera Fulmer <http://artmuseum.msu.edu/exhibitions/future/mfa/1.htm>. Fulmer is now Associate Professor/Program Developer-Coordinator in Graphic Design, Charles Stewart Mott Community College, Flint, Michigan. On *Anger*, see Artist Statement by Katherine Krcmarik <http://www.artmuseum.msu.edu/exhibitions/future/mfa/2.htm>. Krcmarik is currently an adjunct faculty member, Fine Arts and Social Sciences Division, Mott Community College, Flint, Michigan.

30. Roberta Smith, "It May Be Good but Is It Art?" *New York Times*, September 4th, 1988 <http://tinyurl.com/Smith-ButIsItArt-NYTimes>, 1; Grace Glueck, "Art on the Firing Line," *New York Times*, July 9th, 1989 <http://tinyurl.com/Glueck//ArtOnFiringLine-NYTimes>, 3. On these and similar remarks by other critics, see *What Art Is*, 11–12. Smith is now co-chief art critic at the *Times*.

31. András Szántó (Author/Project Director), *The Visual Arts Critic: A Survey of Visual Arts Critics at General-Interest Publications in America*, National Arts Journalism Program, Columbia University, Columbia University, 2002 <http://www.najp.org/publications/researchreports/tvac.pdf>.

32. The anonymous respondent's forthright remarks continue: "Being able to interpret the mysteries bestows a certain importance on the critic, making him

essential to the whole enterprise, an insider. It can be a seductive role. It can be very, very difficult, then, for a critic to step back and make a clear-headed, unbiased appraisal, especially if doing so means pronouncing something artistically worthless or nonsensical. He's too heavily invested" <http://criticavitjkj.blogspot.com/2014/04/the-visual-art-critic-survey-of-art.html>. For a critic to make such a judgment would in effect be to declare that a thing dubbed *art* by his artworld peers is *not* art. Few have the courage to do so.

33. In *What Art Is*, Michelle Kamhi and I argue that despite continual efforts by alleged experts to "educate" the public on the merits of avant-garde work, ordinary people tend to remain unpersuaded. We offer numerous examples (3–7). For opinion pieces critical of such antitraditional work, by columnists and writers who are not art critics, as well as statements by ordinary people expressing similar views, see the Aristos Awards at <http://www.aristos.org/aris-award-3.htm>.

34. Measured against the standards implied in this essay and elaborated in *What Art Is*, not one of the eighty-four individuals cited in the survey qualifies as an "artist."

35. Mark Stevens, "Paint by Numbers," *Vanity Fair*, December 2013 <http://tinyurl.com/Stevens-PaintNumber-VanityFair>.

36. Purportedly alluding to novelist Hart Crane's suicide by drowning in 1932, *Diver* <http://www.moma.org/collection/object.php?object_id=89254> was a study for a painting of the same name. Carol Vogel, a *New York Times* art writer, has described it as follows: "Drawn on brown paper with charcoal, chalk, pastel, and probably watercolor, the work abstractly suggests a diver in motion, showing two sets of hands, one touching and pointing down as though preparing to dive and the other coming back up as if the figure were rising" ("The Modern Adds Art as Its Building Grows," December 16, 2003) <http://tinyurl.com/Vogel-ModernAddsArt-NYTimes>. *Diver* (1962–1963), in fact, does no such thing, abstractly or otherwise. See also note 37.

37. "A Happy Source of Riches in a Pair of Scowling Busts," *New York Times*, January 28th, 2005. As if one such catalogue were not enough, another is underway. See "The Catalogue Raisonné of the Drawings of Jasper Johns" (includes a photograph of Johns working on *Diver* in 1963), the Menil Collection, 2014 <http://jasperjohnsdrawings.menil.org>. See note 36, above.

38. Regarding McEvilley's views, see above, pp. 170–71; and <http://tinyurl.com/ok7qzgq>. On SVA's MFA program in Art Writing, see <http://artwriting.sva.edu/?page_id=49>.

39. That slogan is the title of the Epilogue to an official history of the NEA through 2008, which is said by the NEA to cover its "sometimes controversial history with candor, clarity, and balance." See "National Endowment for the Arts: A History, 1965–2008," ed. by Mark Bauerlein, with Ellen Grantham, 2009 <http://arts.gov/sites/default/files/nea-history-1965-2008.pdf>. See also "Arts and Public Support," my critique of the NEA, in Ronald Hamowy, *Encyclopedia of Libertarianism*, Los Angeles: Sage, 2008 <http://tinyurl.com/Torres-ArtsAndPublicSupport>.

40. On the 2015 NEA Shakespeare initiative, see <http://arts.gov/national/shakespeare>. On the 2015 Jazz Masters initiative, see <http://arts.gov/honors/jazz>.

41. About the "Operation Homecoming" initiative, see <http://www.defense.gov/news/newsarticle.aspx?id=26832>.

42. [*a*] The NEA grantmaking process is fraught with avant-garde bias. The "Objectives" section of the NEA's "Art Works" Guidelines, for example, emphasizes "innovative forms of art-making" <http://tinyurl.com/NEA-GuidelinesObjectives>.

Similarly, the Visual Arts Guidelines cite support for "contemporary artists" and their projects, "[i]nnovative uses of technology or new models in the creation of new work," and exhibitions of "contemporary art with a focus on science/technology collaborations" <http://tinyurl.com/NEA-VisualArtsGuidelines>.

[*b*] A Visual Arts grant was awarded to enable artists "to create, interpret, and present new work" at the American Academy in Rome. Originally traditionalist in its outlook and aims, the Academy (which was founded in 1894 by the neoclassical sculptors Augustus Saint-Gaudens and Daniel Chester French and other like-minded individuals) now notes that "times . . . have changed since its inception." They sure have. By its own account, it is now "a forward-moving, forward-thinking community of artists and scholars enlightened by . . . history . . . dedicated to preserving its past while linking that past to the demands and sensibilities of contemporary society" http://www.aarome.org/about/place/academy>. In today's cultural climate, one can easily guess what sort of "new work" will be featured there.

[*c*] The only direct evidence I know of regarding the NEA's avant-garde bias is a rejection letter it sent in 1988 to the recently established New York Academy of Art, turning down its application for a grant. According to Gregory Hedberg, the Academy's founder and first director, the letter stated that its "traditional education would stifle creativity in young artists." See Hedberg's essay "A New Direction in Art Education," in *Realism Revisited: The Florence Academy of Art* (Bad Frankenhausen, Germany: Panorama Museum, 2003), reprinted in the exhibition catalogue *Slow Painting: A Deliberate Renaissance* (Atlanta: Oglethorpe University Museum of Art, 2006), 11–15. Commenting on the Academy's grant rejection, Wendy Steiner (no doubt an NEA partisan) claims that, in spite of it, the NEA was "not exactly a hotbed of avant-gardism" (*The Real Real Thing: The Model in the Mirror of Art*, Chicago: University of Chicago Press, 2010, 154).

[*d*] Visual Arts Grants Panels purportedly consist of "experts with knowledge and experience in the area under review." Each of the panels is said to be "diverse with regard to geography, race and ethnicity, and artistic points of view" <http://tinyurl.com/NEA-GrantReviewProcess>. Notwithstanding alleged diversity regarding "artistic points of view," however, the five visual arts experts on each panel tend to be predominantly avant-gardist. Consider, for example, the qualifications and artistic points of view of the members of Art Works I, Panel A, for Fiscal Year 2015 <http://tinyurl.com/NEA-ArtWorksPanelA>: Bryant K. Adams, <http://bkadamsiamart.tumblr.com/bio>; Sara Daleiden, <http://www.mke-lax.org/wp-content/uploads/2012/04/soul-daleiden-about-/0213122.pdf>; Erin Riley-Lopez <http://www.albright.edu/freedman/history-mission.html>; Xochi Solis <http://xochisolis.com/about> and <http://utvac.org/about/about-vac>; and Bryan Suereth <http://www.disjecta.org>. At the NEA, it seems, anyone can be an art "expert."

[*e*] Panel recommendations are forwarded to the National Council on the Arts. The NEA's chairman has final approval, but the Council plays the most crucial role in the decisionmaking process <http://arts.gov/about/national-council-arts>. Consisting mainly of eighteen voting members appointed by the President, the Council advises the chairman (who chairs the Council). It also makes recommendations regarding such matters as funding guidelines and leadership initiatives. Two of the three current members who are visual arts professionals are staunch avant-gardists.

[*f*] A representative Council member is Olga Viso, executive director of the Walker Art Center in Minneapolis, which "ranks among the five most-visited modern/contemporary

art museums in the United States" <http://www.walkerart.org/about/mission
-history>. On Viso, see <http://arts.gov/about/national-council-arts/olga-viso> and
Susannah Schouweiler, "POV: A Chat with Walker Art Center's Director, Olga Viso," *Mn
Artists*, April 23, 2008 <http://tinyurl.com/POV-ChatWithViso>. Another member, Rick
Lowe, is an "Artist, Community Organizer" best known for having created *Project Row
Houses* (1993), an "ongoing, collaboratively produced artwork" that "emphasizes that
art can be functional rather than detached from people's needs and struggles [and] implic-
itly acknowledges that a contemporary avant-garde can exist" <http://economyexhibition
.stills.org/artists/rick-lowe/>. That project is not cited in his NEA bio <http://arts.gov/
about/national-council-arts/rick-lowe>. But further indication of its artworld status
comes from Michael Kimmelman (the former long-time chief art critic of the *New York
Times*, and now its architecture critic), who declared that *Project Row Houses* "may be
the most impressive and visionary public art project in the country" and characterized
Lowe as someone who "tried to think afresh what it meant to be a truly political artist"
("In Houston, Art Is Where the Home Is," *New York Times*, December 17th, 2006).

 43. [*a*] Regarding the reduced "American Masterpieces" initiative, see Jacqueline
Trescott, "NEA's 'Masterpieces': A Tour With Less Force," *Washington Post*, April 21st,
2005 <http://tinyurl.com/Trescott-NEA-Masterpieces>.

 [*b*] A representative Visual Arts grant was the one awarded in 2010 to the Mint
Museum in Charlotte, N.C. for the exhibition *Romare Bearden: Southern Recollections*
<http://www.mintmuseum.org/art/exhibitions/detail/romare-bearden-southern
-recollections>. Bearden (1911–1988) is generally characterized as an avant-garde or
modernist artist. See, for example, Nnamdi Elleh, "Bearden's Dialogue with Africa and
the Avant-Garde," in *Embracing the Muse, Africa and African American Art* (exhibition
catalogue), New York: Michael Rosenfeld Gallery, 2004. See also Robert O'Meally,
Kobena Mercer, et al., *Romare Bearden in the Modernist Tradition* (New York: Romare
Bearden Foundation, 2009), which discusses Bearden's relationship to modernism, post-
modernism, and the avant-garde. Bearden is best known for his collages (and pho-
tomontages)—which, like the collages of Picasso and Braque in the early twentieth
century, are not art because they are not a "selective re-creation of reality." See above,
note 5. Yet Michael Kimmelman opined that Bearden's collages "are among the glories
of American art." "Life's Abundance, Captured in a Collage," *New York Times*, October
15, 2004 <http://tinyurl.com/Kimmelman-Bearden>.

 [*c*]Regarding NEA "Visual Arts Touring"exhibitions, see <http://www.apts
.org/node/526/view>.

 44. For all the National Medal of Arts recipients since its inception in 1985, see
<http://arts.gov/honors/medals/year-all>. To be fair, two of the twenty-two whose names
I recognize were not avant-gardists—the sculptor Frederick Hart (posthumous, 2004)
and Andrew Wyeth (2007). Hart is best known for his Washington National Cathedral
Creation Sculptures <http://tinyurl.com/Hart-CreationSculptures> and his Vietnam
Veterans Memorial sculpture, *Three Soldiers* <http://mallhistory.org/items/show/64>.
On the avant-garde-inspired myth that represents Maya Lin's Wall as *the* Memorial,
ignoring the two other official parts, consisting of traditional sculptures (Hart's work and
Glenna Goodacre's *Vietnam Women's Memorial* (commemorating the nurses who
served), see my article "When Journalistic Misfeasance Becomes Felony," *Aristos*,
November 2004 <http://www.aristos.org/aris-04/nytpubed.htm>. On the controversy
over Lin's Wall and the ensuing compromise that gave rise to Hart's *Three Soldiers*, see
Tom Wolfe, "The Artist the Art World Couldn't See," *New York Times Magazine*, January

2, 2000, reprinted at <http://www.jeanstephengalleries.com/hart-wolfe.html>; and Wolfe's "Frederick Hart: Life and Passion," *Sculpture Review*, Spring 2000. See also Robert Tracy, "The Wall vs. 'Three Soldiers'" <http://tracyfineart.com/threesoldiers/>. Tracy, a painter, served two tours in Vietnam with the Marines.

45. Rosalind Ragans, *ArtTalk*, New York: McGraw-Hill, 4th ed., 2005 <http://www.weebly.com/uploads/3/2/3/0/3230217/art_talk__text_4th_ed.pdf>, 374.

46. On consciousness, Rand wrote: "Art *is* inextricably tied to man's survival . . . to that on which his physical survival depends: to the preservation and survival of his consciousness. . . . The source of art lies in the fact that man's cognitive faculty is *conceptual* –i.e., that man acquires knowledge . . . not by means of single isolated percepts, but by means of *abstractions*;" and "*Art brings man's concepts to the perceptual level of his consciousness and allows him to grasp them directly, as if they were percepts.*" *This* is the psycho-epistemological function of art and the reason for its importance in man's life" (*Romantic Manifesto*, 17 and 20, all emphases in original).

47. *ArtTalk*, 378 and 381. Ragans misdefines *realism* as a "Mid-nineteenth-century artistic style in which familiar scenes are presented as they actually appeared" (471).

48. *ArtTalk*, 381, 384–85.

49. On Duane Hanson, see *What Art Is*, 326*n*22, 464*n*91; *Who Says That's Art?*, 46, 75, 76; and Kamhi, "Modernism, Postmodernism, or Neither? A Fresh Look at 'Fine Art,'" *Aristos*, August 2005 <http://www.aristos.org/aris-05/fineart.htm>. On Richard Estes, see Ken Johnson, "'Richard Estes: Painting New York City' Features Works in Abstract Realism," *New York Times*, March 19th, 2015; and Artsy <https://www.artsy.net/artist/richard-estes>. On Chuck Close, see *What Art Is*, 281, 462*n*88, and 463*n*91; and "Portraiture or Not? The Work of Chuck Close," *Aristos*, February 2012 <http://www.aristos.org/aris-12/close.htm>. Close was one of the top ten living artists included in a contemporary artworld "pantheon" in the 2002 nationwide survey, *The Visual Arts Critic* (see above, note 31).

50. Laurie Schneider Adams, *A History of Western Art*, New York: McGraw-Hill, 2011, 1; full text at <http://www.scribd.com/doc/74004418/A-History-of-Western-Art#scribd>. Two avant-gardists who utilize animal carcasses are Damien Hirst and Marc Quinn. On Hirst, see numerous references in *Who Says That's Art?*. On Quinn, see "Cybernetic Engineered: *Cloned & Grown Rabbits*," *Factum Arte* <http://www.factum-arte.com/pag/67/Cybernetic-Engineered> and <http://www.factum-arte.com/ind/6/Marc-Quinn>.

51. *History of Western Art*, 581 <http://tinyurl.com/Adams-HistoryWesternArt>.

52. Despite the pretentious term *art educator*, the great majority of NAEA members are K–12 art *teachers*. The term "educators" appears a dozen times on the "About Us" page of the NAEA website, however, while "teachers" appears just once <http://www.arteducators.org/about-us>. As Jacques Barzun long ago pointed out, teaching refers to the process of "leading a child to knowledge, whereas education properly refers to a completed development" ("Occupational Disease: Verbal Inflation," lecture delivered before the National Art Education Association, Houston, March 18th, 1978; reprinted in *Begin Here: The Forgotten Conditions of Teaching and Learning*, 105, Chicago: University of Chicago Press, 1991. This essay should be required reading for every art teacher.

53. Alice Lai and Eric L. Ball, "Students Online as Cultured Subjects," *Studies in Art Education*, Fall 2004, 20–33 <http://eric.ed.gov/?id=EJ740502>. The authors teach at Empire State College, State University of New York.

54. Kenneth M. Lansing, "Addendum to 'Why We Need a Definition of Art,'" *Aristos* (December 2004) <http://www.aristos.org/aris-04/lansing2.htm>. On abstruseness and other lapses in scholarly writing, see my "Scholarly Engagement: When It Is Pleasurable and When It Is Not," *Journal of Ayn Rand Studies* 5:1 (Fall 2003), 105–110 <www.aristos.org/editors/jars-lt.pdf>.

55. Charles R. Garoian and Yvonne M. Gaudelius, "Performing Resistance," *Studies in Art Education*, Vol. 46, No. 1 (Fall 2004) <https://www.questia.com/library/journal/1P3-724580471/performing-resistance>. On buzzwords, see above, note 7.

56. [*a*] Carpenter is now Associate Editor of *Studies in Art Education*. He is also the "chief executive artist" for Reservoir Studio, a "social action collective." His "visual artwork" is said to "confront social issues and critique historical, cultural, and political constructs." <https://sova.psu.edu/profile/b-stephencarpenter-ii>.

[*b*] The current editor of *Art Education* is James Haywood Rolling Jr., chairman of Syracuse University's graduate and undergraduate art education programs. As a visual artist, Rolling focuses on "mixed media explorations and portraiture of the human condition, viewing studio arts practices as an essential form of social research." He is actively involved in "instigating the reconceptualization of the art education discipline as a natural nexus of interdisciplinary scholarship where visual art, design, and other creative practices intersect as an avenue of social responsibility. . . . His scholarly interests include . . . visual culture & identity politics . . . social justice & community-engaged scholarship, and narrative inquiry in qualitative research" <http://vpa.syr.edu/directory/james-haywood-rolling-jr>. See also his March 2013 article in *Art Education*, in which he suggests that in "The Hijacking of Art Education" (*Aristos*, April 2010 <http://www.aristos.org/aris-10/hijacking.htm>) Michelle Kamhi may have misconstrued "socially responsible art education practices" as "the intrusion of teachers' personal political agendas" ("Art as Social Response and Responsibility: Reframing Critical Thinking in Art Education as a Basis for Altruistic Intent," 7 <http://tinyurl.com/Carpenter-ArtSocialResponse>).

[*c*] In a recent *Art Education* editorial, Rolling notes: "[O]ur very different encounters with the art world and our varying experiences of art practice and arts pedagogy help shape our definitions of what art is" and often work "to obscure the rich interwoven nature of the larger story of the Arts" ("Interwoven Arts Education Pedagogies: From the Formalist, to the Informative, to the Transformative, to the Performative," May 2015 <http://tinyurl.com/RollingJr-InterwovenArts>). In that light, he should realize that his own experience obscures the rich nature of the traditional contemporary art that Kamhi and I write about in "What About the *Other* Face of Contemporary Art?," *Aristos*, June 2008 <http://www.aristos.org/aris-08/otherface.htm>, originally published in the March 2008 issue of *Art Education*.

57. Olivia Gude, "Postmodern Principles: In Search of a 21st Century Art Education," *Art Education*, January 2004 <http://tinyurl.com/Gude-PostmodernPrinciples>, 10. Gude is now on the Editorial Advisory Board of *Studies in Art Education*.

58. Gude, "Art Education for Democratic Life," <https://naea.digication.com/omg/Art_Education_for_Democratic_Life>. Gude's radical view of art's function in shaping the "democratic life" of students is apparent in such assertions as "[q]uality art education provides access to the art and practices of making through which today's youth can actively investigate local and global themes"; and "[i]n challenging outmoded worldviews, contemporary art prepares people to engage, to shape, (and sometimes to preserve) aspects of our ever-changing world."

59. Kamhi, "Where's the *Art* in Today's Art Education?," *What Art Is* Online, November 2002 <www.aristos.org/whatart/arted-1.htm>; and John Stinespring, "Moving from the Postmodern Trap," annual meeting of the National Art Education Association, Miami Beach, Florida, March 22nd, 2002. See also Kamhi, "Rescuing Art from 'Visual Culture Studies,'" *Aristos*, January 2004 <www.aristos.org/aris-04/rescuing.htm>, reprinted in *Arts Education Policy Review*, September/October 2004; and *Who Says That's Art?*, 174–75, 178–79, and 288*nn*22, 23. The liberal bias of art critics is openly acknowledged by Ken Johnson: "It is one of the big lies of the serious art world that anything goes. That may be the case in regard to form, material and techniques, but when it comes to cultural politics, my art world leans decidedly leftward." "Achieving Fame Without a Legacy," *New York Times*, June 22nd, 2012.

60. Eliseo Vivas, "The Objective Basis of Criticism," *Creation and Discovery: Essays in Criticism and Aesthetics*, New York: Noonday Press, 1955 <http://catalog.hathitrust.org/Record/001435972>. For the first Vivas quote on page 184 of this essay, click on "Full view." At the title page, jump to page 191 of the book and then scroll down to page 192 for my last Vivas quote. The block quote on page 185 and the quote immediately preceding it are from Vivas's Preface (ix).

61. [*a*] Following are key reviews and citations of *What Art Is* not already noted: (1) Roger Kimball, "Can Art Be Defined?" *The Public Interest*, Spring 2001, <http://tinyurl.com/Kimball-CanArtBeDefined>, reprinted, with minor revisions, in Kimball, *Art's Prospect: The Challenge of Tradition in an Age of Celebrity*, Chicago: Ivan R. Dee, 2003 (see authors' response at <http://www.aristos.org/editors/resp-pi.htm>); (2) Ronald F. Lipp, "Atlas and Art," in *Ayn Rand's* Atlas Shrugged: *A Philosophical and Literary Companion*, ed. by Edward W. Younkins, Hampshire, U.K.: Ashgate, 2007, 143–155 (on *What Art Is*, see esp. 145), <http://tinyurl.com/Lipp-AtlasAndArt-p143>; and (3) Carlin Romano, *America the Philosophical*, New York: Knopf, 2012, 363 <http://tinyurl.com/CarlinRomano-America>. (*What Art Is* is the only scholarly Rand study of many published since 1995 [the publication date of Chris Matthew Sciabarra's groundbreaking *Ayn Rand: The Russian Radical*] that is cited by Romano, who is Professor of Philosophy and Humanities at Ursinus College and Critic-at-Large of the *Chronicle of Higher Education*. He was the Literary Critic of the *Philadelphia Inquirer* from 1984 to 2009.)

[*b*] Penn State Press: (1) Michelle Marder Kamhi and Louis Torres, "Critical Neglect of Ayn Rand's Theory of Art," Vol. 2, No.1, Fall 2000, 1–46 <http://www.jstor.org/stable/41560130>; (2) The Aesthetics Symposium (a discussion of Rand's philosophy of art "inspired by" *What Art Is*), Vol. 2, No. 2, Spring 2001,<http://www.aynrandstudies.com/jars/v2_n2/2_2toc.asp>; see also <http://www.jstor.org/stable/i40075330>; (3) Kamhi,"What 'Rand's Aesthetics' Is, and Why It Matters" (Reply to The Aesthetics Symposium), Vol. 4, No. 2, Spring 2003, 413–489 <http://www.jstor.org/stable/41560230>; (4) Torres, "Scholarly Engagement: When It Is Pleasurable, and When It Is Not" (Reply to The Aesthetics Symposium), Vol. 5, No. 1, Fall 2003, 105–151 <http://www.aristos.org/editors/jars-lt.pdf>.

62. Jacques Barzun, "In Depth" interview, Book TV (C-Span 2), May 6th, 2001 (last half hour), and personal correspondence, October 5th, 2001; both quoted in "A Jacques Barzun Compendium" <http://www.aristos.org/barzun.htm>. Barzun's biographer, Michael Murray (*Jacques Barzun: Portrait of a Mind*, Savannah: Beil, 2011), notes that he was "a *cultural* historian, a practitioner of a discipline he had helped to create, in which the arts bulk large" (xv). Barzun told Murray he was a "cheerful pessimist" (xvi).

By the time they met (1979), he had concluded that the West was in decline. In 1973 he had delivered a series of lectures at the National Gallery of Art (dealing in part with the *avant-garde*), published as *The Use and Abuse of Art*, Princeton: Princeton University Press, 1974 <http://tinyurl.com/Barzun-UseAndAbuse> [search for *avant-garde* and see esp. 14, 51, and 137]. See the retroactive Aristos Award for the book at <http://www .aristos.org/aris-award-3.htm#Barzun-1974>. See also *From Dawn to Decadence: 500 Years of Western Cultural Life*, Barzun's magnum opus, published in 2000, esp. 643–651 and 713–732. I dedicate this essay to his memory.

10. More Matter and Less Art: The Pernicious Role of the Artist in Twentieth-Century Visual Art

1. October 31st, 2014 (the 497th anniversary of Luther's posting the original ninety-five Theses) I posted fifty-five theses on the front door of the Museum of Modern Art in New York, challenging them to debate the very nature of visual art. Even though Glenn Lowry's assistant recognized me, the institution has stonewalled any further response, hoping the whole matter will go away. Obviously, public opposition to this will make it impossible. A copy of the fifty-five theses is on my webpage <www.geoffbent .com> under "Writing Samples." If you think a debate on these issues will be worthwhile, email a line or two to glowry@MoMA.org or write him at Glenn Lowry, MoMA, 11 West 53rd Street, New York, NY 10019. You can't pretend to be the world forum on all things visual and ignore the occasional dissenting opinion. Thanks for your help!

About the Authors

GEOFFREY BENT has published essays that have been reprinted in *The Best American Essays* series and the international collection Shakespearean Criticism. His novel *Silent Partners* was endorsed by Scott Turow and featured in the *Chicago Reader*. His paintings have appeared in galleries and museums in twenty states. On October 31st, 2014 (the 497th anniversary of the original Ninety-Five Theses), he posted fifty-five theses on the Museum of Contemporary Art's front door, challenging the axioms of modernism. They have chosen to block the debate with silence. Please write to MoMA, 11 West 53rd Street, New York, NY 10019, and say you support Bent's challenge.

PAUL A. CANTOR is Clifton Waller Barrett Professor of English at the University of Virginia. He has taught at Harvard University in both the English and the Government Departments. From 1992 to 1999, he served on the National Council on the Humanities. He has published on a wide variety of subjects, including Shakespeare, Renaissance drama, Romanticism, modern drama, literary theory, and popular culture. His most recent books are *Literature and the Economics of Liberty* (co-edited with Stephen Cox) and *The Invisible Hand in Popular Culture: Liberty vs. Authority in American Film and TV*.

PAUL LAKE was a Stegner Fellow in poetry at Stanford University, where he received his MA He has taught English and Creative Writing at Santa Clara University and Arkansas Tech. Since 2006, he has been the poetry editor of *First Things*. His poems and essays have been widely published, and he has authored the poetry collections, *Another Kind of Travel* and *Walking Backward*, as well as two novels, *Among the Immortals* and *Cry Wolf: A Political Fable*. In 1988, he won The Porter Prize for Literary Excellence, an award given to one Arkansas writer each year. In 2013 his poetry collection *The Republic of Virtue* won the Richard Wilbur Award and was published by the University of Evansville Press.

JONATHAN LE COCQ is Professor of Music at the University of Canterbury, Christchurch, New Zealand. He studied philosophy at Warwick and music at Goldsmiths', London and Lincoln, Oxford, and his research ranges from French music of the sixteenth and seventeenth centuries to the philosophy and political economy of music. He was editor of the early music journal *The Consort*, and has been active as a performer on lute and related instruments. He is presently involved in University management as Pro-Vice-Chancellor and Dean of Arts.

MICHELLE MARDER KAMHI is an independent scholar and critic. She co-edits *Aristos*, an online review of the arts, and is the author of *Who Says That's Art? A Commonsense View of the Visual Arts* (Pro Arte Books, 2014). She also co-authored *What Art Is: The Esthetic Theory of Ayn Rand* (2000). Articles by her have appeared in the *Wall Street Journal*, *Art Education*, and *Arts Education Policy Review*, among other publications. She is a member of the American Society for Aesthetics, the National Art Education Association, and the National Association of Scholars.

ELIZABETH MILLÁN is Professor of Philosophy at DePaul University in Chicago. She works on aesthetics, German Idealism/Romanticism and Latin American Philosophy. She has published on early German Romanticism, Alexander von Humboldt, and Latin American philosophy and is the author of *Friedrich Schlegel and the Emergence of Romantic Philosophy* (2007) and co-editor (with Bärbel Frischmann) of *The New Light of German Romanticism* (Schöningh Verlag, 2008). Recently she served as guest editor, with Hugo Moreno, of a special volume on *Latin American Aesthetics* for *Symposium: Canadian Journal of Continental Philosophy* (Vol. 18, No. 2, Fall 2014) and with John Smith of *Goethe and German Idealism*, special volume of *Goethe Yearbook* (2011).

RAY SCOTT PERCIVAL obtained a BSc degree in Psychology at The University of Bolton, England, a Master's in Philosophy at The University of Warwick, and a PhD in Philosophy at The London School of Economics. He is the founder and editor of The Karl Popper Web (1995) and was for ten years (1988 to 1998) organizer of the Annual Conference on the Philosophy of Sir Karl Popper, both sponsored by the LSE, Dublin City University and The Open Society Institute, New York. The sponsorship was awarded to "a uniquely gifted individual." He taught MA students philosophy of science at the University of Lancaster and, from 2004 to 2012, he taught at the United Arab Emirates University, specializing in the philosophy of mind and the philosophy of science. He was awarded a prize for pioneering educational video podcasts at the University. Since 1990, he has published many scholarly articles and also reviews for *Nature*, *New Scientist*, *Science Spectrum*, the *Times Higher* Educational *Supplement*, and *National Review*. In 2000 Percival was listed by Baron's Who's Who as one of five hundred "world leaders for the new century." He is the author of *The Myth of the Closed Mind: Explaining Why and How People are Rational*, and produces the YouTube channel: Ray Scott Percival.

HENNING TEGTMEYER is Associate Professor for Metaphysics and Philosophy of Religion at the Hoger Instituut voor Wijsbegeerte at KU Leuven. He received his PhD in 2004 and completed his *Habilitation* in 2012, both at the University of Leipzig. He is the author of *Formbezug und Weltbezug. Die Deutungsoffenheit der Kunst* (2006); *Kunst* (de Gruyter, 2008) and co-editor (with S. Herrmann-Sinai), of *Metaphysik der Hoffnung: Ernst Bloch als Denker des Humanen* (2012) and (with S. Rödl) of *Sinnkritisches Philosophieren* (2013), and author of *Gott, Geist, Vernunft: Prinzipien und Probleme der Natürlichen Theologie* (2013).

LOUIS TORRES is an independent scholar and critic. He is co-editor of *Aristos*, an online review of the arts which he founded as a print journal in 1982, and is co-author of *What Art Is: The Esthetic Theory of Ayn Rand* (2000). Articles by him have appeared in *Art Education*, the *Journal of Ayn Rand Studies*, and *The Encyclopedia of Libertarianism*.

He is a member of the American Society for Aesthetics, the National Association of Scholars, and the National Art Education Association. At present he is writing a book with the working title *Trust Betrayed*, which examines the role of trustees in promoting avant-garde incursions into traditional art museums and other public institutions.

FREDERICK TURNER, Founders Professor of Arts and Humanities at the University of Texas at Dallas, was educated at Oxford University. A poet, critic, interdiciplinary scholar, public intellectual, translator, and former editor of *The Kenyon Review*, he has authored over thirty books, including *Shakespeare and the Nature of Time*; *Genesis: an Epic Poem; Beauty; The Value of Values; The Culture of Hope; Hadean Eclogues; Shakespeare's Twenty-First Century Economics; Paradise: Selected Poems 1990-2003, Two Ghost Poems,* and *Epic: Form, Content, and History*. His many honors include the Levinson prize for poetry and the Milan Fust Prize, Hungary's highest literary honor.

Index

233